Imagined Israel(s)

Jewish Identities in a Changing World

General Editors

Eliezer Ben-Rafael
Yosef Gorny
Judit Bokser Liwerant

VOLUME 35

The titles published in this series are listed at *brill.com/jicw*

Imagined Israel(s)

Representations of the Jewish State in the Arts

Edited by

Rocco Giansante
Luna Goldberg

BRILL

LEIDEN | BOSTON

Cover illustration: Gal Weinstein, *Sun Stand Still*, 2017 metallic wool and felt and plywood 648 × 678 cm Israel Pavilion, Venice Biennale, 2017. Photo by: Elad Sarig.

The publication of this book is made possible with the aid of The Alexander R. Dushkin Fund of the Avraham Harman Institute of Contemporary Jewry, The Hebrew University of Jerusalem.

Library of Congress Cataloging-in-Publication Data

Names: Giansante, Rocco, 1977– editor. | Goldberg, Luna, editor.
Title: Imagined Israel(s): representations of the Jewish state in the arts
 / edited by Rocco Giansante, Luna Goldberg.
Description: Leiden ; Boston : Brill, [2023] | Series: Jewish identities in a changing world, 15707997 ; volume 35 | Includes index. | Summary: "The return of Jews to their ancestral land can be seen as an act of imagination. A new country, citizenship, language, and institutions needed to be imagined in order to be created. The arts, too, have contributed to this act of envisioning and shaping the Jewish state. By examining artistic representations of Israel, Imagined Israel(s): Representations of the Jewish State in the Arts explores the ways in which the Israel imagined abroad and the one conjured within the country intersect, offering a space for the co-existence of sociopolitical, cultural, and ideological differences and tensions"—Provided by publisher.
Identifiers: LCCN 2022056943 (print) | LCCN 2022056944 (ebook) |
 ISBN 9789004530072 (hardback) | ISBN 9789004530720 (ebook)
Subjects: LCSH: Arts, Israeli. | Popular culture—Israel. |
 Israel—Civilization. | Israel—In art.
Classification: LCC NX573.7.A1 I43 2023 (print) | LCC NX573.7.A1 (ebook)
 | DDC 704.9/4995694—dc23/eng/20230105
LC record available at https://lccn.loc.gov/2022056943
LC ebook record available at https://lccn.loc.gov/2022056944

Typeface for the Latin, Greek, and Cyrillic scripts: "Brill". See and download: brill.com/brill-typeface.

ISSN 1570-7997
ISBN 978-90-04-53007-2 (hardback)
ISBN 978-90-04-53072-0 (e-book)

Copyright 2023 by Rocco Giansante and Luna Goldberg. Published by Koninklijke Brill NV, Leiden, The Netherlands.
Koninklijke Brill NV incorporates the imprints Brill, Brill Nijhoff, Brill Hotei, Brill Schöningh, Brill Fink, Brill mentis, Vandenhoeck & Ruprecht, Böhlau, V&R unipress and Wageningen Academic.
Koninklijke Brill NV reserves the right to protect this publication against unauthorized use. Requests for re-use and/or translations must be addressed to Koninklijke Brill NV via brill.com or copyright.com.

This book is printed on acid-free paper and produced in a sustainable manner.

Contents

List of Figures IX

Introduction 1
 Rocco Giansante and Luna Goldberg

PART 1
Building from the Ground up: Landscape, Language, and Culture

1 The Visual Type as an Image of a People: Hebrew Typography throughout History and Its Representation of Jewish and Israeli Identity 19
 Guy Eldar

2 Fictional Canon: Reconsidering Karl Schwarz's *Modern Jewish Art in Palestine* 40
 Noa Avron Barak

3 Taming the Levant: Reflections on Zionism, Orientalism, and Depictions of Tel Aviv-Yaffo in Israeli and International Comics 55
 Ofer Berenstein

PART 2
Consuming Images: Israel in America

4 Fractured Communities, Anxious Identities: Reconsidering Israel on the American Stage 79
 Ellen W. Kaplan

5 The Sabra within the Schlemiel: Diverging Modes of American Jewish and Israeli Masculinity in Jewish American Literature 95
 Samantha Pickette

6 Messianic Affinities: Tali Keren's *The Great Seal* and *Un-Charting* 110
 Chelsea Haines

7 The Short Life of the Israeli Superspy: Imagining Israel in
 Twentieth-Century American Crime Fiction 129
 Reeva Spector Simon

8 Israel through the Viewfinder: Claude Lanzmann and Susan Sontag Film
 the Jewish State 145
 Rocco Giansante

PART 3
Within, without: Becoming Glocal

9 Tarnishing History through Matter: Gal Weinstein's *Sun Stand Still* at the
 Israeli Pavilion in Venice 161
 Luna Goldberg

10 Contemporizing (Yemenite) Ethnicity: Hybrid Folklore in Mor Shani's
 "Three Suggestions for Dealing with Time" Dance Trilogy for Inbal
 Dance Theater 176
 Idit Suslik

11 A Rough, Country Face: an Iranian Intellectual Retells
 the Holocaust 196
 Samuel Thrope

12 Imagined Israel? Israel in Contemporary British Theater 204
 Glenda Abramson

PART 4
Realizing Visions: Israel Reimagined

13 Resemblance, Difference, and Simulacrum in Palestinian and
 Israeli Parafiction Art 231
 Keren Goldberg

14 Playing Soldiers: Reimagining the Israeli Defense Forces on the Fringe Stage 257
 Jacob Hellman

15 Disrupting Holy Binaries: the Work of Gil and Rona Yefman 279
 Yarden Stern

 Index 299

Figures

1.1 David full typeface family, reproduced by Monotype, 2012 28
1.2 Michal Shomer's multi-gender "Welcome" sign (set in Alef typeface), https://multigenderhebrew.com/ 35
2.1 *Six Out of More than Two Hundred: Mizrachi Artists according to Zalmona*, Ortal Ben Dayan, 2010 40
2.2 *Nine Out of More Than Four Hundred – The Mizrachim By Kirshenbaum*, Meir Gal, 1997 41
3.1 *Impression de Tel Aviv*, Giardino, 2007 62
6.1 *The Great Seal*, Interactive installation/performance. Teleprompters, microphone, touch screen, speakers, 12 × 12 feet custom printed rug, HD video, HD monitors, Tali Keren, 2016–2018 112
6.2 *Un-Charting*, 180-degree curved screen with 3D animation. Installation view, Tali Keren, 2021 122
6.3 *Un-Charting*, 180-degree curved screen with 3D animation. Video still, Tali Keren, 2021 122
7.1 Cover art: Andrew Sugar, *The Aswan Assignment*, photo by author 136
7.2 Cover art: books by Nelson DeMille published in 1979 and 2000, photo by author 142
9.1 Map of the Giardini, 26th Venice Biennale catalogue, published June 14, 1952 164
9.2 Exterior of the Israeli Pavilion, designed by Zeev Rechter, 1952, image by Luna Goldberg 168
9.3 *Jezreel Valley in the Dark, Sun Stand Still*, Gal Weinstein, 2017. Coffee, polyurethane, metallic wool, felt, and plywood, Israel Pavilion, Venice Biennale, 2017, images by Luna Goldberg and Claudio Franzini 170
9.4 Installation and detail shots of *Ornament, Sun Stand Still*, Gal Weinstein, 2017, images by Lee Barbu 171
10.1 *While the Fireflies Disappear* (2018). Choreography: Mor Shani. Performed by Inbal Dance Theater, photo by Efrat Mazor 186
10.2 *Lechet* (2020). Choreography: Mor Shani. Performed by Inbal Dance Theater, photo by Efrat Mazor 189
13.1 Tamir Zadok, *Gaza Canal*, 2010, 09:00 min video, film still, image courtesy of the artist 233
13.2 Khaled Jarrar, *State of Palestine*, 2011, the design of a passport stamp, c-print diasec on aluminum, 125 cm (diameter), image courtesy of Wilde Gallery 243
13.3 A passport stamped with Khaled Jarrar's *State of Palestine* stamp, image courtesy of the artist 244

13.4 Allison Carmel's cancelled passport, image courtesy of the artist 245
13.5 Khaled Jarrar, *State of Palestine*, 2012, German post edition, 26 × 18 cm, edition of 50, image courtesy of Wilde Gallery 246
13.6 Khaled Jarrar, *State of Palestine*, 2015, Anemone stamps, C-print on diasect, 145 × 165 cm, image courtesy of Wilde Gallery 247
13.7 Khaled Jarrar, *State of Palestine*, 2020, annexation postal stamp design, image courtesy of the artist 252
15.1 *The Garden of Eden*, Rona Yefman, 2002 279
15.2 *Gil on The Rocks*, Rona Yefman, 1995 283
15.3 *Owls*, Rona Yefman, 1998 285
15.4 *Sexual Dependency*, Rona Yefman, 1998 289
15.5 *One Summer Evening*, Gil Yefman, 2006 291
15.6 *Tumtum*, Gil Yefman, 2008 293
15.7 *Rona&I Doll*, Gil Yefman, 2010 295

Introduction

Rocco Giansante and Luna Goldberg

1 Israel and the Diaspora

The relationship between Israel and the Jewish communities around the world has always been complex, intermittently moving between the opposite poles of rejection and embrace. The establishment of the State of Israel, in the mind of its founders, was meant to sanction the end of the millennia-long diasporic experience and announce the return of all Jews to the Motherland, thus normalizing Jewish existence: they were a people like any other, and could live as such together in one place.

This project of normalization captured the imagination of many Jews, but it also generated resistance and outright rejection. In pre-Holocaust Europe, many Jews embraced and cherished their national identities. The Yiddish-speaking workers of the socialist Bund party (i.e., the Algemeyner Yidisher Arbeter Bund in Lite, Poyln, un Rusland, or the "General Jewish Workers' Union in Lithuania, Poland, and Russia"), for example, expressed their commitment to the places and societies in which they lived by using the concept of *doikayt* ("hereness"), which describes an attachment to and an investment in the European homelands of Yiddish-speaking Jews, as opposed to Ottoman/Mandate Palestine or the Americas.

The opposition to the Zionist project continued to surface also after World War II and the destruction of the European Jewish civilization. In the United States, the Reform movement, renouncing ethnocentrism to promote an interpretation of Judaism that could be in harmony with the modalities of the American way of life, elected North America—the *Goldene Medina*—as the promised land that would secure the prosperity of and a secure future for the Jewish people. In many ways, the Six-Day War (1967) affected the relationship between diaspora Jews and Israel, investing the Jewish state with a central role in the construction of Jewish identity in the diaspora. The images of the victorious Israeli army defeating Egyptians and Jordanians, entering the Old City of Jerusalem, and conquering the locations of the biblical narrative, filled with pride many Jews who discovered the existence of Jewish power. The centrality of the Jewish state in the construction of Jewish identities became even more evident in the European context of smaller Diasporic communities returning to life after the Holocaust.

This rapprochement between Israel and the diaspora proved to be temporary. Since the 1980s, an array of reasons connected to the political (the Israeli-Palestinian conflict), the religious (the decline of religious sentiment and the personalization of religion), and the sociological (the digital revolution and new modes of living) have complicated this relationship even more, radicalizing attitudes and multiplying the forms of disengagement from and engagement with Israel beyond the Zionist-non-Zionist binary. The complexity of the Israeli-diaspora relationship has become a source of anxiety for Jewish leaders and institutions, who are worried that the weakening of the bond between the Jewish state and young Jews around the world may negatively affect their commitment to the Jewish people and to Jewish identity. Moreover, because of the identification of mainstream Jewish institutions with Zionism, the anti-Zionist stance can be read as a revolt against the Jewish establishment and the creation of a grassroots Judaism that challenges the monopoly of actors such as synagogues, federations, organizations, and rabbinical associations.

Aside from being a concern to Jewish professionals and cultural institutions, the relationship between Israel and the diaspora has become an important object of study in academia. Dov Waxman's *Trouble in the Tribe: The American Jewish Conflict over Israel*, for example, explores the place of Israel in the American Jewish community, arguing that "Israel is fast becoming a source of disunity for American Jewry, and that a new era of American Jewish conflict over Israel is replacing the old era of solidarity."[1] The alarming description contained in Waxman's book finds a more optimistic counterpoint in Theodore Sasson's *The New American Zionism*: "Across multiple fields, including advocacy, philanthropy, and tourism, American Jews have stepped up their level of engagement with Israel. Attitudinally, they remain as emotionally attached to Israel as they have been at any point during the past quarter-century." Despite this, continues Sasson, "the relationship of American Jews to Israel has changed in several important ways."[2] For this reason, studies on the topic of Israel and the diaspora have multiplied. Volumes like *We Stand Divided: The Rift between American Jews and Israel* by Daniel Gordis, *The Israeli Century: How the Zionist Revolution Changed History and Reinvented Judaism* by Yossi Shain, and *Israeli Judaism: Portrait of a Cultural Revolution* by Shmuel Rosner, Camil Fuchs, and Eylon Levy highlight the differences between the (mostly American) Jewish experience and the Israeli one.[3] Focusing on political, social, and ideological

[1] https://press.princeton.edu/books/hardcover/9780691168999/trouble-in-the-tribe, accessed January 1, 2020. See Dov Waxman, *Trouble in the Tribe: The American Jewish Conflict over Israel* (Princeton, NJ: Princeton University Press, 2016).

[2] Theodore Sasson, *The New American Zionism* (New York: New York University Press, 2014), 2.

[3] Daniel Gordis, *We Stand Divided: The Rift between American Jews and Israel* (New York: HarperCollins, 2019); Yossi Shain, *The Israeli Century: How the Zionist Revolution Changed*

trends, these volumes describe the process of the Israelization of Judaism, and discuss the differences between Israeli Jews and the Jews of the world.

Omri Asscher's *Reading Israel, Reading America: The Politics of Translation between Jews* tackles the clash between American and Israeli Jews over the contours of Jewish identity by considering the translations of American Jewish novels in Israel and Israeli Jewish novels in America. In the "misunderstandings" that characterize the translations—with their omissions and additions—Asscher sees the manifestation of the cultural tensions between Israeli and American Jewry.[4]

Imagined Israel(s) enters this conversation by analyzing the interaction between Israel and the diaspora in the arts. By confronting the representations of Israel—produced in and out of the country—this volume suggests a different way to consider the relationship between the Jewish state and the Jews around the world. Beyond the lenses of politics, sociology, and religion, the reflection on the multiple ways in which Israel is imagined not only generates a novel perspective on the country, but functions as a bridge between the many attitudes toward Israel.

While other volumes have looked at the representations of Israel in the arts,[5] *Imagined Israel(s)* is the only book to our knowledge that draws on artistic production both in Israel and abroad as a means of presenting a nuanced image of Israel, which stretches beyond stereotypical representations of war and conflict, while also encompassing the experience and perspective of the Jewish diaspora and other communities.

2 Art and Nation-Building: Israel at the Venice Biennale

Since its inception, the Venice Biennale has served as an archetype for biennials. The oldest international art exhibition of its kind, the Venice Biennale was first held in 1895 and functioned much like a world's fair, bringing together nations through a focus on contemporary art. In its early years, the Biennale

History and Reinvented Judaism (New York: Wicked Son, 2021); Shmuel Rosner, Camil Fuchs, and Eylon Levy, *Israeli Judaism: Portrait of a Cultural Revolution* (Jerusalem: The Jewish People Policy Institute, 2019).

4 Omri Asscher, *Reading Israel, Reading America: The Politics of Translation between Jews* (Stanford, CA: Stanford University Press, 2020).

5 Eran Kaplan's *Projecting the Nation: History and Ideology on the Israeli Screen* (New Brunswick, NJ: Rutgers University Press, 2020) considers Israeli history through film. Rachel S. Harris and Ranen Omer-Sherman, the editors of *Narratives of Dissent: War in Contemporary Israeli Arts and Culture* (Detroit: Wayne State University Press, 2012), survey a number of contemporary projects in the fields of visual arts, music, literature, poetry, film, and theater, focusing on Israel's wars.

took the form of one salon-style exhibition in the Central Pavilion. Featuring both Italian and international artists, each country could exhibit one to two works by invitation. By 1907, however, foreign countries were invited to build national pavilions around the Central Pavilion in the Giardini, each presenting the work of one or more artists to represent the nation. A means of revitalizing portions of the city that were previously abandoned and of repositioning Venice within an international context, the Biennale sought to provide a platform to showcase works of international artists, improve diplomatic or international relations, and generate tourism by attracting visitors from abroad.

Yet, a closer look at the countries holding pavilions in the Giardini exposes a source of much criticism for the Biennale model—its foundation as a platform through which powerful nations could showcase national cultural production. The 30 permanent pavilions in the Giardini represent leading nations such as the United States, France, and Switzerland, countries that held significant economic power and global influence in the twentieth century.[6] While Israel's pavilion was built in 1952, the initial correspondence about building a pavilion in Venice predates the Jewish state, indicating stakeholders' already present preoccupation with Israel's image on a global stage.

In their lecture "Disrupting Utopia: Hans Haacke's Germania or Digging Up the History of the Venice Biennale," Miriam Jordan and Julian Jason Haladyn elaborate on the role and function of national pavilions. They note:

6 The full list of countries with national pavilions built in chronological order along with their architects includes:

"1907 Belgium (Léon Sneyens); 1909 Hungary (Géza Rintel Maróti); 1909 Germany (Daniele Donghi) demolished and rebuilt in 1938 (Ernst Haiger); 1909 Great Britain (Edwin Alfred Rickards); 1912 France (Umberto Bellotto); 1912 Netherlands (Gustav Ferdinand Boberg) demolished and rebuilt in 1953 (Gerrit Thomas Rietveld); 1914 Russia (Aleksej V. Scusev); 1922 Spain (Javier De Luque) with facade renovated in 1952 by Joaquin Vaquero Palacios; 1926 Czech Republic and Slovak Republic (Otakar Novotny); 1930 United States of America (Chester Holmes Aldrich and William Adams Delano); 1932 Denmark (Carl Brummer) expanded in 1958 by Peter Koch; [1932 Polish Pavilion;] 1932 Venice Pavilion (Brenno del Giudice), expanded in 1938; 1934 Austria (Josef Hoffmann); 1934 Greece (M. Papandreou—B. Del Giudice); 1952 Israel (Zeev Rechter); 1952 Switzerland (Bruno Giacometti); 1954 Venezuela (Carlo Scarpa); 1956 Japan (Takamasa Yoshizaka); 1956 Finland (Hall Alvar Aalto); 1958 Canada (BBPR Group, Gian Luigi Banfi, Ludovico Barbiano of Belgiojoso, Enrico Peressutti, Ernesto Nathan Rogers); 1960 Uruguay; 1962 Nordic Countries: Sweden, Norway, Finland (Sverre Fehn); 1964 Brazil (Amerigo Marchesin); 1987 Australia (Philip Cox), rebuilt in 2015 (J. Denton, B. Corker, B. Marshall); [and] 1995 Korea (Seok Chul Kim and Franco Mancuso)." For more information, see "Giardini Della Biennale," *La Biennale di Venezia*, February 15, 2019, https://www.labiennale.org/en/venues/giardini-della-biennale.

The pavilion of a country at an international exhibition, such as the Venice Biennale, is not simply a space for exhibiting artwork or cultural artifacts, but functions as an arena for the construction of a national or supra-national identity. This identity, predicated upon the political and economic motives of the specific country exhibiting, forms a representation of the nation as a progressive and cultural empire or enterprise.[7]

As with Hans Haacke's iconic 1993 intervention in the German Pavilion, Israeli artists too have sought to question and criticize the idealized or utopic image of the nation presented by the pavilion and its architecture through methodologies of critique. In recent years, however, the repetition of such works has become a recurring trope within the biennial circuit. Often commissioned by a country's State Department or Ministry of Culture, the means of critique "can easily become extensions of the [nation]'s own self-promotional apparatus, [where] the artist becomes a commodity with a purchase on 'criticality.'"[8] Deemed critical within reason, the artists and their works thus become a mechanism through which the nation can present itself as progressive, and the artists' criticality can be subject to getting lost amid the spectacle of the works.[9]

In 2011, for instance, Shimon Peres, a politician who served as both the Prime Minister and President of Israel over the course of his career, gave a speech for

[7] Miriam Jordan and Julian Jason Haladyn, "Disrupting Utopia: Hans Haacke's Germania or Digging Up the History of the Venice Biennale" (lecture presented at the conference Charged Circuits: Questioning International Exhibition Practices, Concordia University, Montreal, QC, March 14, 2008).

[8] Miwon Kwon, "One Place after Another: Notes on Site Specificity," *October* 80 (1997): 85–110, here 102. It is important to note that Israeli Pavilion exhibitions are primarily funded by the Israeli Ministry of Culture, inevitably complicating the notion of subversion or critique within this context, as the Ministry is active in the selection of artists representing the state. While the artist selection process shifts from year to year, artists and their proposals must be approved by the Ministry in order to exhibit in the national pavilion.

[9] It is worth mentioning that while these artists intentionally engage in a critical discourse around the nation, the materiality and aesthetic qualities of their works forge yet another entry point into their exhibitions. As Caroline Jones emphasizes in her book, *The Global Work of Art: World's Fairs, Biennials, and the Aesthetics of Experience* (Chicago: University of Chicago Press, 2017), Biennial culture has grown to embrace art as experience. A growing phenomenon and means of staging the nation, works on display in Venice (among other biennials) have increasingly taken the form of installation-based, performative, and multimedia works for visitors to both consume and become part of. Israeli artists too have shifted toward these modes of art-making, something we will examine more closely in relation to the structural interventions that the artists enact in the Israeli Pavilion. Yet in their materiality and performativity, the critical and political commentary ingrained within the works are often at risk of being overlooked, problematizing the reception of such works. See Jones, *The Global Work of Art: World's Fairs, Biennials, and the Aesthetics of Experience*, 86.

the opening of Sigalit Landau's Biennale exhibition, *One Man's Floor Is Another Man's Feelings*. Peres began with an aside on Italy, a nation whose long and rich history has rendered the country "a museum from the beginning to the end ... a place which is still romantic [today]."[10] Shifting toward Israel, he went on to speak of the Jewish state and its accomplishments, adapting his rhetoric about the nation to the artistic production that was being shown in the Israeli Pavilion. He noted:

> You know, Israel is 63 years old, and in those 63 years, we tried to translate a dream into a reality, quite successfully. Now, the artists say what are you doing? Who asked you to replace a dream with a reality? What we have to do is to replace a reality with a dream. Let us dream again.[11]

Here, Peres's speech can be read in two ways. Referencing the Zionist dream of settlement and the return to Eretz Yisrael (the "Land of Israel"), his language imposes or rather implies a certain politicized (patriotic or nationalistic) reading of the work, stripping it of its critical lens on the nation. Through this frame, Landau's exhibition, whose works accompany Peres's words, is read not as a reflection on the sociopolitical issues that plague the state and the region, but rather as an idyllic, even utopic image or representation of the nation—advocating a return to this dream, to the nation's Zionist roots and ideals. In his closing remarks, Peres further related this national "dream" to the Italian context by drawing attention to the Italian-Israeli partnership in the international exhibition. Addressing the President of the Biennale among others, he exclaimed: "When I see the Italian romance and the renewal of our dream, it's a great match, and I really want to thank you for hosting our dream in your romance, it goes together and it is an instinctive understanding."[12] Again, here, words such as "renewal," "dream," and even "romance" are charged with the weight of the nation's past and the image it sought to promote within the Biennale platform. Through Peres's speech, we can witness how exhibitions in international contexts such as the Biennale are instrumentalized by political forces for the sake of both nation-branding and the furthering of international relations.

10 Shimon Peres, "Opening Speech for Sigalit Landau's *One Man's Floor is Another Man's Feelings*" (speech, 54th Venice Biennale, Israeli Pavilion, Venice, Italy, June 3, 2008), accessed April 15, 2018, http://www.kamelmennour.com/media/4870/sigalit-landau-opening-speech-by-president-shimon-peres.html.
11 Ibid.
12 Ibid.

INTRODUCTION 7

A second reading of Peres's speech, however, offers another interpretation—one perhaps more conscious of the current failures and tensions inherent in the state. Here, the reversal in meaning lies in his use of the words "reality" and "dream." In his segment positing an artistic need to "replace a reality with a dream," one can assume that Peres is suggesting or referring to a reality that is imperfect, one in need of repair, perhaps in light of the state's current political instability. Through this lens, we can interpret his words to insinuate that through their works artists are responding to the contemporary situation and reimagining what a "reality" for the nation could be. By using language that resists a particular interpretation, Peres's speech retains an ambiguous quality. His choice of words and the references he adopted thus allow for slippage in the meaning of his content, much like the artistic interventions that have marked the Israeli Pavilion, and whose meanings shift according to one's disposition. This volume will examine a number of works created by artists both within and outside of Israel, which, by existing within the gap between national representation and critique, allow for multiple interpretations and projections of Israel.

3 Israeli Images from Abroad: Counterimages?

Whereas the representation of the Israeli state on a platform as renowned as the Biennale has undoubtedly been influenced and manipulated by the government, artists working outside of Israel have also tried to shape perceptions of the country. How does one go about capturing the multiplicity and complexity of a place, its people, and lifestyles? This very question is at the heart of French photographer Frédéric Brenner's project *This Place*. Initiated in 2005, *This Place* was conceived as an exhibition featuring works by 12 contemporary photographers who set out to present "a visual counter-argument to the prevailing, often polarised, representations of Israel and the West Bank in both national and international news media. Whilst on the one hand acknowledging and paying heed to the region's ongoing conflicts, *This Place* also asks that we look beyond this—that we widen and multiply our lens."[13] Taken between 2009 and 2012, the photographs that make up the exhibition range in subject matter and style, having been taken by celebrated international photographers including Wendy Ewald, Martin Kollar, Josef Koudelka, Jungjin Lee, Gilles

13 Charlotte Cotton, "This Place: Introduction," *This Place*, accessed February 16, 2022, http://www.this-place.org/about/introduction/.

Peress, Fazal Sheikh, Stephen Shore, Rosalind Solomon, Thomas Struth, Jeff Wall, Nick Waplington, and Brenner himself.

In capturing images for *This Place*, the participating photographers approached the project from their own lens, each artist meditating on that which was most captivating to them. Fazal Sheikh, for instance, chose to document traces of displacement from the Arab-Israeli War of 1948 and its ongoing impact on Palestinian and Bedouin communities. Aerial images of the desert capture how the land has been altered over time as a result of afforestation, development, militarization, and demolition. Stephen Shore, on the other hand, focused on contested landscapes and architecture across Israel and the West Bank, photographing sites of historic and religious importance as well as street scenes and individual subjects. Whereas Sheikh and Shore turned toward the land, Wendy Ewald used *This Place* as a platform to collaborate with 14 communities across the region to create "a collective portrait of life in Israel and the West Bank. She worked with shopkeepers in the Jerusalem market, Gypsy children in the Old City, elderly Palestinian women in East Jerusalem, high-tech workers in Tel Aviv, as well as elementary schools in Nazareth and military academies."[14]

For years, the exhibition traveled throughout Europe and Israel, as well as to institutions—many of them universities—across the United States. It served as a starting point for dialogue, with many university museums encouraging faculty to use the exhibition for interdisciplinary and cross-campus collaborations and to develop programming around the region itself. In 2016, when on view at the Brooklyn Museum, the exhibition also became a site and catalyst for a protest organized by the Decolonial Cultural Front and Movement to Protect the People.[15] The protesters "expressed their concerns with the 'artwashing' of serious issues in Israel and Palestine," and accused the exhibition of instrumentalizing art and artists "to normalize oppression, displacement, and dispossession of people."[16] Specifically, the group called attention to the funders of the exhibition, many of which have donated funds to the Israeli Defense Forces. This reception, in and of itself, underlines Israel's complicated position globally. Much like each photographer's body of work captured and fulfilled its maker's desires, so too did the exhibition—a desire meant to create "a diverse and fragmented portrait, alive to all the rifts and paradoxes of this

14 Wendy Ewald, "This Is Where I Live," *This Place*, accessed February 20, 2022, http://www.this-place.org/photographers/wendy-ewald/.

15 Rebecca McCarthy, "Faced with Brooklyn Museum Inaction, Protesters Target Two Exhibitions," *Hyperallergic*, July 28, 2016, https://hyperallergic.com/297401/faced-with-brooklyn-museum-inaction-protesters-target-two-exhibitions/.

16 Ibid.

important and much contested space," so as to become a screen onto which viewers could map their own projections of the country.[17]

4 Screens and Media: the Intersection of Visions

The image of Israel on the global stage is the product of the intersection between what it projects externally and what is projected onto it. While the state exports positive images in order to influence public opinion and while private actors may publish critical representations of the nation, the non-Israeli uses Israel as a screen onto which an imagined country is projected. This is the case of the Jewish diaspora, whose relationship with Israel is charged with elements that are strictly connected to its internal dynamics as well as to those dynamics not connected to the Jewish state, whose perceptions are greatly shaped by the international spotlight on the nation and the conflicts within it.

The arts have long served the purpose of representing a nation and embodying a country's lasting values while fostering a sense of collective memory. In today's globalized world, they further function as a means of critical self-reflection on the nation, contemporary culture, and politics. The Israeli Pavilion at the Venice Biennale, for instance, offers a platform for both the promotion of the Israeli state on a global stage as well as a critique of the Israeli nation-state on behalf of national artists. Meanwhile, artists abroad evoke another Israel, which speaks to the visions and hopes of the diaspora built on Zionist mythologies, biblical prophecies, socialist humanism, and negation. The projections of Israel produced by the nation's artistic communities and by non-Israelis suggest an intermediate space with an expanded vision of Israel, "which gives rise to something different, something new and unrecognizable, a new area of negotiation of meaning and representation."[18]

The objective of our edited volume is to present this expanded vision of Israel encompassing ideological approaches, political beliefs, and cultural identities to complicate the image of Israel and to showcase the value of the arts in reimagining national narratives and memory. These acts of reimagination allow for an alternative gaze to see through the many layers of identity and self-representation, with the aim of radically reconfiguring who has the authority to mold the immaterial landscape of the nation.

17 Cotton, "This Place: Introduction."
18 Homi K. Bhahba, *The Location of Culture* (1994; repr. London: Routledge, 2006).

To this day, the transnational space of Israeli art has yet to be fully mapped out despite the fact that "the concept of transnational [studies] is now an established area of enquiry"[19] serving scholars who recognize the limitations affecting the paradigm of the nation, especially when addressing cultural phenomena generated and consumed in a world that is increasingly interconnected, multicultural, and polycentric. In *Imagined Israel(s)*, contributors identify and investigate specific manifestations of Israeli transnationality through the arts: the films of Diasporic Jewish filmmakers focusing on Israel, the literature of American and European Jews describing their relation to the Jewish state, the movements of Israeli choreographers conceptualizing the experience of Jewish self-determination, the work of artists visualizing the complexities and political reality of Israel today. Ours should not be considered an attempt to "Israelize" Jewish artists from around the world: their inclusion in a study about transnational Israeli art cinema is justified not only by the singularity of Jewish peoplehood that still persists today "amid a world of diversified, new and expanded diasporas,"[20] but, more importantly, by the centrality of Israel, both as a country and as a symbol, in the construction of Jewish identities worldwide.

On the screen, on the page, and on the canvas, the image(s) of Israel produced by Israel's artistic establishment stand next to several works about Israel produced by non-Israelis. These works evoke another Israel, which speaks about the visions and hopes of the diaspora. Shmuel Eisenstadt writes: "Many Jews search in Israel for the manifestation of those dimensions of Jewish existence and themes of Jewish civilization for which they longed; not only those of political and military strength and collective identity, but also those of social justice, full religious fulfillment, or for some great civilizationary vision, as well as those of 'simple' communal-familial Jewish solidarity."[21]

5 Book Overview

The purpose of this edited volume is, first of all, to establish connections between the imagery generated by Israeli artists from within the country

[19] Will Higbee and Song Hwee Lim, "Concepts of Transnational Cinema: Towards a Critical Transnationalism in Film Studies," *Transnational Cinemas* 1, no. 1 (2010): 7–21, here 8.

[20] Judit Bokser-Liwerant, "Jewish Diaspora and Transnationalism: Awkward (Dance) Partners," in *Reconsidering Israel—Diaspora Relations*, ed. Eliezer Ben-Rafael, Judit Bokser Liwerant, and Yosef Gorn (Leiden: Brill, 2014), 369–404.

[21] Shmuel Eisenstadt, "The Jewish Experience in the Contemporary Scene: The Transformations of the Nation-State and the Development of New Inter-Civilizational Relations," *European Journal of Social Sciences* 44, n. 135 (2006): 157–169, here 165.

and the imagery generated by artists based abroad in the diaspora. In this sense, this book aims to explore, for the first time, this double movement that crosses the screen and contributes to the creation of images of Israel that are at once critical from the inside and visionary from the outside. By tracing the transnational inputs that make the image of Israel, we problematize the role that arts play in the construction of Israeli and Jewish identities, aiming to do so not only by examining works that enrich the national discourse with the insertion of new political subjectivities and social characters (e.g., Mizrachi Jews, Palestinian Israelis, Haredim), but also by analyzing art that carries visions of an alternative reality.

Chapters are dedicated to in-depth readings of artistic works that, because of their aesthetic qualities and/or the historical moment in which they were produced and consumed, signal turning points in the representation of Israel. The purpose of this organizational framework is threefold. First, it is to bring forward the textual strategies that these works employ to redefine Jewish identity in light of social, political, and cultural processes taking place in the diaspora and the Jewish state. Second, it is to explore the role that images play in the construction and transformation of identities, in particular in the context of the visual overexposure that characterizes contemporary late capitalist society. And third, it is, by confronting the images of Israel as a concept with the images of Israel as a real place, to consider the nature of the indexicality of these images and to discuss the question of the truthfulness of such images. In this sense, the publication of our book about the transnational representations of Israel on screens tries to answer the question of how identity is constructed in the diaspora in relation to the Motherland and vice versa. In a world made of (sometimes) porous borders, mass migrations, global phenomena, and technologically induced ubiquity, the transnational artistic expressions reflecting the Jewish state create a space that affords simultaneously the coexistence of multiple identities, the radical critique of dominant narratives, and a sense of belonging and also of not belonging. Challenging the cultural, social, and political status quo, the transnational images of Israel not only prove "imagery's disrespect for the protocols of power,"[22] but denaturalize identity and install a sense of unfixity in our very conception of the self.

The first section of the volume, "Building from the Ground up: Landscape, Language, and Culture," reflects on the foundations of the State of Israel, many of which precede the state. Guy Eldar's chapter, "The Visual Type as an Image of a

22 John Osborne and Michael Wintle, "The Construction and Allocation of Identity through Images and Imagery: An Introduction," in *Image into Identity: Constructing and Assigning Identity in a Culture of Modernity*, ed. Michael Wintle (Amsterdam: Éditions Rodopi BV), 15–30.

People: Hebrew Typography throughout History and Its Representation of Jewish and Israeli Identity," examines the history of Hebrew typography and how its development mirrors that of the Jewish state. Through a survey of typefaces, Eldar traces the evolution of type, its influence on Israeli society and culture, and its impact in creating a new visual voice for Israel globally. Whereas Eldar examines typography design, Noa Avron Barak, in her chapter "Fictional Canon: Reconsidering Karl Schwarz's *Modern Jewish Art in Eretz Yisrael*," focuses on the early Israeli national art canon as an ideological reflection of the hegemonic Zionist political establishment in pre-state Israel. Specifically, she illustrates how art was used instrumentally to represent Jewish creativity in Palestine as a consequence of Jews returning to their land, where the geographic territory of Zion, its soil, and its light, are the main points of reference for Israeli artists, past and present. The final chapter in this section is Ofer Berenstein's "Taming the Levant: Reflections on Zionism, Orientalism, and Depictions of Tel Aviv-Jaffa in Israeli and International Comics." In this chapter, Berenstein examines how the role of Tel Aviv as the "first Hebrew city" is manifest visually in Israeli and international comics from pre-independence proto-comics to current mainstream and alternative graphic narrative works. The chapter tracks and reviews depictions of Tel Aviv landmarks, architectural monuments, cityscape, and urban-life scenes from various works, artists, and genres, stretching from the late 1930s to the late 2010s, in an attempt to understand what elements make the city of Tel Aviv so easily identifiable.

The second section, "Consuming Images: Israel in America," considers the imageries that Israeli and American Jews send to each other, conditioning mutual and self-perceptions, interpretations of Judaism, and cultural practices. The major poles of contemporary Jewish life—the United States and Israel together—generate the most powerful iconographies of Judaism. In "Fractured Communities, Anxious Identities: Reconsidering Israel on the American Stage," Ellen W. Kaplan examines contemporary plays performed on American stages and how they shape and reshape Jewish Americans' relationships with Israel. The plays are explored through their substance and the dialogue that emerges through their performance. While the play *If I Forget* highlights the generational divides in attachment to Israel, *My Name Is Rachel Corrie* is a textbook for the way the "theater of the real" influences reality, sparking significant media controversy. Kaplan argues that, confronted with shameful representations of Israeli Jews, many young, liberal American Jews choose to relegate their Jewish identities in favor of universalism. Samantha Pickette's "The Sabra within the Schlemiel: Diverging Modes of American Jewish and Israeli Masculinity in Jewish American Literature" considers the representation of Israel in American Jewish literature, specifically focusing

on the ways in which American Jewish authors often invoke Israeli Jewish masculinity—aggressive, physical, cunning—as a mirror image of American Jewish masculinity—passive, intellectual, cautious. Looking at relevant works from Saul Bellow, Philip Roth, Jonathan Safran Foer, and Nicole Krauss, Pickette examines the various literary imaginings of Israeli culture in American literature and explores how post-1967 American Jewish literature increasingly employs Israel as a lens through which to analyze, criticize, and magnify the complexities of American Jewish male identity.

In "Messianic Affinities: Tali Keren's *The Great Seal* and *Un-Charting*," Chelsea Haines looks at Tali Keren's *The Great Seal* to trace the latent history and contemporary implications of the shared messianism between the United States and Israel. Tali Keren's work references Benjamin Franklin and Thomas Jefferson's design for the US seal, proposed in 1776, which depicts Moses leading the Israelites out of Egypt, revealing an undercurrent in American ideology, the legacy of which remains in the dozens of New Zion towns dotting the North American landscape and is expressed today by Christian Evangelical support for the Jewish state. Haines looks at *The Great Seal* in the context of Keren's broader practice and alongside several contemporary Israeli artists, in order to trace their shared aspirations in charting an expanded dialectic of Israeli national image-making abroad and their role in international diplomacy today. The following chapter, Reeva Spector Simon's "The Short Life of the Israeli Superspy: Imagining Israel in Twentieth-Century American Crime Fiction," focuses on American perceptions of Israelis in the context of crime fiction. Israeli heroes, including James Bond and Rambo types, suddenly appeared in the wake of Israel's victories on the battlefield. Following the First Lebanon War (1982) and the increasing opposition of world public opinion to Israel's policies in the West Bank, a negative Israeli emerged. Simon contends that the portrayal of Israelis is an important indicator of political perception. Finally, in "Israel through the Viewfinder: Claude Lanzmann and Susan Sontag Film the Jewish State," Rocco Giansante considers Lanzmann's *Why Israel* as an example of nation image-building from the outside. The Holocaust, the *kibbutz*, the Mizrachi *aliyah*, the Ultra-Orthodox, the settlers in Hebron, the memory of the Spartacus League in Germany—all of these fragments of life, edited together, compose the Israel of Lanzmann, which coincides with the "reappropriation of violence" by the Jews. The reality of the Yom Kippur War (1973), which broke out soon after the completion of the film, problematized the issue of violence for the young state. Following the war, Susan Sontag, another Diasporic intellectual, arrived in Israel to construct her own image of the country. The Israel of her *Promised Lands* is still shaking from the tragedy of the war. From the post-Holocaust image of the survivor Lanzmann to the traumatized

image of Sontag, up to today's representations, Israel stands as a mirror for the diaspora: reflect its own views back on itself.

The third section, "Within, without: Becoming Glocal," considers the image and representation of Israel globally and the development of an aesthetic that blends vernacular and global trends, language, and style. Luna Goldberg's chapter, "Tarnishing History through Matter: Gal Weinstein's *Sun Stand Still* at the Israeli Pavilion in Venice," examines Gal Weinstein's 2017 Biennale exhibition and how the artist uses materiality and installations that disrupt the modernist architecture and functionalist aesthetic of the Pavilion as a means of critiquing how the nation forged its image on a global stage, while simultaneously reflecting on the current state of the country. Whereas Goldberg's essay focuses on work outside of Israel, Idit Suslik's chapter, "Contemporizing (Yemenite) Ethnicity: Hybrid Folklore in Mor Shani's 'Three Suggestions for Dealing with Time' Dance Trilogy for Inbal Dance Theater," considers Inbal Dance Theater's complex history of integrating diverse cultural and artistic influences in its choreographies to contemporize Yemenite ethnicity. Through a close analysis of Mor Shani's dance trilogy, Suslik argues that his choreographies function as a *third space*[23] where "Inbalite" language is continually updated and included in the choreographic present. Samuel Thrope's chapter, "A Rough, Country Face: An Iranian Intellectual Retells the Holocaust," takes as its subject "Journey to the Land of Israel," a text written by leading Iranian intellectual Jalal Al-e Ahmad in 1963 following his visit to the young state of Israel as part of an Israeli diplomatic mission in Tehran—part of the then-increasing cultural, military, and economic ties between the Shah's Iran and the Jewish state. Exploring how Al-e Ahmad depicts Israel in narrative terms, Thrope's chapter focuses on a visit to the Holocaust Memorial Yad Vashem and the critical role that it played in Al-e Ahmad's understanding of the Jewish state. Lastly, in "Imagined Israel? Israel in Contemporary British Theater," Glenda Abramson examines the representation of Israel in four British plays published over the last two decades. Responding to a 2017 American magazine article that asked why, with regard to Israel, "British theatre can only produce shrill anti-Israel agitprop," Abramson considers instances of critical judgment of Israel in British plays.

The last section of the book, "Realizing Visions: Israel Reimagined," deals with radical acts of the imagination. Keren Goldberg's chapter, "Resemblance, Difference, and Simulacrum in Israeli and Palestinian Art," illustrates the way in which the image of Israel/Palestine is reflected and transformed through parafictional works, fictive constructs that are experienced, for different

23 Bhabha, *The Location of Culture.*

reasons and for different periods, as facts rather than as fictional artworks. The permeable separation between fiction and reality returns in the following chapter, "Playing Soldiers: Reimagining the Israeli Defense Forces on the Fringe Stage" by Jacob Hellman. On the fringe theater stage, Israel and its military culture are transfigured into an uncanny combination of real elements, the reflections of the new media, and fictional forms of dramaturgy. Showcasing the contemporary Israeli imagination, these plays ask questions of politics, morality, and identity. Finally, in "Disrupting Holy Binaries: The Work of Gil and Rona Yefman" Yarden Stern reveals the ways in which popular religious myths and historically freighted Jewish terms and rituals can become vehicles through which to transform familial relations and sibling belonging. Focusing on the art practice of Rona and Gil Yefman, this article connects the acts of national imagination to the process of a radical redefinition of the self. The imagination at the service of institutions and ideologies, thus, turns into a tool for the liberation of the individual and, possibly, the creation of a new collective.

The articles in this volume cover a wide range of artistic practices and locations. Each contribution deepens the relationship between politics and the imagination, assigning to the arts a role in experimenting with new forms of being in the world for us as a community and as individuals. Editing these works together, we aim to renew the debate about Israel, the Jewish diaspora, and the image of the Jewish state in the world. Moving beyond the charted territories of sociopolitical discourse, we consider the artistic imagination as a possible lens through which to look anew at the place of Israel in the world and reevaluate its relationship with the diaspora and other nations. From the imagination of a new Jewish commonwealth to the possible forms that this commonwealth can or should take (Zionist, religious, cultural), the articles in this volume affirm the emancipatory role of artistic practice and the radical power of its politics.

PART 1

Building from the Ground up: Landscape, Language, and Culture

∴

CHAPTER 1

The Visual Type as an Image of a People: Hebrew Typography throughout History and Its Representation of Jewish and Israeli Identity

Guy Eldar

> [Letterforms] place the content in historical and cultural context ... Fonts are rich with the gesture and spirit of their own era.[1]
> MICHAEL ROCK

∴

The written word is at the basis of human culture. It is at the core of any exchange of knowledge, and thus influences much of our history and that of human development. While typography has not gone through great change in the course of its time,[2] it has still expanded style, changed in fashion, and adapted to ever-advancing technologies,[3] and has thus influenced culture and society and their visuality.

With that in mind, Mila Waldeck demonstrates the connection between typography and national identity. She argues that the origin of this connection lies in language being at the basis of nationalism, in the close bond between tradition and nationality, and in the use of culture in upholding political

1 Michael Rock, "Typefaces Are Rich with the Gesture and Spirit of Their Own Era," in *Looking Closer 3 Classic Writings on Graphic Design*, ed. William Drenttel, Michael Bierut, Steven Heller, and D. K. Holland (New York: Allworth Press, 2001), 122–125, here 123.
2 Typography is the arrangement and specification of type in preparation for printing. Traditionally associated with printing from metal type, it is now equally applied to typesetting produced by any type composition system. See Alan Livingston and Isabella Livingston, "Typography," in *The Thames and Hudson Dictionary of Graphic Design and Designers* (London: Thames and Hudson, 1998), 197. Typography is a mechanical mass-reproduced technique, and as such its beginning is marked by the invention of Johannes Gutenberg's printing press in the mid-fifteenth century.
3 Friedrich Friedl, Nicholas Ott, and Bernard Stein, *Typography: An Encyclopedic Survey of Type Design and Techniques throughout History* (New York: Black Dog & Leventhal Publishers, Inc., 1998), 7–8.

ideas.[4] Hebrew is a language unique to the Jewish people, and thus the story of its typography is closely connected with the course of its history. The advances in printing technologies and in the style of typefaces may be observed as a projection of the Jewish people and the State of Israel. I will argue that key moments in Hebrew type-design history correspond with events in Jewish and Israeli history. These junctions are followed by connected typographic change and advancement in the visuality of the Hebrew letter.

The history of Hebrew typography may be defined by four typographic stages.[5] These are: (1) the ritual texts and their visual manifestation; (2) the revival of the Hebrew language—spoken and visual; (3) the typographical pillars of a national identity; and (4) the digitizing of Hebrew and its multilingual internationality and versatility. As this chapter will highlight, the typefaces—each of their own time—were created to fulfill functional communication needs while assisting in the establishment of the visual culture and identity of the Jewish people and state.

1 Ritual Texts and Their Visual Manifestation

The invention of Gutenberg's printing press, in the mid-fifteenth century, required the creation of metal type for printing. Just as Gutenberg used the written style of his time and culture for the first typeface in print, so did the first Hebrew printers.[6] Although the Latin typefaces saw many developments from the introduction of typography until the twentieth century, Ilana Waldman quotes Henri Friedlander in saying that the Hebrew letter ceased its development and change in the same time period.[7] The first Hebrew typefaces were based on handwritten religious Hebrew manuscripts and were not detached

4 Mila Waldeck, "Typography and National Identity" (paper presented at the Proceedings of the 9th Conference of the International Committee for Design History and Design Studies, 2014).
5 It should be noted that typography may refer to a wide range of designs, art forms, and visual communications, such as the arrangement of text in print or other media, the design of textual emblems and text-based logos, and the creation and innovation of new styles and shapes of typefaces. The current chapter will refer only to the latter in an examination of the history of typography and its cultural-national significance.
6 His D-K 202 typeface, in what we call today "Blackletter style," was based on Textura, the medieval scribes' handwriting style.
7 Ilana Waldman, "Henri Friedlander, Master of Print and Book, and His Contribution to Fine Hebrew Printing" [Hebrew] (Master's Thesis, The Hebrew University of Jerusalem, 1993).

from these written traditions.[8] Most of these typefaces were created by non-Jewish printers that had no knowledge of the language, and could only copy it from found historical sources or base it on the work of anonymous Jewish scribes.[9] Many of these printers had arranged the Hebrew text without even knowing its meaning.[10]

In the early centuries of printing, there was not one cohesive typographic style for Hebrew, as congregations were scattered throughout Europe with texts that were influenced by different predecessors. Designer Zvi Narkis notes four styles of these early typeface traditions. The first dated Hebrew book in print from 1475, arranged and printed by Avraham ben Garton ben Yishaq, of Reggio di Calabria, is based on a semi-cursive Sephardic handwriting style.[11] That same year, Meshullam Cusi Rafa ben Moshe Ya'acov, in Pieve di Sacco, used a typeface based on an Ashkenazi handwriting style.[12] In 1480, Avraham ben Shlomo Conat, in Mantua, based his typeface on a semi-cursive Italian handwriting style. And finally, the prominent printers of the Soncino family fixed the widely accepted use of a Sephardic-style[13] typeface in an attempt to comply with the visual flavors of the large Sephardic communities in southern Italy and beyond.[14] These different styles in the early stages of printing demonstrate the initial separation of Hebrew typography by the origin of different handwriting styles, in accordance with the backgrounds of their creators and audiences. However, it should be noted that some cross-style characteristics may be detected. For instance, designer and printer Moshe Spitzer claims that though Soncino typeface is Sephardic-based, the Ashkenazi style is inherent

8 Simon Prais, "Design Considerations Affecting the Simultaneous Use of Latin and Hebrew Typography" (Master's Thesis, Manchester Polytechnic, 1985), 9.

9 Leila Avrin, "The Art of the Book in the Twentieth Century," in *A Sign and A Witness: 2,000 Years of Hebrew Books and Illuminated Manuscripts*, ed. Leonard Singer Gold (New York: The New York Public Library, 1988), 125–139, here 125.

10 Moshe Farjoun, *Comparative and Institutional Development: A Study of the Development of Modern Hebrew Typography and of the Printing Press and Publication in Israel* (Tel Aviv: Tel Aviv University, 2003).

11 This style would later be named Rashi after Rabbi Shlomo Yitzchaki, as this style would become widely used in the printing of his commentary for the Talmud and Hebrew Bible, though it has nothing to do with his handwriting style.

12 A twelfth-century handwriting drawn by quill and considered as "Gothic Hebrew." It is an angular handwriting, based on thick horizontals and extra-thin verticals, and, according to Avrin, not highly legible. See Leila Avrin, "Acrophonic, Micrographic, Typographic: The Story of Hebrew Letters," *Fine Print* 12, no. 1 (1986): 21–27, here 24.

13 The thirteenth-century Sephardic handwriting, which was influenced by the use of reed in its creation, is squared with closely equal weighted verticals and horizontals.

14 Zvi Narkis, "Landmarks in Hebrew Typography" [Hebrew], in *Book of Print* [Hebrew], ed. Erhardt D. Stiebner (Tel Aviv: The National Printing Workers Association, 1992), 77–82.

in the overemphasized horizontal elements, as well as in the lack of definition of the letters' basic forms.[15] This initial array of styles highlights the lack of a unified Hebrew typography prior to the twentieth century.

Soncino typefaces spread quickly as the family's business expanded rapidly in many cities and countries around Europe, and they became the basis for imitation by many printers.[16] It may be assumed that the high aesthetic nature of these letters[17] and their growing popularity led to the continuing creation of the Sephardic-based style for the following four centuries.

The Sephardic typographic characteristics dominated prominent Hebrew designs throughout the eighteenth century, as the demand for Hebrew kept steady, mostly as an exotic "Oriental" addition to leading type-foundries. Typographers such as Guillaume Le Bé in the sixteenth century, Nicholas Kis, and Christoffel van Dijck in the seventeenth century, and Fermin Didot in the late eighteenth century, created their own Hebrew typefaces. Jewish printers took advantage of these types, showing no interest in creating new styles.[18] These typefaces, however, as elegant and highly appreciated as they were (and still are), could not reflect a true identity of the Jews spread across the world, especially since they were created by non-Jewish designers. According to designer Yehuda Hofshi, "if you can't read the language, then you can't design the font in the language."[19] He suggests that one needs to know the history and background of a language in order to design typefaces in that language.

These same misunderstandings of the Hebrew language find themselves at the root of the creation of Meruba[20] typeface in the late eighteenth century. In the wake of the Italian Renaissance, attempts were made to match the Hebrew typefaces with those of modern style Latin (such as Didot and Bodoni), exemplifying a high contrast between the thick and thin components of the letters.[21] Hebrew typography historian Ittai Tamari criticizes the dominant

15 Moshe Spitzer, "About Our Letters" [Hebrew], in *Aley Ain: Minchat Dvarim (Offerings of Texts) in Honor of Shlomo Zalman Schocken on His Seventieth Birthday* [Hebrew] (Jerusalem: N. P., 1948–1952), 481–501.
16 Narkis, "Landmarks in Hebrew Typography."
17 These faces also paired nicely with the Uncial Latin letters. See Avrin, "Acrophonic, Micrographic, Typographic," 24. Thus, when setting religious texts in both languages, Christian printers could keep a harmonious composition.
18 Avrin, "Art of the Book," 125–126.
19 As quoted in Shayna Tova Blum, "Design Research: Typography within the Israeli Linguistic Landscape," *Faculty and Staff Publications* 48 (2015), 9, https://digitalcommons.xula.edu/fac_pub/48.
20 "Square" in Hebrew.
21 Zvi Narkis, "Narkis, Narkisim and All the Rest," in *Type Is Forever: A Collection of Texts Devoted to the Design of the Hebrew Letter*, ed. Moshe Spitzer (Jerusalem: Ministry of

"fashion" of the period, saying that the lack of a fundamental understanding of the letters when visually "translating" between two different sign systems led to the creation of pale and meaningless imitations.[22] In a paper about the development of the Hebrew letters, Spitzer claims that the letters of Meruba had become extremely similar to one another (thus reducing legibility), and that the typeface as a whole destroyed the fundamental shapes of Hebrew.[23] Similar attempts, beginning in the early nineteenth century, included Drugulin and others alike, and they emphasized the need for differences between thick and thin while incorporating characteristics of the Ashkenazi style. The rise in demand for printed material from the mid-nineteenth century onward furthered the creation of low-quality typefaces of the same kind. By the end of the century, Hebrew printing worldwide was dominated by these typographical designs.[24]

2 Revival of the Hebrew Language: Spoken and Visual

Notions of nationalization that spread throughout Europe in the nineteenth century initiated thinking about a national rebirth of the Jewish people. In turn, the idea of a Jewish state served as a catalyst for turning Hebrew into a day-to-day spoken language. The Haskalah movement,[25] in combination with enthusiasm from the Zionist newcomers to the Land of Israel, and the practical need to bridge the language barrier between different Jewish communities served as grounds for the revival of Hebrew. By the 1920s, Hebrew began spreading in the Jewish Yishuv ("Settlement") in Palestine.[26]

In tandem with the revival of Hebrew as a spoken language, the Zionist movement recognized the need to match its secular ideas with an

 Education and Culture, The Department of Jewish Religious Culture, 1989); Prais, "Design Considerations."
22 As quoted in Farjoun, *Comparative and Institutional Development*.
23 Spitzer, "About Our Letters."
24 Farjoun, *Comparative and Institutional Development*.
25 A Judaic European movement of the late eighteenth- and nineteenth-centuries that attempted to acquaint Jews with European and Hebrew languages and with secular education and culture as supplements to traditional Talmudic studies. See "Haskala," in *Encyclopaedia Britannica*, ed. Aakanksha Gaur et al., accessed January 17, 2022, https://www.britannica.com/topic/Haskala.
26 Shlomo Izre'el, "Processes of the Formation of Spoken Hebrew in Israel" [Hebrew], in *Speaking Hebrew: Research of the Spoken Language and Linguistic Differences in Israel* [Hebrew], ed. Shlomo Izre'el with the aid of Margalit Mendelson (Tel Aviv: Tel Aviv University Press, 2001), 218–219.

appropriate typeface. The movement found such a companion in the revolutionary Frank-Rühl typeface.[27]

At the beginning of the twentieth century, cantor, educator, and Sofer Stam[28] Rafael Frank, of Leipzig, Germany, researched Hebrew typography and recognized its flaws. He wished to design a better typographic solution.[29] Three objectives stood before Frank as he set out to design his typeface: (1) improving the aesthetics of existing typography by adopting the Sephardic style of the Italian printers of the fifteenth and sixteenth centuries and their successors, specifically Daniel Bomberg; (2) enhancing the legibility of Hebrew typography by emphasizing the differences between resembling Hebrew letters; and (3) casting longer-lasting metal types than were in use at the time.[30] The proportions and ornamentation of earlier typefaces were altered completely within this typeface.[31] Frank-Rühl is slightly darker than its predecessors, devoid of sharp corners, and with its design Frank aspired to fix past mistakes as he reduced the contrast between thick and thin, and better differentiated the letters of the alphabet.[32] Frank was keen to maintain a high level of legibility and a clean and balanced design for the letters while staying true to the traditional Hebrew letter structure in his design.[33] In addition, the typeface was slightly narrower than its predecessors, thus more economical in its use of space,[34] and it was the only typeface of its time to have Nikud.[35] The typeface did not carry any distinct characteristics, which enabled it to be used in a wide variety of content.[36] Frank-Rühl was quickly adopted for the design of diverse textual materials, mostly secular and mundane. With a rise in Hebrew texts, outside the realm of religious context, Frank was among the first Jewish type designers who saw Hebrew typography as representing a living language.[37] Previous printers' and designers' work was meant chiefly for the setting of

27 National Library of Israel, "A New Typeface for the New Jew" [Hebrew], *The Librarians—The National Library's Blog*, December 2, 2019, https://blog.nli.org.il/frankruehl/.
28 Torah scribe.
29 Waldman, "Henri Friedlander, Master of Print."
30 Gideon Stern, *About Typography and Printing Type* [Hebrew] (Ra'anana, Israel: Hoshen, 2004).
31 Farjoun, *Comparative and Institutional Development*.
32 Waldman, "Henri Friedlander, Master of Print."
33 Ada Yardeni, *The Book of Hebrew Script: History, Fundamentals, Styles, Design* (Jerusalem: Carta, 1991).
34 Waldman, "Henri Friedlander, Master of Print."
35 Hebrew punctuation markings that indicate vowels and the pronunciation of words.
36 Farjoun, *Comparative and Institutional Development*.
37 Avrin, "Art of the Book," 125.

religious text, while here was a designer who had poetry, news, philosophy, and more as the objects of his type design.

In 1908, Frank found a partner for the creation of his typeface in Friedrich Eugen Schmidt, co-owner of the C. F. Rühl printing house and type foundry. Schmidt and his partner, Karl Prautzsch, were in the business of printing Hebrew books, and understood the need for a better typeface. The combined efforts of the cantor and printing house bestowed upon the typeface its name—Frank-Rühl.[38] Its widespread use was enabled by the purchase of C. F. Rühl by the world-renowned and established Berthold letter-casting firm. Its hold across Europe and the United States enabled the spread of Frank-Rühl, with its initial catalog being published in 1924.[39] It would soon become the face of Hebrew text around the world, devoid of religious connotations or deep historical ties, and it is still the leading body-text typeface for Hebrew books and newspapers in Israel today.[40]

The demand for new Hebrew typefaces was on the rise, as the operations of the Zionist movement grew and the Yishuv expanded.[41] While Frank-Rühl was sufficient for textual Hebrew needs, other fonts were needed for a variety of visual purposes. The interwar period saw the development of two opposing type-design trends.

The first was inspired by German expressionism; it was supported by Bauhaus, and set upon itself to create Hebrew sans-serif faces (mainly for display purposes).[42] Haim is an angular and robust typeface, removed from the structure of the Hebrew letter, that was designed in 1929 by Jan (Yacov) Le Witt. The lighter Aharoni, by Tuvia Aharoni, was designed in 1938.[43] Under this trend of sans-serif typefaces, the designer Adi Stern, the current president of the Bezalel Academy of Arts and Design, also mentions Miriam, 1924, by Rafael Frank; Sapir, 1938 or earlier; and Wallish Block, c.1930s.[44] These faces not only enabled the setting of headings and signs, but also introduced Hebrew and the Jewish people as equals among the world languages and nations. These designs

38 Gil Weissblei, "A Man Under His Typeface" [Hebrew], *Segula* 125 (2020), https://bit.ly/3P4FMD8.
39 Farjoun, *Comparative and Institutional Development*.
40 Waldman, "Henri Friedlander, Master of Print."
41 Narkis, "Landmarks in Hebrew Typography."
42 Waldman, "Henri Friedlander, Master of Print."
43 Narkis, "Landmarks in Hebrew Typography."
44 Adi Stern, "The Design of Hebrew Type in the First Decade of Israeli Statehood," in *New Types: Three Pioneers of Hebrew Graphic Design*, ed. Ada Wardi, 35–68 (Jerusalem: The Israel Museum, 2016).

kept up with world design trends and helped elevate Hebrew to the level of the Latin-derived Romance languages.

The second design trend of the period sought to revive and enhance the beauty and heritage of Hebrew typography. Among these typefaces were Franzisca Baruch's Stam, 1923, based on an Ashkenazi handwritten Haggadah; Schocken-Baruch, 1926,[45] based on the Italian Sephardic style;[46] and Marcus Behmer's Soncino, 1928.[47] Alongside the worldly inclusion brought about by the above sans-serif typefaces, the humanistic faces balanced the overall Hebrew visuality of the period by celebrating its glorious typographic past. It is a reminder that the Jewish bond, prior to the establishment of the State of Israel, is foremost one of heritage and religion.

The center of Hebrew design transferred from Europe to Palestine with the reopening of the Bezalel Academy of Arts and Design in 1935, which attracted many German Jewish designers, and which offered a new type-design course headed by Yerachmiel Schechter. By the end of World War II, however, Hebrew typography and printing in Palestine were of poor quality and in need of considerable rejuvenation.[48]

3 The Typographical Pillars of a National Identity

An impressive number of new typefaces were published in the young Israeli state between the years 1954 and 1958,[49] many of which were developed with the encouragement of Moshe Spitzer.[50] Historian Shmuel Peretz attributes these to the stabilization of the printing industry after the establishment of the state and the rising need for new and improved typefaces.[51] Stern, on the other

[45] Initial sketches of the design are found from 1926, but the actual casting came about only in 1947. See Stern, "Design of Hebrew Type."

[46] Waldman, "Henri Friedlander, Master of Print."

[47] Soncino was ordered by the first organization of Jewish bibliophiles in Berlin, which was established in 1924. The organization, Soncino—Friends of the Hebrew Book Society (named after the famed printers family), found Frank-Rühl unfitting for the awakening of Jewish culture, as it lacked historical markings, and instead sought out Behmer's design. See Philipp Messner, "Hebrew Type Design in the Context of the Book Art Movement and New Typography," in *New Types: Three Pioneers of Hebrew Graphic Design*, ed. Ada Wardi (Jerusalem: The Israel Museum, 2016), 21–33, here 24.

[48] Messner, "Hebrew Type Design," 29.

[49] Narkis, "Landmarks in Hebrew Typography."

[50] Waldman, "Henri Friedlander, Master of Print."

[51] As quoted in Farjoun, *Comparative and Institutional Development*.

hand, emphasizes that the creation of these new typefaces came as a part of the cultural awakening and the need to adapt to typographies of the time.

Quoting Rothchild and Lipman—two important designers of the time—Stern notes that the duo called for the creation of a bridge, "closing the gap from the distant past, and connecting Hebrew typography to the present."[52] These new typefaces not only created new visual possibilities for the printers of Israel, but also set new standards in Hebrew type design. Furthermore, some of them reinvented the Hebrew letters, while incorporating and fusing together an assortment of inspirations and cultural influences. Narkis referred to the appearance of his competitors' typefaces as one of the most significant events in Hebrew typography and as an expression of the national rebirth of the field of the Hebrew letter.[53] These represented the coming together of the people of Israel in the new state, as it took its place among the nations of the world.

In 1954, Itamar (Ismar) David published David (Fig. 1.1). It is a calligraphic typeface, thin and elegant with no embellishments.[54] David served as a pleasant replacement for Frank-Rühl and earlier text typefaces.[55] The design began in the 1930s after David immigrated to Palestine, but the contract for the manufacturing of the letters was only signed in 1947, between David and Intertype. Two styles of David, upright and semi-cursive,[56] were cast in three weights each—light, normal, and bold.[57]

David sought to structure his typeface in a classic Eastern style in order to distance himself from European designs. By his own admission, he wanted to reconnect with a more fundamental structure of the Semitic ancient shapes, and define their proportions in a way that would create a more cohesive texture.[58] David's affinity with local design heritage was a major deviation from past designs.[59] As such, it serves as a significant cornerstone of early Israeli typographic design (among many other ingenuities of this typeface).

52 Stern, "Design of Hebrew Type."
53 Narkis, "Narkis, Narkisim and All the Rest."
54 Waldman, "Henri Friedlander, Master of Print."
55 Meir Sadan, "Ne'eman la'makor (True to the Original)," *Redesign*, June 29, 2016, https://meirsadan.github.io/david-libre/.
56 A display style (sans-serif) did not come into realization. See Stern, "Design of Hebrew Type."
57 Sadan, "Ne'eman la'makor."
58 Stern, "Design of Hebrew Type."
59 In an interview with Blum, designer Oded Ezer claims that the influence of Arabic on Israeli typography was non-existent, as the Bezalel Academy of Arts and Design would rely solely on European designs and style. See Blum, "Design Research," 9.

אבגדהוזחטיכלמנסעפצקרשתדםןץ
אבגדהוזחטיכלמנסעפצקרשתדםןץ
אבגדהוזחטיכלמנסעפצקרשתדםןץ
אבגדהוזחטיכלמנסעפצקרשתדםןץ
אבגדהוזחטיכלמנסעפצקרשתדםןץ
אבגדהוזחטיכלמנסעפצקרשתדםןץ
אבגדהוזחטיכלמנסעפצקרשתדםןץ
אבגדהוזחטיכלמנסעפצקרשתדםןץ
אבגדהוזחטיכלמנסעפצקרשתדםןץ

FIGURE 1.1 David full typeface family
REPRODUCED BY MONOTYPE, 2012

The typeface Hatzvi was published in 1956. It was designed by Zvi (Theo) Hausman, who passed away before its completion. The design was finalized by Spitzer, and was the first originally designed typeface to be casted in his own factory, Otiot Yerushalayim ("Jerusalem Letters"). It was first introduced in bold form as a display face, yet after its popularity became evident Spitzer added four more versions: medium, light, hollow, and white.[60]

Hatzvi is an open and vibrant typeface. Its lines are almost uniform in their thickness with hints of accents at their edges, and it is strongly based on the structure of early medieval letters.[61] The accents of the typeface are reminiscent of serifs in this non-serif creation[62] never-before seen in Hebrew typography, which inspired future creations. Hatzvi uniquely combines Bauhaus-inspired typeface with a strong understanding of and respect for the Hebrew letter. It created a local visual Israeli statement while maintaining a strong connection to world typographic styles.

The 1957 typeface Korén by Eliyahu (Korngold) Korén was produced in France specifically for the printing of a new Hebrew Bible in Jerusalem between 1962 and 1964.[63] It is inspired by thirteenth- to fifteenth-century Sephardic manuscripts.[64] The beautiful letters are highly readable—they are

60 Stern, "Design of Hebrew Type."
61 Waldman, "Henri Friedlander, Master of Print."
62 Stern, "Design of Hebrew Type."
63 Waldman, "Henri Friedlander, Master of Print."
64 According to Stern, it is evident that older Hebrew letters' foundations play a part in the type's design. See Stern, "Design of Hebrew Type."

sharp, almost never rounded, with balanced contrasts faintly serifed and few diagonals always parallel to one another.[65] Tamari commends the typeface's success above all others in the setting of the Nikud.[66] The Korén Bible was the first printed Bible in the world created solely and entirely by Jews, and soon became the official Bible of the State of Israel, upon which its presidents are sworn into office.[67]

Korén was the first Hebrew typeface to be designed with a specific purpose. Art historian Batya Doner sees in this mission of creating a typeface for the printing of the Bible an expression of the bond between typography and the state.[68] This endeavor could be considered as a way to include and accommodate Jewish religious texts and rituals[69] within the secular Jewish state. Korén served as a typographic bridge between the religious and the secular, though it was mostly used for the former.

In 1958, an official public notice was released announcing the introduction of a new typeface, Hadassah, designed by Henri Friedlander. This announcement came after a long design process that started in 1931 and was finalized in Israel with the support of Spitzer. Friedlander was seeking to create a modern Hebrew typeface—Hadassah is highly legible and has a clean and elegant appearance.[70] The typeface seems to consist of horizontals and verticals of even weight, with strong and firm bracketed serifs. However, a close inspection reveals the slight contrasts in weights and restrained curves in 14 of the 22 letters.[71] Friedlander mentioned in his writings the combination of both Ashkenazi and Sephardic influences.[72] The typeface is therefore a visual homage to the "melting pot" concept of the young Israeli state. In theory, the Zionist movement, followed by the founding fathers of Israel, wished to employ the concept of meshing together the many cultures of the gathering Jews in the young state. However,

65 Avrin, "Art of the Book," 129.
66 Ittai Tamari, "Introduction: Milestones in the Development of the Hebrew Letter" [Hebrew], in *New Hebrew Letter Type* (Tel Aviv: Tel Aviv University, 1985), 1–59.
67 Stern, "Design of Hebrew Type," 54.
68 Batya Doner, "History of Practical Graphics" [Hebrew], in *History of the Jewish Community in Eretz-Israel since 1882; Part I: The Establishment of a Hebrew Culture* [Hebrew], ed. Moshe Lissak and Zohar Shavit (Jerusalem: The Israeli Academy of Sciences, 1998), 535–555.
69 It should be noted that many publications of Orthodox Jews in Israel still use typefaces from or inspired by the nineteenth-century samples, namely, those that preceded Frank-Rühl.
70 Tamari, "Introduction."
71 Avrin, "Art of the Book."
72 Stern, "Design of Hebrew Type."

in practice, Ashkenazi elites suppressed Sephardic or Mizrahia[73] characteristics in the emerging combined culture.[74] Thus Hadassah is a visual display of an idealized culture, combining diverse heritages into a cohesive, unified outcome.

The last of these early Israeli typefaces is Narkis Block, 1958, the first of many faces from prolific designer Zvi Narkis. It was originally designed with seven weights,[75] for hand-setting and Letraset. The typeface traces the shape and structure of the Hebrew letter. The calligraphic hand is evident in modulations between the letter's components. Furthermore, Narkis Block enforces the direction and movement of Hebrew, as it has no symmetrical characters (as opposed to past faces such as Haim and Miriam).[76] Narkis Block is extremely legible, as this was a priority for the designer in all his typographical work.

Another major innovation of this typeface is the reversal of weight differences and tension between horizontal and vertical lines. In Hebrew, the weight stress is usually on the horizontals. In order to create the multi-weight family, Narkis needed to allow the vertical strokes room to grow, and so he reversed the stress of the letters. This change was carried on by many designers after Narkis's example.[77]

Narkis Block is a flexible functional typeface considered by many as the Hebrew Helvetica, and is in frequent use even today. Yet again, the design brought worldly ideas such as ones from the Swiss/International Typographic Design Style of its time, and assimilated them into Hebrew and into the visualization of the young state. Narkis Block, and its younger brothers, Narkis Tam and Narkis Hadash, were created with the setting of Hebrew and Latin languages in mind, and set the path for many designers to achieve such combinations in the future.

The move to photosetting and later digital-setting further advanced the introduction of new typefaces. At the same time, the popularity of Letraset allowed for the easy testing of new typefaces. These expedited the creation of new typefaces. Among these, Narkis mentions Ada, by Ada Yardeni; Yahalom and Sal'it, by Shmuel Sela; and Oron, by Asher Oron. And yet, the Israeli pioneer designs surely carry among them a visual typographic statement of the new state. The combination of Eastern and Western, old and new, religious and

73 Mizrahi—Eastern, usually refers to Middle Eastern or Arab influences.
74 Yosef Gorny, "The 'Melting Pot' in Zionist Thought," *Israel Studies* 6, no. 3 (2001): 54–70.
75 An astounding amount, for its time, even among Latin faces.
76 Stern, "Design of Hebrew Type."
77 Ibid.

secular, Ashkenazi and Sephardic, and international and local not only opened up possibilities for further developments of Hebrew type design, but also represented the diversity of a society coming together in a textual-visual form.

4 The Digitization of Hebrew and Its Multilingual Internationality

The first computerized Hebrew typesetter was established in 1964 by Shmuel Gutman in Jerusalem.[78] Gutman's part in the digitization of Hebrew typography, however, may be more infamously known because the designer's work during the 1980s. The mid-1980s saw swift developments in Hebrew typeface design. The introduction of the personal computer and the digital communication revolution not only changed the role of type in reflecting the style of its time, but also enabled new design tools to ease the advances of its shape. Such tools were made available to any creator seeking to explore type design. Questions of quality, responsibility, availability, and more arose in this expanding field.[79]

One of the greatest style controversies of the time among Israeli designers was the Hebrew version of Arial, which was designed by Baruch Gorkin for Apple, although the final design was purchased by Microsoft. The general claim against the typeface was that it was a deformed version of Narkis Tam or Narkis Hadash, which led to a lawsuit against Microsoft for misuse of the face.[80] Although Gorkin was able to prove his design was original and did not rely on Narkis's designs, Microsoft settled the case with Narkis.[81]

Despite the questions of originality and quality, the Hebrew Arial is the most popular typeface used on the Internet and is used in many digital displays.[82] Out of the free faces that come with any personal computer, Arial is the most minimalistic and clear, and the most fit for small size text onscreen. Past faces

[78] Yaronimus, "Israeli Font Designers—Part I: Computer Pioneers" [Hebrew], *Ot-Ot-Ot Magazine*, May 12, 2019, https://bit.ly/378rTCA.
[79] Yehuda Hofshi, "Current Type Design in Israel" [Hebrew], *Vitrina* 1 (2007): 61–79.
[80] "13 Things You Didn't Know about Letters," *Blazer Online*, January 27, 2016, http://www.blazermagazine.co.il/thelist/24463.
[81] "Koren Publishing Inc. et al. vs. Microsoft Israel Inc. et al.," in *TLV 5315-04-08* (Tel Aviv: Central District Court, 2011), https://www.law.co.il/media/computer-law/koren_publishers_f2pi8KS.pdf.
[82] Hebrew Arial is extremely popular in vernacular design as well, as it is free and available on every computer, and for many years it had served as the default typeface with every new file generated by MS Office.

had difficulties in translating to the screen due to low resolutions and display issues in early computers, and therefore did not come into use.[83]

A cultural-visual study comparing Frank-Rühl and Arial concluded that Arial lacks cultural signs, and that it does not possess a connection with the Hebrew letter and its heritage.[84] Such a loss of identity may also be seen in the mistransformation of classic Hebrew typefaces into MS Office, many of which were designed by Gutman. Representations of Hebrew in digital form became a grave issue for designers of the period.

The groundbreaking contribution of Zvika Rosenberg and his foundry, Masterfont, was deeply rooted in those ill-designed early digital typefaces, as he saw the need for new and versatile typefaces. In the late 1980s, Rosenberg started his company by selling many designs of his own and others, including some of the leading typefaces in Hebrew culture, under exclusive contract.[85] On the one hand, Rosenberg supplied a dire need for digital typography in abundance. On the other hand, many of the typefaces were not well executed (most likely due to rushed work) and might have been used for specific one-of-a-kind scenarios or for display purposes only.

Type designer Nadav Ezra made his first steps in design under contract with Masterfont. In 1999, he founded Fontbit, where he served as lead designer. He was self-aware in his approach to professional growth. Ezra noted there was a desire among users for someone to compete with Masterfont and that there was a need to "satiate the hunger," and this realization resulted in a colorful carnival of typefaces.[86] One may read between the lines and see his actions an understanding of the low quality of some of his previous typographic products. In the last few years, Ezra has devoted himself to studying Hebrew typography more closely, and has produced new text typefaces as a result, showing that he now has a better historical understanding of Hebrew typographical roots.

It should be noted that the typography of the 1980s and 1990s was experimental around the world. With the introduction of computers and with postmodernism at its peak, deconstructed designs such as that of David Carson and experimental typography as showcased by Emigré with designers Rudy Vanderlans and Zuzana Licko were commonly accepted. In this context,

83 Doron Fishler, "Arial: The Transparent King of the Web" [Hebrew], *Nana10.co.il*, April 18, 2010, http://www.nana10.co.il/Articles/?ArticleID=712462.
84 Yuval Sa'ar, "Something Is Going on with Hebrew Type: Anad with Language at Large—A Discussion" [Hebrew], *Haaretz Online*, September 3, 2010, http://www.haaretz.co.il/misc/1.1220327.
85 Yaronimus, "Israeli Font Designers—Part I."
86 Ibid.

having hundreds of new playful Hebrew typefaces may be recognized as being part of a worldwide trend at the time, and should not be judged harshly.

Personal professional growth and development, as mentioned above with Nadav Ezra, may be seen in the paths taken by many other current Israeli designers, as all of them have been on a constant search for their own visual typographic voice, and have not had any formal typographic training. The Bezalel Academy of Arts and Design ceased its type design training with the retirement of Asher Oron in the 1970s, making Rosenberg, who studied under him, the last formally trained Hebrew type designer still operating today. Though some sporadic courses have emerged throughout the years in Israeli design academies, it may be argued that the passing of the torch, from one generation to another, has been severed. On the other hand, professional and academic continuity may only be observed in the twentieth century. As such, current leading Israeli type designers have been developing their skills in a manner not much different from that of Soncino, Bomberg, and Frank: studying past designs and adapting them into new typefaces relevant to the present.

Yanek Iontef started his work in typography with a Latin typeface he created during his studies at Bezalel, which was based on cardboard stencil stamps.[87] Over the years, he took inspiration from Latin typeface as well as from local vintage signs and publications in creating a wide variety of typefaces. In recent years, he has been digitizing and "cleaning up"[88] classic typefaces Frank-Rühl, Hadassah, and, most recently, Narkis's complete typeface library. He has also designed Hebrew versions for Latin typefaces, such as Parmigiano by designers Riccardo Olocco and Jonathan Pierini.

Similarly, designer Oded Ezer has long been experimenting and investigating the Hebrew letter. His first major success was the typeface Alchima'ee, 2004. With multiple styles and weights, it is considered a milestone in current Hebrew type design.[89] In 2011, Ezer introduced Rutz, which he suggested was "a new Hebrew typeface for the twenty-first century."[90] The typeface is a Hebrew companion to Vesper by Rob Keller of Mota Italic. Ezer has collaborated on

87 Meir Sadan, "Interview with Yanek Iontef, Summer 2003," *Ha'Oketz* 2003, http://oketz.com/iontef/.
88 In an interview with Yuval Sa'ar, Iontef explained how by redigitizing Hadassah he dusted off the dirt and wear of the typeface, returning it to its old glory and to what (in his opinion) Friedlander originally intended. See Yuval Sa'ar, "Yanek Iontef: I Took Hadassah and Cleared Its Dust, the Dirt Accumulated in Its Corners" [Hebrew], *Portfolio*, October 20, 2015, https://www.prtfl.co.il/archives/85038.
89 Hofshi, "Current Type Design in Israel."
90 Yuval Sa'ar, "Designing a 22nd-Century Classic," *Haaretz Online*, January 5, 2011, https://www.haaretz.com/israel-news/culture/1.5103735.

Hebrew designs for other internationally renowned designers and typefaces, and says he is constantly looking to innovate and surprise himself and his colleagues.[91]

Such recent collaborations may be seen from designer Michal Sahar as well. Like Ezer, Sahar started with original designs based on various inspirations. Her first breakthrough typeface was Darom, a sans-serif face that gained popularity through 7 *Yamim* (*Days*) magazine. She has been creating typefaces out of commercial and branding needs, and has been deeply involved in the creation of multilingual typefaces[92] such as Greta and Fedra with Peter Bil'ak.

Sahar is partnered in Ha'Gilda with designer Danny Meirav (Ha'Tayas) who specializes in novelty and revival typefaces.[93] The two collaborated with designers Mushon Zer Aviv and Nir Yenni in the design and release of Alef, a free-for-use typeface intended to replace Arial on the web. The typeface was granted the support of the Israel Internet Association.[94]

A younger generation of designers is acknowledged by Yaronimus, most of whom have found their first bearings and display platforms on social networks and Internet blogs and forums. Avraham Kornfeld and Alef-Alef-Alef, Eliyahu Fried, Ben Natan, and Daniel Grumer are some of Israel's leading up-and-coming typography designers, each creating many impressive typefaces, including national and international collaborations.[95]

Israeli type design is a vibrant and lively discipline, constantly engaging with new designers and raising important sociocultural issues. Such awareness-raising projects include Liron Lavi-Turkenich's Aravrit and Michal Shomer's Multi-Gender Hebrew. Lavi-Turkenich's final Master's project from the University of Reading, UK, created word combinations of Hebrew and Arabic, in an effort to promote coexistence.[96] Shomer's final Bachelor's project from HIT (Holon Institute of Technology) in Israel created new typographic symbols that simultaneously appeal to males, females, and people identifying as non-binary, and has been adopted in signage throughout the country (Fig. 1.2).[97]

91 Yaronimus, "Israeli Font Designers—Part II: Internet Pioneers" [Hebrew], *Ot-Ot-Ot Magazine*, May 18, 2019, https://bit.ly/3MNTxnD.

92 Typefaces with alphabets of different languages, such as Latin, Hebrew, Arabic, or various Slavic languages (Cyrillic), under one cohesive design.

93 Yaronimus, "Israeli Font Designers—Part II."

94 Ibid.

95 Yaronimus, "Israeli Font Designers—Part III: Children of the Internet" [Hebrew], *Ot-Ot-Ot Magazine*, May 25, 2019, https://alefalefalef.co.il/israeli-font-designers3/.

96 https://www.aravrit.com/.

97 https://multigenderhebrew.com/.

THE VISUAL TYPE AS AN IMAGE OF A PEOPLE

FIGURE 1.2 Michal Shomer's multi-gender "Welcome" sign (set in Alef typeface)
HTTPS://MULTIGENDERHEBREW.COM/

Both projects have raised a lively debate among designers as well as non-professionals. They also demonstrate how typography is taking its place of importance in Israeli society and culture today.

It is clear that the digital age of Hebrew typography has had two major impacts on Israel's typographic image. On the one hand, the gap in formal type design training in Israel is evident in the early stages of many of these designers' careers. Their first steps in type design and the release of initial typefaces seldom reached the depth and detail of past classics. However, the growing engagement with the field of Hebrew type design has helped advance the variety, versatility, knowledge, and quality of designers' work, as well as that of the collective market.

5 Conclusion: from a Typographically Voiceless People to a Typographically Vocal State

This chapter has drawn the connection between Jews and typography in terms of national identity and the path toward it. As a significant element in every society and culture, typography has been a tool of representation. For the

Jewish people and the State of Israel, the development of Hebrew typography can be observed from the printing of early Hebrew books until today. However, in light of this complete historical survey, two major points may be drawn.

First, the number of typefaces created and used within each period varies in relation to the state of print, society, and culture. As mentioned above, in the first few centuries of printing, Hebrew printing exemplified several directions of style based on the origins of printers and readers. No cohesive visual direction is apparent, though Soncino typefaces and their successors have been prominent. In the late nineteenth century, some attempts were made to match the Hebrew with the Latin alphabet, and print centered on a set of similar ill-designed typefaces. The introduction of Frank-Rühl united Hebrew print around one typeface, with some minor visual accompanying typefaces of the same period. The designs presented with the establishment of the State of Israel might not have overthrown the dominance of Frank-Rühl in print, but did increase the number of textual-visual possibilities for typefaces while highlighting and combining an array of traditions and inspirations. As opposed to the early design period of Hebrew typography, where influences seldom merged into any one typeface, these were bold designs portraying the new state and allowing it to come into its own visual-cultural identity. We may look at the evolution of Hebrew typography as an hourglass: it consisted of several typefaces at the beginning, it coalesced around one typeface at the turn of the twentieth century, and then the number of designed typefaces expanded from statehood onward until digitization.

Second, it is clear to see the change in importance of and the attention given to typography throughout the years. A strong contrast stands between the early printers of Hebrew and the current designers of the field. As mentioned above, Rafael Frank created his typeface for a living language and treated his design with the intention of its wide use and high legibility. Prior printers did not attend to typography in the same manner and were mostly settled in using type created by non-Jews. Nowadays, Hebrew type design has come full circle, where Israeli designers are the ones creating Hebrew companions to celebrated Latin typefaces by renowned designers. In doing so, these designers represent Israel and Hebrew among the nations of the world.

Bibliography

"13 Things You Didn't Know about Letters." *Blazer Online,* January 27, 2016. http://www.blazermagazine.co.il/thelist/24463.

Avrin, Leila. "Acrophonic, Micrographic, Typographic: The Story of Hebrew Letters." *Fine Print* 12, no. 1 (1986): 21–27.

Avrin, Leila. "The Art of the Book in the Twentieth Century." In *A Sign and a Witness: 2,000 Years of Hebrew Books and Illuminated Manuscripts*. Edited by Leonard Singer Gold, 125–139. New York: The New York Public Library, 1988.

Blum, Shayna Tova. "Design Research: Typography within the Israeli Linguistic Landscape." *Faculty and Staff Publications* 48 (August 2015). https://digitalcommons.xula.edu/fac_pub/48.

Doner, Batya. "History of Practical Graphics" [Hebrew]. In *History of the Jewish Community in Eretz-Israel since 1882; Part I: The Establishment of a Hebrew Culture* [Hebrew]. Edited by Moshe Lissak and Zohar Shavit, 535–555. Jerusalem: The Israeli Academy of Sciences, 1998.

Farjoun, Moshe. *Comparative and Institutional Development: A Research of the Development of Modern Hebrew Typography and of Printing Press and Publication in Israel*. Tel Aviv: Tel Aviv University, 2003.

Fishler, Doron. "Arial: The Transparent King of the Web" [Hebrew]. *Nana10.co.il*., April 18, 2010. http://www.nana10.co.il/Articles/?ArticleID=712462.

Friedl, Friedrich, Nicholas Ott, and Bernard Stein. *Typography: An Encyclopedic Survey of Type Design and Techniques throughout History*. New York: Black Dog & Leventhal Publishers, Inc., 1998.

Gorny, Yosef. "The 'Melting Pot' in Zionist Thought." *Israel Studies* 6, no. 3 (2001): 54–70.

"Haskala." In *Encyclopaedia Britannica*. Edited by Aakanksha Gaur et al. Accessed January 17, 2022. https://www.britannica.com/topic/Haskala.

Hofshi, Yehuda. "Current Type Design in Israel" [Hebrew]. *Vitrina* 1 (2007): 61–79.

Israel, National Library of. "A New Typeface for the New Jew" [Hebrew]. *The Librarians— The National Library's Blog*, December 2, 2019. https://blog.nli.org.il/frankruehl/.

Izre'el, Shlomo. "Processes of the Formation of Spoken Hebrew in Israel" [Hebrew]. In *Speaking Hebrew: Research of the Spoken Language and Linguistic Differences in Israel* [Hebrew]. Edited by Shlomo Izre'el with the aid of Margalit Mendelson, 217–238. Tel Aviv: Tel Aviv University, 2001.

"Koren Publishing Inc. et al. vs. Microsoft Israel Inc. et al." [Hebrew]. In *TLV 5315-04-08* [Hebrew]. Tel Aviv: Central District Court, 2011. https://www.law.co.il/media/computer-law/koren_publishers_f2pi8KS.pdf.

Livingston, Alan, and Isabella Livingston. "Typography." In *The Thames and Hudson Dictionary of Graphic Design and Designers*, 196. London: Thames and Hudson, 1998.

Messner, Philipp. "Hebrew Type Design in the Context of the Book Art Movement and New Typography." In *New Types: Three Pioneers of Hebrew Graphic Design*. Edited by Ada Wardi, 19–29. Jerusalem: The Israel Museum, 2016.

Narkis, Zvi. "Landmarks in Hebrew Typography" [Hebrew]. In *Book of Print* [Hebrew]. Edited by Erhardt D. Stiebner, 77–82. Tel Aviv: The National Printing Workers Association, 1992.

Narkis, Zvi. "Narkis, Narkisim and All the Rest" [Hebrew]. In *Type Is Forever: A Collection of Texts Devoted to the Design of the Hebrew Letter* [Hebrew]. Edited by Moshe

Spitzer, 103–107. Jerusalem: Ministry of Education and Culture, The Department of Jewish Religious Culture, 1989.

Prais, Simon. "Design Considerations Affecting the Simultaneous Use of Latin and Hebrew Typography." Master's Thesis, Manchester Polytechnic, 1985.

Rock, Michael. "Typefaces Are Rich with the Gestures and Spirit of Their Own Era." In *Looking Closer 3: Classic Writings on Graphic Design*. Edited by William Drenttel, Michael Bierut, Steven Heller, and D. K. Holland, 122–125. New York: Allworth Press, 2001.

Sa'ar, Yuval. "Designing a 22nd-Century Classic." *Haaretz Online*, January 5, 2011. https://www.haaretz.com/israel-news/culture/1.5103735.

Sa'ar, Yuval. "Something Is Going on with Hebrew Type: Anad with Language at Large—A Discussion" [Hebrew]. *Haaretz Online*, September 3, 2010, http://www.haaretz.co.il/misc/1.1220327.

Sa'ar, Yuval. "Yanek Iontef: I Took Hadassah and Cleared Its Dust, the Dirt Accumulated in Its Corners" [Hebrew]. *Portfolio*, October 20, 2015. https://www.prtfl.co.il/archives/85038.

Sadan, Meir. "Interview with Yanek Iontef, Summer 2003." *Ha'Oketz*, 2003. http://oketz.com/iontef/.

Sadan, Meir. "Ne'eman La'makor (True to the Original)." *Redesign*, June 29, 2016. https://meirsadan.github.io/david-libre/.

Spitzer, Moshe. "About Our Letters" [Hebrew]. In *Aley Ain: Minchat Dvarim (Offerings of Texts) in Honor of Shlomo Zalman Schocken on His Seventieth Birthday* [Hebrew], 481–501. Jerusalem: N. P., 1948–1952.

Stern, Adi. "The Design of Hebrew Type in the First Decade of Israeli Statehood." In *New Types: Three Pioneers of Hebrew Graphic Design*. Edited by Ada Wardi, 19–29. Jerusalem: The Israel Museum, 2016.

Stern, Gideon. *About Typography and Printing Type* [Hebrew]. Ra'anana, Israel: Hoshen, 2004.

Tamari, Ittai. "Introduction: Milestones in the Development of the Hebrew Letter" [Hebrew]. In *New Hebrew Letter Type* [Hebrew], 1–59. Tel Aviv: Tel Aviv University, 1985.

Waldeck, Mila. "Typography and National Identity." Paper presented at the Proceedings of the 9th Conference of the International Committee for Design History and Design Studies, 2014.

Waldman, Ilana. "Henri Friedlander, Master of Print and Book, and His Contribution to Fine Hebrew Printing" [Hebrew]. Master's Thesis, The Hebrew University of Jerusalem, 1993.

Weissblei, Gil. "A Man under His Typeface." [Hebrew]. *Segula* 125 (2020). https://bit.ly/3P4FMD8/.

Yardeni, Ada. *The Book of Hebrew Script: History, Fundamentals, Styles, Design.* Jerusalem: Carta, 1991.

Yaronimus. "Israeli Font Designers—Part I: Computer Pioneers" [Hebrew]. *Ot-Ot-Ot Magazine*, May 12, 2019. https://bit.ly/378rTCA.

Yaronimus. "Israeli Font Designers—Part II: Internet Pioneers" [Hebrew]. *Ot-Ot-Ot Magazine*, May 18, 2019. https://bit.ly/3MNTxnD.

Yaronimus. "Israeli Font Designers—Part III: Children of the Internet" [Hebrew]. *Ot-Ot-Ot Magazine*, May 25, 2019. https://alefalefalef.co.il/israeli-font-designers3/.

CHAPTER 2

Fictional Canon: Reconsidering Karl Schwarz's *Modern Jewish Art in Palestine*

Noa Avron Barak

In 2010, artist Ortal Ben Dayan posed in front of the newly renovated and reopened Israel Museum. In her hands, she held the Hebrew edition of the book *A Century of Israeli Art*, written by the museum's chief Israeli art curator, Yigal Zalmona. Titled *Six out of More Than Two Hundred: Mizrachi Artists according to Zalmona* (Fig. 2.1), the photo depicts Ben Dayan holding Zalmona's book by the mere six pages dedicated to Mizrachi artists.[1] It is a takeoff of Meir Gal's 1997 work, *Nine out of More Than Four Hundred: The Mizrachim by Kirshenbaum*

FIGURE 2.1 *Six Out of More than Two Hundred: Mizrachi Artists according to Zalmona*
ORTAL BEN DAYAN, 2010

1 In Israeli art historiography, Mizrachi artists are artists originating from North Africa and Eastern Jewish Diasporas.

FIGURE 2.2
Nine Out of More Than Four Hundred – The Mizrachim By Kirshenbaum
MEIR GAL, 1997

(Fig. 2.2). Both artists reflect on the minor *textual* representation of Mizrachi Jews in historiography. In other words, they do not just critique the history at large, but point particularly at the way it is represented in books. However, while Gal's critique focuses on hegemonic Zionist historiography as manifested in Kirshenbaum's well-known and respected book, *Toldot Israel BaDorot HaAchronim* (*The History of Israel in the Last Decades* [1968]), Ben Dayan's work, I claim, does not engage with Israeli art historiography representation in general, but rather visually critiques the Israeli art canon's textual representation.

The canon in Zalmona's book, which Ben Dayan wishes to critique, refers to the conventional story of Israeli art as that which began with Boris Schatz's "Bezalel" school and gradually developed into its contemporary phase—a part of a global network of art forms and artists. Mizrachi Jews were excluded from this story, just as they were in Kirshenbaum's. However, Ben Dayan does not point at specific artworks to engender her critique, but rather highlights a popular textual representation of Israeli art, a museal survey book. Although her choice to pose in front of the Israel Museum debunks the relationship between canon construction and power regimes in the art field as manifested in contemporary discourse,[2] her tribute to Gal's work also reveals the connection

2 The connection between the formation of the canon and art museums has been widely discussed in research over the past three decades. See Michael Camille, "Rethinking the

between canon formation and the *textual* representation of it. In this article, I wish to take this textual-canonic connection a step further and delve into the Israeli art canon, not just as mere textual representation of significant *history*, but as Hebrew fictional *literature*. In what follows, I argue that textual representations of the Israeli art canon should be analyzed through a literary methodology that in turn will foster our understanding of its construction.

A Century of Israeli Art celebrated the occasion of the Israel Museum's renovation and its new installation of Israeli art. Despite never having been academically peer-reviewed, Zalmona's book has been used in Israeli art survey courses taught in local and global academia.[3] Although viewed as an art history book that allegedly portrays Israeli artistic creation objectively in the last one hundred years, *A Century of Israeli Art* textually represents only the Israeli art canon as constructed by the Israel Museum's collection over the years. This collection of artworks and the narrative constructed around it features the work of "great" and timely Israeli art-masters deemed worthy of the national museum. It features famous figures from the cultural history of Zionism stably configured in the story—Boris Schatz, Nachum Gutman, Reuven Rubin, Yosef Zaritsky, Raffi Lavie, and Joshua Neustein, to name a few. These artists took part in the national endeavor of Israeli art production: some in practice, like Rubin and Gutman, and others, like Schatz and Lavie, also through their pedagogy. Thus, Zalmona's focus on these artworks and artists of Israel makes the book, by definition, a textual representation of the canon.[4]

However, to understand how this book and its genre not only represent the canon but also advance its naturalization and dissemination to the public,

Canon: Prophets, Canons, and Promising Monsters," *The Art Bulletin* 78, no. 2 (1996): 198–201; David Carrier, "Art and Its Canons," *The Monist* 76, no. 4 (1993): 524–534; Ruth Iskin, ed., *Re-Envisioning the Contemporary Art Canon: Perspectives in a Global World* (New York: Routledge, 2017); Gregor Langfeld, "The Canon in Art History: Concepts and Approaches," *Journal of Art Historiography* 19 (2018), https://pure.uva.nl/ws/files/32456294/langfeld.pdf; Hubert Locher, "The Idea of the Canon and Canon Formation in Art History," in *Art History and Visual Studies in Europe: Transnational Discourses and National Frameworks*,ed. Matthew Rampley, Thierry Lenain, Hubert Locher, Andrea Pinotti, Charlotte Schoell-Glass, and C. J. M. (Kitty) Zijlmans (Leiden: Brill, 2012), 29–40; Gillian Perry and Colin Cunningham, *Academies, Museums, and Canons of Art* (New Haven, CT: Yale University Press, 1999); Charles Werner Haxthausen, ed., *The Two Art Histories: The Museum and the University* (Williamstown, MA: Sterling and Francis Clark Art Institute, 2002).

3 See current syllabus at Tel Aviv University and NYU as two examples among many.
4 Israeli art critic Yonatan Amir discussed Zalmona's book in an essay published in the online art and culture magazine *Erev Rav*, which also featured the photograph of Ben Dayan's work. Like Ben Dayan and this article, Amir also views Zalmona's book as representative of the Israeli canon. See Yonatan Amir, "One Hundred Years of Isolation," *Erev Rav: Art. Culture. Society*, 2010, https://www.erev-rav.com/archives/8301. I thank Amir and Ben Dayan for allowing me the rights to print the work and for the details they provided regarding its creation.

I present its connection with modern Hebrew literature, a connection I dub "art literature." This article will thus perform a literary analysis of one such book, Karl Schwarz's *Modern Jewish Art in Eretz Yisrael* (1941). Like Zalmona's, Schwarz's early book is the manifestation of art literature commonly perceived as art history. I will show that Schwarz's book is in fact a short novel of sorts. Using a literary structure that dates back to biblical stories and mythology, the text created a bond with its readers, promoting in its distribution the creation of an *imagined consensus* regarding its content. Although it reads as a history book in the eyes of Israeli art historiography, I claim that it is a textual representation of canon, exposing the fictional elements of Israeli art canons—Schwarz's book representing an early manifestation, Zalmona's a late one.

I will first establish my literary analysis through the theoretical works of literary critic Frank Kermode and historian Hayden White on the connection between history and literature. After acknowledging the fact that history—and art history in particular—contains fictional elements, I will present the idea that art canons as partial histories have a particular bond to literature due to their textual representation in popular books. Through these books, art canons are disseminated to the public, establishing the selected artworks and artists in them as part of the consensus, as far as their historical significance is concerned.[5] However, because this consensus occurs *after* the story has been written and distributed, it cannot *a priori* claim to reflect a stable, widespread acknowledgment of artistic value. I therefore refer to it as an *imagined consensus*. By viewing these books as popular art literature rather than art history and by performing a critical examination of Schwarz's canon, the latter's association with the construction of Israeli nationalism can be better understood. This article proposes an alternative understanding of the Israeli art canon by positing its fictional and imagined components, inasmuch as it has included particular artworks and artists and excluded others for the sake of the Zionist project. This nationalist tale propelled the notion that Israeli art is modern Jewish art at its finest, a feat supposedly made possible only within the confines of the Land of Israel. By examining the first book ever written on art in Israel as art literature via literary examination, I will expose the connection between the construction of art history in Israel as a Zionist endeavor, fiction literature, and Israeli art canons.

5 I use the term "consensus" through Chantal Mouffe's definition of it as a political stabilator of temporary hegemony and as a term that will always entail the practice of selection. See James Martin, *Chantal Mouffe: Hegemony, Radical Democracy, and the Political* (London: Routledge, 2013).

1 Canon as Fiction

Viewing the canon as fictional in essence is grounded in the theoretical notion concerning the relationship between history and literature, as articulated in the writings of Hayden White and Frank Kermode. Both scholars operated at the intersection of history and literature research. They presented the idea of the narrative essence of history-writing as informed from literary structures, and asked fellow scholars to embrace rather than deny this literary influence.[6] This connection alludes to the idea that the scientific-historic text, like the historical novel, is only "based on a true story," that it holds imaginative-fictive elements, and that it does not have a singular validity to the historical truth.[7] In the context of art history, both the catalog raisonné of canonic artist Vermeer and the novel *Girl with a Pearl Earring* (1999) by Tracy Chevalier contain fictional elements that construct the narrative they offer, and the writer's imagination takes a prominent place in the representation of a historical story. Although contemporary academic (art) history has the lead on historical truth, following Northrop Frye's notion of literature as the ultimate critic of culture,[8] Kermode and White promoted a view according to which both genres hold great significance in the study of humans' cultural history. This, I claim, is particularly relevant to art history. Indeed, the premise of this article is that, in addition to rigorous historical methodology, a literary analysis of textual representations of history can engender insights into art history and its formation.

Over the past three decades, the notion of history as narrative has become widely acknowledged in art history, primarily influenced by (but not directly associated with) Kermode's and White's work.[9] However, contrary to contemporary scholarship, which mainly discusses the validity of one narrative over the other, my theoretical framework viewing the canon as fiction wishes to point to the literary elements of the art history text. The critical debate on the connection between history and literature has far-reaching implications:

6 For a thorough discussion on White's and Kermode's scholarship and their interactions, see Frank Ankersmit, Ewa Domańska, and Hans Kellner, *Re-Figuring Hayden White* (Stanford, CA: Stanford University Press, 2009); D. L. LeMahieu, "Kermode's War," *Literature and History* 25, no. 1 (2016): 76–94; and Hayden White, "Historical Fictions: Kermode's Idea of History," *The Critical Quarterly* 54, no. 1 (2012): 43–59.

7 Hayden White, *The Content of the Form: Narrative Discourse and Historical Representation* (Baltimore: Johns Hopkins University Press, 1987); Hayden White, *The Practical Past* (Evanston: Northwestern University Press, 2014); Frank Kermode, *The Sense of an Ending: Studies in the Theory of Fiction* (Oxford: Oxford University Press, 2000); Frank Kermode, *Poetry, Narrative, History* (Oxford: Blackwell, 1990).

8 Northrop Frye, *Anatomy of Criticism: Four Essays* (New York: Atheneum, 1966).

9 Robert Doran, "Editor's Introduction," in *The Fiction of Narrative: Essays on History, Literature, and Theory, 1957–2007*, ed. Robert Doran (Baltimore: Johns Hopkins University Press, 2010), xiii–xxxii; Jacqueline Rose, "The Art of Survival," *Critical Quarterly* 54, no. 1 (2012): 16–19.

the binding of history and fiction, suggesting that history has little grounding in true historical reality, is a controversial view. I apply the idea of history as fiction to the art history sphere, reduced to the discussion of textual representations of the canon and its implication for notions of canonicity or canon formation mechanisms. Instead of framing the entire history of art as fiction, as suggested by Mark Ledbury in *Fictions of Art History*, I choose to examine textual representations of the canon as fictional.[10] These representations are already acknowledged as partial and partisan.[11] Therefore, the act of viewing only the canon (rather than history) as fictional, I claim, raises less opposition and can be dispersed more broadly.

2 A Novel about Land

In 2019, Alec Mishory published a textbook for a new course on Israeli art at the Open University. *From Ofakim Hadashim to Ruach Acheret: Israeli Art 1948–1988* was the first textbook ever written about Israeli art.[12] Although it does show the methodological turn in art history research and pedagogy, the book primarily aligns with the canonic narrative of Israeli art as portrayed in Zalmona's book (i.e., beginning with Schatz and presenting a Zionist essence). In the introduction, Mishory critically discusses historical writing about Israeli art, but axiomatically addresses only eight books he regards as seminal in the history of Israeli art. The first of these is Schwarz's *Modern Jewish Art in Eretz Yisrael*.

Viewing this book as a work of art history is not a surprising perspective, as Schwarz was indeed a venerated art historian and museum professional. He was trained at the highly esteemed University of Heidelberg and was an active art historian in early-twentieth-century Germany. At the time of writing his book, Schwarz served as the first professional director of the Tel Aviv Museum of Art, which opened in 1932, and from the beginning held a significant role in the local art field.[13] In fact, Schwarz was "called to duty" because of his experience as the founder of the Jewish Museum in Berlin (which unfortunately opened its doors the year Hitler rose to power in Germany, and closed soon

10 Mark Ledbury, ed., *Fictions of Art History* (Williamstown, MA: Sterling and Francine Clark Art Institute), 2013.
11 Iskin, *Re-Envisioning the Contemporary Art Canon*; Anne Brzyski, *Partisan Canons* (Durham, NC: Duke University Press, 2007).
12 Alec Mishory, *From Ofakim Hadashim to Ruach Acheret: Israeli Art 1948–1988* [Hebrew] (Ra'anana, Israel: Lamda, 2019).
13 Graciela Trajtenberg, *Between Nationalism and Art: The Construction of the Israeli Art Field during the Yishuv Period and the First State Years* [Hebrew] (Jerusalem: Magnes Press, 2005).

thereafter).[14] *Modern Jewish Art in Eretz Yisrael* was the first book Schwarz wrote in Hebrew focusing on the art production of Jewish artist immigrants to Israel (then Palestine) at the turn of the century. It was also the only book on art in Palestine and one written by a leading professional in the art scene at that time. One can safely say that like Zalmona's book, Schwarz's too was the textual representation of the canon of its time. However, a rereading of the book through the prism of literature reveals that it is no less fictional as it is historical, alluding to the fictional elements of canons as partly invented stories with limited connection with historical truth (however defined).

Schwarz's book is divided into six textual-narrative chapters: "Introduction," "Architecture," "Art of Sculpture," "Art of Painting," "Graphic Art," and "Crafts." Such art historical distinctions in respect to medium will continue in future writing on Israeli art, crystalized in disciplinary study. This categorization by artistic form was meant as a sign of professionalism directly influenced by Schwarz's art history training and his certified legitimacy to write about art. Thus in the historiography of Israeli art, Schwarz's book is indeed perceived as the beginning of art historic writing on visual arts.[15] However, although Schwarz uses professional art history terminology—dividing the book according to medium and stylistic categories, analyzing the form and content of the artworks, and contextualizing Jewish art in Palestine with its European counterpart—the real subject of the book is not Jewish art or even Jewish artists; rather, it is a short novel on the Land of Israel/Eretz Yisrael.

Indeed, Schwartz's book is not a history book. Its main protagonist is the Land of Israel, a specific territory in the Middle East—a land that, with the return of the Jews, could once again provide a platform from which great Jewish art could grow. The plot spans from ancient times to the present day of its writer. The goal of art in Eretz Yisrael is declared, from the very beginning of the text, as being part of the Zionist new cultural construction. Eretz Yisraeli art, explains Schwarz, forms the building blocks of the young nation which seeks for itself a cultural unity, one that can only occur in the Land of Israel. Schwarz writes:

14 Chana Schutz, *Karl Schwarz and the Beginning of the Tel Aviv Museum, 1933–1947* [Hebrew] (Tel Aviv: Tel Aviv Museum of Art, 2010).

15 Before Schwarz, writing on art mainly appeared in newspaper or literary periodicals whose writers were mostly not trained in art history. See Dalia Manor, "Facing the Diaspora: Jewish Art Discourse in 1930s Eretz Israel," in *Israeli Exiles: Homeland and Exile in Israeli Discourse*, Ofer Shiff (Sdeh Boker, Israel: Ben Gurion University, 2015), 13–51; Dalia Manor, "Israeli Modernism in Art: East or West, Local or Universal—Beginning of a Dispute" [Hebrew], in *Israeli Modernism or Modernism in Israel* [Hebrew], ed. Oded Heilbronner and Michael Levin (Tel Aviv: Resling, 2010), 67–97.

This is a pioneering attempt at describing young *Eretz Yisraeli* art in its many variants and uncover[ing] its aspirations and goals which are debated by artists, yet at the same time remain suspended in subconsciousness.

A land whose early history is embedded in the dawn of humanity, a land from which one of the most exalted religions had sprung, slowly faded into wars and lost more and more of its value and significance. Hundreds of years of neglect have driven this land into poverty and depletion. Fields of flowers destroyed, forested hills became barren rock, and eventually the desolate land was nothing more than a wasted settlement. Nothing remained of that spiritual awakening of the people of yore ... the offspring of the nation, for whom the land of Israel was a birthright, dispersed throughout the world. Then the call of the awakeners was sounded and a new prophet rose and declared: "If you will it, it is no dream!" ... The barren land bore fruit. It is a young country, searching for its place in the real world. It wishes to develop a culture of its own. It seeks expression through life and art ... but aspiration alone is not enough. Foundations that are often heterogeneous must be unified into a new organic unity and not be allowed to grow arbitrarily: moreover, one must create an entire spiritual and cultural unit, a *nation* beyond concept, one skilled enough to produce and develop new forces of creation.[16]

What is the connection between Schwarz's "new Jewish art" and the "young Israelite art" described in its introduction? Schwarz attempts to show that they are identical—the young Israelite art being in fact the new Jewish art.

By configuring the book's time frame of art production from the glory days of the ancient Judaic land and its people to the slow decay and wilderness that prevailed when the land was emptied of its Jewish inhabitants, Schwarz binds the Land of Israel with Jewish art. Just as the Land of Israel is under revival, so is its art. Both are in progress, yet not at their peak. While the physical construction of the land is developing well, the final goal is spiritual unity in the form of national culture. Only the development of a national culture will truly allow the land—which by the end of Schwartz's introduction has become a nation—to grow by means of spiritual creation in the form of great Jewish art. Schwarz binds together these two concepts—Jewish and Israelite—through the Land of Israel. This is yet another indication that the novel is not about art but about land, namely Eretz Yisrael.

16 Karl Schwarz, *Modern Jewish Art in Eretz Yisrael* (Jerusalem: Rubin Mass, 1941), 10–15.

3 Biblical Literary Structures in Textual Representations of Canon

A literary analysis of Schwarz's book unveils the biblical literary archetypes that reside in it. The detailed characterization of these archetypes, as Frye, Kermode, and White will assert, both in literature and in history can provide a better understanding of the collective subconscious. Indeed, literary archetypes, especially those that originate in the Bible, exist in modern Western historiography and can be termed "historical archetypes."[17] For example, literary-historical archetypes found both in the Bible and in modern literature, such as the binding, the father's death, and the motherland, are also widespread in historiography. The way they have changed over hundreds of years and their present interpretation are indicative of the changes in society itself: the modern binding structure embeds the modern fear of conservatism; the father's death unveils the secularization of society; and the motherland that appears after the father's death is the main archetype of nationalism.[18] In the Zionist context, the motherland archetype possesses a particular and dual meaning that points at both land and people.[19] Addressing Schwarz's text through the prism of historical archetypes shows that his text is a part of modern Hebrew literature, where the concepts of land, nation, and art merge into one entity to which the geography of Israel gives concrete form.

Indeed, the historical archetypes employed by Schwarz were used by philosophers, authors, and poets of hegemonic Zionism. Two other examples are the idea of the return to Eretz Yisrael and the conquest of the desert (*kibush ha'shmama*). These archetypes are rooted in the biblical Books of Joshua, Ezra, Nehemiah, and Lamentations, which tell the historical tale of the destruction of the Temple, the desertion of the land, and the future glorious return to it. These archetypes bring forth a general desire to return to a better, amended version of the past. In this literary biblical structure, the physical Land of Israel is once again of the utmost importance: it shall only bear fruit for its rightful heirs, its true sons. The desert was formed through the Exile, the *Galut*, and can be successfully conquered through the return to it. The negative metaphor of destruction and banishment poses the desert as a place of the rebirth of the nation. In modern Zionist literature, the metaphorical sense of the desert has changed to represent an authentic return and reconnection between the native inhabitants and the deserted land, so that together they will make it

17 Harold Fisch, *A Remembered Future: A Study in Literary Mythology* (Bloomington: Indiana University Press, 1984).
18 Ibid., 91–171.
19 Ibid., 138.

FICTIONAL CANON

anew.[20] These two literary archetypes, also found in Schwarz's book, portray the return of the Jews to their homeland as a guarantee that the land will flourish again.[21]

The Land of Israel is used by Schwarz not only as a territorial entity, but as a literary metaphor originating in the Bible. He writes:

> The Land of Israel is a land of contradiction ... There's Biblical Israel, and then there's Modern Israel ... This is the juncture of thousands of years.
>
> Here the artist is offered a myriad of opportunities ... All that is created here is the fruit of mere decades ... We must be conscious of these facts when assessing the artistic achievements of this country in the modern era. For even with the colorful spectrum of life in this land, of old and new, breathtaking and ever-changing vistas, Israel is yet to be viewed as a land of art ... "The spirit of art" is still absent ...[22]
>
> It is therefore too soon to talk about Eretz-Yisraeli painting in the same manner as French, Dutch or German art. It is a matter left for the future, the role of generations, the result of ceaseless labor and fruit of tradition. We are already seeing seedlings of this development, and for the time being, it is sufficient.[23]

Through Schwarz's prose, it is understood that only within the borders of Eretz Yisrael can true modern Jewish art be produced by its artists. Schwarz's plot portrays the story of new art in Eretz Yisrael by focusing on the conditions of the land. Through his writing, the story of the land narrates itself and is used as a metaphor for the success of the entire Zionist project and the cultural construction at play. Much like the pioneers transformed a neglected wasteland into a fruitful land, so do the artists grow from the land the seedlings of art. However, the story of both the pioneers of land and the pioneers of art has not yet come to an end. Nevertheless, surprisingly enough, Schwarz does find art in Eretz Yisrael and names a long list of Eretz-Yisraeli paintings and artists in his text. This paradox is instrumental for Schwarz and used to convince the reader that the art is indeed rooted in the land itself. By pointing to the artists

20 Yael Zerubavel, "The Desert as a Mythical Space and Site of Memory in Hebrew Culture" [Hebrew], in *Myths in Judaism: History, Thought, Literature* [Hebrew], ed. Moshe Idel and Ithamar Gruenwald (Jerusalem: Zalman Shazar Center for Jewish History, 2004), 223–236.
21 Yosef Salmon, "'Renew Our Days as of Old': A Zionist Myth" [Hebrew], in *Myths in Judaism: History, Thought, Literature* [Hebrew], ed. Moshe Idel and Ithamar Gruenwald (Jerusalem: Zalman Shazar Center for Jewish History, 2004), 207–223.
22 Schwarz, *Modern Jewish Art*, 61–62.
23 Ibid., 77.

producing art in this old-new land, the mythic power of the land is portrayed as able to transform Jewish art to Israeli art as its ultimate modern form.

4 The Artists as Antagonists

If the Land of Israel is the protagonist of Schwarz's novel, the artists described by him are the antagonists that partake in the development of the plot, thus helping the land reach its goal of growing and producing art. Nachum Gutman, for example, is portrayed as "one of Eretz Yisrael's true painters" … as he "set deep roots in this land's culture."[24] Contrary to Gutman, who arrived in Palestine early enough to be truly organically and naturally affected by its unique character, Moshe Castel represents—per Schwartz—the damaging effect of Paris on Jewish artists, even those born in Palestine. He describes Castel in the following manner:

> Moshe Castel, for example, despite having been born in Israel, became a true Frenchman after years of living in Paris. He is a descendent of a Spaniard family, long-time dwellers of Israel. He attended school in Jerusalem, then lived in Paris, and only returned to settle in Israel before the outbreak of the current war. His entire artistic perspective is still overly affected by the artistic spirituality of Paris, and he will require many more attempts before he will be acclimated to the conditions of this land.[25]

Castel's subplot, as others in the text, is developed and constructed, again, through the motif of *return*, which resonates from the introduction and the return to Zion that it describes. In addition to the dimension of time that advances the plot, Schwarz also develops a spatio-geographic dimension between Europe and Palestine that is structured through individual artist's biographies as exemplified in the quote about Castel's physical and artistic journey. Just as the land was emptied and unable to grow art, Castel too cannot create true Jewish art from outside its boundaries. Only when the artists return to their true land and confront the struggles of everyday life can they start to grow art from within it. In Schwarz's representation of historical archetypes, the potential of growing art from within is a direct result of

24 Ibid., 81–82.
25 Ibid., 95–96.

the artist's entanglement with the land, physically and spiritually. Schwarz's account of Jacob Steinhardt in the last paragraph of the chapter titled "The Art of Painting" is also illuminating in this regard:

> Steinhardt's achievements in the field of painting over the past several years testify to this war, which even the most skilled artist is forced to wage here. We struggle to imagine a more direct and honest battle than that faced by Jacob Steinhardt. His works reflect the problematic nature of new art. How often did the artist succumb to depicting in color the strong and singular impression of the Old City! The eternal city, shrouded by the mightiness of antiquity, is still a mystery—much like this entire land we so deeply love and have been bound to for thousands of years, yet still have to physically and emotionally conquer if we are to fully merge with it. Only then will we be worthy of bearing the ancient-contemporary culture of our country.[26]

This paragraph is a good representation of the subject of Schwarz's novel: not art, but the Land of Israel and its potential for cultural revival. The book comes full circle, describing the land of oppositions. Steinhardt's art practice, which at first appears to be the subject of the paragraph, is revealed to be secondary, thereby stressing the main idea: the centrality of the land. Here, we are treated to a unique example of Schwarz stepping outside of his role as an objective narrator, as he directly addresses the reader, bringing together the two dimensions of being. Through a joint love of the Land of Israel, the authoritative author of the story is naturally united with his readers, allowing the story to be accepted by the wider public. Schwarz wrote a Zionist novel for a Zionist reader that could identify with the narrative. The fact that this particular story *became* a consensus is thus not surprising, especially due to his place in hegemonic art historiography. However, as this state of agreement developed *after* the story was told, it cannot be a reflection of it.[27] This is an *imagined consensus* around the canon, which was a canon that was formulated with the help of a literary construction of its textual representations—a canon that is, in fact, a part of art literature as much as it is a part of art history.

26 Ibid., 109.
27 The connection between modern Jewish art and Israeli art as portrayed by Schwarz was far from reaching consensus during this period. See Manor, "Facing the Diaspora."

5 Conclusion

This article revealed the fictional elements that constructed Karl Schwarz's book, *Modern Jewish Art in Eretz Yisrael*, and placed it not in the sphere of art history, but in that of art literature. It was the first and only book written on art in Israel in Hebrew. Due to the central role of its author in the developing art field in Palestine, it became a narrative that also represented a canon, albeit only for a short time. Indeed, the centrality of Steinhardt as portrayed in Schwarz's canon, for example, changed quite quickly. Benjamin Tammuz's *The Story of Art in Israel* (1963) already shows Steinhardt's marginalization in the story.[28] However, the canon represented in Schwarz's book was not the result of a consensus over the artistic production of portrait artists, but of the authoritative role of its author and, no less important, his ability to connect with his readers. Although the artists and artworks that constructed the story in Schwartz's textual representation of the canon quickly gave way to other figures in later canonic art literature written in Israel, the historical archetypes in it are replicated in later books as well. Some took on new forms, others remained as myths. This, I claim, serves as yet another exemplification of the fictional element of the canon of Israeli art.

The discussion on the Israeli art canon in this chapter was done by way of a literary deconstruction of its textual representations in the book perceived as historiography. By doing so, I was able to show that canons are not only partisan or partial histories, but are also fictional in form, hence my continued reference to it as a novel. What can the fictions of the Israeli canon tell us about Israeli art history or its cultural history at large? This is the subject of future publications. And as this text, although scientifically constructed, contains fictional elements in it, I allow myself to conclude that the whole story has not been told and is "to be continued."

Bibliography

Amir, Yonatan. "One Hundred Years of Isolation." [Hebrew] *Erev Rav: Art. Culture. Society*, 2010. https://www.erev-rav.com/archives/8301.

Ankersmit, Frank, Ewa Domańska, and Hans Kellner. *Re-Figuring Hayden White*. Stanford, CA: Stanford University Press, 2009.

Brzyski, Anne. *Partisan Canons*. Durham, NC: Duke University Press, 2007.

28 Benjamin Tammuz, *The Story of Art in Israel* [Hebrew] (Givatayim, Israel: Masadah, 1980).

Camille, Michael. "Rethinking the Canon: Prophets, Canons, and Promising Monsters." *The Art Bulletin* 78, no. 2 (1996): 198–201.

Carrier, David. "Art and Its Canons." *The Monist* 76, no. 4 (1993): 524–534.

Doran, Robert. "Editor's Introduction." In *The Fiction of Narrative: Essays on History, Literature, and Theory, 1957–2007*. Edited by Robert Doran, xiii–xxxii. Baltimore: Johns Hopkins University Press, 2010.

Fisch, Harold. "A Remembered Future: A Study in Literary Mythology." Bloomington: Indiana University Press, 1984.

Frye, Northrop. *Anatomy of Criticism: Four Essays*. New York: Atheneum, 1966.

Haxthausen, Charles Werner, ed. *The Two Art Histories: The Museum and the University*. Williamstown, MA: Sterling and Francis Clark Art Institute, 2002.

Iskin, Ruth, ed. *Re-Envisioning the Contemporary Art Canon: Perspectives in a Global World*. New York: Routledge, 2017.

Kermode, Frank. *Poetry, Narrative, History*. Oxford: Blackwell, 1990.

Kermode, Frank. *The Sense of an Ending Studies in the Theory of Fiction*. Oxford: Oxford University Press, 2000.

Langfeld, Gregor. "The Canon in Art History: Concepts and Approaches." *Journal of Art Historiography* 19 (2018). https://pure.uva.nl/ws/files/32456294/langfeld.pdf.

Ledbury, Mark, ed. *Fictions of Art History*. Williamstown, MA: Sterling and Francine Clark Art Institute, 2013.

LeMahieu, Daniel. "Kermode's War." *Literature and History* 25, no. 1 (2016): 76–94.

Locher, Hubert. "The Idea of the Canon and Canon Formation in Art History." In *Art History and Visual Studies in Europe: Transnational Discourses and National Frameworks*. Edited by Matthew Rampley, Thierry Lenain, Hubert Locher, Andrea Pinotti, Charlotte Schoell-Glass, and C. J. M. (Kitty) Zijlmans, 29–40. Leiden: Brill, 2012.

Manor, Dalia. "Facing the Diaspora: Jewish Art Discourse in 1930s Eretz Israel." In *Israeli Exiles: Homeland and Exile in Israeli Discourse* [Hebrew]. Edited by Ofer Shiff, 13–51. Sdeh Boker, Israel: Ben Gurion University, 2015.

Manor, Dalia. "Israeli Modernism in Art: East or West, Local or Universal—Beginning of a Dispute" [Hebrew]. In *Israeli Modernism or Modernism in Israel* [Hebrew]. Edited by Oded Heilbronner and Michael Levin, 67–97. Tel Aviv: Resling, 2010.

Martin, James. *Chantal Mouffe: Hegemony, Radical Democracy, and the Political*. London: Routledge, 2013.

Mishory, Alec. *From Ofakim Hadashim to Ruach Acheret: Israeli Art 1948–1988* [Hebrew]. Ra'anana, Israel: Lamda, 2019.

Perry, Gillian, and Colin Cunningham. *Academies, Museums, and Canons of Art*. New Haven, CT: Yale University Press, 1999.

Rose, Jacqueline. "The Art of Survival." *Critical Quarterly* 54, no. 1 (2012): 16–19.

Salmon, Yosef. "'Renew Our Days as of Old'—A Zionist Myth" [Hebrew]. In *Myths in Judaism: History, Thought, Literature* [Hebrew]. Edited by Moshe Idel and Ithamar Gruenwald, 207–223. Jerusalem: Zalman Shazar Center for Jewish History, 2004.

Schutz, Chana. *Karl Schwarz and the Beginning of Tel Aviv Museum, 1933–1947* [Hebrew]. Tel Aviv: Tel Aviv Museum of Art, 2010.

Schwarz, Karl. *Modern Jewish Art in Eretz Yisrael* [Hebrew]. Jerusalem: Rubin Mass, 1941.

Tammuz, Benjamin. *The Story of Art in Israel* [Hebrew]. Givatayim, Israel: Masada, 1980.

Trajtenberg, Graciela. *Between Nationalism and Art: The Construction of the Israeli Art Field during the Yishuv Period and the First State Years* [Hebrew]. Jerusalem: Magnes Press, 2005.

White, Hayden. "Historical Fictions: Kermode's Idea of History." *The Critical Quarterly* 54, no. 1 (2012): 43–59.

White, Hayden. *The Content of the Form: Narrative Discourse and Historical Representation*. Baltimore: Johns Hopkins University Press, 1987.

White, Hayden. *The Practical Past*. Evanston, IL: Northwestern University Press, 2014.

Zerubavel, Yael. "The Desert as a Mythical Space and Site of Memory in Hebrew Culture" [Hebrew]. In *Myths in Judaism: History, Thought, Literature* [Hebrew]. Edited by Moshe Idel and Ithamar Gruenwald, 223–236. Jerusalem: Zalman Shazar Center for Jewish History, 2004.

CHAPTER 3

Taming the Levant: Reflections on Zionism, Orientalism, and Depictions of Tel Aviv-Yaffo in Israeli and International Comics

Ofer Berenstein

Tel Aviv-Jaffa is Israel's largest city, central business hub, and cultural nexus.[1] "The first Hebrew city," as it is often referred to,[2] is not only the first to be founded but also the one most present in pop culture. Artists are both products and creators of their culture,[3] and art is a form of communication that provides people with a frame of reference with which they can make sense of reality.[4] If so, one can learn a great deal about Israeli culture from examining the depiction of Tel Aviv-Jaffa in pop culture.

This chapter focuses on depictions of Tel Aviv-Jaffa in comics (both Israeli and international), and it does so for two main reasons: first, to chart which landmarks have become urban icons of Tel Aviv-Jaffa in the past and in the present; and second, to ask how, if at all, the choice of landmarks, their depiction, and their inclusion in the narrative of the city's history relate to the desired perception of reality about Israel and Israeli society as *Western outposts* in the East—a perception originally desired by its Zionist founders.[5]

Comics were chosen as the focus of this article because of its duality as both an art form and mass medium that, at times, has reached the highest exposure rate among young Israelis after radio.[6] Therefore, comics have likely had

1 This chapter is based, in part, on presentations given at the Annual Conference of the Association of Israel Studies in 2016 and at the Icon Sci-Fi and Fantasy Festival's Academic Track in 2009.
2 Eran Razin, "Tel Aviv-Yafo: Additional Information." In *Encyclopedia Britannica*, ed. Aakanksha Gaur et al., accessed March 11, 2020, https://www.britannica.com/place/Tel Aviv-Yafo/additional-info.
3 Nicholas Mirzoeff, "What Is Visual Culture?" in *The Visual Culture Reader*, ed. Nicholas Mirzoeff (London: Routledge, 1998), 4–13.
4 Ernest H. Gombrich, *Art and Illusion: A Study in the Psychology of Pictorial Representation*, 6th ed. (New York: Phaidon, 2002); John R. Searle, "The Logical Status of Fictional Discourse." *New Literary History* 6, no. 2 (1975): 319–332.
5 Amiel Alcalay, *After Jews and Arabs: Remaking Levantine Culture* (Minneapolis: University of Minnesota Press, 1993).
6 Eli Eshed, *From Trazan to Zbeng: The Story of Popular Literature in Hebrew* [Hebrew] (Tel Aviv: Bavel, 2002).

a greater role to play in establishing the collective memory of the city and in imparting sociocultural values to its residents than other fine arts. And this is partly due to comic readers' (as art spectators) internalization of information and use of said information to construct their reality, both historical and current.[7]

With that said, the goal of this chapter is not to chart the history of Israeli comics. Therefore, the comics referenced are by no means a representative sample or an exhaustive list of representations of Tel Aviv-Jaffa. Rather, the review undertaken in this chapter admittedly focuses on select works in which creators paid attention to emerging or outstanding elements in the urban landscape. The corpus includes proto-comics from the 1930s, comics from the late 2010s, and others in between. However, it is not organized based on years of publication, but rather on the landmarks that the publications depict.

Zionism is the ideological framework that guided the foundation and building of the State of Israel as the Jewish nation-state.[8] The process of unraveling Zionism's reflection in comics in this chapter takes a two-step approach. In the first step, using geography studies' concept of *urban icons*, an understanding will be established about the ways in which the straightforward depiction of sites in Tel Aviv and Jaffa promotes particular perceptions of Israel fitting the time of publication and the Zionist narrative. The second step will build upon the concept of *collective memory* in demonstrating how the overall differences in depictions of Tel Aviv and Jaffa feed into the ongoing Zionist effort to tame the Levant and Westernize it.[9]

1 Theoretical Frames of Reference

This article focuses on the visual mentioning of actual city sites in Tel Aviv in magazines, which serves as a symbol for some higher sociocultural meaning. To that end, the concepts of *urban symbols* and *urban icons* stand as practical theoretical terms with which depictions of cityscapes can be assessed culturally. Examining depictions of sites and urban scenery in Tel Aviv-Jaffa through

Eshed argues that youth magazines, the main arena of comic publications in Israel, were read by most Israeli children and young adults in the 1940s, 1950s, and 1960s, and that they remained popular well into the 1970s.

7 Søren Kjørup, "George Inness and the Battle at Hastings, or Doing Things with Pictures." *The Monist* 58, no. 2 (1974): 216–235; Searle, "The Logical Status of Fictional Discourse."
8 The term will not be further unpacked in this chapter for lack of space.
9 Jacqueline Kahanoff, *Bein shenei 'olamot (Between Two Worlds)*, ed. David Ohana (Jerusalem: Keter, 2005).

the lens of urban icons offers an opportunity to appreciate the value of city landmarks both for their recounting of specific locations in the real world and as visual stand-ins for cultural values that the creators of the comics wished to impart on their readers.

Arnon Golan proposes that urban symbols "are usually landmarks—material objects or architectural structures that express varied cultural, social, and political ideas or values" and that "the distinguishing characteristic of urban icons from mere urban symbols is the primacy of [their] visual representation."[10] In other words, an urban symbol is grounded in space. In contrast, an urban icon represents said urban symbol as it is reproduced and distributed via multiple media to a point where the depiction of that urban symbol becomes a metonym of its host city.[11] Golan further proposes that the symbolic value of urban icons can also change or disappear over time, with changes to public perceptions of it.[12] Finally, Golan proposes that creating and maintaining the status of urban icons has become an essential part of the branding effort of major cities and their ruling elites as the latter ensure the status of these former as global nodes of culture.[13]

Through the review process, specific patterns of depiction emerge. These patterns extend beyond distinct urban icons to represent the city as an urban macro-unit on a sociopolitical level. To make sense of these patterns, one requires a different frame of reference that can explain the meaning of representation in social terms. The term *collective memory* is helpful in cases like this. Collective memory refers to social groups' aggregated knowledge and shared recollection of meaningful events. It is a bank of visual imagery, historical facts, personal anecdotes, cultural customs, and reality perceptions that organize how self-defined groups understand their history and remember it.[14] Unlike history, which aspires to accuracy, objectivity, and comprehensive perspective on a matter, collective memory is narrower in scope. It considers only such information that supports the narrative promoted by the group members who share it and its goals and benefits.[15]

10 Arnon Golan, "The Street as Urban Icon? Tel Aviv's Rothschild Boulevard." *Urban Geography* 36, no. 5 (2015): 721–734, here 721–722.
11 Vanessa Schwartz in Golan, "The Street as Urban Icon?," 721.
12 Golan, "The Street as Urban Icon?," 724.
13 Ibid., 723.
14 Jeffrey K. Olick, Vered Vinitzky-Seroussi, and Daniel Levy, "Introduction to *The Collective Memory Reader*," in *The Collective Memory Reader*, ed. Jeffrey K. Olick, Vered Vinitzky-Seroussi, and Daniel Levy (Oxford: Oxford University Press, 2011), 3–63.
15 James V. Wertsch and Henry L. Roediger III, "Collective Memory: Conceptual Foundations and Theoretical Approaches," *Memory* 16, no. 3 (2008): 318–326. I recognize that this is an oversimplification of a highly elaborate theoretical matter. However, as is the case

2 Tel Aviv's Urban Icons through the Ages

Tel Aviv was founded in 1909 as a humble garden suburb of Jaffa for Jews. The "Garden City," as it was nicknamed, held promise for its residents to be a modern, European-like environment.[16] The streets of Tel Aviv were straight and clean; the population young, vibrant, and healthy. The single-family houses had picket and stone fences and small private yards surrounded each of them.

2.1 Tel Aviv's Early Urban Icons

The first illustrations of Tel Aviv in Israeli children's magazines were in Nachum Gutman's work in *Davar Leyeladim*. Gutman was instrumental in crystalizing the looks of early Tel Aviv in pop culture.[17] Gutman identified the city's first urban icon: the Herzliya Hebrew Gymnasium building.

As early as 1931, Gutman cast the building of Herzliya Hebrew Gymnasium as the city's prime iconic landmark in a decision that echoed the intentions of the city's founders.[18] Gutman made a point to draw the building as a magnanimous structure looming over the smaller picket-fenced townhouses somewhat exaggeratedly,[19] thus stressing the importance of modern education and knowledge as essential values of the young city.

In the mid-1930s, Gutman attempted to establish the scenery of the new and modern Tel Aviv port as the city's second iconic landmark.[20] However, this attempt failed as the port rarely appeared in Israeli comics. Oddly though, Tel Aviv first appearance in international comics—Marvel Comics' *The Incredible Hulk* #256[21]—relied extensively on the scenery of the port. In the story, the Hulk arrives at the Tel Aviv port as a stowaway. He gets mixed up in a fight with Israeli soldiers, and Israel's superheroine, Sabra. He then witnesses a terrorist attack, and eventually teaches Sabra a lesson in humility and humanity. While the moral of the story may be considered politically radical for its time, the depiction of Tel Aviv throughout it is puzzling and leaves much to question.

with other theoretical matters in this chapter, the term will not be further explored for lack of space.

16 Iris Aravot, "Mythical Dimensions of the Tel Aviv Century," *The International Journal of the Arts in Society: Annual Review* 6, no. 2 (2011): 237–258.
17 Lea Naor, *Quest for Colors: The story of Nachum Gutman* [Hebrew]. Jerusalem: Yad Yitzhak Ben-Zvi.
18 Razin, "Tel Aviv-Yafo."
19 See illustration of early Tel Aviv by Gutman at https://www.text.org.il/index.php?book=0512063.
20 See the cover page illustrations of 1936's issue #9 (November 19, 1936) or 1937's issue #7 (May 30, 1937) of *Davar Leyeladim*.
21 Bill Mantlo and Sal Buscema, *The Incredible Hulk*, Vol. 256 (New York: Marvel Comics Group Inc., 1981).

For starters, Tel Aviv's port was closed and decommissioned in the 1960s. Therefore, it is baffling to include it in a narrative published in 1981. Ignoring that and focusing solely on the scenery is even more baffling. The port is described as one that big ocean liners can anchor in.[22] Yet Tel Aviv's port was relatively shallow and could not accommodate large ships. Instead, passengers and cargo were unloaded to smaller rafts and barges to get ashore. The city neighborhood in the immediate vicinity of the port is illustrated as a cluster of slanted roofed buildings[23]—but the residential buildings adjacent to the Tel Aviv port were of high density and flat-roofed. The confusion continues when the Hulk gets to the marketplace, where he meets people wearing traditional Arab head garbs[24]—a rare occurrence for Arab residents of Tel Aviv-Jaffa in the 1980s. The only image that reflects an actual building in the port's area is on page 18. The building in the background is reminiscent of the looks of the pavilions in the *Levant Fair Grounds*, Tel Aviv's exhibition grounds complex. The result of this depiction is a distorted representation of Tel Aviv as an exotic oriental Mediterranean city, one that is very much in contradiction to its already established image as a modern, Western-like metropolis in other pop culture content.[25]

The depiction of Tel Aviv as a modern, thriving urban center, with a strong foundation of education in the form of its Gymnasium building, survived well into the 1940s, even though the condition of the building itself deteriorated. As the years passed, the Gymnasium building lost relevance and nearly disappeared from comics' illustrations in the late 1940s. Yet, the iconic status of the building did not disappear completely. Instead, it changed meaning from symbolizing Tel Aviv in general to a marker of its historic "Garden City" era.

2.2 Tel Aviv's Bauhaus "White City" Quarter

Aryeh Navon, *Davar Leyeladim*'s second-leading illustrator during the mid-1930s, is credited with cementing the foundations of Tel Aviv as the "White City"—a quintessential manifestation of the form of International Style architecture known as the Bauhaus style[26]—in collective memory. Navon caught with his line art numerous city scenes to accompany the texts of his co-creator/writer, the poet Leah Goldberg. An excellent example of that quality

22 Ibid., 7.
23 Ibid., 12.
24 Ibid., 17–18.
25 Aravot, "Mythical Dimensions of the Tel Aviv Century."
26 Ibid.

can be found in the strips of *Uri-Muri*,[27] Navon and Goldberg's first foray into the world of comics.[28] One example, in *Uri-Muri the Giant Takes a Rest in Tel Aviv*,[29] stands to show how Navon positioned this unique architectural style at the heart of Tel Aviv's iconic scenery by illustrating the Bauhaus-style San Remo Hotel.

Depictions of the city through Bauhaus-style buildings became a mainstay. In the early 1950s, Bauhaus casually appeared in the urban background scenery of Shmuel Sihor and Elisheva Nadel's *Sharp-eyed Efraim* (1953). In the late 1950s and early 1960s, Dani Plant used known Bauhaus-inspired scenery to ground comics' narratives in Tel Aviv through artwork alone. In one case, in the first installments of *The Paratroopers Attack* (1959), he drew the well-known train buildings of Meonot Ovdim ("Labourers' Housing") with extreme accuracy.[30] This neighborhood built in the late 1930s did not get much attention in earlier comics. However, by the 1950s it was a well-known area of central Tel Aviv and thus gained an iconic, recognizable status. Later, Plant returned to the same sites in the first installment of *Secret Agent No. 17* (1959–1960).

Mr. Tea (1986) is a comic by Michel Kichka about a boy who travels in time to different periods in the history of the Jewish people by drinking tea. Bauhaus depictions stand out in one of the comic's stories when Mr. Tea returns to the Declaration of Independence of the State of Israel in 1948. In the story, Kichka meticulously illustrated the Bauhaus-inspired Hall of Independence building (also known as the Dizengoff House) in central Tel Aviv where the ceremony was held.[31] Kichka heavily relied on historical reference photos to establish credibility in this work. Yet, despite the apparent Bauhaus looks of the building, the overall outcome seems to contribute more to the collective memory of the Declaration of Independence ceremony than it does to the memory of Tel Aviv's urban landscape, because urban scenery was downplayed compared with other elements of the story.

27 Leah Goldberg and Aryeh Navon, "Uri-Muri" [Hebrew], *Davar Leyeladim* (Tel Aviv: Davar, 1936–1937).
28 Galit Gaon, "How to Write Comics in Hebrew: The Early Years 1935–1975" [Hebrew], in *Israeli Comics Part 1: The Early Years 1935–1975* [Hebrew] (Holon, Israel: The Israeli Cartooning and Comics Museum, 2008).
29 Goldberg and Navon, "Uri-Muri."
30 See scanned version of the story at https://tinyurl.com/59weytzm, and compare with the photos at http://project-tlv.info/places/meonot-ovdim/ and https://tinyurl.com/3st854tb. Yariv Amatzia and Dani Plant, "The Paratroopers Attack" [Hebrew], *Haaretz Shelanu*, 1959.
31 Michel Kichka, "*Mister Tea* in the 2038 Mondial" [Hebrew], November 10, 2014, https://bit.ly/3vMQvuh.

Kichka returned to the iconography of Bauhaus buildings as urban icons of Tel Aviv in his tribute project to commemorate the city's 100th anniversary—an illustrated yearly calendar (2008). Kichka illustrated an imaginary International Style building at different periods (the 1950s, 1970s, 1990s, 2000s, and 2010s [i.e., the near future]). More important than the nuance in each illustration is, in this case, Kichka's assertions that this "imaginary 'Bauhaus' building tells the story of Tel Aviv through the decades" and that Bauhaus and Tel Aviv are synonymous in his mind.[32]

Vittorio Giardino, the famous Italian comic artist, explained Bauhaus's allure as an urban icon of Tel Aviv in a master class he gave during the 2007 Israeli CAC Festival using similar reasoning. Taking a black marker to the page, he described how he "noticed the Bauhaus style first. Then, [he noted] how buildings in Tel Aviv have small narrow yards, with shrubs in them, and often a tree—a palm or Italian cypress. Then a narrow sidewalk wraps around it all."[33] The combination of these elements is, according to Giardino, as unique as the combination of nose ridge and eyebrows are on a person's face (Fig. 3.1).

Depictions of Tel Aviv Bauhaus buildings became even more common in Israeli comics in the early 1990s. In 1990, Uri Fink, Israel's most prolific comic creator, set parts of the story *Havlei Mashiah (Messiah Nonsense)*—his final project at Bezalel Academy of Arts and Design—in Tel Aviv.[34] Fink illustrated a nondescript Bauhaus building as a representation of central Tel Aviv.[35]

The works of Yirmi Pinkus are often set in Tel Aviv. Some of the 1990s strips of *Hamora Hava (Eve the Teacher)* he created with writer Rogel Alper frequently had Bauhaus buildings in the background. Most notable are the strips from September 12, 1997, February 20, 1998, and October 30, 1998.[36] Pinkus also set the story *Tonight in Apartment #6* from the book *Happy End* (2002) in the heart of the "White City."[37] On pages 164–165, Pinkus illustrated the iconic Bauhaus building set in the shadow of the city's rising skyscrapers to denote its city-center location. In another example, Rutu Modan described the same area on page 24 of *Exit Wounds* (2007). Her setting the residence of her protagonist Gabriel's dad in the region signals that the family was long rooted in Tel Aviv.

32 Ibid., 2 (quote) and 14.
33 Vittorio Giardino, *Comics Creation Master Class* [Performance], Tel Aviv Cinematheque, Tel Aviv, August 26, 2007.
34 Uri Fink, *Havlei Mashiah* (Ben Shemen, Israel: Modan, 1990).
35 Ibid., 7.
36 Rogel Alper and Yirmi Pinkus, "Hamora Hava," *Ha'Ir*, 1997–2001.
37 Yirmi Pinkus, "Tonight in Apartment #6" [Hebrew], in *Happy End* (Ben Shemen, Israel: Modan, 2002), 161–189.

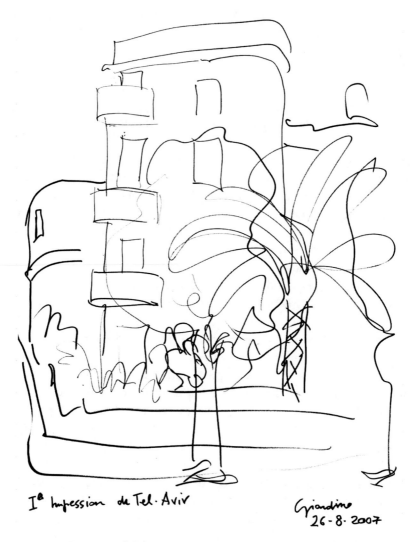

FIGURE 3.1 *Impression de Tel Aviv*
GIARDINO, 2007

Both Pinkus and Modan use the "White City" setting as a metonym for the heart of the city—the residential core, the private and quiet place in the heart of the metropolis. Yet, while Pinkus often illustrated Bauhaus in clean, crisp lines, the buildings in Modan's work—as in others during the 2000s—accentuates their decrepit condition and the overall aging of central Tel Aviv in general. Such are, for example, depictions of Bauhaus buildings in Itamar

Fradni's *Mi Sham!?* #2 (2007) and Liav Tzabari's *The Road to Happiness* in *Hatzofar Magazine* #4 (2007).[38]

Nimrod Reshef's *Uzi: Urban Legend* #4 (2009) takes an unusual approach to the aging of Tel Aviv's Bauhaus buildings. For example, he illustrated the famous Ship Building (56 Levanda Street, Tel Aviv) on the cover of issue #4.[39] Reshef opted not to present the building in its decrepit and crumbling state, but rather as its potential ageless self as part of an overarching message about spirituality and higher planes of existence.[40]

Identifying Tel Aviv by its cluster of International Style buildings carries two meanings with it, as far as it relates to the Zionist narrative. First, the tenets of the philosophy of the style fit the values of the Zionist movement neatly—simplicity, functionality, convenience, and humbleness.[41] Second, the name of the architectural style (international) denotes modernity, education, and culture, which are values that, according to Zionism, set apart the Jewish people from Levantines.[42] The term may have lost the branding battle to the school's name that birthed it (the Bauhaus school in Dessau, Germany), but its success in striking roots globally sustained the value still. In that regard, representing Tel Aviv through its Bauhaus buildings sends a message that the city is modern and convenient to live in and that it is not snobbish or pretentious: it is a unique place worthy of attention.

2.3 *Towering Tel Aviv: a City Defined by Its Skyscrapers*

It took Tel Aviv almost three decades (from the late 1930s to the late 1960s) to produce a new landmark that functioned as an explicit urban icon and that replaced the Gymnasium building successfully. That icon was Tel Aviv's first skyscraper—the Shalom Meir Tower (or "Shalom Tower," as it is colloquially referred to), which had its first stage completed in 1965. The fascination with Shalom Tower in comics of that era may be counted as an early sign of Israeli

38 The artists illustrated two buildings across from the other in the Neve Sha'anan neighborhood in southern Tel Aviv. Fradni illustrated the Callamero house and Tzabari illustrated the Scharno house. Images of both can be seen at https://tinyurl.com/8xhz7hkf. Itamar Fradni, *Mi Sham!?* #0 (Tel Aviv: Self-Published, 2007); Liav Tzabari, "The Road to Happiness" [Hebrew], *Hatzofa* 4, 2007.

39 Nimrod Reshef, *Uzi: Urban Legend*, 4 Vols (Tel Aviv: Self-Published, 2005–2009).

40 See the artwork at https://tinyurl.com/4c8uuuyd and a photo of the building at https://tinyurl.com/2p98sej4.

41 "International Style—Architecture," in *Encyclopaedia Britannica*, ed. Aakanksha Gaur et al., accessed July 1, 2022, https://www.britannica.com/art/International-Style-architecture.

42 Jacqueline Kahanoff, "Reflections of a Levantine Jew," *Jewish Frontier* (1958): 7–11.

artists' later presentation of Tel Aviv as modern and vibrant through its various skyscrapers.

The tower, the tallest in the Middle East at that time, attracted the attention (and imagination) of many artists, mainly in cinema but in other media as well,[43] and its first appearance in comics is probably hinted at as a narrow rectangle shape in a frame at the bottom of chapter #8 of Yariv Amatzia (pseudonym of Pinchas Sadeh)[44] and Asher Dickstein's story *The Humming Eye and the Three Crowns Stamp* (1965).[45]

By the early 1970s, the silhouette of Shalom Tower became an urban icon of Tel Aviv in comics. The tower appeared in many notable stories published by *Haaretz Shelanu*, the leading Israeli children's magazine at the time. Contributing to the stature of the iconic building in pop culture was the completion of an observation deck on its roof. The observation deck offered residents of and visitors to Tel Aviv a new vantage point of the city, and visual artists quickly used that in their stories. Consider, for example, the story *Meliselda, or the Coming of the Gods* by Amatzia/Sadeh with illustrator Giora Rotman (1971).[46] In the first two installments of the story, readers saw a profile view of the tower as part of the city's skyline and a view of the city from the observation deck. A few years later, Amatzia/Sadeh and Rotman returned to use the tower in two of the longer stories they created about Agent Yoram's adventures: *The Turkish Box* (1973) and *The Laughing Mask* (1974). However, while earlier stories of Amatzia/Sadeh glorified the Shalom Tower as a remarkable achievement, current depictions did not portray it as the beacon of successful entrepreneurship or national pride that it once was. Instead, the creative duo began to recognize the decreasing urban stature of the tower's area and the increase in nefarious activities in its surroundings.

In *The Turkish Box*, a story about Agent Yoram and his assistant Razya's battle against a Tel Aviv drug ring financed by the Egyptian Intelligence Service, the nightclub where drugs are sold is across the street from the Shalom Tower and, in two scenes (in installments #5 and #6 of the story) Razya is being

43 Ido Rosen, "Skyscrapers and Heroines in Metropolitan Tel Aviv" [Hebrew], *Fireflies: Journal of Film and Television* 1 (2008): 97–110.
44 See Eli Eshed, "Pinchas Sadeh Writes Comics" [Hebrew], March 14, 2003, https://web.archive.org/web/20080703195354/http://sadeh.corky.net/2003_03_14_articale.html.
45 A scanned version of the story is available at https://tinyurl.com/258th8hh. Yariv Amatzia and Asher Dickstein, "The Humming Eye and the Three Crowns Stamp" [Hebrew], *Haaretz Shelanu*, 1965.
46 Yariv Amatzia and Giora Rotman, "Meliselda, or the Coming of the Gods" [Hebrew], *Haaretz Shelanu*, 1971.

abducted from the washrooms of the Shalom Tower Department Store.[47] In these scenes, the tower's lower level seems extremely shady, compared with the earlier depiction of the building not three years before. The underpass is dark and threatening, there is apparent litter on the sidewalk, and the building across the street seems old and stained.

The Laughing Mask is a crime story about youth gangs in Tel Aviv and Agent Yoram's attempts to foil their doings. Early installments of the story show the shoreline and skyline of south Tel Aviv from the Jaffa area. The skyline in the story is illustrated as a dark silhouette with the shadow of Shalom Tower looming over the rest of the area, giving the impression that dark things lurk around it.

Despite its declining stature, Shalom Tower's iconic value remains a constant in Israeli comics. Depictions of the tower frequently appeared in the works of Zeev Engelmeir—for example, cover pages he created for the *Ha'Ir* newspaper in 1994 and the *Achbar Ha'Ir (City Mouse)* magazine in 1995 and 1997.[48] Later depictions of the tower include works by Anat Even-Or (5–12) and Noga Meltzer (*Joyful Days*) in the 2008 anthology *Based Upon a True City*[49] as well as by Nimrod Reshef (*Uzi: Urban Legend* #1–#4, 2005–2009).

Shalom Tower also enjoyed international recognition as a distinct urban icon of Tel Aviv. The tower first appeared in Marvel Comics' *Excalibur* #121, *With Friends Like These*...[50] The issue's opening page presents an unmistaken likeness of Shalom Tower as the headquarters of the Mossad, Israel's intelligence agency.

Tim Dinter's depiction of the tower (*Small World—Big Orange*, 2005) is more realistic than the *Excalibur* story. Dinter illustrated the tower looming over the Carmel open market on page 8. However, other skyscrapers are more prominent in the story. In this regard, for Dinter (and Nimrod Reshef in *Uzi: Urban Legend*), the Shalom Tower is an urban icon of southern Tel Aviv, while for Ben Raab and Trevor Scott and other artists it is not geographically restricted in that way. Still, both appearances establish the claim that Shalom Tower had earned itself the status of a timeless iconic landmark of Tel Aviv in both the local and global collective memory.

47 See scans of it at https://tinyurl.com/5n374ch8. Yariv Amatzia and Giora Rotman. "The Turkish Box" [Hebrew], *Haaretz Shelanu*, 1973.
48 Zeev Engelmeir, *Engelmeir* (Tel Aviv: Am Oved, 2001), 10, 12, 85.
49 Sami Berdugo et al., *Based Upon a True City* [Hebrew] (Tel Aviv: Self-Published, 2008).
50 Ben Raab and Trevor Scott, "With Friends Like These," *Excalibur*, Vol. 121 (New York: Marvel Comics Group Inc., 1998).

While Shalom Tower could be seen as a symbol of Israel's modernity, its economic and technical success, and its entrepreneurship, there is an apparent difference in the way the Shalom Tower fits into the grander sociopolitical and ideological picture of Israeli culture when compared with the way earlier iconic sites functioned in the comics of the previous era. The earliest iconic site—the Gymnasium building—served as a testimonial to the success of the Zionist project. Later, depictions of the "White City" quarter grounded the Zionist project in such values as modernity, democracy, socialism, self-resilience, humbleness, and practicality. Shalom Tower tells of a different brand of success—one of, and by, individuals. In that regard, Shalom Tower was not recognized or envisioned as a national effort. It is a multi-purpose building for commercial purposes. With all its appeal as an architectural feat of a young society, Shalom Tower demonstrated how, despite being rooted in socialism politically, Israel was increasingly developing its private sector and increasingly individualistic.

Shalom Tower's stature as Tel Aviv's defining urban icon took a hit with the completion of newer, taller, and more architecturally distinct towers in the city from the 1990s onward. Leading among these are the three (triangle, circle, and square) towers of the Azrieli Center complex. The Azrieli Towers, as they are often referred to, were built between 1996 and 1999. The complex is located on Begin Road and Kaplan Street in Tel Aviv's downtown area. Nearly any comic story set in Tel Aviv since 1999 depicts these towers either as a setting for scenes or in the further background, defining the city's skyline.

Strips of *Hamora Hava*[51] published in *Ha'Ir* on February 2, 1998, and May 17, 1998 were the first appearances of the Azrieli Towers in comics. Both were published before work on the circle and triangle towers was completed. In the comics, the round shape of the circle tower looms over the city's skyline and reshapes it. Since then, the Azrieli Towers have appeared in the skyline of Pinkus's *Tonight in Apartment #6* (2002), on the cover of Moshik Gulst's *Yoman Yisraeli* (2003), in several scenes of Tim Dinter's *Small World—Big Orange* (2005), on the cover of Muly Yachbes and Daniel Bux's *Rocky the Alligator* (2006), and in Hagai Giller's one-pager free comic book day strip *The Tel Aviv Bubble* (2007), to name a few.

In 2006, the construction of the third tower—the square—restarted, and it was completed by 2007. Comics published after that point in time depict the Azrieli Towers as a trio. Some notable examples are *Ein Seora*,[52] which

51 Alper and Pinkus, "Hamora Hava."
52 Avi Blair and Assa Ziedman, *Ein Seora* (Tel Aviv: Seora MeHa'ayin Publishing, 2010).

has the trio on its cover and in the inside artwork, *Mike's Place*,[53] *Tel Aviv—Alexanderplatz*,[54] and Krzysztof Ostrowski's *Full Stomach* (2008)[55] to name a few. Nimrod Reshef's *Uzi: Urban Legend* series (2005–2009) is unique, in that the first two issues, published in 2005 and 2006, set extensive scenes at the towers when only two had been built and returned to them in issue #4 (2009) with the third tower present.

Various other towers dot the Tel Aviv skyline and appear in Israeli and international comics. Most of the stories noted above depict, in addition to either Shalom Tower, Azrieli Towers, or both, a long list of towers including the Isrotel Hotel Tower (on top of Dizengoff Center Mall), the Rubinstein Towers, the IBM Tower, City Gate Towers, the new Ministry of Defence Tower, Tel Aviv City Tower, and David Intercontinental Hotel. The list of buildings and comics that depict them is too long to present here and is continually expanding.

What is it about these towers, which connects them to the Zionist narrative that Israeli society likes to tell itself? A simple answer to this question is that as part of the Zionist aspiration to embody modernism, show national success and pride, and establish Israel (vis-à-vis central Tel Aviv) on the global map, modern urban icons must be uniquely designed, grand in nature, and continuously appear in various media to maintain the city's stature as a local landmarks in a global world.[56] A more thorough answer is that, after achieving the original goals of Zionism, the current plans of Zionists are to cement the status of Israel as a leading global power and prove to the world that the Jewish people of Israel are resourceful.[57] Building skyscrapers sends these messages because skyscrapers are a testament to the ample resources invested in erecting them.[58]

3 Jaffa in Comics through the Ages

Reviewing the depiction of Jaffa in Israeli and international comics proves to be an easy task, mainly because the city did not appear in comics very

53 Jack Baxter, Joshua Faudem, and Koren Shadmi, *Mike's Place: A True Story of Love, Blues, and Terror in Tel Aviv* (New York: First Second Books Shadmi, 2015).
54 Gill Elkabetz "Tel Aviv—Alexanderplatz" [Hebrew], in *The A4 Gang Strikes Again* [Hebrew] (Tel Aviv: Self-Published, 2017), 8–11.
55 Krzysztof Ostrowski, "Full Stomach," in *Kompot: An Israeli-Polish Comics Book*, ed. Zeev Engelmeir et al. (Warsaw: The Adam Mickiewicz Institute, 2008), 37–64.
56 Golan, "The Street as Urban Icon?"
57 Oz Almog, *The Sabra: The Creation of the New Jew* (Berkeley: University of California Press, 2000).
58 Golan, "The Street as Urban Icon?"

often. When Jaffa did appear, it followed rigid patterns of both representation and site selection. Jaffa's earliest illustrated appearances in Israeli children's magazines were, similarly to those of Tel Aviv, by *Davar Leyeladim*'s house illustrators Nachum Gutman and Aryeh Navon during the 1930s. Scenes set in Jaffa appeared with growing numbers over the years and more noticeably in the late 1990s and the 2000s.

Reviewing depictions of Jaffa reveals three dominant urban icons that symbolize it: the waterfront/port, the modern neighborhoods, and the old city.[59] Except for minor differences in the depiction between the comics before and after the 1990s, most depictions present similar characteristics, regardless of publication year or even the origin of the artist (Israeli or foreign).

3.1 *The Waterfront*

The waterfront category relates to depictions of Jaffa Hill (aka Andromeda's Hill) as viewed from either the waterline or from the sea. The buildings are shown clumped together densely, tumbling down the hill into the sea and extending far outside the panel inland. Depictions of the city from these directions include representing the port itself (the wharf, a rowboat, or sailboat), the domed and high-arched Arab houses, a mosque's minaret or two, and, sometimes, a church tower. This view of Jaffa is not particular to comics, and similar scenery can be found in ancient, medieval, and romantic art.

One of the first waterfront images in proto-comics was an illustration by Gutman in *Davar Leyeladim* late in 1932. However, Gutman illustrated the city flatly, as if it were not on a hill. *The Laughing Mask*[60] is the first time that the waterfront imagery appeared in comics in an iconic way. After that, near-identical depictions of the waterfront appeared in the works of Nimrod Reshef (*Uzi: Urban Legend* #2),[61] Dorit Maya Gur (*Falafelman* #3),[62] and Lukasz Mieszkowski (*Jewmanji*).[63]

Depiction of the waterfront communicates two messages in the comics. The first is that Jaffa is an ancient Levantine port city. The combination of

59 There are a good number of historical photographs of Jaffa showing these three categories here: http://www.lula-design.com/2011/09/blog-post_14.html.
60 Yariv Amatzia and Giora Rotman, "The Laughing Mask" [Hebrew], *Haaretz Shelanu*, 1974.
61 Reshef, *Uzi: Urban Legend* #2, 30 (2006).
62 Dorit Maya Gur, *Falafelman*, Vol. 3 (Tel Aviv: Self-Published, 2008), 1.
63 Lukasz Mieszkowski, "Jewmanji," in *Kompot: An Israeli-Polish Comics Book*, ed. Zeev Engelmeir et al. (Warsaw: The Adam Mickiewicz Institute, 2008), 91–104, here 94. In addition, a partial view of the waterfront appeared in the works of Harold Foster (*Prince Valiant*, Vol. 3 [Seattle: Fantagraphics 2011 (1941)]) and Hergé (*Tintin au Pays de l'Or Noir* [Paris: Casterman, 1948]) as well.

minarets, wharf, and high-arched buildings conveys this point. Second, and more importantly, the otherness of Jaffa is presented both as an expression of a noble savage and a reason to fear it.[64] The (dis)organization of the urban space (buildings, streets, public spaces) stresses the untamed and non-Western/European nature of the Levantine space.[65] It can do so positively or negatively, depending on the needs of the comics' particular narrative.

3.2 The Modern Neighborhoods

Jaffa's modern neighborhoods, mostly Noga (predominantly Jewish 1970s housing on the inland northern end of Jaffa) and Ajami (predominantly Arab, located south of the old city by the sea), are a rough place according to Israeli comics (no international comics depicted these areas). Sites that resemble the two neighborhoods appeared in comics less frequently than the waterfront imagery, but they nevertheless did appear to a significant extent.

The depiction of the modern central streets of Jaffa in Israeli comics follows similar lines to that of southern Tel Aviv in the Israeli comics of the 1970s and later. They are depicted as a dense, rundown, dirty, and dishevelled place. Be it the urban decay of the streets of "The Gap" (the area later known as the Noga neighborhood) in *The Laughing Mask* of Amatzia and Rotman (1974), the rundown eclectic-style buildings of upper Yafet Street in Etgar Keret and Assaf Hanukah's *Streets of Rage*[66] with the unpaved street and the bums sitting on the sidewalk, or the mess of cars, dug up roads, and stores' awnings of lower Yafet Street at the heart of the Ajami neighborhood in Reshef's *Uzi: Urban Legend* #2.[67]

According to Israeli comics, Jaffa's residential neighborhoods are still a not-so-tamed Levantine space. Yet they are unmistakably identifiable and distinct, nonetheless. This depiction bears the historical markers of Levantine culture, mixed with the rot and decay that modern Western urban slums are recognized for, and it creates the looks of Tel Aviv's backyard: the side that it prefers to forget and that has only negative iconic recognition.

3.3 The Old City

The Old City category relates to depictions of the inner streets and public spaces of Jaffa's Old City (the Jaffa Hill area). Such depictions are the least

64 Edward Said, *Orientalism* (New York: Vintage Books, 1979).
65 Alcalay, *After Jews and Arabs*.
66 Etgar Keret and Assaf Hanukah, "Streets of Rage" [Hebrew], in *Streets of Rage* [Hebrew] (Tel Aviv: Zmora-Bitan Publishers, 1997), 3–10, here 6.
67 Reshef, *Uzi: Urban Legend* #2, 9 (2006).

common in the works reviewed. However, they present the most changes to area over time.

Most of the earlier depictions of Old Jaffa's inner streets are narrow-scoped sketches of a single building or a cluster of buildings with apparent Arab/Levantine characteristics such as domed rooftops, wide entry arches, and arched windows. Such depictions appeared in the strips of *Bloffer + ½* and scenes of *The Laughing Mask*.[68] At times, the focus shifted from houses to mosques—for example, Al-Bahr Mosque (the Sea Mosque) in *HaBalash David* by Joshua Tan Pai (1948).[69]

As depicted in these comics, the streets of the old city are dirty, dark, threatening, and uninviting; they are sites of crimes, violence, and poverty. The protagonists of the stories—most often Israeli Jewish good Samaritans—arrive at Jaffa to fight crime and restore order or at least with hopes of doing so. The criminals are not necessarily Arab, as one might think. Jaffa was resettled after 1948 with Jewish immigrants from Poland, Romania, Bulgaria, Greece, and North Africa. The mix of poor housing, low incomes, few municipal services, and seaport access made it an exceptional place for real-life criminals and gangs to blossom.[70] Comic stories reflected this reality unabashedly.

The overall tone of these stories had a good fit with the ongoing Zionist narrative of Jaffa being a Levantine wild space in dire need of taming. The memory of Jaffa's historic glory by its residents, along with its lower status after the merge, required authorities to keep oppressing the local culture to ensure no culture wars erupted.[71] Early 1950s comics commented on these matters as well. For example, *Blofer + ½* discussed the municipal efforts to erase the Arab memory by changing the names of Jaffa's streets from Arabic to Hebrew. In that way, the Levant (vis-à-vis Jaffa) may have been conquered but not entirely tamed. However, actual efforts to improve living conditions or infrastructure in Jaffa did not occur for decades to come.

The depictions of the Old City changed drastically in the early 2000s in response to actual changes in Jaffa that started in the mid-1990s. Around that time, the Jaffa Development Corporation, a company founded in 1961 by the State of Israel and the municipality, became wholly owned by the city and started investing heavily in restoring the Old City for touristic purposes. Several comics that were published in the early 2000s noted those changes.

68 Yossi and Orah, "Bloffer + ½" [Hebrew], *Ha'aretz Shelanu*, 1953–1958; Amatzia and Rotman, "The Laughing Mask."
69 Joshua Tan Pai, "HaBalash David (Detective David)," *Micki Maoz Magazine*, 1948.
70 Ruth Kark, *Jaffa: A City in Evolution* (Jerusalem: Yad Yitzhak Ben-Zvi, 1990).
71 Kahanoff, *Bein shenei 'olamot*.

For example, Reshef's *Uzi: Urban Legend* (2005–2009) has extensive scenes set in parts of Jaffa. Reshef has been heavily invested in depicting Jaffa's Old City's restored looks, as he used those sites as plot mechanisms that establish the Kabbalah and spiritual aspects of his comics. In issue #1,[72] Uzi's boss, Cohen, strolls around the St. Peter's Church and the Armenian Church in conversation with the character of a local spiritualist, Rabbi Elijah. In issue #2,[73] Uzi chases a demon through the renovated streets of the Old City. The two run through the maze of alleyways and passages only to have the demon stopped by Rabbi Elijah right by the door of the Libyan Synagogue (Beit Zunana) at the heart of Old Jaffa. Casting Jaffa as a spiritual focal point alludes to its historical roles in ancient biblical stories and highlights the efforts to mask its native Levantine origins under Jewish tourism-oriented gentrification efforts.

Modern depictions of Jaffa show that the Zionist project of taming the city (and by extension, the Levantine nature of Israel's coastal area) had succeeded, at least in part. The streets are clean, the houses well cared for, and the people are orderly. Even the Arab beggar and her baby seem decent and polite.[74] Yet, one can claim that there is an interesting subtext in illustrating the Old City of Jaffa as a gentrified and tamed Levantine space and choosing to include its original population—the Arab—as broken-spirit beggars.

4 A Tale of Two Cities: Considering the Subtext in the Depiction of Tel Aviv and Jaffa

Tel Aviv the first Hebrew city, the Zionist beacon of success—first national, then economic, and finally cultural—has a lasting place in the collective memory of Israel. Jaffa, the ancient city that predated Tel Aviv, but that was left behind as its underdeveloped backyard, is set in most stories as the contrast to Tel Aviv. Where Tel Aviv is the site of cultural creation, Jaffa was the site of cultural destruction (through drug trafficking, for example). Tel Aviv is a modern city looking forward; Jaffa is an ancient ruin testifying to the past. Finally, where Tel Aviv is representative of modernity and advancement, Jaffa is religious and stagnant. The only positive aspect of Jaffa is that its old historical quarter can be used, by Tel Aviv's elites, as an exotic attraction for tourists. In a sense, the restoration of Jaffa was not done to better the lives of its residents, but to boost the stature and appeal of Tel Aviv as a rounded-up place that offers old and

72 Reshef, *Uzi: Urban Legend* #1, 14–17 (2005).
73 Reshef, *Uzi: Urban Legend* #2, 10–11 (2006).
74 Ibid., 15.

new and that stands by the requirements that currently make a city an iconic global metropolis.[75]

Comic stories in Israeli children's magazines in the 1930s–1980s significantly promoted the perception of the two urban entities as success and struggle stories of Zionism. Once established, this perception persisted locally and traveled internationally, as seen in international comics' depictions of the city. However, when it turned global, the collective memory used these urban icons to promote different narratives. For Israeli artists, the contrast between Tel Aviv and Jaffa serves as a mechanism that commemorates the Zionist attempt to conquer the land and bring glory to the Jewish state. For foreign artists, the contrast between Tel Aviv and Jaffa serves as a plot device that distinguishes the cultured from the savage, and the Western from the Oriental. This simultaneous use of urban icons to different ends is a prime example of glocalization, which is "the co-presence of both universalizing and particularizing tendencies" in current world cultures.[76] While so, these underlying patterns further ground both the local and global narratives, each for its audience and own ends. Sadly, these patterns leave little hope for Jaffa and its residents to ever break out of this process.

Finally, in the grander scheme of things, the last point to be made in this chapter is that, unlike other nations' comics, which tended to be cultural outliers creating alternative cultures or surviving as underground cultural scenes, Israeli comics always remained close to the public consensus dictated by its elites and continuously expressed the country's hegemonic elite's narratives without ever being officially recruited (or sanctioned) to do so by the state. This lack of criticism and lack of promotion of contradicting sociopolitical narratives in Israeli comics means that there is very little room for non-hegemonic voices to be heard in Israeli culture (past and present alike).

Bibliography

Alcalay, Ammiel. *After Jews and Arabs: Remaking Levantine Culture*. Minneapolis: University of Minnesota Press, 1993.

Almog, Oz. *The Sabra: The Creation of the New Jew*. Berkeley: University of California Press, 2000.

75 Golan, "The Street as Urban Icon?"
76 Roland Robertson, "Globalisation or Glocalisation?," *The Journal of International Communication* 1, no. 1: 33–52.

Alper, Rogel, and Yirmi Pinkus. "Hamora Hava." *Ha'Ir*, 1997–2001.

Amatzia, Yariv, and Asher Dickstein. "The Humming Eye and the Three Crowns Stamp" [Hebrew]. *Haaretz Shelanu*, 1965.

Amatzia, Yariv, and Dani Plant. "The Paratroopers Attack" [Hebrew]. *Haaretz Shelanu*, 1959.

Amatzia, Yariv, and Giora Rotman. "Meliselda, or the Coming of the Gods" [Hebrew]. *Haaretz Shelanu*, 1971.

Amatzia, Yariv, and Giora Rotman. "The Laughing Mask" [Hebrew]. *Haaretz Shelanu*, 1974.

Amatzia, Yariv, and Giora Rotman. "The Turkish Box" [Hebrew]. *Haaretz Shelanu*, 1973.

Aravot, Iris. "Mythical Dimensions of the Tel Aviv Century." *The International Journal of the Arts in Society: Annual Review* 6, no. 2 (2011): 237–258.

Baxter, Jack, Joshua Faudem, and Koren Shadmi. *Mike's Place: A True Story of Love, Blues, and Terror in Tel Aviv*. New York: First Second Books, 2015.

Berdugo, Sami, Omer Hoffman, Nitzan Shorer, Yotam Fishbein, Ayuji Fadidas, Ronit Mirski, Anat Even-Or, and Noga Meltzer. *Based Upon a True City* [Hebrew]. Tel Aviv: Self-Published, 2008.

Blair, Avi, and Assa Ziedman. *Ein Seora*. Tel Aviv: Seora MeHa'ayin Publishing, 2010.

Bux, Daniel, and Muly Yachbes. *Rocky the Aligator*. Yavne: Self Published, 2006.

Dinter, Tim. "Small World—Big Orange." In *Cargo, Comics Journalism Israel—Germany*, 7–34. Berlin: Avant-Verlag, 2005.

Elkabetz, Gill. "Tel Aviv—Alexanderplatz" [Hebrew]. In *The A4 Gang Strikes Again* [Hebrew], 8–11. Tel Aviv: Self-Published, 2017.

Engelmeir, Zeev. *Engelmeir*. Tel Aviv: Am Oved, 2001.

Eshed, Eli. *From Trazan to Zbeng: The Story of Popular Literature in Hebrew* [Hebrew]. Tel Aviv: Bavel, 2002.

Eshed, Eli. "Pinchas Sadeh Writes Comics" [Hebrew]. March 14, 2003. https://web.archive.org/web/20080703195354/http://sadeh.corky.net/2003_03_14_articale.html.

Fink, Uri. *Havlei Mashiah*. Ben Shemen: Modan, 1990.

Foster, Harold. *Prince Valiant*. Vol. 3. Seattle: Fantagraphics, 2011 [1941].

Fradni, Itamar. *Mi Sham!?* #2. Tel Aviv: Self-Published, 2007.

Gaon, Galit. "How to Write Comics in Hebrew: The Early Years 1935–1975" [Hebrew]. In *Israeli Comics Part 1: The Early Years 1935–1975* [Hebrew] [Exhibition Catalog]. Holon, Israel: The Israeli Cartooning and Comics Museum, 2008.

Giardino, Vittorio. *Comics Creation Master Class*. Performance. Tel Aviv Cinematheque, Tel Aviv, August 26, 2007.

Giller, Hagai. *The Tel Aviv Bubble*. Self Published, 2007.

Golan, Arnon. "The Street as Urban Icon? Tel Aviv's Rothschild Boulevard." *Urban Geography* 36, no. 5 (2015): 721–734.

Goldberg, Leah, and Aryeh Navon. "Uri-Muri" [Hebrew]. *Davar Leyeladim*, 1936–1937.
Gombrich, Ernest H. *Art and Illusion: A Study in the Psychology of Pictorial Representation*. 6th ed. New York: Phaidon, 2002.
Gulst, Moshik. *Yoman Yisraeli [Israeli Diary]*. Ashkelon: Self Published, 2003.
Hergé. *Tintin au Pays de l'Or Noir*. Paris: Casterman, 1948.
"International Style—Architecture." In *Encyclopaedia Britannica*. Edited by Aakanksha Gaur et al. Accessed July 1, 2022. https://www.britannica.com/art/International-Style-architecture.
Kahanoff, Jacqueline. *Bein shenei 'olamot (Between Two Worlds)*. Edited by David Ohana. Jerusalem: Keter, 2005.
Kahanoff, Jacqueline. "Reflections of a Levantine Jew." *Jewish Frontier* (1958): 7–11.
Kark, Ruth. *Jaffa: A City in Evolution*. Jerusalem: Yad Yitzhak Ben-Zvi, 1990.
Keret, Etgar, and Assaf Hanukah. "Streets of Rage" [Hebrew]. In *Streets of Rage* [Hebrew], 3–10. Tel Aviv: Zmora-Bitan Publishers, 1997.
Kichka, Michel. "Mr. Tea." *Mashehu magazine*, 1986.
Kichka, Michel. *Tel Aviv 100 Years*. Jerusalem: Olimat International, 2008.
Kichka, Michel. *"Mister Tea* in the 2038 Mondial" [Hebrew]. November 11, 2014. https://bit.ly/3vMQvuh.
Kjørup, Søren. "George Inness and the Battle at Hastings, or Doing Things with Pictures." *The Monist* 58, no. 2 (1974): 216–235.
Mantlo, Bill, and Sal Buscema. *The Incredible Hulk*. Vol. 256. New York: Marvel Comics Group Inc., 1981.
Maya Gur, Dorit. *Falafelman*. Vol. 3. Tel Aviv: Self-Published, 2008.
Mieszkowski, Lukasz. "Jewmanji" [Hebrew/Polish]. In *Kompot: An Israeli-Polish Comics Book*. Edited by Zeev Engelmeir et al., 91–104. Warsaw: The Adam Mickiewicz Institute, 2008.
Mirzoeff, Nicholas. "What Is Visual Culture?" In *The Visual Culture Reader*. Edited by Nicholas Mirzoeff, 4–13. London: Routledge, 1998.
Naor, Lea. *Quest for Colors: The Story of Nachum Gutman* [Hebrew]. Jerusalem: Yad Yitzhak Ben-Zvi, 2012.
Olick, Jeffrey K., Vered Vinitzky-Seroussi, and Daniel Levy. "Introduction to *The Collective Memory Reader*." In *The Collective Memory Reader*. Edited by Jeffrey K. Olick, Vered Vinitzky-Seroussi, and Daniel Levy, 3–63. Oxford: Oxford University Press, 2011.
Ostrowski, Krzysztof. "Full Stomach." In *Kompot: An Israeli-Polish Comics Book*. Edited by Zeev Engelmeir et al., 37–64. Warsaw: The Adam Mickiewicz Institute, 2008.
Pinkus, Yirmi. "Tonight in Apartment #6" [Hebrew]. In *Happy End*, 161–189. Ben Shemen, Israel: Modan, 2002.
Plant, Dani. "Secret Agent No. 17." *Haaertz Shelanu*, 1959–1960.

Raab, Ben, and Trevor Scott. "With Friends Like These. ..." *Excalibur*. Vol. 121. New York: Marvel Comics Group Inc., 1998.

Razin, Eran. "Tel Aviv-Yafo: Additional Information." In *Encyclopedia Britannica*. Edited by Aakanksha Gaur et al. Accessed March 11, 2020. https://www.britannica.com/place/Tel Aviv-Yafo/additional-info.

Reshef, Nimrod. *Uzi: Urban Legend*. 4 Vols. Tel Aviv: Self-Published, 2005–2009.

Robertson, Roland. "Globalisation or Glocalisation?" *The Journal of International Communication* 1, no. 1: 33–52.

Rosen, Ido. "Skyscrapers and Heroines in Metropolitan Tel Aviv" [Hebrew]. *Fireflies: Journal of Film and Television* 1 (2008): 97–110.

Said, Edward. *Orientalism*. New York: Vintage Books, 1979.

Searle, John R. "The Logical Status of Fictional Discourse." *New Literary History* 6, no. 2 (1975): 319–332.

Sihor, Shmuel, and Elisheva Nadel. "Sharp-eyed Efraim." *Haaretz Shelanu*, 1953.

Tan Pai, Joshua. "HaBalash David (Detective David)." *Micki Maoz Magazine*, 1948.

Tzabari, Liav. "The Road to Happiness" [Hebrew]. *Hatzofa* 4, 2007.

Wertsch, James V., and Henry L. Roediger III. "Collective Memory: Conceptual Foundations and Theoretical Approaches." *Memory* 16, no. 3: 318–326.

Yossi and Orah. "Bloffer + ½" [Hebrew]. *Ha'aretz Shelanu*, 1953–1958.

PART 2

Consuming Images: Israel in America

CHAPTER 4

Fractured Communities, Anxious Identities: Reconsidering Israel on the American Stage

Ellen W. Kaplan

"Use your Jew-powers, bro!" My son Michael was selling produce at the farmers market near the small family farm where he'd been working over the summer, and Jews in rural North Carolina were few and far between. His coworker meant the comment as a compliment, a jolly nod to the Jewish talent for selling, but in a larger sense for excelling at everything. Jewish achievement and Jewish brilliance, extolled by non-Jews as the inverse of negative stereotypes, have been a point of pride. Israel's establishment and success has been a major example of Jewish exceptionalism—of "Jew-powers."

But as Daniel Gordis states, we face a "waning of attachment to Israel among American Jews, especially but not exclusively younger American Jews."[1] This ambivalence—this "waning of attachment"—is wrapped in disillusion: Jews don't have "super-powers," and Israel is tarnished, branded as the aggressor in an unjust war.

This chapter seeks to examine a handful of recent plays on American stages that address this disillusion either directly by staging arguments that challenge Israel's place in Jewish American identity, or indirectly by causing public outrage in Jewish theater-going communities, which has led to boycotts, cancellations, and subsequent cries of censorship. I have not elected to focus on plays that take Israeli identity, Israeli politics, or religious life within Israel as their focus: among the many worthy plays I do not examine is, notably, *Oslo*[2] by J. T. Rogers, which (like David Edgar's magnificent play *The Prisoner's Dilemma*)[3] is a study of the processes and people involved in high-level, almost impossible, negotiations. *Oslo* is a brilliant work, but for college-age Jews it is

1 Daniel Gordis, "Why Many American Jews Are Becoming Indifferent, or Even Hostile, to Israel," *Mosaic*, May 8, 2017, https://mosaicmagazine.com/essay/israel-zionism/2017/05/why-many-american-jews-are-becoming-indifferent-or-even-hostile-to-israel/.
2 J. T. Rogers, *Oslo* (New York: Theatre Communications Group, 2017).
3 David Edgar, *The Prisoner's Dilemma* (London: Nick Hern Books, 2001).

ancient history, and, for those aware of the failure of the Oslo accords, hardly an encouraging narrative.[4]

My students' knowledge of Jewish history is typically scant, their analysis of politics in the Middle East is shallow, and their connection to a Jewish socio-ethnic identity is threadbare.[5] Rare is the Jewish Smith student who, outside of self-proclaimed "safe spaces," openly supports Israel. Many young Jews are *disenchanted*, as they realize that Israel is not David to an Arab Goliath, not an unsullied democracy in a sea of illiberality. Many feel that they were sold "a bill of goods" by Jewish institutions, only to discover that Israel does not live up to the ideals it espouses.[6] Israel fails the utopia test: it is a country like any other. There are no special "Jew powers."

Jewish American liberals—and I am one—wrestle with competing, even antithetical value systems. Assimilation has created a cohort of secular, highly educated, politically progressive Jews who shed Jewish particularity for a universalist, liberal-Protestant ethos. Andrea Most explains how early Jewish immigrants to America reinvented themselves by adopting new identities on the stage.[7,8]

4 There are certainly plays aplenty that look at Israel and Palestine. In February 2017, for example, Semitic Commonwealth and Silk Road Rising in Chicago held a staged reading series of six plays by prominent Arab and Jewish Israeli authors, which explored "the human toll of the Israeli-Palestinian conflict." See American Theatre, "Two States, Sure, but How About a Six-Play Solution?" February 10, 2017, http://www.americantheatre.org/2017/02/10/two-states-sure-but-how-about-a-six-play-solution. This is all to the good, and such presentations stimulate dialogue and offer humane and often complex insights into the conflict. They are not directly about Jewish American identity, and as such fall outside the scope of this chapter.

5 The pull of religious identity is even less compelling for modern American Jews. Brian Sutton-Smith makes the observation that "Charles Taylor, in *Sources of the Self: Making of Modern Identity*, suggests that, increasingly, in the search for what makes life worth living, twentieth-century persons have moved from finding their implicit ontologies in religious and even scientific sources and have substituted instead their own secular pursuits and experiences." See Brian Sutton-Smith, *The Ambiguity of Play* (Cambridge, MA: Harvard University Press, 2009), 177.

6 This phrase is a quote from my 30-year-old son, who served as a "lone soldier" in the Israel Defense Forces, took Israeli citizenship, studied and lived in Israel, led several Birthright trips, and worked for years in the Jewish non-profit sector. Surely, many young Jews feel quite differently, and have more positive views of Jewish and Israeli institutions. But this is an important viewpoint that needs to be heard.

7 Andrea Most, *Making Americans: Jews and the Broadway Musical* (Cambridge, MA: Harvard University Press, 2004).

8 Andrea Most, "A Pain in the Neck and Permacultural Subjectivity," in *Perma/Culture: Imagining Alternatives in an Age of Crisis*, ed. Molly Wallace and David V. Carruthers (London: Routledge, 2018), 15–25.

In her discussion of the "new" Jewish American, Most refers to John Locke's notion that religion is not the business of the state; rather, Locke posits, it is a private affair, requiring only interior faith. This runs directly counter to the Jewish idea of communal obligation and public acts. Assimilating Jews adopted the liberal-Protestant ethos, adopting the idea that we simply "go to different churches," and in so doing relinquished signs of difference and thereby saw the loosening of communal bonds.

Individual rights take priority over corporate claims. Young, liberal, American Jews choose universalism over particularism, idealism over pragmatism, and a utopian outlook that values the "brotherhood of man" over group or nation-state. With no direct experience of threat, no personal memory of the Holocaust, they see little reason to identify with Israel as a place of refuge. Israel seems to require support (economic, political, existential) from diaspora Jews, but for some it is a burdensome, or even baseless, claim.

This chapter considers how Israel's evolving impact on Jewish American identity is refracted on the contemporary American stage, with particular attention to plays that speak to generational divides in attachment to Israel, as measured in the 2013 Pew Report, and discussed in Dov Waxman's *Trouble in the Tribe*.[9] Theater is an important gauge of contemporary culture; theater artists and audiences are typically inquisitive, engaged, and politically progressive. By its nature, it is a public forum and community-making activity, insisting on dialogue as a core value and happening always in the *now*.

The plays examined here ask Jewish American audiences to reconsider their relationship to Israel. They are not about the conflict *per se*, nor do they look at schisms and debates within Israel, but rather challenge Jewish Americans to reexamine how they see Israel. In their production and reception, these plays reveal a generational divide and sit uncomfortably across political and religious axes that define the scope of Jewish American identity.

I begin with *If I Forget* by Steve Levenson (the 32-year-old Jewish author of the Tony-award-winning musical *Dear Evan Hansen*), in which Jewish Studies professor Michael Fischer is a self-avowed atheist, but his rejection of Judaism goes deeper. "Heritage ... is actually a very problematic concept,"[10] he says to his non-Jewish wife, Ellen. Their daughter Abby is in Israel on Birthright, a trip

9 Pew Research Center, *A Portrait of Jewish Americans*, October 1, 2013, https://www.pew research.org/religion/2013/10/01/jewish-american-beliefs-attitudes-culture-survey/?msclkid=cb7391c4ce5c11ec875da3de4767256b; Dov Waxman, *Trouble in the Tribe: The American Jewish Conflict over Israel* (Princeton, NJ: Princeton University Press, 2016).
10 Steven Levenson, *If I Forget* (New York: Dramatists Play Service, 2017), 6.

Ellen has encouraged, but which causes Michael to anguish over Abby's physical, and psychological, well-being.

Michael has written a book, *Forgetting the Holocaust*, in which he proclaims that Jews shamelessly exploit the Holocaust in order to generate political support for Israel. At the end of Act One, Michael's father Lou recounts what it felt like for him, an American GI and a Jew, to see the gas chambers, the piles of corpses, the emaciated bodies: "The ones we found, the ones who were still alive ... it was worst with them."[11] What struck the GIs most was that some of these skeletal survivors "went back and found the guards, the Germans, and rounded them up ... men who didn't weigh a hundred pounds, you could see the bones sticking out of their skin."[12] These men smashed the faces of those Germans who had killed their parents. "We just stood and watched. And we were glad."[13] Lou's experience of the Holocaust was tangible, the memory indelible, and the connection to Israel, while not explicit, is clear. The liberated prisoners, whose fury exceeded all bounds, were in Dachau because there was no safe haven where they, as Jews, could flee to.

There is a generational divide, between fathers who have seen the consequences and survived a bloody century, and the sons for whom history is an abstraction. Lou speaks the language of obligation, and though he doesn't mention Israel, the play begins with Lou watching TV reports of violence in Jerusalem following the collapse of the peace process in 2000.

Lou completely rejects Michael's book, which has as its thesis that "Israel, and the right-wing allies of Israel in the United States ... use the Holocaust, the memory of the Holocaust, to get American Jews, to support certain kinds of policy prerogatives in the Middle East."[14]

According to Michael, the "marketing" of the Holocaust is key to manipulating American Jews (and everyone else) into supporting Israel. "The best way to win an argument about Israel? Change the subject back to the Holocaust." The lynchpin of American Jewish identity is not "culture or food or religion" but "the six million. We've been manipulated ... to feel constantly victimized, constantly afraid."[15] Israel's existence is justified by the Holocaust, which Israel uses as a rhetorical device to defend itself from critique.

This argument circulates off stage, influencing those already inclined to suspect the Jewish state as a corrupted political project. By asserting that support

11 Ibid., 58.
12 Ibid., 58.
13 Ibid., 59.
14 Ibid., 54.
15 Ibid., 55.

for a Jewish state is due to a "trick" played on naïve Americans, Jews and non-Jews alike, it trivializes one central rationale for Israel's existence. It negates or ignores other reasons for Israel to exist (including a two-thousand-year connection to the land); that it is based on limited knowledge and impoverished thinking, however, makes it simplistic enough to persuade those for whom history is only, in Lou's words, "an abstraction."[16]

Lou fought in a war to save civilization, and saw firsthand the consequences of civilization's collapse. But the generational rift is clear: Lou's son Michael is a self-fashioning individual with *rights*, not *obligations*; implicitly, he asks "What do Jews owe *me*?" He is a universalist; he asks why Jews haven't responded to, say, genocide in Bosnia, or Rwanda, failing to see that many Jews do just that. But Michael rejects what he sees as an exclusive claim to victimhood, in which the memorialization of the Holocaust erases awareness of equally compelling causes.

On the night I saw *If I Forget*, the full house reacted audibly and with some displeasure to Michael's provocative assertions. My companions, a Jewish college student and a colleague married to an Israeli American, saw Michael as a *provocateur* whose arguments are intentionally incendiary. Both recognized the anti-Israel arguments as ones they'd heard, almost verbatim, on campus and beyond. While they firmly rejected Michael's stance as absurdly one-sided, it is becoming more salient (certainly on campuses across the United States) as time goes on.

Across three generations of the Fischer family, we see the "splintered tribe" that Dov Waxman identifies;[17] it dramatizes the generational and political divides quantified in the 2013 Pew Report. (A graphic from the Report hangs in the lobby of the theater.) The pull of individualism and a commitment to a generalized notion of social justice outweigh the group cohesion central to the entire Israeli project.

This divide is more sharply drawn in *My Name Is Rachel Corrie* (MNRC) though only one voice speaks. This univocal portrayal of a young idealist, killed accidentally or murdered in cold blood by an IDF soldier driving a tank (under dispute, but related as simple fact in the penumbral scene of the play), there are no "sides" to argue. "Jew power" has come to mean the power to kill.

During the 2014 war in Gaza, I discussed the situation with one of my students. She, a Jew, stood fervently against the Israeli incursion; moreover, the Israeli state, in her estimation an oppressive theocracy with right-wing (irredeemable) policies, did not need to exist. (Another student told me that all

16 Ibid., 59.
17 Waxman, *Trouble in the Tribe*; Pew Research Center, *A Portrait of Jewish Americans*.

the Jews in Israel should move to the Upper West Side. That, in her estimation, would end the problem.) She admittedly knew very little about the history or political situation, but to her that did not matter; she was allied with the underdog. Israel is strong, the Palestinians weak. *Ipso facto*, the Palestinians are right.

MNRC captures and mobilizes this generic idealism. The play was compiled, edited, produced, and presented by Alan Rickman and Katherine Viner, both high-profile British anti-Zionists (Rickman was a well-known actor; Viner an editor for London's *Guardian*); it has had numerous showings in the United States, and its subject and ostensible author is an American girl. But, as theater historian Carol Martin points out in *Theatre of the Real*, a playwright is "someone who has wrought words into dramatic form with the deliberate intention of creating a specific structure of meaning."[18] The snippets from Corrie's emails, notes, and diaries are edited and arranged by Rickman and Viner for maximum political effect. The result is a one-sided polemic that draws power from the ghost of a girl—an innocent, an idealist—who died too soon, but who is not the actual playwright in any traditional sense.

Rather, MNRC is put together by two avowedly pro-Palestinian activists as a blanket condemnation of Israel's actions in Gaza. As Carol Martin says, it is a partisan work in which "Rickman and Viner's role is anything but transparent."[19] As unacknowledged co-authors, they have selected and assembled Corrie's writings as "unqualified truth."[20] Corrie herself may have fully embraced an anti-Israel, pro-Palestinian narrative, but here she is burnished as a passionate idealist whose voice alone communicates truth. Nothing is problematized, nothing is questioned. I quote Martin at length:

> *Corrie* does not mention the suffering of Israelis at the hands of Palestinian suicide bombers and from Qassam rockets expressly targeting civilians. Why wasn't this part of Corrie's consideration? Why are Israeli and Palestinian points of view about themselves absent from the play? What about the historic Israeli overtures to peace? Why wasn't Egypt's oppressive military rule of Gaza before the 1967 war and its subsequent border blockade part of the story? Where is the other side of the story? Where is the truth in a partial story?[21]

18 Carol Martin, *Theatre of the Real* (London: Palgrave Macmillan, 2013), 124.
19 Ibid., 128.
20 Ibid., 128.
21 Ibid., 124 (emphasis added).

Theater is self-evidently dialogic, which certainly doesn't preclude having a point of view. But Rachel Corrie did not write a play, she wrote diary entries and emails, some of which were selected posthumously and arranged into a play whose editors, says Martin, have "eliminat[ed] the need for other views or information."[22] Their decision to take credit only as editors "exonerates them of responsibility for the controversial content of the drama."[23] They make "their selection and arrangement of documents appear to be natural, inevitable and comprehensive."[24] For those theatergoers not interested in disputation, a simple narrative is offered.

Theater of the real (verbatim theater, theater of witness, works that purport to represent "what really happened"), by presenting itself as truthful, as unfiltered documentation, actually *influences* reality; according to Martin, it "participates in what we know and how we come to know it."[25] Such theater can expand understanding and contribute to a dialogic exploration of the thorny circumstances of history, but "it can also oversimplify, inflame prejudices, and support one-sided perspectives."[26] This is precisely what MNRC does; in Martin's words, it is just a "one-sided view of the conflict."[27]

MNRC opened in London in 2005 at the Royal Court Theatre to comparatively little controversy. Its remounting in New York met with far more opposition: Ben Brantley in his *New York Times* review (2006) says that MNRC "makes its delayed American debut freighted with months of angry public argument, condemnation, celebration and prejudgment: all the heavy threads that make up the mantle of a cause célèbre."[28] Jim Nicola, artistic director of the New York Theatre Workshop (NYTW), and Lynn Moffatt, its managing director, had extended an invitation to produce the play, which they later either rescinded or indefinitely postponed (NYTW and the London team differ on this). Community members expressed concerns that the play was "recklessly naïve," and offered a "distorted view" of a complex situation.[29] Ultimately, MNRC had a month-long run at the Minetta Lane Theatre in New York, and then toured the United States.

22 Ibid., 124.
23 Ibid., 124.
24 Ibid., 131.
25 Ibid., 120.
26 Ibid., 120.
27 Ibid., 122.
28 Ben Brantley, "Notes from a Young Idealist in a World Gone Awry," *New York Times*, October 16, 2006, https://www.nytimes.com/2006/10/16/theater/reviews/16rach.html.
29 Jesse McKinley, "Play about Demonstrator's Death Is Delayed," the *New York Times*, February 28, 2006, https://www.nytimes.com/2006/02/28/theater/newsandfeatures/play-about-demonstrators-death-is-delayed.html.

In production, *MNRC* is not nearly as galvanizing as the media controversy it sparked; Ben Brantley called the Minetta Lane production "listless." As a work of dramaturgy, it is unimpressive. As polemic, it is potent. The script presents a young woman who in her courage and idealism is unassailable. Corrie comes across as a passionate, politically committed young woman whose life was snuffed out by a faceless, militarized machine. The play is carefully calibrated as a "countdown to a tragic death."[30] Corrie may have been a "naïve pawn,"[31] but she stood up for the underdog, and that makes her a heroine for many who share her values.

For a production of *MNRC* at the New Rep Theatre in Boston, I was asked to write a short piece for the theater's newsletter. My essay, "Murdering Innocence, Murdering Hope" argues that groups like the ISM (International Solidarity Movement), which recruit activists like Rachel, destroy any chance for dialogue or meaningful change. After the performance, I was supposed to speak on a panel. But Rachel's parents were in the audience, and I could not bring myself to impugn their lost daughter. Rachel died in service of her ideals. Her sacrifice gives her moral authority, and she inspires many young, liberal Jews.

As the story of a young girl's death, *My Name Is Rachel Corrie* is terribly sad. As a play, it is thin, even boring. As a sociological phenomenon, though, it carries a political wallop. Ari Roth, former artistic director of Theater J in Washington, DC, claims that Rachel Corrie has usurped Anne Frank for the millennial generation:

> The creation of ... Rachel Corrie, is an unconscious, or very deliberate hijacking of the symbol of Anne Frank as [an] icon of indiscriminate violence and victimization. Its emotional effectiveness serves to shove the icon of Anne Frank off the stage and replace it with a newly minted edition of our millennium's new martyr. *Shalom*, Anne Frank and *Ahalan*, Rachel Corrie.[32]

Rachel Corrie shares Anne Frank's fundamental belief "in the goodness of human nature," and, as Ben Brantley says, this is "sure to strike sadly familiar chords." It also rings in a new tune. Those who see the world as a place of moral absolutes, in which we are called to cherish the victim and condemn

30 Brantley, "Notes from a Young Idealist in a World Gone Awry."
31 Ibid. Brantley, in discussing NYTW's withdrawal of its offer to produce the play, said: "Ms. Corrie has been held up as both a heroic martyr (by Yasir Arafat, among others) and a terminally naïve pawn."
32 Ari Roth, email message to author, April 21, 2006, quoted in Carol Martin, *Theatre of the Real* (London: Palgrave Macmillan, 2013), 138.

the powerful without question, suffer from what dancer/choreographer Bill T. Jones calls "toxic certainty."[33] They may well embrace Jewish values, but they inhabit a world that holds no (ostensible) threat to Jews, and so they can afford to be certain of which "side" they are on. Corrie is a martyr, and young idealists want to be on *her* side.

This notional "divide across generations" allows us to better understand the plays we've discussed so far: If Lou Fischer is the grandfather, his son Michael is the father, and Rachel Corrie is our wayward daughter, then Caryl Churchill takes on the role of a scolding nanny. Churchill's *Seven Jewish Children*, written in January 2009 during Operation Cast Lead, claims that Jews have transformed themselves from history's victims to victimizers of the forsaken.

Seven Jewish Children spans 70 years of Jewish history in seven short scenes with a total playing time of less than ten minutes. It is noteworthy for its poetic compression and innovative form, and the extreme brevity and relentless repetition (almost every line begins "Tell her" or "Don't tell her") creates an obsessive rhythm. This remarkable construction allows for any number of voices to speak—as parents, relatives, friends—to an unseen child who must be protected, sheltered, and carefully taught. *Seven Jewish Children* is intimate in its rendering of family and global in its view.

The play is notable too for its harsh invective, its controversial thesis, and for the several short plays written as *responsa* by Jewish American playwrights. One of these plays, Deb Margolin's *Seven Palestinian Children*, regularly performs on a double bill with Churchill's play; together, they have toured as far away as Brazil and Iran.

Seven Jewish Children damns what it sees as the callous brutality of present-day Jews, the result, it alleges, of the historical trauma of the Jewish people. The first scene seems to take place during the Holocaust: the girl is hiding from people who would kill her. The next scene looks back to what happened. "Tell her there were people who hated Jews/Don't tell her/Tell her it's over now/Tell her there are still people who hate Jews."[34] Subsequent scenes move to pre-state Israel, through the establishment of Israel in 1948, up to the occupation of the territories. "Don't tell her who used to live in this house."[35]

In scene 6, the family has moved to the settlements:

33 Ginia Bellafante, "Political Footwork from Bill T. Jones," *New York Times*, September 21, 2005, https://www.nytimes.com/2005/09/21/arts/political-footwork-from-bill-t-jones.html.
34 Caryl Churchill, *Seven Jewish Children* (London: Nick Hern Books, 2009), 3.
35 Ibid., 4.

> Don't tell her about the bulldozer/Don't tell her it was knocking the house down/Don't tell her anything about bulldozers/Don't tell her the trouble about the swimming pool/Tell her it's our water, we have the right.
>
> Tell her we're stronger/tell her we're entitled/Tell her they don't understand anything except violence/Tell her we want peace/Tell her we're going swimming.[36]

Bret Stephens, in the *Wall Street Journal*, calls *Seven Jewish Children* "trite agit-prop."[37] But the rhetorical short-cuts, sloganeering, and simplistic caricatures are effective; they *stick*. Churchill's "agit-prop" encourages lazy thinking that serves her highly partisan agenda.

The contentious final scene is set during the invasion of Gaza that prompted Churchill to write the play. The scene culminates in a monologue, which Tony Kushner and Alisa Solomon call "an explosion of rage, racism, militarism, tribalism and repellent indifference to the suffering of others."[38] The monologue builds in percussive rhythms toward its climax:

> Tell her we're the ones to be sorry for, tell her they can't talk suffering to us. Tell her we're the iron fist now, tell her it's the fog of war, tell her we won't stop killing them till we're safe, tell her I laughed when I saw the dead policeman, tell her they're animals living in rubble now, tell her I wouldn't care if we wiped them out, the world would hate us is the only thing, tell her I don't care if the world hates us, tell her we're better haters, tell her we're chosen people, tell her I look at one of their children covered in blood and what do I feel? Tell her all I feel is happy it's not her.

This is followed by three short lines that end the play: "Don't tell her that./Tell her we love her./Don't frighten her."[39]

Seven Jewish Children has generated bitter controversy, particularly in the United States. In a conversation published in *The Atlantic* between Jeffrey Goldberg and Ari Roth, who directed readings of the play at Theater J, the two

36 Ibid., 5–6.
37 Bret Stephens, "The Stages of Anti-Semitism," *Wall Street Journal*, March 31, 2009, https://www.wsj.com/articles/SB123846281350272143.
38 Tony Kushner and Alisa Solomon, "Tell Her the Truth," *The Nation*, April 13, 2009. Alisa Solomon and Tony Kushner, theater critic and playwright, respectively, are prominent Jewish American theater artists who have been vocal critics of Israeli policies. In a defense of Churchill's play published in *The Nation*, they call it "dense, beautiful, elusive and intentionally indeterminate," as well as "incendiary." The monologue at the end of the play is, they assert, nothing that they have not heard (from Jews) before.
39 Churchill, *Seven Jewish Children*, 7.

debate whether the play should be given a public forum. Goldberg believes it is a deliberate calumny, and should not be given an imprimatur by a high-profile Jewish theater company. He calls the play "a short polemic directed against one party in a complicated conflict" and "a drive-by shooting of a play" that "demonizes the Jewish state" and associates "Jews with the spilling of innocent blood" (referencing the medieval blood libel); Jews—or the "Israeli branch of the Jewish people"—are painted as "morally obtuse to the point of criminality."[40]

Roth agrees that Churchill "wrote a play to hurt Israel," but feels that while it is "pernicious" there is "something really strong and right about it too." He reads it as being about the fundamental need to protect our children. It is important not only for its artistry, but for the cold-eyed critique of Jewish Israeli reality it presents. Roth is "a struggling Jew" who loves Israel, which is part of what motivates him to engage in "critical inquiry." "We in the Jewish community are motivated to do things because we love Israel. Even if we criticize Israel, we criticize because we love."

Ultimately, Theater J presented *Seven Jewish Children* along with Deb Margolin's *Seven Palestinian Children*, followed each night by a talk-back session. Margolin calls Churchill's play a skewed "psycho-history" of Jewish suffering; she felt compelled to respond. Her play, subtitled *A Play for the Other*, imagines what Palestinian parents might be saying to their progeny. She echoes Churchill's formula, writing her play in seven short scenes, opening most lines with "Tell him/Don't tell him." Margolin is empathetic, even tender, but the voices are explicitly encouraging violence and inculcating hate:

> Show him the key to our house that's still in his father's pocket/ Don't show him/Show him his father's gun ... /Tell him Death is sweet.
> Scene 1

> Tell him about/Jerusalem/Tell him they live there now/Tell him we can't live there now.
> Scene 4

> Tell him he will see his father and brother in glory/Tell him they don't understand anything but violence.
> Scene 5

40 Jeffrey Goldberg and Ari Roth, "Caryl Churchill: Gaza's Shakespeare, Or Fetid Jew-Baiter?" *The Atlantic*, March 25, 2009, https://www.theatlantic.com/international/archive/2009/03/caryl-churchill-gaza-apos-s-shakespeare-or-fetid-jew-baiter/9823/.

A searing monologue comes, as in Churchill's play, at the end:

> Tell him the world hates the Jews and always has hated them. Tell him there's a reason why people hate.
> Scene 7[41]

In *The Eighth Jewish Child*, yet another brief play that is in dialogue with Churchill, written by Jewish American Robbie Gringras, the opening lines are:

> Tell her it is more complicated than that/Tell her that we love Israel/Tell her that we hate Israel/Tell her that Israel is in our veins.[42]

Finally, I will now look at two plays that were written contemporaneously by non-Israeli Jews living in Jerusalem during the bloodiest year of the Second Intifada. The first, *Crossing Jerusalem*, written by Julia Pascal, was performed in London in 2003 and in revival in 2015. A US production in Miami at the Michael-Ann Russell Jewish Community Center's Cultural Arts Theater was suspended after four shows "in order to avoid any further pain and to engage in rigorous, vibrant conversation that advances our community."[43]

Crossing Jerusalem takes place during the Second Intifada, as a Jewish family "crosses over" to a restaurant in East Jerusalem owned by a Christian Arab. The family decides to hold a birthday celebration at Sammy's, regardless of the possible risk. Aleks Sierz, in his August 8, 2015, review, explains: "As bombs explode in cafés and on buses, the events of the drama illustrate the tight embrace of the personal and the political."[44]

The story is built on parallels and coincidences. Yusuf's father spent seven years in Ariel, a settlement, working for the Kaufman family, the same family having dinner at Sammy's restaurant. Yusuf now demands $5,000 as compensation for what his family lost. Yusuf's father, Mahmoud, lived with the Kaufmans and rarely saw his own children. When he left the Kaufman's employ, he was arrested for stealing a gold ring, and spent the rest of his life in jail. Lee, the younger Kaufman sibling, says: "Mahmoud was with us night and day. He should have been with his kids, but he wasn't, he was with us. Of

41 Deborah Margolin, *Seven Palestinian Children* (London: Royal Court Theatre, 2009).
42 Robbie Gringras, *The Eighth Jewish Child* (Washington, DC: TheaterJ, 2009).
43 Times of Israel Staff, "Miami Jewish Center Cancels Play Criticized as Anti-Israel," *Times of Israel*, February 19, 2016, https://www.timesofisrael.com/miami-jewish-center-cancels-play-criticized-as-anti-israel/.
44 Aleks Sierz, "Crossing Jerusalem, Park Theatre," *The Arts Desk*, August 8, 2015, https://www.theartsdesk.com/node/75850/view.

course we never paid him properly. We gave him money to do the jobs no Jew wants to do."[45]

Yael, the birthday girl (she's turning 30), is a Mizrachi Jew who has married into the Kaufman family. She is sexually attracted to Yusuf, and, as the others leave, she lingers behind to make him an offer. They bond over their Arab identity, she empathizes with his pain, and she tries to give him money as compensation for what his family has lost. It turns out that decades earlier, Varda, the matriarch of the Kaufman clan—a hard-driving, rather nasty Israeli woman who accurately describes herself as a liar and a thief—fell into bed with Mahmoud and gave him the jewelry with which he was caught.

Yusuf and his stone-throwing brother Sharif will never get back what was taken from them, neither the land nor their father. Yael feels "embarrassed,"[46] she says "disloyal,"[47] for empathizing with Yusuf and wanting to make up for the injustice done to his father. She is guilty and not sure when her husband Gideon asks her: "Where do your loyalties lie?"[48]

Gideon, meanwhile, is wracked with guilt about having to serve in the Occupied Territories. In fact, he will refuse his current call-up: better to go to jail and be condemned as a coward than risk becoming the monster he became "last December," when he was posted in Ramallah. Speaking in short sentences, barely able to verbalize, he sounds like a person just coming to face a significant trauma:

> I got out of the tank. I went up to one of the kids. I dragged him into a field. I made him kneel. I blindfolded him. I tied his hands behind his back. His breathing was very fast, he was sweating. I lifted my rifle. I didn't know what I was going to do. I wanted to smash him to the ground.[49]

Gideon relates how he wanted to "beat until there was nothing left of him." What he recalls is "a crack ... and then another. Sharp. Steel against bone." After it was over, the boy "shit himself with fear" and Gideon vomited "all over his uniform."[50] The disgust he feels about his murderous rage is unpalatable, unacceptable, a rejection of his own humanity. "I may be a rotten Israeli but at least I can try to be a decent Jew."[51]

45 Julia Pascal, *Crossing Jerusalem* (London: Oberon, 2003), 54.
46 Ibid., 56.
47 Ibid., 57.
48 Ibid., 67.
49 Ibid., 75.
50 Ibid., 75.
51 Ibid., 76.

Though the play is structured around parallel histories, Palestinian violence is presented very differently. Yusuf's younger brother Sharif, who at the conclusion of the play, becomes a suicide bomber, blows up the bus on which Gideon was traveling. But Sharif's violence is justified by his situation: while he hates the Jews (he tells Sammy that he is a servant to the Jews, and that he is disgusted by "all those Israeli girls who want to kiss Arab ass"),[52] he loves the land and is fighting to redeem it. His tactics endanger him, and Yusuf wants them both to leave for America, but never questions the validity of what he is doing.

My own play, *Pulling Apart*, examines the *matsav*[53] through the eyes of a family that has made *aliyah*, and whose central characters struggle not with shame or guilt, but with questions of obligation. The moral predicament of how to live in this land—*whether* to live here, as Josh, the American brother who reluctantly visits his sister Sarah, from whom he is estranged—how to respond to the communal and historical obligations of Jewish identity, how to live *as a Jew*: these are the core questions Sarah and her family wrestle with as the world is exploding around them. There is moral perplexity, interfamilial rage, and concern for ethical action in a brutal and brutalizing situation. But there is neither guilt nor shame.

Of the plays discussed above, three (*My Name Is Rachel Corrie*, *Seven Jewish Children*, and *Crossing Jerusalem*) have seen controversies that have led to public uproar, show cancellations, and cries of censorship. When Jim Nicola announced the postponement/cancellation of *MNRC* in the NYTW's 2006–2007 season, there was an outcry among members of the New York theater community. Playwright Edward Machado called the cancellation "the worst kind of censorship imaginable."[54] Vanessa Redgrave decried it as a "catastrophe."[55] Jason Fitzgerald, in his essay "The Second Life of Rachel Corrie," asserts that "Jim Nicola was, in the end, the best thing to happen to *My Name Is Rachel Corrie*."[56] The cancellation at NYTW was followed by a month-long run in New York and bookings across the country.

52 Ibid., 68.
53 The word *matsav* means "situation" in Hebrew, but it is commonly used to refer to the conflict between Israelis and Palestinians.
54 Eduardo Machado, "Up Front." Laura Pels Foundation Keynote Address. Presented at the American Airlines Theater, New York, June 5, 2006.
55 Amy Goodman, "Legendary Actor Vanessa Redgrave Calls Cancellation of Rachel Corrie Play an 'Act of Catastrophic Cowardice,'" *Democracy Now!* March 8, 2006, https://www.democracynow.org/2006/3/8/legendary_actor_vanessa_redgrave_calls_cancellation.
56 Jason Fitzgerald, "The Second Life of Rachel Corrie," *Hot Reviews*, accessed September 10, 2021, http://www.hotreview.org/articles/secondlifeofrachcor.htm.

Positioning the American Jewish community as conservative, defensive, and against free speech is self-defeating. Mounting a robust defense, responding through engagement and debate, is far more likely to appeal to a generation of Jews who are already asking questions. Tamping down or trying to snuff out other arguments, no matter how distasteful or inflammatory those arguments may be, will only further alienate those for whom Jewish identity is divided, fractured, and anxious.

In *Not In God's Name*, Jonathan Sacks makes a simple, illuminating point: "The source of violence lies in our need to exist in groups, which leads to in-group altruism and out-group hostility."[57] The Pew Report, along with anecdotal evidence based on observations on campus, and a look at recent plays and their reception on American stages, together imply that many (young, liberal) American Jews are switching their identification from Jewish American to a more cosmopolitan and universalist "citizen of the world." In their eyes, the in-group and out-group are changing places.

Bibliography

American Theatre. "Two States, Sure, but How About a Six-Play Solution?" February 10, 2017. http://www.americantheatre.org/2017/02/10/two-states-sure-but-how-about-a-six-play-solution.

Bellafante, Ginia. "Political Footwork from Bill T. Jones." *New York Times*, September 21, 2005. https://www.nytimes.com/2005/09/21/arts/political-footwork-from-bill-t-jones.html.

Brantley, Ben. "Notes from a Young Idealist in a World Gone Awry." *New York Times*, 2006. https://www.nytimes.com/2006/10/16/theater/reviews/16rach.html.

Churchill, Caryl. *Seven Jewish Children*. London: Nick Hern Books, 2009.

Edgar, David. *The Prisoner's Dilemma*. London: Nick Hern Books, 2001.

Fitzgerald, Jason. "The Second Life of Rachel Corrie." *Hot Reviews*. Accessed September 10, 2021. http://www.hotreview.org/articles/secondlifeofrachcor.htm.

Goldberg, Jeffrey, and Ari Roth. "Caryl Churchill: Gaza's Shakespeare, Or Fetid Jew-Baiter?" *The Atlantic*, March 25, 2009. https://www.theatlantic.com/international/archive/2009/03/caryl-churchill-gaza-apos-s-shakespeare-or-fetid-jew-baiter/9823/.

Goodman, Amy. "Legendary Actor Vanessa Redgrave Calls Cancellation of Rachel Corrie Play an 'Act of Catastrophic Cowardice.'" *Democracy Now!*, March 8, 2006.

57 Jonathan Sacks, *Not in God's Name: Confronting Religious Violence* (New York: Schocken, 2017), 152.

https://www.democracynow.org/2006/3/8/legendary_actor_vanessa_redgrave_calls_cancellation.

Gordis, Daniel. "Why Many American Jews Are Becoming Indifferent, or Even Hostile, to Israel." *Mosaic*, May 8, 2017. https://mosaicmagazine.com/essay/israel-zionism/2017/05/why-many-american-jews-are-becoming-indifferent-or-even-hostile-to-israel/.

Gringras, Robbie. *The Eighth Jewish Child*, Washington, DC: Theater J, 2009.

Kushner, Tony, and Alisa Solomon. "Tell Her the Truth." *The Nation*, April 13, 2009. https://www.thenation.com/article/archive/tell-her-truth/.

Levenson, Steven. *If I Forget*. New York: Dramatists Play Service, 2017.

Machado, Eduardo. "Up Front." Laura Pels Foundation Keynote Address. Presented at the American Airlines Theater, New York, June 5, 2006.

Margolin, Deborah. *Seven Palestinian Children*. London: Royal Court Theatre, 2009.

Martin, Carol. *Theatre of the Real*. London: Palgrave Macmillan, 2013.

McKinley, Jesse. "Play About Demonstrator's Death Is Delayed." *New York Times*, February 28, 2006. https://www.nytimes.com/2006/02/28/theater/newsandfeatures/play-about-demonstrators-death-is-delayed.html.

Most, Andrea. "A Pain in the Neck and Permacultural Subjectivity." In *Perma/Culture: Imagining Alternatives in an Age of Crisis*. Edited by Molly Wallace and David V. Carruthers, 15–25. London: Routledge, 2018.

Most, Andrea. *Making Americans: Jews and the Broadway Musical*. Cambridge, MA: Harvard University Press, 2004.

Pascal, Julia. *Crossing Jerusalem*. London: Oberon, 2003.

Pew Research Center. *A Portrait of Jewish Americans*. October 1, 2013, https://www.pewresearch.org/religion/2013/10/01/jewish-american-beliefs-attitudes-culture-survey/?msclkid=cb7391c4ce5c11ec875da3de4767256b.

Rogers, J. T. *Oslo*. New York: Theatre Communications Group, 2017.

Sacks, Jonathan. *Not in God's Name: Confronting Religious Violence*. New York: Schocken, 2017.

Sierz, Aleks. "Crossing Jerusalem, Park Theatre." *The Arts Desk*, August 8, 2015. https://www.theartsdesk.com/node/75850/view.

Stephens, Bret. "The Stages of Anti-Semitism." *Wall Street Journal*, March 31, 2009. https://www.wsj.com/articles/SB123846281350272143.

Sutton-Smith, Brian. *The Ambiguity of Play*. Cambridge, MA: Harvard University Press, 2009.

Times of Israel Staff. "Miami Jewish Center Cancels Play Criticized as Anti-Israel." *Times of Israel*, February 19, 2016. https://www.timesofisrael.com/miami-jewish-center-cancels-play-criticized-as-anti-israel/.

Waxman, Dov. *Trouble in the Tribe: The American Jewish Conflict over Israel*. Princeton, NJ: Princeton University Press, 2018.

CHAPTER 5

The Sabra within the Schlemiel: Diverging Modes of American Jewish and Israeli Masculinity in Jewish American Literature

Samantha Pickette

At the end of Saul Bellow's 1970 novel *Mr. Sammler's Planet*, Holocaust survivor Artur Sammler, and his former son-in-law, artist and Israeli transplant Eisen, encounter a fight in the street involving the Black pickpocket whom Sammler has been shadowing throughout the story. This final showdown functions as an emblem of the various versions of masculinity that exist within the scope of the novel: Sammler's diasporic masculinity, situated in both the Jewish American sphere of his current life and the European sphere of his youth; Eisen's Israeli Jewish masculinity, developed as a reaction to his experiences in Nazi-occupied Europe and in Soviet Russia; and the pickpocket's Black masculinity, an alternative mode of masculine identity performance that further underscores the diverging paths that Holocaust survivors Sammler and Eisen have chosen.

It is no mistake that upon seeing the fight Sammler turns to Eisen to intervene, or that Eisen misunderstands Sammler's desire to stop the violent encounter and instead takes his Jewish-themed sculptures—"medallions" featuring Stars of David, rams' horns, and Hebrew inscriptions calling for strength— and beats the pickpocket over the head with them.[1] Eisen's Israeli strength renders him "brutal" as he literally weaponizes his Jewishness into a force that both victimizes the powerless (in this case, a Black man who exists on the outskirts of a racist and classist society that dehumanizes him) and separates itself from the ethos of authentic Jewish identity. Sammler, horrified by Eisen's actions and by the insensitivity of Eisen's justification for the violence, rejects Eisen's attempts to align himself with Sammler on moral grounds; as Eisen tells Sammler: "You can't hit a man like this just once ... you must really hit him. Otherwise he'll kill you. You know ... You were a Partisan."[2] While they both fought in the war and both killed in order to survive, Sammler refuses to see himself as connected to the "homicidal maniac" Eisen or to embrace

[1] Saul Bellow, *Mr. Sammler's Planet* (1970; repr. New York: Penguin Books, 1995), 239–240.
[2] Ibid., 241–242.

his sensibilities.[3] Instead, Sammler aligns himself with the pickpocket, who for Sammler has been a source of fascination, fear, admiration, and identification throughout the novel, as well as a symbol of the complex dichotomy between victimizing and being victimized: "The black man was a megalomaniac. But there was ... a certain princeliness ... mad with an idea of *noblesse*. And how much Sammler sympathized with him—how much he would have done to prevent such atrocious blows!"[4] The conclusion of *Mr. Sammler's Planet* differentiates between Sammler's and Eisen's respective approaches to Jewish masculinity, and ultimately repudiates Eisen's Israeli power in favor of Sammler's diasporic sensitivity; using the figure of the Black pickpocket as a dual symbol of historical oppression and masculine potency, *Mr. Sammler's Planet* aligns Sammler (and thus Jewish diasporic masculinity) with the pickpocket, and in doing so asserts a version of Jewish masculinity that opposes Israeli conceptions of masculine strength and upholds diasporic Jewish maleness as an ideal.

In many ways, *Mr. Sammler's Planet*'s characterization of Sammler and Eisen acts as a microcosm for the relationship that Jewish American literature has with Israel, and specifically the manner in which Jewish American authors often invoke Israeli Jewish masculinity—aggressive, physical, cunning—as a mirror image of Jewish American masculinity—passive, intellectual, cautious. Stereotypical Israeli masculinity draws from the image of the "new Jew" cultivated by political Zionists like Theodor Herzl and Max Nordau and European Jewish intellectuals like Sigmund Freud at the turn of the twentieth century. Pre-1948, the new Jew—a manifestation of the "muscle Judaism" espoused by Nordau as a masculine force that would overcome the "pitiable weakness" of diaspora Jewry—was a political and cultural mechanism meant to undermine European antisemitic conceptions of Jewish weakness and effeminacy by introducing a new paradigm of Jewish male fervor, autonomy, and strength.[5] Post-1948, the "Sabra" continued this project of rebuilding Jewish masculinity, with greater emphasis placed on the difference between Israeli Sabras and *galut* (diaspora) Jews who "went like lambs to the slaughter" during the Holocaust.[6] In this context, Jewish authenticity revolved not only around displays of masculine strength, but also around geography: "true Jews" lived in Israel, whereas feminized *galut* Jews lived in the perpetual exile of the diaspora.

3 Ibid., 244.
4 Ibid., 243.
5 Quoted in Paula E. Hyman, *Gender and Assimilation in Modern Jewish History: The Roles and Representation of Women* (Seattle: University of Washington Press, 1995), 144–145.
6 Yael Zerubavel, "The 'Mythological Sabra' and Jewish Past: Trauma, Memory, and Contested Identities," *Israel Studies* 7, no. 2 (2002): 115–144, here 118.

Depictions of Jewish American masculinity elicit stereotypes of *galut* Judaism, even as they display a sense of ambivalence about the implied inferiority of Jewish American masculinity compared to Israeli masculinity. While the Holocaust destroyed European Jewry, the post-World War II Jewish American experience was marked by rapid assimilation into the White middle class, suburbanization, and the successful acculturation of American customs. Still, as Rachel Kranson discusses, Jewish American men in the postwar years faced Americanized versions of European antisemitic claims of Jewish male weakness, exacerbated by the fact that "the proliferation of professional, breadwinning Jewish men ... seemed to reinforce stereotypes of Jewish men as greedy, puny, and cowardly."[7] Gendered critiques of assimilated Jewish American men, coupled with a mid-century glorification of Israel (and "tough" Israeli muscle Jews) in American literature, film, and popular culture, further perpetuated the image of Israeli masculinity as more "real" than Jewish American masculinity, and of Israel as a more legitimate site for Jewish identity building than the United States. At the same time, despite the popularity of Zionism and the fledgling State of Israel within the American Jewish community, American Jews largely refused to see themselves as part of an exilic group whose vitality needed to be proved.

As *Mr. Sammler's Planet*'s uneasy juxtaposition of Sammler and Eisen suggests, the role of Israel in Jewish American literature is marked by a profound ambivalence, one which is made all the more complicated by gendered comparisons between American and Israeli modes of masculine identity formation. Using Philip Roth's *The Counterlife* (1986) and *Operation Shylock: A Confession* (1993) and Jonathan Safran Foer's *Here I Am* (2016) as case studies, this chapter examines the various literary imaginings of Israeli culture in American literature, using gender as a lens through which to understand the role that Israel plays in Jewish American stories. Israel functions as a point of comparison, an alternate reality, a projection of hopes and fears, and, most importantly, a distinctive "other." The Israeli "other" is more of a threat to the Jewish American male psyche than the all-American, non-Jewish man; while the latter's position in the Christian American ruling class places him above the Jewish American man for reasons that are both inwardly and outwardly indelible, the Israeli's overt masculinity contradicts the Jewish American man's conception of himself as weak because of his Jewishness. The figure of the Israeli man in Jewish American literature often forces the Jewish American male protagonist to confront the consequences of diasporic Jewish life and the

7 Rachel Kranson, *Ambivalent Embrace: Jewish Upward Mobility in Postwar America* (Chapel Hill: University of North Carolina Press, 2017), 106.

possibilities, both aspirational and foreboding, that Israeli Jewish life evokes. Ultimately, in considering the diverging modes of Jewish masculinity depicted in representations of Israel/Israelis in Jewish American literature, this chapter explores how post-1967 Jewish American literature increasingly employs Israel as a lens through which to analyze, criticize, and magnify the complexities of Jewish American male identity. At the same time, this canon uses Israel, and specifically Israeli masculinity, as a symbolic site for reaffirming the legitimacy and authenticity of a Jewish American diaspora created and perpetuated almost exclusively by Jewish men.

1 Jewish American Emasculation and Moral Superiority in Philip Roth's *The Counterlife* (1986) and *Operation Shylock: A Confession* (1993)

While *The Counterlife* and *Operation Shylock* are not Philip Roth's first depictions of the relationship between American Jews and Israel—Alexander Portnoy's inability to maintain an erection and his subsequent attempted rape of a female soldier while visiting Israel at the end of *Portnoy's Complaint* (1969) marks Roth's initial attempt to reflect on the Jewish American male psyche through the lens of Israeli emasculation—together both novels form Roth's most significant literary rumination on Israel's impact on Jewish American male identity. Debra Shostak suggests that Israel in Roth's novels "poses an identity crisis for the diaspora Jew largely because of its symbolic power as the Jewish 'home.'"[8] Both *The Counterlife* and *Operation Shylock* present an ambivalent version of Israel filtered through the eyes of a series of mostly Jewish American men who project their gendered insecurities onto the "symbolic power" of Israel as a site of Jewish authenticity and legitimacy and, in turn, struggle to feel at home with the version of Jewishness that Israel represents for them.

The Counterlife revolves around three parallel timelines in the life of writer Nathan Zuckerman: one in which Nathan's brother, Henry, is rendered impotent as a result of a heart condition and dies during bypass surgery; one in which Henry survives the surgery and moves to Israel; and one in which Nathan is the impotent brother who dies during heart surgery. *Operation Shylock* tells the story of a fictionalized version of Philip Roth, who travels to Israel to find and confront a man also named Philip Roth who is posing as the author and

[8] Debra Shostak, "The Diaspora Jew and the 'Instinct for Impersonation': Philip Roth's 'Operation Shylock,'" *Contemporary Literature* 38, no. 4 (1997): 726–754, here 742.

using his platform to spread the gospel of "Diasporism," an anti-Zionist ideology rooted in the idea that the true Jewish homeland exists in the European countries where *Yiddishkeit* flourished pre-Holocaust. Both novels focus on a Roth-inspired protagonist, and both place masculine virility (or lack thereof) at the center of their stories—in the second "counterlife," Henry's impotence and his subsequent second chance at achieving a more "authentic" Jewish manhood drives his decision to embrace his new identity as "Hanoch," a militant Zionist, whereas the imposter Philip's (nicknamed "Pipik" by the real Philip) devotion to Diasporism stems from his desire to leave a legacy before he dies from an aggressive cancer that has already necessitated the surgical removal of his penis. Displays of masculine potency—both literal and figurative—permeate Nathan's and Philip's respective journeys through Israel, and the spectrum of Jewish masculinities that Nathan and Philip encounter offer various versions of Jewish male performance, all of which ultimately affirm Nathan's and Philip's status as the moral centers of their respective stories.

Henry's and Pipik's sojourns to Israel serve as antidotes to their failed masculinity. Henry's failures are ideological in nature, and his journey functions as *The Counterlife*'s articulation of the stereotypical binary between American Jewish hollowness and Israeli Jewish substance. His heart procedure—a risky surgery he undergoes against the advice of his cardiologist and the wishes of his wife so that he can continue engaging in an affair with his dental assistant—catalyzes his transformation into Hanoch, and he begins to understand his heart condition and the sexual impotence that accompanied it as a physical manifestation of the "sickness," "meaninglessness," and "disease" of Jewish American masculinity: "I was so conventionalized I never felt anything ... My office blow job, the great overwhelming passion of a completely superficial life ... the Jewish male's idolatry—worship of the shiksa ... the original Jewish dream of escape."[9] Henry's subsequent adoption of his new persona, Hanoch, marks a transition away from his past as a "prosperous, comfortable ... galut [Jew], bereft of any sort of context in which to actually be Jewish," and toward an embrace of a masculine identity rooted in Henry's perception of Israel as a place that will allow for him to become more authentic, more Jewish, and more alive than he was as a dentist in New Jersey:

> There's a world outside the Oedipal swamp, Nathan, where what matters isn't ... what decadent Jews like you think but what committed Jews like the people here *do*! Jews who aren't in it for laughs, Jews that have something more to go on than their hilarious inner landscape! Here they

9 Philip Roth, *The Counterlife* (New York: Vintage International, 1986), 110–111.

have an *outer* landscape, a nation, a world! ... This isn't some exercise for the brain divorced from reality! This isn't writing a novel, Nathan. Here people don't jerk around like your fucking heroes worrying twenty-four hours a day about what's going on inside their heads and whether they should see their psychiatrists—here you fight, you struggle.[10]

Israel functions as a symbolic site of rebirth, where Henry can shed himself of the "galut" mentality that characterizes Jewish American masculinity—a failed form of masculinity primarily concerned with empty intellectualism, sexual neuroses, and assimilation into a hegemonic culture that undermines Jewish authenticity—and embrace an Israeli persona rooted in political and ideological potency.

In many ways, Pipik plays the same role in *Operation Shylock* that Henry does in *The Counterlife*, albeit from the opposite end of the political spectrum. Whereas Henry/Hanoch counteracts his failed masculinity with Zionism, militancy, and a rejection of *galut* inauthenticity, Pipik counteracts his physical deficiencies by rejecting Israeli hyperviolence, which he believes lacks an authentic Jewish ethos, instead upholding post-Zionistic diasporism as the only viable path for Jewish survival. However, Pipik still makes the distinction between the powerful, active version of masculinity he embodies—as a former private detective drawn to dangerous cases, as an MP during the Korean War, and as an ardent diasporist who sees Jewish assimilation as "living like a man"—and the emasculated "make-believe" that characterizes Philip's state of being.[11] As Pipik tells Philip in the letter he sends him begging Philip to allow him to continue using his name and likeness to promote diasporism: "I AM THE YOU THAT IS NOT WORDS."[12] Similarly to Henry's dismissal of Nathan's writing as "some exercise for the brain divorced from reality," Pipik's self-identification as the version of Philip Roth not driven by words, but by actions, suggests the inadequacy in the *luftmensch* version of Jewish American masculinity espoused by Roth's oeuvre. Together, Henry and Pipik present an alternative vision of the Jewish male predicated on ideological commitment, a rejection of Jewish American complacency, a recognition of Israeli power, and, especially in the case of Pipik, who attempts to demonstrate the "reality" of his manhood to Philip by exposing his prosthetic penis, physical displays of masculine sexual potency.[13]

10 Ibid., 111, 140.
11 Philip Roth, *Operation Shylock: A Confession* (New York: Vintage International, 1993), 196, 200.
12 Ibid., 87.
13 Ibid., 205.

While Roth provides Henry and Pipik platforms to articulate their respective visions, Nathan and Philip—as stand-ins for Roth himself—ultimately dismantle their legitimacy, and in doing so they re-emasculate Henry and Pipik in order to reveal the instability of their reframings of Jewish masculinity. Nathan undermines the motivations behind Henry's newfound claims to an ancestral Jewish identity rooted in Israel as the geographic center of Jewish authenticity: "Maybe the Jews begin with Judea, but Henry doesn't and he never will. He begins with WJZ and WOR, with double features at the Roosevelt on Saturday afternoons and Sunday doubleheaders at Ruppert Stadium watching the Newark Bears."[14] More than a simple valorization of secular Jewish American culture, however, Nathan positions secular American Jewishness not as the "spiritual suicide" that the members of Henry's Hebrew *ulpan* classify it, but as a legitimate mode of Jewish identity performance.[15]

Roth further reinforces this view in two significant ways. First, he juxtaposes Nathan's relative reasonability with the extremist rhetoric of men such as Mordecai Lippman, the "embodiment of potency" in charge of Henry's militant settlement community in the West Bank; Jimmy Ben-Joseph, the crazed student who attempts to hijack Nathan's flight in order to bring attention to his anti-Holocaust remembrance movement; and Henry himself, who insists that "in America the massacre of [my] Judaism couldn't have been more complete."[16] Second, and perhaps more importantly, *The Counterlife* provides further credence to Nathan's perspective through the characterization of Nathan's Israeli-born friend, Shuki, whose criticisms of Israeli extremism, of Lippman's fascism, and of the disingenuity of "ignorant" American Jews like Henry, seemingly confirm Israel's status not as the haven of Jewish authenticity that Henry imagines it, but rather as "the *homeland* of Jewish abnormality": "The fact remains that in the Diaspora a Jew like you lives securely, without real fear of persecution or violence, while we [Israelis] are living just the kind of imperiled Jewish existence that we came here to replace ... we are the ghettoized, jittery little Jews of the Diaspora, and you are the Jews with all the confidence and cultivation that comes of feeling at home where you are."[17] *The Counterlife* thus destabilizes the mythic image of Israel as the singular Jewish homeland, and reveals Israeli masculinity as a mask adorned by non-Israeli-born Jewish men like Lippman, Ben-Joseph, and Henry, who appropriate its qualities in order to overcome their own feelings of inadequacy, ineffectuality, and emasculation. As Shuki suggests multiple times during Nathan's visit to Israel, it is Nathan—the

14 Roth, *The Counterlife*, 133.
15 Ibid., 103.
16 Ibid., 137, 110.
17 Ibid., 75, 77–79.

Jewish American writer who is secular, deeply tied to American culture, and uncertain of whether he even wants to circumcise his unborn son—who most closely resembles a "normal Jew."[18]

Operation Shylock similarly disarms Pipik by emphasizing the artificiality of Pipik's masculinity, and by subverting the radicalism of Pipik's ideas. Philip's emasculation of Pipik—both literal, in his mocking of Pipik's penile implant as a metaphor for his inauthenticity as a man and in his seduction of Pipik's girlfriend, and figurative, in his christening of the imposter/twin with the infantilizing nickname "Moishe Pipik"—strips Pipik of his power while reasserting Philip's own fortitude. Furthermore, as in *The Counterlife*, *Operation Shylock* provides a plethora of voices attempting to define Jewish identity: some, like Pipik and like Philip's Palestinian friend, George Zaid, are too extreme to be taken seriously; others, like the fictionalized version of Israeli author Aharon Appelfeld, presented as "the Jewish man [Philip] is *not*" and Smilesburger, Philip's Israeli foil and the enigmatic Mossad agent who recruits Philip for a mission uncovering the identities of Jews donating to the Palestinian cause, provide moderate Israeli points-of-view that echo Philip's ambivalence.

As Debra Shostak suggests, *Operation Shylock* revolves around Philip's Jewish "identity crisis"—"whether to throw his lot with the 'healthy' and powerful image that is the Israeli Jew or to hang with the madmen, the Zees and Pipiks who reinforce ... the conventional representation of the Diaspora Jew."[19] Shostak goes on to argue that Philip's choice to perform Smilesburger's mission—and Roth's choice to omit the mission itself from the text—stems from the "issue of representation that has been implicit throughout the novel."[20] It is no mistake, then, that the novel ends with Philip in a New York deli—a symbol of Jewish American culture—or that Philip's description of the now-retired Smilesburger echoes his conception of the Jewish American psyche—"[Smilesburger] is what 'Jew' *is* to me ... Worldly negativity. Seductive verbosity. Intellectual venery ... malice ... comedy ... endurance ... injury ... impairment."[21] In accepting Smilesburger's mission, Philip rejects the extremism and artificial masculinity represented by Pipik and diasporism. In omitting the details of the mission from the narrative and concluding with Philip and his Israeli mirror image firmly situated in an American Jewish space, Roth rejects the essentialism embedded in Zionism's repudiation of the diaspora and affirms the legitimacy of the Jewish American homeland.

18 Ibid., 158.
19 Shostak, "The Diaspora Jew and the 'Instinct for Impersonation,'" 742.
20 Ibid., 748.
21 Roth, *Operation Shylock*, 394.

Both *The Counterlife* and *Operation Shylock* are ultimately about Jewish authenticity, but it is a specifically male Jewish authenticity that seeks to define what it means to be a Jewish man; Roth locates true Jewishness not in the diaspora in general, but in the Jewish American milieu of his literary oeuvre—as such, both novels assert America's status as the real "promised land" for Jewish men, upholding the Rothian paradigm of Jewish American masculinity as the most viable, authentic way of being Jewish. Karen Grumberg frames her reading of the Rothian binary between Israel and the diaspora in terms of the pastoral; while Israel is a modern pastoral, the diaspora is anti-pastoral, "wounded and thereby not 'whole.'"[22] As Grumberg goes on to suggest: "Though this conception suggests a valorization of Israeli Jewish identity, it actually asserts the authenticity of the Diaspora Jew, since, for Roth, Jewishness is characterized by complexity and conflict."[23] In other words, the "completeness" represented by Israel—in its Jewish autonomy, its historical and biblical significance, and its powerful masculine ethos—is less "Jewish" than the incompleteness of the American diaspora (a fact that underscores why Nathan feels just as uncomfortable in Israel as he does in England; both the Jewish and WASPish pastorals make him feel visible as the "wrong" kind of Jew). Roth makes a distinction between the diaspora of the Zionist imagination—the humiliation and emasculation of the *galut*—and the reality of the American Jewish diaspora—the "neutral, unmarked *golah*" that rejects the "rhetoric of 'wholeness.'"[24] The diasporism of Pipik and the desperate appropriation of Israeli identity by Henry is, in this sense, *galut*. The confident acceptance of Jewish masculine instability and incompleteness by Nathan and Philip is *golah*—they do not need to be "whole" in order to be "real" Jews. Israel therefore acts as the narrative device that allows Roth to demonstrate that, while Nathan and Philip may be diaspora Jews, their acceptance of the "wound" of the diaspora marks their authenticity as Jews and as men.

2 Israeli Masculinity as a Mirror for the Jewish American Man in Jonathan Safran Foer's *Here I Am* (2016)

While *The Counterlife* and *Operation Shylock* delve into the dichotomy between diasporic and Israeli claims to Jewish male identity, Roth firmly situates both

[22] Karen Grumberg, "Necessary Wounds and the Humiliation of *Galut* in Roth's *The Counterlife* and *Operation Shylock*," *Philip Roth Studies* 5, no. 1 (2009): 35–59, here 36.
[23] Ibid., 36.
[24] Ibid., 54.

narratives in the hands of Jewish American men who project their own insecurities and desires onto the Israeli milieu. In his 2016 novel *Here I Am*, Jonathan Safran Foer turns Roth's approach on its head, centering the story on the Jewish American family of Jacob Bloch, a disillusioned middle-aged writer in Washington, DC, and their Israeli relatives, who come to visit for the bar mitzvah of Jacob's oldest son, Sam, and become stranded in the Bloch household after a cataclysmic earthquake in Israel predicates an all-out war in the Middle East. While the impending collapse of the State of Israel looms large over Jacob's story, Foer places the narrative action firmly in the American sphere, juxtaposing the familial implosion of Jacob's Jewish American household with the political implosion in the Middle East, and introducing a mélange of Jewish American and Israeli members of the Bloch family who complicate the simplistic binary between diasporic weakness and Israeli strength.

The novel's most significant reflection on Jewish masculinity comes from its mirroring of Jacob with his Israeli cousin, Tamir. Jacob conforms to the prevailing archetypes of Jewish American masculinity, embodying the neuroses, sexual hang-ups, and physical shortcomings of the traditional *nebbish/schlemiel*: he suffers from impotence brought on by a prescription to Propecia he keeps secret because he does not want his wife, Julia, to know he is losing his hair; he sends X-rated text messages to a coworker on a secret cellphone but does not have the courage to engage in a physical affair; he feels unfulfilled by his work writing for television but refuses to let anyone see his passion project, a semiautobiographical book about his family. His family functions as a consistent source of emasculation. Julia—a minor character who serves more as a repository for her husband's and sons' frustrations than anything else—is less hurt by Jacob's texts than she is angry at his affair's seeming confirmation that Jacob "[is] the only person [she knows], or could even imagine, who would be capable or writing such bold sentences while living so meekly."[25] Jacob's three sons, more aware of his crumbling relationship with Julia than he realizes, wonder whether "Dad [is] bad at life."[26] Jacob's father, Irv, a fervent supporter of Israel who clashes with Jacob's political apathy, decries Jacob's lack of strength as he tells his son that "a Jewish fist can do more than masturbate and hold a pen."[27] Jacob himself buys into the idea of a distinctly weak Jewish American masculinity: "Nobody wants to be a caricature. Nobody wants to be a diminished version of [himself]. Nobody wants to be a Jewish man, or a dying man."[28]

25 Jonathan Safran Foer, *Here I Am* (New York: Farrar, Straus and Giroux, 2016), 117.
26 Ibid., 17.
27 Ibid., 205.
28 Ibid., 195.

Foer employs Tamir as a microcosm for Israeli masculinity, and Jacob both idolizes and resents the version of manhood that his Israeli cousin represents: "Tamir tried not to get killed, while Jacob tried not to die of boredom."[29] In a sense, Foer's characterization of Jacob, as well as the differences Jacob sees between himself and Tamir, hearkens back to Roth's characterization of Henry Zuckerman before his transformation into "Hanoch"; the Israeli cousins, Tamir and his son, Barak, render Jacob and his sons "small, weak, ungendered."[30] However, unlike Roth, whose undermining of Henry's newfound Zionism occurs concurrently with a romanticization of Nathan Zuckerman's Jewish American masculine ethos, Foer does not valorize Jacob's masculinity, but instead draws parallels between Jacob and Tamir that ultimately suggest that Israeli masculinity is neither as stalwart nor as one-dimensional as Jacob believes.

While Tamir does evoke many Israeli masculine archetypes—confidence, physicality, tactlessness, patriotism—Foer reveals Tamir as a more sensitive and thoughtful man than Jacob is willing to recognize. He challenges Jacob's blind envy of Tamir's proximity to war and death as a symbol that "the stakes of [Tamir's] life reflect the size of life," compared to Jacob's "so small, so domestic" life.[31] Jacob dismisses Tamir's humanity, instead seeing his cousin as a mirror that reflects his inadequacies back at him; the novel, however, goes deeper than Jacob's myopic view, emphasizing Tamir's devotion to his family, including his son, Noam, a member of the Israeli Defense Forces who is critically injured in the war, and Tamir's distrust of Jacob's glorification of violence as "meaningful," even as he works to find a way to return to Israel so he can defend his homeland. Jacob may be more interested in whether Tamir drives the tank in his unit than in the emotional baggage that comes with serving in a war alongside his own son, but the novel gives Tamir space to express himself: "Today I fired a gun, and my son fired a gun. I never doubted the rightness of my firing a weapon to defend my home, or of Noam doing so. But the fact of us both doing it on the same day cannot be right."[32] In the narrative dismantling of Jacob's interpretation of Tamir, *Here I Am* simultaneously humanizes the one-dimensional "new Jew" stereotype and narrows the gap between diasporic and Israeli modes of masculine identity-building. While Jacob and Tamir come from different (and, in many ways, opposing) cultural contexts, they represent two sides of the same Jewish masculine coin—both men, insecure, imperfect, but well-meaning, want to ensure their family's safety, security, and happiness.

29 Ibid., 223–224.
30 Ibid., 230.
31 Ibid., 392.
32 Ibid., 543.

Here I Am, then, ties Jewish masculinity directly to familial relationships and the development of a healthy Jewish identity passed on from generation to generation (and, specifically, from father to son). The novel's title, of course, recalls the story of the *Akedah*, during which Abraham demonstrates his willingness to sacrifice his son, Isaac, out of devotion to God; Abraham answers God's call by saying "Here I am," a phrase interpreted by Sam Bloch (whose bar mitzvah Torah portion appropriately features the binding of Isaac) as a symbol of "who we are wholly there for, and how that, more than anything else, defines our identity."[33] This idea of being "wholly present" permeates the novel, and Jacob's struggle to define what he wants to be wholly present for—his family, his marriage, his writing, his Israeli cousins, or Israel itself—requires a latent coming-of-age in which Jacob comes to terms with his Jewish American identity and, by extension, his Jewish American masculinity. When war breaks out in Israel and the Prime Minister summons Jewish men from around the diaspora to fight for their homeland, Jacob's initial instinct is to go, both out of a sense of Jewish continuity and kinship with Israel and out of a desire to counteract Tamir's claims that Jacob "won't die for *anything* ... you don't believe in anything."[34]

Jacob's decision to stay in the United States rather than answer the Israeli call for American Jews to "come home" and defend the Jewish homeland is less a reflection of weakness, emasculation, or complacency and more a sign that Jacob has begun to establish the priorities that lay at the heart of his identity:

> What was Israel to him? What were Israelis? They were his more aggressive, more obnoxious, more crazed, more hairy, more muscular brothers ... *over there* ... They were more brave, more beautiful, more piggish and delusional, less self-conscious, more reckless, more themselves. *Over there*. ... After the near-destruction, they were still *over there*, but they were no longer *his*.[35]

The larger political question of the strength of the relationship between American Jews and Israel echoes Jacob's personal journey. Foer uses the fictional destruction and eventual rehabilitation of Israel as a lens through which to consider the growing divide between American and Israeli Jews. The novel subsequently eschews the concept of Jewish American meaninglessness by privileging Jacob's personal drama as equally important to Israel's political

33 Ibid., 103.
34 Ibid., 397.
35 Ibid., 541.

struggles. At the same time, *Here I Am* endorses the idea of multiple Jewish homelands. In other words, Israel—and Jewishness itself—can still survive even if American Jews cannot answer "Here I am" when it calls:

> It's not as if American Jews stopped caring. They continued to vacation and bar mitzvah and *find themselves* in Israel. They winced as their small cuts were first touched by Dead Sea water, winced as their hearts were first touched by "Hatikvah," crammed folded wishes between the rubble of the Wailing Wall, recounted back-alley hummus spots, recounted the thrill of distant rocket strikes, winced as their eyes were first touched by the sun at Masada, recounted the perpetual thrill of seeing Jewish garbagemen, and Jewish firefighters, and Jewish homeless. But the feeling of having arrived, of finally finding a place of comfort, of being *home*, was disappearing.[36]

Moreover, Jacob's name, and the biblical imagery it invokes, further legitimizes the Bloch family's claims to Jewishness and, more importantly, Jacob's claims to Jewish maleness. Just as with Genesis's depiction of the biblical Jacob—mild, intelligent, physically unimpressive (with his "smooth-skinned" arms and face, perhaps bordering on the effeminate) but contemplative—and his double, Esau—an outdoorsman, hunter, physically powerful but impetuous—*Here I Am* provides a set of Jewish male mirror images in Jacob and Tamir.[37] Jacob is weaker and younger, and yet, as in Genesis when Isaac bestows Jacob with the blessing meant for the firstborn son, Esau, *Here I Am* ultimately blesses Jacob's approach to Jewish masculine identity-building and sends the hypermasculine Tamir back to Israel where he belongs. If *Here I Am* is, as critic A. O. Scott suggests, a book that "locates within the American Jewish experience a plausible counter-Zionism, a mode of Jewish identity that Foer refuses to regard as less authentic or heroic than the Israel version," Jacob's name is doubly relevant.[38] After all, later in Genesis, it is Jacob, not Esau, who wrestles with an unnamed angel and is subsequently renamed "Israel" by God, who then tells Jacob/Israel that "a nation, yea an assembly of nations shall descend from you," a story recounted in detail in *Here I Am* in the bar mitzvah speech of Max, Jacob's second son: "[Jacob] wrestled because he recognized that blessings

36 Ibid., 538–539.
37 See Genesis 25:19–27:45 (*Etz Hayim*, 146–159).
38 A. O. Scott, "Invented Disaster and the American Jewish Experience," *The Atlantic*, September 2016, https://www.theatlantic.com/magazine/archive/2016/09/broken-homes/492728/.

were worth the struggle ... *Israel*, the historical Jewish homeland, literally means 'wrestles God.' Not 'praises God,' or 'reveres God,' or 'loves God,' not even 'obeys God.' In fact, it is the *opposite* of 'obeys God.' Wrestling is not only our condition, it is our identity, our name."[39] If "Israel" is understood as the symbolic ancestral homeland of the Jews—the site of Jewish authenticity—and if the biblical Jacob literally becomes "Israel" after wrestling—a manifestation of physical strength but also a synonym for grappling, for contemplating, for reflecting—then Jacob Bloch and his cerebral, insecure, indecisive, and imperfect but ultimately deeply felt Jewishness is just as authentic, if not more so, than that of Tamir. "Israel," in this sense, is less a physical place and more a state of being; Foer thus upholds the United States as an "Israel" in his emphasis on its suitability as a site of Jewish identity-building, and he characterizes Jacob Bloch, his "Israel," as an emblem of Jewish male authenticity.

3 Conclusion: All Men Are Jews, but Are All Jews Men?

As Daniel Boyarin suggests, Ashkenazi Jewish men at the turn of the twentieth century constituted a subculture whose models of masculinity, the religious *yeshiva-bokhur* and the secularized *mensch*, resisted prevailing images of aggressive and active "manliness" in their embrace of *edelkayt*, or "gentleness and delicacy."[40] In many ways, the archetype of the *mensch* lies at the heart of Jewish American conceptions of masculinity that emphasize Jewish male neuroticism and sexual frustration in addition to the "gentleness" that Boyarin discusses. Images of Jewish American masculinity in literature thus perpetuate a stereotypical binary between feminized Jewish men and their hypermasculine "goy" counterparts. The figure of the Israeli man further complicates this binary: rather than solving the gender trouble at the heart of diasporic Jewish masculinity, the paradigm of Israeli hypermasculinity introduces an alternative masculine "other" to which diasporic Jewish men can compare themselves unfavorably.

As such, literary ruminations on Jewish identity and the relationship between American Jews and Israel—especially post-1967—are almost exclusively ruminations on masculinity, gender performance, and Jewish male authenticity. Yet, despite the clear discomfort about the fortitude of Jewish American men compared to their Israeli counterparts found in works like

39 See Genesis 35:9–10 (*Etz Hayim*, 213); Foer, *Here I Am*, 511.
40 Daniel Boyarin, "Unheroic Conduct: The Rise of Heterosexuality and Jewish Masculinity," in *Men and Masculinities in Christianity and Judaism: A Critical Reader*, ed. Björn Krondorfer (London: SCM Press, 2009), 82–95, here 91.

Philip Roth's *The Counterlife* and *Operation Shylock* or Jonathan Safran Foer's *Here I Am*, Jewish American literature most often invokes Israel as a narrative device by which to explore this gendered ambivalence and ultimately to make the case that Jewish American masculinity—and thus Jewish American identity as a whole—embodies a distinctly Jewish ethos that undermines the idea of the American diaspora as *galut*. For Roth, Israel serves both as a site of Jewish American emasculation and, more importantly, as a confirmation of Jewish American moral superiority. For Foer, similarly to Saul Bellow's juxtaposition of Sammler and Eisen in *Mr. Sammler's Planet*, the comparison between Jacob and Tamir demonstrates the novel's employment of the Israeli Sabra as a source of simultaneous attraction and repulsion for diasporic Jewish men. In its upholding of diasporic masculinity and the "woundedness" of the American Jewish diaspora as an ideal, Jewish American literature carves space for the idea of the United States as its own Jewish homeland that is connected to Israel but comprised of its own version of Jewish identity, its own claims to authentic Jewish maleness, and its own distinct and equally significant heritage.

Bibliography

Bellow, Saul. *Mr. Sammler's Planet*. 1970. Reprint. New York: Penguin Books, 1995.

Boyarin, Daniel. "Unheroic Conduct: The Rise of Heterosexuality and Jewish Masculinity." In *Men and Masculinities in Christianity and Judaism: A Critical Reader*. Edited by Björn Krondorfer, 82–95. London: SCM Press, 2009.

Foer, Jonathan Safran. *Here I Am*. New York: Farrar, Straus and Giroux, 2016.

Grumberg, Karen. "Necessary Wounds and the Humiliation of *Galut* in Roth's *The Counterlife* and *Operation Shylock*." *Philip Roth Studies* 5, no. 1 (2009): 35–59.

Hyman, Paula E. *Gender and Assimilation in Modern Jewish History: The Roles and Representation of Women*. Seattle: University of Washington Press, 1995.

Kranson, Rachel. *Ambivalent Embrace: Jewish Upward Mobility in Postwar America*. Chapel Hill: University of North Carolina Press, 2017.

Roth, Philip. *Operation Shylock: A Confession*. New York: Vintage International, 1993.

Roth, Philip. *The Counterlife*. New York: Vintage International, 1986.

Scott, A. O. "Invented Disaster and the American Jewish Experience." *The Atlantic*, September 2016. https://www.theatlantic.com/magazine/archive/2016/09/broken-homes/492728/.

Shostak, Debra. "The Diaspora Jew and the 'Instinct for Impersonation': Philip Roth's 'Operation Shylock.'" *Contemporary Literature* 38, no. 4 (1997): 726–754.

Zerubavel, Yael. "The 'Mythological Sabra' and Jewish Past: Trauma, Memory, and Contested Identities." *Israel Studies* 7, no. 2 (2002): 115–144.

CHAPTER 6

Messianic Affinities: Tali Keren's *The Great Seal* and *Un-Charting*

Chelsea Haines

On July 4, 1776, the edict for the design of the great seal of the United States came on the heels of signing the Declaration of Independence. The founding fathers were well-aware such accoutrements—flags, uniforms, emblems, and the like—would ultimately speak to the sovereignty of their nascent nation-state just as much as the words next to which they just signed their names. The United States needed to *look* the part before being taken seriously by friends or foes. The responsibility for creating the great seal was delegated to Benjamin Franklin, Thomas Jefferson, and John Adams, who collectively struggled to forge the symbolism for the state, vacillating between references to the past and an entirely new aesthetic language. Despite their well-known propensity toward secularism, the first pass of the seal overseen by Jefferson and Franklin was inspired by the Bible. Under specifications from the two founding fathers, the Swiss American artist Pierre Eugene du Simitiere composed a vibrant, if confusing, scene: Moses in the background parting the Red Sea as an Egyptian chariot and its riders are submerged in fast-rising water in the foreground. In the direct center of the seal, a flame surrounded by a ring of smoke forms an angry eye of God, enacting vengeance on the Israelites' enemy.[1] Through this scene, Jefferson and Franklin sought to establish a strong metaphorical connection between the biblical past and their present: the Israelites seeking a homeland as they broke away from their tyrannical overlords. Jefferson himself would describe the first generation of Americans as "the children of Israel in the wilderness ... led by a pillar of fire by night."[2] Surrounding the seal were the words *tyrannis seditio, obsequium deo*: "rebellion against tyrants, obedience to God."[3]

1 Ellen Fernandez-Sacco, "Framing 'The Indian': The Visual Culture of Conquest in the Museums of Pierre Eugene Du Simitiere and Charles Willson Peale, 1779–96," *Social Identities* 8, no. 4 (2002): 571–618, here 583.
2 Thomas Jefferson, "First Inaugural Address (1801)," in *God's New Israel: Religious Interpretations of American Destiny*, ed. Conrad Cherry (Chapel Hill: University of North Carolina Press, 1998), 61–67, here 65.
3 Daniel L. Dreisbach, *Reading the Bible with the Founding Fathers* (Oxford: Oxford University Press, 2017), 105–108.

This first prototype is the starting point for Tali Keren's *The Great Seal* (2016–2018), a multimedia installation and participatory experience. Keren, who was born and raised in Jerusalem and now lives in the United States, mines the complex relationship between the two nation-states in her art, exploring their shared ideologies and tracing how each has understood itself through the lens of the other. *The Great Seal* begins with a somewhat obscure historical moment, relegated to a footnote of official histories of the American Revolution. Of course, Jefferson and Franklin's early design bears no resemblance to the official seal adopted in 1782, a far less laden image of a bald eagle clutching an olive branch in one claw and a bundle of 13 arrows in the other, surrounded by the words *e pluribus unum* ("out of many, one"), visible on the back of every US dollar bill. Despite this rejected design's place on the margins of history, *The Great Seal* implicates its importance in the present by pairing it with a contemporary artifact. In Keren's work, visitors stand on a carpet bearing Jefferson and Franklin's original seal while they read a teleprompter of a speech made at CUFI (Christians United for Israel), an annual Evangelical summit held in Washington, DC. As participants read aloud the speech written by CUFI founder and Texas-based televangelist John Hagee, they make statements that emphatically obliterate the division between religion and state established in the founding documents of both Israel and the United States (Fig. 6.1). "Israel has the right to the borders established by God. Because Messiah is coming. He is coming to Jerusalem, the City of God," participants exclaim, as they hear raucous applause through their headphones.

This chapter analyzes how Keren's *The Great Seal* and *Un-Charting* (2021) reveal what I call "messianic affinities," the complex and contradictory web of projections and transferences crisscrossing the Atlantic that make up the ideological basis of the close Israeli-American relationship. Eschewing narrow definitions of messianism that denote the coming of the messiah, I define messianism more expansively in line with several American and Israeli commentators who use the term to describe how political ideologies have been shaped by notions of national destiny that adopt a decidedly religious slant even when secular in intent.[4] Rather than focusing on kinship relations between Israel and the Jewish diaspora in the United States, Keren's work examines how contemporary connections between these two nation-states have been driven by a growing Christian Evangelical bloc in the United States that is insistent that support for the State of Israel will hasten the Second

4 See, for example, Assaf Harel, "Messianism Is Israel's Most Powerful Force, Embraced by Atheists Too," *Haaretz*, September 5, 2021. https://www.haaretz.com/opinion/.premium.HIGH LIGHT-messianism-is-israel-s-most-powerful-force-embraced-by-atheists-too-1.10175325.

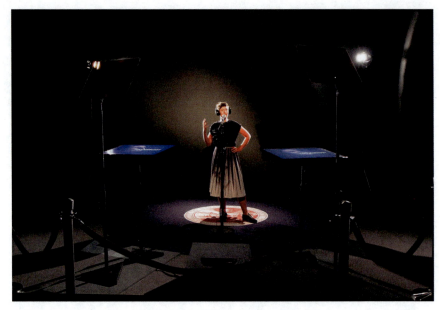

FIGURE 6.1 *The Great Seal*, Interactive installation/performance. Teleprompters, microphone, touch screen, speakers, 12 × 12 feet custom printed rug, HD video, HD monitors
TALI KEREN, 2016–2018

Coming of Jesus Christ. The disjuncture between how these Americans, also known as Christian Zionists, perceive Israel and how Israelis perceive themselves is readily visible in Keren's work, as is the raw political power this rapidly growing group has in shaping US foreign policy in Israel/Palestine. Yet Keren does not leave her work on the level of a sometimes-shocking projection of Israel through the lens of the Christian right. Instead, she charts how current American-Israeli relations are also driven by a common language founded in a messianism tied less to a religious edict than to settlement and expansionism.

The main protagonists of *The Great Seal*—Jefferson and Franklin on the one hand, Hagee on the other—appear to sit on extreme ends of the American experiment. Jefferson, the principal author of the Declaration of Independence and one of the architects of the US Constitution, strongly promoted the separation of church and state and adhered to a decidedly vague deist belief system. An avid scholar of many subjects, including religion, in 1820 Jefferson published *The Life and Morals of Jesus of Nazareth*, more commonly known as the *Jefferson Bible*, an edited version of the New Testament focusing on Jesus's moral philosophy to the exclusion of stories of miracles or supernatural events. Jefferson was known to study the Quran, but he also spent time with Jewish

texts, including the Talmud and Kabbalistic writings, and his correspondence with John Adams demonstrates serious interest in understanding Jewish law and ethics.[5]

John Hagee is a different story; he founded CUFI in 2006 primarily as a lobbyist endeavor, attracting right-wing politicians to Israel's claim of Jerusalem as the capital of the Jewish state and to support the ongoing military occupation of the West Bank. In Hagee's view, the borders of the modern Israeli state must match the borders of the ancient kingdom of Israel as written in the Bible. His Christian belief system comports with the current Israeli government's land claims, a coincidence capitalized on by figures such as former Prime Minister Benjamin Netanyahu who allied with Hagee to muster American support of Likud policies.[6] Despite a shared goal with the State of Israel, Hagee's opinions also often veer toward blatant antisemitism and conspiracy theories. He was thrust onto the national stage in 2008 when then-Republican presidential candidate John McCain was forced to distance himself from Hagee's endorsement after the latter made controversial statements claiming Adolf Hitler was a "half-breed Jew" and stating that the Holocaust took place because Jews disobeyed God.[7]

Despite the enormous intellectual and political differences between the gentleman scholar and the crude televangelist, separated by two hundred years of history, Keren's work succeeds at pulling together a thread that ties Jefferson and Hagee together: a belief in the shared destiny of Israel and the United States. What that meant to each differed considerably, but both have shaped the collective American mindset toward Israel. In *Our American Israel: The Story of an Entangled Alliance*, scholar Amy Kaplan compellingly charts the history of American engagement with the idea of Israel, and how that idea of Israel has translated to material and political support. For Kaplan, Israel has come to operate almost as a surrogate of the United States in the eyes of many Americans, regardless of their religious affiliation. Kaplan argues that, unlike other nation-states, support for Israel is not limited to ethnic or religious identity; instead, with Israel "what might have been the foreign policy concerns of a particular ethnic group came to have long-term symbolic associations

5 Brian Ogren, *Kabbalah and the Founding of America: The Early Influence of Jewish Thought on the New World* (New York: New York University Press, 2021), 5–6.
6 Colum Lynch, "What's Next for Christian Zionists?" *Foreign Policy*, July 19, 2021, https://foreignpolicy.com/2021/07/19/christian-zionists-israel-trump-netanyahu-evangelicals/.
7 Neela Banerjee and Michael Luo, "McCain Cuts Ties to Pastors whose Talks Drew Fire," *New York Times*, May 23, 2008, https://www.nytimes.com/2008/05/23/us/politics/23hagee.html.

with American national mythology. Israel became as much a domestic as a foreign issue."[8]

As Keren's work implies, perhaps no other US alliance has incurred such a passionate response among Americans precisely because Israel has long appeared as a projection of the United States itself. While Kaplan's book focuses on US engagement since the founding of the State of Israel in 1948, Keren's project poetically traces America's imagined ties to Zion to the very day the United States was founded. This national imaginary kinship is literally woven onto the ground in *The Great Seal* where participants stand and read Hagee's speech aloud. As Jefferson and Franklin's design attests, Zion was an early metaphor for the United States. They saw in their breaking away from the purported British tyrant a parallel with the Israelites, who were led by Moses through the wilderness. The "promised land" was an immensely generative concept for American settlers, who named their towns Zion and New Zion as the United States expanded its territory across the North American continent.[9] Some of these settlements were explicitly religious in nature. For example, in the mid-nineteenth century Mormons named the enormous canyon nestled in Utah's southwest corner Zion Canyon, later to become part of Zion National Park. Others sought the name Zion to indicate the more ambiguous promise of manifest destiny, the American principle that the United States' colonization of North America was inevitable, even ordained, by God.

If the story of the Israelites in the wilderness bolstered a special form of American messianism known as manifest destiny in the nineteenth century, the United States later became a wellspring for the modern Zionist movement in the twentieth. Despite its status today as Israel's best and strongest ally, the United States government was not always a hearty supporter of Zionism. Prior to World War II, American interests in the region lay primarily with more oil-rich countries, and specialists from the Central Intelligence Agency were aware that popular American support for a Jewish state in the Middle East would destabilize the government's strategic allies in the region. In the 1940s, the United States' attitude toward Zionism shifted dramatically in relation to two phenomena: the Holocaust and its horrors, which pressed the American public firmly toward the idea of a Jewish state, and the death of President Franklin

8 Amy Kaplan, *Our American Israel: The Story of an Entangled Alliance* (Cambridge, MA: Harvard University Press, 2018), 9.
9 John William Reps, "Cities of Zion: The Planning of Utopian and Religious Communities," in *The Making of Urban America: A History of City Planning in the United States* (Princeton, NJ: Princeton University Press, 1965), 439–474.

Delano Roosevelt.[10] The latter event led to the appointment of Harry Truman to the presidency. In 1948, Truman became the first head of state to recognize Israel, a mere 11 minutes after the state was declared. A devout Christian, Truman couched the United States' support for Israel in quasi-religious terms, employing the newly coined term "Judeo-Christian" to highlight what he saw as the civilizational ties between the two countries.[11] During the Cold War, the concept of Judeo-Christian civilization was used by Americans to distinguish themselves from communist regimes, asserting the United States as the world's moral authority. Despite Israel's then-socialist leanings and relatively non-aligned relationship to the United States and the Soviet Union (the term the Israeli government preferred was "non-identification"), Israel was firmly seen on the side of the Americans, at least by the Americans themselves.[12] Such affinities strengthened, somewhat paradoxically, with the fall of the Soviet Union and the simultaneous rise of politically savvy and well-organized religious blocs in both the United States and Israel, which have supported right-wing governments in both countries.[13] Such alignments appeared to have reached their apotheosis with the Trump presidential administration. In a speech for CUFI in 2019, former Vice-President Mike Pence marked the move of the United States Embassy to Jerusalem by exclaiming "in the words of the prophet Isaiah, for the sake of Zion I will not be silent."[14] This promise had been fulfilled in 2018, to the delight of the Likud government and to many Christians in the United States, who saw the Trump administration as fulfilling the wishes of God.[15]

10 Hugh Wilford, *America's Great Game: The CIA's Secret Arabists and the Shaping of the Modern Middle East* (New York: Basic Books, 2017).
11 K. Healan Gaston, *Imagining Judeo-Christian America: Religion, Secularism, and the Redefinition of Democracy* (Chicago: University of Chicago Press, 2019).
12 "Non-identification" was the preferred term to describe Israeli—Soviet and Israeli—American relations by Moshe Sharett, Israel's Minister of Foreign Affairs (1948–1956) who also served as Prime Minister from 1954 to 1955. The Soviet Union was an early supporter of Israel both diplomatically and militarily. In 1947, during the Anglo-American embargo, the Soviets sold rifles, fighter planes, and bombs to the Haganah through an intermediary in Prague. See Peter Brod, "Soviet-Israeli Relations 1948–56: From Courtship to Crisis," in *The Left Against Zion: Communism, Israel, and the Middle East*, ed. Robert S. Wistrich (London: Vallentine, Mitchell and Co., 1979), 50–70, here 57.
13 Glenn H. Utter, *The Religious Right and American Politics* (New York: Grey House Publishing, 2019), 12–15.
14 "Vice President Pence Remarks to Christians United for Israel Conference," *C-Span*, July 8, 2019, https://www.c-span.org/video/?462373-1/vice-president-pence-addresses-christians-united-israel-conference.
15 David D. Kirkpatrick, Elizabeth Dias, and David M. Halbfinger, "Israel and Evangelicals: New U.S. Embassy Signals a Growing Alliance," *New York Times*, May 19, 2018, https://www

Like *The Great Seal*, Keren's more recent work, *Un-Charting*, from 2021, recovers a footnote of history in order to mine its implications in the present. *Un-Charting* is an immersive animated video installation. Sixteen minutes in length, it absorbs the viewer in a fantastic vision of Jerusalem produced in the mind's eye of Richard Brothers (1757–1824), a British naval officer based in what was then the British colony of Canada at the turn of the nineteenth century. The video starts with a voiceover of a text Brothers wrote in 1798 declaring himself a "Prince of the Hebrews" and laying out his vision for the Holy Land, which he was convinced he would conquer and rebuild in the coming years. Like *The Great Seal*, *Un-Charting* provides a vision of Zion refracted through the lens of prophetic Christianity and North American settler colonialism. In the case of *The Great Seal*, the biblical story of Moses leading the slaves from Egypt sets up an analogy for the United States as a new Zion. In *Un-Charting*, Brothers's prophecy of a new Jerusalem is mapped out in painstaking detail as a harbinger of a new world order, a utopian vision with Brothers himself at the helm. Unlike that of Jefferson and Franklin, Brothers's project of conquest was, of course, never fulfilled. Yet despite his lack of any concrete political or social agenda, Brothers was charged with treason against the British crown. He was later moved from a prison to an asylum with the help of a well-connected follower, where he spent years developing and designing his master plan for Jerusalem.[16] If Keren's previous work reveals the messianic impulses of the American founders, *Un-Charting* lays out the striking spatial logic of Brothers's vision of Jerusalem. In both, Keren threads between political philosophy and religion, with messianism as their shared line.

Un-Charting begins with an opening shot of the sun rising against a seemingly endless sea with no land in sight. A fleet of ships comes into view, one with a crowned lion at the mast, evoking the ships of the Crusaders who sought to reclaim the Holy Land for Christendom. A voiceover narration begins—an androgynous voice reads Brothers's prophecy—and the scene quickly shifts to Keren's interpretation of Brothers's design: a perfectly gridded city. Brothers had developed this meticulous plan over several years, publishing it in 1801 as *A Description of Jerusalem: Its Houses and Streets, Squares, Markets, and Cathedrals, The Royal and Private Palaces, with the Garden of Eden in the Centre, as Laid down in the Last Chapters of Ezekiel*.[17] Brothers's vision as master

-nytimes-com.ezproxy1.lib.asu.edu/2018/05/19/world/middleeast/netanyahu-evangelicals-embassy.html.

16 Paul M. Zall, "Richard Brothers: The Law and the Prophet," *The Wordsworth Circle* 45, no. 3: 187–293, here 240.

17 Richard Brothers, *A Description of Jerusalem: Its Houses and Streets, Squares, Colleges, Markets, and Cathedrals, The Royal and Private Palaces, with: The Garden of Eden in the

architect of a new Jerusalem bears no relation to the actual city, perched in the craggy plateaus of the Judean Mountains. Instead, he presents a pure orthogonal vision of Jerusalem divided into four squares, which are then divided into four squares and so on, creating a checkerboard pattern; at the city's heart lies the Garden of Eden. While he claimed inspiration from the Book of Ezekiel, Brothers also believed in individual divination, and that angels communicated directly with him to shape events that would lead to a new world order that would culminate in the construction of this city.[18]

Brothers's esoteric interpretation of biblical texts appears chimeric but largely innocuous upon first glance. However, its eccentricity belies the origins of a damaging racial pseudo-philosophy. *A Description of Jerusalem* marked the culmination of Brothers's work as a leader and proponent of British Israelism (also known as Anglo-Israelism), a movement defined by the belief that men and women of Anglo-Saxon origin are the hidden descendants of the ten tribes of Israel.[19] While Brothers acquired a devoted but limited following during his lifetime, after his death his ideas were rationalized and expanded upon by figures such as John Wilson and Edward Hine, who sought to tie their beliefs to new archeological and linguistic discoveries in the Levant. Despite a lack of any grounding in fact, their writings emphasizing British racial superiority through a direct genetic lineage from King David helped to justify colonial expansionism around the world—if the British are the chosen people according to this theory, the logic followed that they were ordained by God to conquer the world. While British Israelism had been largely abandoned in mainstream political discourse by the twentieth century, its pseudoscientific and quasi-religious concepts of race migrated across the Atlantic, where it became a wellspring for some of the most vicious White supremacist groups in the United States, including the Ku Klux Klan and the neo-Nazi terrorist organization the Aryan Nations.[20] Brothers's theories navigate a thorny terrain of ethno-religious logic. If on the one hand he appears to align himself

Centre, as Laid down in the Last Chapters of Ezekiel. Also the First Chapter of Genesis Verified, as Strictly Divine and True: And the Solar System, with All Its Plurality of Inhabited Worlds, and Millions of Suns, as Positively Proved to Be Delusive and False: by Mr. Brothers [With Plates] (Printed for George Riebau, 1801), Nineteenth Century Collections Online (accessed February 11, 2022).

18 Eitan Bar-Yosef, *The Holy Land in English Culture, 1799–1917: Palestine and the Question of Orientalism* (Oxford: Clarendon Press), 2005.

19 Melton J. Gordon, "British Israelism," in *Encyclopedia of World Religions: Encyclopedia of Protestantism.* 2nd ed. (Boston: Facts on File, 2016).

20 Stephen E. Atkins, "Aryan Nations," in *Race and Racism in the United States: An Encyclopedia of the American Mosaic*, ed. Charles A. Gallagher and Cameron D. Lippard, Vol. 1. (Santa Barbara, CA: Greenwood, 2014): 77–79, *Gale eBooks*, accessed February 11, 2022.

with the Jewish people—describing himself as a "Prince of the Hebrews" and a descendant of King David—on the other, it promotes latent antisemitic ideas of bloodlines and genetic determinism made manifest by his followers. Armed with the knowledge of Brothers's destructive legacy, the gridded city of Brothers's imagination becomes as disturbing as it is immersive.

Brothers's plan is, appropriately enough, designed with a top-down approach—looking at the city from above before carving out details on the ground; the view of the city from above had a long history of religious connotations, with "orthogonal projections commonly thought to resemble God's view from on top of the world."[21] This divine geometry of Brothers's rigid orthogonal plan, so antithetical to the physical city of Jerusalem, is the focus of the first few minutes of *Un-Charting*. The animation zooms back and forth from this God's eye view along the perfectly gridded city of Brothers's imagination. Highlighted in an electric yellow, the lines appear to form the grid of an immersive video game or a postmodern city plan à la Rem Koolhaas's *Delirious New York*. But the gridded city would have been familiar during Brothers's day as well. In colonial North America, where Brothers lived before institutionalization, the grid would become an essential component of what architectural historian Dell Upton has called the republican spatial imagination of the United States. As Upton states, "the grid's seductive power was grounded in widespread beliefs in essentially spatial qualities of social, political, and economic order that might be labeled as the spatial imagination."[22] The grid aided surveyors as they sought to demarcate and conquer land, plot by plot, to eventually sell to farmers and landowners. The interest in gridded planning was not limited to rural areas; cities like Philadelphia—where Jefferson and Franklin were on July 4, 1776, when they were tasked with coming up with the great seal of the United States—were laid out along perfectly orthogonal lines. The grid imposed a sense of order and stability on a foreign and untamed land and allowed the law of individual property to take effect by literally parceling out plots for private development. In other words, in North America the grid became a language of spatial control and domestication with implications well beyond its use as a mode of surveying and planning. Within the grid, all things are ordered, logical, and, most importantly, transparent. Everything is exposed to the divine eye of God.

21 Peter Otto, "Negotiating the 'Holy Land': Cross-Cultural Encounters from Bonaparte to Blake," *Postcolonial Studies* 23, no. 3 (2020): 404–429, here 414.
22 Dell Upton, *Another City: Urban Life and Urban Spaces in the New American Republic* (New Haven, CT: Yale University Press, 2008), 122.

If the "new world" of North America that Brothers inhabited relied on an imposed geometry of control, Jerusalem itself was in the process of undergoing other rapid transformations, both physically and discursively. In 1798, the same year Brothers published some of his first texts declaring himself "Prince of the Hebrews," Napoleon invaded Egypt and Syria, including what is today Israel. While France's victory was short-lived, it opened the door to far more extensive European intervention in the region. Napoleon brought scholars, artists, and translators with him to study and depict the people and places he conquered. These scholars remained well after the French military had left, and together with their British counterparts formed the scholarly discipline known as Orientalism, which was focused on accumulating encyclopedic knowledge of the region.[23] As Edward Said described at length, Orientalists inflected their research with their own biases and political priorities, perhaps nowhere more than in Ottoman Palestine, the site of Christianity's Holy Land.

The Holy Land had always held a special place in the Christian imagination as the birthplace of the religion, with Jerusalem as its jewel. Over the centuries, Christians had projected upon the city all manner of characteristics and qualities, some much more fanciful and imaginative than others. Soon after Christianity was legalized in the Roman Empire, Helena, mother of Emperor Constantine, traveled to Jerusalem, where she established the Church of the Holy Sepulchre on the site where she believed Jesus was crucified, buried, and resurrected.[24] Later, the Crusaders saw Jerusalem as the heart of their civilizational heritage, and early European maps frequently placed the city at the center of the world.[25] It was in the late eighteenth and early nineteenth centuries, however, that the Christian concept of the Holy Land intersected with the beginnings of the modern Zionist movement. Following the emancipation of the Jews during the French Revolution, Napoleon had invited *israélites*, French Jews, to establish Jerusalem as the capital of a new Jewish state, to essentially operate as a French colony in the Middle East.[26] While Napoleon's vision was not realized, the social fabric of Ottoman-controlled Palestine was transformed rapidly in the nineteenth century both by the increased interest in the Holy Land by Christian European and American pilgrims and tourists and by the surge of Jewish immigrants from the 1880s onward who made up the first waves of the *aliyot*.

23 Edward Said, *Orientalism* (New York: Pantheon Books, 1978).
24 Charles Odahl, "The Dynastic Tragedy and Helena's Pilgrimage," in *Constantine and the Christian Empire* (London: Routledge, 2010), 202–221.
25 See, for example, the Bünting Clover Leaf Map, published in 1581.
26 Otto, "Negotiating the 'Holy Land,'" 405.

Rather than understand these as two different historical phenomena—Zionism and Christian visions of the Holy Land—Keren's work underscores how their intersections produce present-day political realities. In *Un-Charting*, Brothers's narration of the new Jerusalem abruptly disappears, and we are presented with another voice, this one much closer to our current time and place (Figs. 6.2 and 6.3). We hear a woman with a Midwestern American accent introduce herself as Cheryl Morrison, Director of Israel Outreach of the Faith Bible Chapel in Denver, Colorado. Morrison explains her work in a tone of almost overwhelmed emotion and appreciation, asserting emphatically that the State of Israel is proof of the existence of God and the truth of the Bible. She works to further relations between the United States and Israel, which she does through trips to Israel and collaborations with Israeli organizations. One such collaboration is with the Gvanim Dance Company, which works with the Faith Bible Chapel to bring American dancers to Israel to perform for the Israel Defense Forces (IDF). Led by Gvanim choreographer Ilana Segev, the American dancers perform and sing popular and folk songs, sometimes in Hebrew without knowing the words. Morrison praises this exchange program, which has taken place every year since 1977, in the highest terms, relating it as being akin to a religious experience. She explains:

> God has given us this amazing gift of the great privilege of being able to go to IDF bases ... It's just, we say every year, "who are we that God lets us do this?" And I've said this to the group many times "You get to perform for the Mighty men of David." ... If the Bible was being written today these soldiers would be who the Bible would be written about. Their names would be here just like David.

The voiceover then shifts to Segev, who is decidedly less passionate in her tone. She describes the seemingly religious experience the Faith Bible Chapel dancers have in Israel with a detached sense of wonderment, commenting that "for them, it's the holy of holies."

Through the voices of Morrison and Segev, the viewer comes to understand that these two figures have very different ideas of Israel. Morrison appears to see Israel as an exotic and ancient land; there is a Christian-inflected Orientalism in her words as she relates IDF soldiers to the ancient warriors of the time of King David. It wouldn't be preposterous to conclude at first glance that the Israeli side of this collaboration may be a result of cynical opportunism, as we might claim for the Israeli governmental institutions and politicians who have welcomed the support of CUFI and figures like John Hagee—not because they believe in their messianic vision of Israel or their claims bordering on

antisemitism, of course, but because they can influence Americans to support Israeli policies at all costs. Segev, however, demurs from such derisive readings. She has a much more measured and nuanced take, at times seeking to rhetorically remove herself from the messianic tone of the Faith Bible Chapel while at the same time asserting the value of the collaboration. Segev knows the present-day political implications of symbolically tying the Evangelical Church in the United States to Israel, and specifically the IDF, but she appears to downplay these effects. In Segev's words, "it's as if I moved the screen of politics aside."

The "screen of politics" implies that this Israeli-American collaboration can effectively move beyond the thorny world of international relations and ongoing conflict in Israel/Palestine and move to a place of affinity and belonging within the shared values of Judeo-Christianity. Yet Keren's work does not allow this comment to stand unchecked. As Morrison recalls the magic of being in the Holy Land, Keren's animation transforms from Brothers's mathematical grid into a stretch of dry, barren land with nondescript warehouses enclosed in a fence of barbed wire. A tumbleweed rolls past the screen as Morrison waxes about the Holy Land and the great privilege of performing for the IDF.

The desolate landscape featured here is modeled on the Tze'elim military base in southern Israel near the border with Gaza. Established in 2005 as a 7.4 square mile city designed for simulated mission training, Tze'elim has acted as a large-scale testing ground for various IDF incursions into Gaza, the West Bank, Lebanon, and Syria.[27] Designed to aid Israeli troops in urban warfare tactics following the Second Intifada, this simulacrum of a city includes a mosque, shopping district, housing complexes, and even a cemetery. Also known as Baladia City (*balad* translates to "village" in Arabic), Tze'elim was built by the United States Army Corps of Engineers and was primarily funded through the United States government.

As the camera pans across this simulated desertscape, the voiceover shifts again to Segev, who recalls a conversation with Morrison about the Israel-Palestine conflict and the occupation of the West Bank. According to Segev, Morrison chided Israel for being too accommodating to Palestinians and for not being thorough enough in their expulsion from the newly created State of Israel in 1948. Segev, quoting Morrison, recounts the latter's comments:

27 "Urban Warfare Training Center—Simulating the Modern Battlefield," *Israeli Defense Forces*, October 26, 2011, https://www.idf.il/en/minisites/training-and-preparation/urban-warfare-training-center-simulating-the-modern-battle-field/. See also "War Games: Israeli Urban Warfare," *VICE News*, July 9, 2014, https://www.vice.com/en/article/zm7dbe/war-games-israeli-urban-warfare.

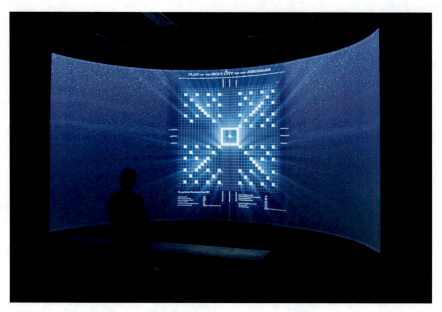

FIGURE 6.2 *Un-Charting*, 180-degree curved screen with 3D animation. Installation view
TALI KEREN, 2021

FIGURE 6.3 *Un-Charting*, 180-degree curved screen with 3D animation. Video still
TALI KEREN, 2021

> You Israelis, you Jews, made a historical mistake for which the world would never forgive you. ... That you didn't act like the Americans who took all the Indians, put them all in one place instead of leaving them all in the middle of the country. Why did you leave all the Arab residents in the middle of the country?

Segev then offers her own opinion, agreeing with Morrison that "she is right. I try to think from the head, but I often think from the heart." Segev's revelation that she would prefer the removal of Palestinians from their homes comes on the heels of Morrison arguing that the Israelis had made a "mistake," and that they hadn't done things the American way. For Morrison, American violence and terror against Native Americans had been necessary for the United States to thrive. These sentiments casually advocating ethnic cleansing through forced population transfer are horrifying. They are also not historically accurate. Characterization of Native Americans as the "vanishing race" has been a potent aspect and even justification for American manifest destiny despite the fact over nine million Native Americans live in the United States today.[28] Similarly, the idea that Israelis could (not to mention should) have easily disposed of all Palestinians living within the declared borders of the State of Israel belies the historical realities of the 1948 War.[29] But material reality seems to be beyond the point here—it is the shared sentiment that matters. As the viewer hears this euphemistic talk of potential crimes against humanity, Keren's animated barren landscape is eclipsed in a massive dust storm. As the dust settles, the ships of Brothers's prophecy reappear, this time destroyed in a massive shipwreck.

In *Un-Charting*, Keren touches again on a deeply dark side of messianic affinity between the United States and Israel. Keren's earlier project *Heat Signature* (2018) operates almost as a second act to *The Great Seal*, evoking how the ideological formations laid out in the earlier project manifests in the world through material violence. In a darkened room, a manipulated version of Jefferson and Franklin's great seal appears as a specter brought to visibility through an infrared camera and electric heaters. As the temperature fluctuates in the room, aspects of the image come into focus, drawing attention not only

28 "Census Shows Increase in Native Population," *National Indian Council on Aging, Inc.*, accessed November 24, 2021, https://www.nicoa.org/census-shows-increase-in-native-population/.

29 Benny Morris, *1948: A History of the First Arab-Israeli War* (New Haven, CT: Yale University Press, 2008).

to the visitor's physical relationship to the work of art but also to body temperature as a mode of surveillance and control. With *Heat Signature*, visitors are able to listen to interviews from a media scholar, lawyer, and drone sensor operator, each testimony providing insight into the blurring lines between the material body, heat, and light and shadow under the conditions of contemporary warfare.

More than a strategic alliance, beyond a metaphor of settling the wilderness, Keren's work reveals how the United States shares with Israel an ideology that perceives its conquest of the land as preordained destiny. It is this concept of settler colonialism as a moral right to the land that Keren hints continues to bind the special relationship between these two nation-states. This powerfully imagined relation to the land evokes Thomas More's *Utopia*, which the author located in the Americas. A Greek-derived term referring to both the "good place" (*eu-topos*) and the "no place" (*u-topos*), a utopia is a landscape that always remains imaginary, occluding the material realities of the place and people it is projected on.[30] These projections necessarily mask the exclusionary violence integral to the creation of both nation-states, an opaque violence that also materializes today through advanced military warfare. In *Heat Signature*, the drone sensor operator remarks that "it would be like playing shadow puppets on the wall ... I watched the man turn into the exact same color as the rubble he was on, where he was indistinguishable." The drone operators never come face to face with the individuals they kill. In *Un-Charting*, Brothers's imaginary Jerusalem bears no resemblance to the physical city; Israeli soldiers simulate warfare scenarios on specially constructed military bases; American folk dancers dress as Israeli soldiers. In both projects, the violent encounter remains just outside the limits of direct, visible experience. Yet the material reality of this violence lingers almost unutterably.

Keren's work doesn't just reveal these complex, contradictory, and unsettling connections between the United States and Israel, she also points to the role that we as witnesses play in constructing, perpetuating, or dismantling them. Viewers become involuntary participants in *The Great Seal* as they literally take the voice of the Evangelical pastor to speak of Israel's right to the land as ordained by God. This controlled participation makes viewers aware of their own positions, both in the installation and in society, as they ponder whether or not they agree with the words they are speaking. In *Un-Charting*, the viewer does not become a participant but is absorbed in the immersive video-game-like environment. By establishing the scene as a virtual reality and

30 Thomas More, *Utopia* (1551), ed. George M. Logan and Robert M. Adams (Cambridge: Cambridge University Press, 2002).

by introducing figures as if players in a game, the installation insures that viewers are both absorbed in the ideological narrative constructed by the scene and distanced from it. Once engaged in the video, the viewer is only knocked out of the visual pleasure of Keren's work by Segev's suddenly shockingly serious talk of taking the Native Americans and Palestinians to "put them in one place." This statement is heightened by the most absorbing visual elements of *Un-Charting*. As the animated video flies and zooms through this imagined landscape, it recalls our era of the "video game war," in which conflicts are fought through drone technology and simultaneously broadcast to our televisions and homes.

In both *The Great Seal* and *Un-Charting*, the viewer is in a sense interpolated—that is, enmeshed within a social network with limited freedom to express their thoughts. *Un-Charting* concludes with a performance from the dancers of the Faith Bible Chapel within Brothers's design of a new Jerusalem. The dancers perform Israeli folk dances to a soundtrack inserted by Keren: Christian rock music replaces the Israeli folk songs. They wear garb of various units of the IDF, each uniform slightly different from the rest, while their individual faces are blurred out by a glowing light that emanates from their bodies. Their faces, their individual identities, are very much beside the point in this virtual environment; they are there to play their role. Like Brothers, whose vision of a new Jerusalem also included detailed descriptions of costumes and performances and rituals that individuals in the city would enact, the dancers in *Un-Charting* play their role as Israeli soldiers, but in their case they are Israeli soldiers for Jesus.[31] As they conclude their routine by dancing to Keren's intervening soundtrack, a song appropriately titled "Messiah," these dancers enact the close, contradictory, sometimes jumbled sense of national affinity between Israel and the United States.

By telescoping between past and present, Keren's work lays out the roots of the current American-Israeli relationship, revealing the long-held shared national fantasies and imagination that bind the two together. However, *The Great Seal* and *Un-Charting* do not elide past and present but demonstrate how the North American fascination with Israel developed over a long period of time, changing shape and shifting form to meet political realities. Through these two projects, we understand how the powerful American projection of Israel has taken root, for they demonstrate how Israel, in the words of the editors of this volume, operates as "the product of the intersection between what it projects externally and what is projected onto it." Through strategies of participation and absorption, Keren's work also directly addresses what Holocaust

31 Otto, "Negotiating the 'Holy Land,'" 411.

scholar Michael Rothberg calls "the implicated subject."[32] Inspired by Hannah Arendt's notion of collective responsibility, Rothberg argues that everyone in society has not just a role to play, but a degree of ethical responsibility for events that take place. Importantly, responsibility is not the same as guilt, and to be an implicated subject means that one does not take on the mantle of perpetrator or victim. Instead, it offers a nuanced and multidirectional way of understanding how individuals are caught in the crosshairs of history and what limited agency they have to act—and atone—in these circumstances. The implicated subject includes those who don't meet the legal threshold for culpability: those who may benefit from unequal systems or passively perpetuate harm against others in the face of what they believe to be correct. The implicated subject, for Rothberg, is a "transmission belt of domination," but one that can be broken through a self-awareness of our interconnectedness and the limits of our agency.[33] Keren's work challenges us as its viewers to understand how and where we are implicated, whether American or Israeli, demonstrating how political ideology crosses the Atlantic and transforms material reality as a result.

Bibliography

Atkins, Stephen E. "Aryan Nations." In *Race and Racism in the United States: An Encyclopedia of the American Mosaic*. Edited by Charles A. Gallagher and Cameron D. Lippard, 77–79. Vol. 1. Santa Barbara, CA: Greenwood, 2014. *Gale eBooks*, accessed February 11, 2022.

Banerjee, Neela, and Michael Luo. "McCain Cuts Ties to Pastors Whose Talks Drew Fire." *New York Times*, May 23, 2008. https://www.nytimes.com/2008/05/23/us/politics/23hagee.html.

Bar-Yosef, Eitan. *The Holy Land in English Culture, 1799–1917: Palestine and the Question of Orientalism*. Oxford: Clarendon Press, 2005.

Brod, Peter. "Soviet-Israeli Relations 1948–56: From Courtship to Crisis." *The Left against Zion: Communism, Israel, and the Middle East*, ed. Robert S. Wistrich, 50–70. London: Vallentine, Mitchell and Co., 1979.

Brothers, Richard. *A Description of Jerusalem: Its Houses and Streets, Squares, Colleges, Markets, and Cathedrals, The Royal and Private Palaces, With: the Garden of Eden in the Centre, as Laid down in the Last Chapters of Ezekiel. Also the First Chapter of*

[32] Michael Rothberg, *The Implicated Subject: Beyond Victims and Perpetrators* (Palo Alto, CA: Stanford University Press), 2019.

[33] Ibid., *The Implicated Subject*, 35.

Genesis Verified, as Strictly Divine and True: And the Solar System, with All Its Plurality of Inhabited Worlds, and Millions of Suns, as Positively Proved to Be Delusive and False: by Mr. Brothers [*With Plates*]. Printed for George Riebau, 1801. *Nineteenth Century Collections Online.*

"Census Shows Increase in Native Population." *National Indian Council on Aging, Inc.* Accessed November 24, 2021. https://www.nicoa.org/census-shows-increase-in-native-population/.

Dreisbach, Daniel L. *Reading the Bible with the Founding Fathers*. Oxford: Oxford University Press, 2017.

Fernandez-Sacco, Ellen. "Framing 'The Indian': The Visual Culture of Conquest in the Museums of Pierre Eugene Du Simitiere and Charles Willson Peale, 1779–96." *Social Identities* 8, no. 4 (2002): 571–618.

Gaston, K. Healan. *Imagining Judeo-Christian America: Religion, Secularism, and the Redefinition of Democracy*. Chicago: University of Chicago Press, 2019.

Gordon, Melton J. "British Israelism." In *Encyclopedia of World Religions: Encyclopedia of Protestantism*. 2nd ed. Boston: Facts on File, 2016.

Harel, Assaf. "Messianism Is Israel's Most Powerful Force, Embraced by Atheists Too." *Haaretz*, September 5, 2021. https://www.haaretz.com/opinion/.premium.HIGHLIGHT-messianism-is-israel-s-most-powerful-force-embraced-by-atheists-too-1.10175325.

Jefferson, Thomas. "First Inaugural Address (1801)." In *God's New Israel: Religious Interpretations of American Destiny*. Edited by Conrad Cherry, 106–112. Chapel Hill: University of North Carolina Press, 1998.

Kaplan, Amy. *Our American Israel: The Story of an Entangled Alliance*. Cambridge, MA: Harvard University Press, 2018.

Kirkpatrick, David D., Elizabeth Dias, and David M. Halbfinger. "Israel and Evangelicals: New U.S. Embassy Signals a Growing Alliance." *New York Times*, May 19, 2018. https://www-nytimes-com.ezproxy1.lib.asu.edu/2018/05/19/world/middleeast/netanyahu-evangelicals-embassy.html.

Lynch, Colum. "What's Next for Christian Zionists?" *Foreign Policy*, July 19, 2021. https://foreignpolicy.com/2021/07/19/christian-zionists-israel-trump-netanyahu-evangelicals/.

Odahl, Charles. "The Dynastic Tragedy and Helena's Pilgrimage." In *Constantine and the Christian Empire*, 202–221. London: Routledge, 2010.

Ogren, Brian. *Kabbalah and the Founding of America: The Early Influence of Jewish Thought on the New World*. New York: New York University Press, 2021.

Otto, Peter. "Negotiating the 'Holy Land': Cross-Cultural Encounters from Bonaparte to Blake." *Postcolonial Studies* 23, no. 3 (2020): 404–429.

Messer, Yael, ed. *Tali Keren: The Great Seal*, Exh. cat. Tel Aviv: Center for Contemporary Art, 2018.

More, Thomas. *Utopia* (1551). Edited by George M. Logan and Robert M. Adams. 2nd ed. Cambridge: Cambridge University Press, 2002.

Morris, Benny. *1948: A History of the First Arab-Israeli War*. New Haven, CT: Yale University Press, 2008.

Reps, John William. "Cities of Zion: The Planning of Utopian and Religious Communities." In *The Making of Urban America: A History of City Planning in the United States*, 439–474. Princeton, NJ: Princeton University Press, 1965.

Rothberg, Michael. *The Implicated Subject: Beyond Victims and Perpetrators*. Palo Alto, CA: Stanford University Press, 2019.

Said, Edward. *Orientalism*. New York: Pantheon Books, 1978.

Upton, Dell. *Another City: Urban Life and Urban Spaces in the New American Republic*. New Haven, CT: Yale University Press, 2008.

"Urban Warfare Training Center—Simulating the Modern Battlefield." *Israeli Defense Forces*, October 26, 2011. https://www.idf.il/en/minisites/training-and-preparation/urban-warfare-training-center-simulating-the-modern-battle-field/.

Utter, Glenn H. *The Religious Right and American Politics*. New York: Grey House Publishing, 2019.

"Vice President Pence Remarks to Christians United for Israel Conference." *C-Span*, July 8, 2019. https://www.c-span.org/video/?462373-1/vice-president-pence-addresses-christians-united-israel-conference.

"War Games: Israeli Urban Warfare." *VICE News*, July 9, 2014. https://www.vice.com/en/article/zm7dbe/war-games-israeli-urban-warfare.

Wilford, Hugh. *America's Great Game: The CIA's Secret Arabists and the Shaping of the Modern Middle East*. New York: Basic Books, 2017.

Zall, Paul M. "Richard Brothers: The Law and the Prophet." *The Wordsworth Circle* 45, no. 3: 187–293.

CHAPTER 7

The Short Life of the Israeli Superspy: Imagining Israel in Twentieth-Century American Crime Fiction

Reeva Spector Simon

Beginning in the early 1970s and lasting for a decade or so, American spy novel aficionados were treated to a rare spectacle. Many of the heroes in American spy novels and political thrillers were Israelis.[1] Often, they were American Jews who immigrated to Israel and, like Dov Shalev, the Israeli Ambassador to the United Nations in Leonard Harris's *The Masada Plan* published in 1976, was "the perfect choice for the New York post; not only did he speak the language of the natives, he had the medals and the glamour the job needed and the eloquence and sex appeal to woo Hadassah ladies and other friends of Israel at lunches, dinners, and receptions, or wherever funds had to be raised and Israeli positions explained."[2] Charged with safeguarding Israel's security after an Arab attack that forced the Jewish state to move its capital from Jerusalem to Tel Aviv, Shalev is a positive, heroic figure. He asserts Israeli agency in international politics and is adept at playing nuclear poker with a weak American president who, acceding to pressure from big oil and pandering to Arab interests, withholds aid to Israel at critical moments and pushes Israel to nuclear brinkmanship.

The Masada Plan is one of more than 40 spy novels and political thrillers that feature an Israeli hero who was thoroughly acceptable to an American reading public and almost interchangeable with the American heroes who starred in the hundreds of spy novels and thrillers that were becoming a staple of popular culture. A decade later, however, almost imperceptibly, Israelis, including Americanized Israelis, suddenly appear in American novels as villains, once again playing nuclear poker, only now prepared to bring the world to Armageddon for reasons of religious nationalism. By the end of the twentieth century, we find Israeli characters portrayed as mere props on the international stage, as objects—to be saved spiritually by American Evangelical Christians and physically by American heroes with their superpower technology.

1 This study also includes British authors published in the United States.
2 Leonard Harris, *The Masada Plan* (New York: Popular Library, 1976), 45–46.

The question, of course, is why the sudden emergence and precipitous eclipse of Israeli superheroes in American crime fiction? The answer lies with an analysis of the genre and an examination of the relationship between popular culture and politics.

1 Spy Novels, Thrillers, and the Publishing Market

Let us note first of all that American popular culture is market-driven. Unlike "literature" or the cultural canon that is imposed from above by arbiters of high culture, popular culture—and crime fiction that is a part of it—is defined from below; readers choose what *they* want to read as opposed to what they are told they ought to read. In a market where crime fiction accounts for one-quarter of the fiction sales by English-reading book purchasers, publishers, often despite their own political views, are ready to provide readers with what they believe readers want. Therefore, spy novels and thrillers play a role in framing political discourse not by imposing political views but by reflecting the reading public's perceptions of peoples and events through the lens of its own cultural myths.[3]

Spy novels and thrillers—included in the general category of crime fiction that also includes detective novels—are simple literary constructions that are inherently political and account for more than 90 percent of the crime fiction published that uses the Middle East for plot or characterization. Unlike traditional mysteries that are written according to rules that require specific clues in a well-defined puzzle, they are composed of specific, identifiable components: a stalwart hero who reflects the reader's values, a nefarious villain, and a plot or conspiracy of apocalyptic proportions directed by the villain against the hero and his nation, his society, or even Western civilization.

The novels rely on emotion, not intellect. Readers are drawn to them by familiar images or hints of reality. As sales of spy novels and thrillers rose through the 1980s, authors began to take their fictional inspiration directly from newspaper headlines. The suspense created in describing the hero's attempts to thwart the conspiracy that the reader intuitively knows will not succeed is the glue that rivets eyes to the page. Unlike the classic mystery crime novel where active reader involvement in the solution of the puzzle is part of the process, spy novels and thrillers presuppose a passive readership that works vicariously along with the hero to thwart the conspiracy—the more ingenious the better in order to reflect the creative imagination of the author and to generate book sales.

3 Dominick LaCapra, *History, Politics, and the Novel* (Ithaca, NY: Cornell University Press, 1987).

Ultimately market-driven, and by and large critically unfettered, spy novels and thrillers provide a useful lens through which to gauge how American perceptions of Israelis have shifted over time. Admittedly, individual crime novels reach fewer people than films, but evidence of reach via numbers of titles published, outright sales, paperback reissues, library readership over a long shelf-life, and the lack of advocacy oversight that cautions movie producers against outright one-sided stereotyping should attract more scholarly interest than it has.[4]

Over the course of the twentieth century, the nature of the Arab-Israeli conflict has changed. As seen through the lens of crime fiction, American perceptions of Israelis have also shifted not only along with the authors' perceptions of political events, but also with how publishers have gauged readers' receptivity of their interpretations of these events. In a genre of fiction where the "plot" and characters are vital, how spy novels and thrillers have portrayed Israelis, the relation of Israel to American policy in the region, and issues of Zionism is an important indicator of political perception.

2 The Impact of the 1967 War on American Crime Fiction

Until the 1960s, very few crime fiction novels appeared that were specifically related to Palestine/Israel. The British dominated the genre, and their imperial interests lay in Egypt, Iraq, and the Arabian Peninsula, where most of the novels were set. When Jews or Zionists did appear in American novels, they were usually incidental to the plot and reflected pre-World War II Jewish stereotypes. In one of the few American spy novels about the conflict in Palestine, F. Van Wyck Mason's *The Cairo Garter Murder* (1938), United States Colonel Hugh North interacts with a Jewish Haganah representative negotiating an arms deal, who is described as "a fox-faced Bulgarian Jew with eyes like gimlets and a distressing shuffle. Furtiveness and suspicion were his outstanding characteristics as he sidled in slowly, jerking a series of elaborate bows."[5] His speech is full of "*oy vays*" and his handshake is moist and flabby. The character confuses the reader, who, like most Americans, is not quite sure what to make of the Jewish agent. General American disinterest in Israel continued with the onset of the Cold War, where the Middle East (in fact and fiction) became the backdrop for East-West confrontations, not the Arab-Israeli conflict.

4 Reeva Spector Simon, *Spies and Holy Wars: The Middle East in Twentieth Century Crime Fiction* (Austin: University of Texas Press, 2010), 3–5.
5 F. van Wyck Mason, *The Cairo Garter Murders* (Garden City, NY: Doubleday, 1938), 119.

The 1967 Six Day War brought the Middle East and the Israeli hero to American crime fiction. While it is true that the overwhelming positive reaction to the Israeli victory in 1967 clearly contributed to the use of the Arab-Israeli conflict as an appropriate and a convenient theme for thrillers and spy novels, the war was only one factor. Others included developments in the publishing industry, politics in the United States and in Britain, events in the Middle East, and the changing image of the Jew.

The success of Ian Fleming's James Bond novels had important repercussions on the publishing industry. For the first time, spy novels hit bestseller lists, and after President John F. Kennedy said that he read them, everyone wanted to read Ian Fleming. Or, having read Fleming, readers could now choose from the innumerable James Bond copycats that began to appear as publishers scurried to create James Bond clones for the burgeoning market.[6] At the same time, paperback books emerged as legitimate publishing vehicles that were no longer relegated to pulp novels alone, so that not only were bestsellers remarketed in cheaper editions, but paperback originals began to appear in bookstores, airport kiosks, supermarkets, and drugstores. In order to satisfy increasing demand, spy novels and thrillers were churned out much like Romance novels and comic books—often written to a specific formula by a stable of writers. British, Australian, and Israeli writers joined American authors in competing for a share in an American market growing insatiable for the exploits of super-spies. Authors included non-Jews and Jews, journalists, diplomats, members of American, British, and intelligence organizations who served in the Middle East, Peace Corps volunteers and NGO professionals, retired military officers and mercenaries, specialists on military hardware, business and finance, advertising, and American and Israeli academics and politicians.[7]

Publishers and writers saw in the Israeli victory over the Arabs in 1967 and the subsequent triumphs of Israeli intelligence another arena for their fictional operatives and agents. Israeli intelligence successes such as the capture of Adolph Eichmann, the lifting of Soviet radar from Egyptian territory, the raid on Entebbe, the spiriting away of gunboats from Cherbourg harbor, and

[6] Examples include the Nick Carter series's Killmaster; Gerard De Villiers' agent Malko; and Adam Hall's Quiller.

[7] Examples include American journalists Marvin Kalb and Ted Koppel, *In the National Interest* (New York: Simon and Schuster, 1977); CIA operative E. Howard Hunt, *The Gaza Intercept* (New York: Stein and Day, 1981); Israeli MK Michael Bar Zohar [under pseud. Michael Barak], *The Secret List of Heinrich Roehm* (New York: William Morrow, 1976); US Vice President Spiro T. Agnew, *The Canfield Decision* (New York: Playboy, 1976); and Academic Howard M. Sachar, *The Man on the Camel* (New York: Times Books, 1981).

the sudden acquisition of material for nuclear weapons gave the Mossad a reputation equal to the Soviet KGB, the American CIA, and the British MI6. At the same time, Britain and America were losing stature internationally. By the end of the 1960s, the British had lost an empire; both countries were worried about Soviet moles in their intelligence services; and America, mired in Vietnam, was fearful of domestic conspiracy after a decade of assassinations. Spy novels and thrillers were ready for new heroes, and Israelis were suddenly believable and inherently marketable.

By 1967, the image of the American Jew and the Jewish Israeli had also changed. After World War II and the participation of hundreds of thousands of American Jews in combat, the "tough Jew" character emerged to counter the stereotype of the Jew as helpless, weak, and nerdy. Introduced into American fiction by writers who were combat veterans, the character was epitomized by Ari Ben Canaan, Leon Uris's hero in *Exodus*.[8] The book and the film were credited with establishing Jews and Israelis as Westerners and as heroes modeled on the image of the actor Paul Newman—the quintessential American.[9] These were Israeli blond, blue-eyed heroes endowed with intelligence and good looks, tempered with a dose of humanity, and backed by a superb military intelligence apparatus that was saving Israel and Western civilization from certain destruction. Not only were they Western, but these Israelis could be easily interchanged with Americans. Dov Shalev appealed to Jewish and Christian readers because he embodied Western heroic characteristics and was more American than "Jewish"—he had a Christian girlfriend and the Israelis he defended did not eat lox and bagels.

In essence, what this fictional hero represented was the extension in fiction of the Americanization of the Israeli and of Israel, a phenomenon that had been developing since the emergence of the State of Israel in 1948. Just as the Americanized view of Israel or America as Zion became a Jewish projection of what Israel ought to be, the Israeli hero in popular fiction represented a synchronization of an American/Israeli typology operating in a world where American and Israeli interests coalesced. This was a view of the Israel of the pioneering spirit and democracy, of Israel as a "light unto the nations," whose mission was to spread ideals of social justice and democracy to the rest of the

8 Leon Uris, *Exodus* (New York: Bantam, 1958).
9 Michelle Mart, "Tough Guys and American Cold War Policy: Images of Israel 1948–1960," *Diplomatic History* 20, no. 3 (1996), 357–380. See also Deborah Dash Moore, "From David to Goliath: American Representations of Jews around the Six Day War," in *The Six Day War and World Jewry*, ed. Eli Lederhendler (Bethesda: University Press of Maryland, 2000), 69–80.

world. It was an Israel governed by the Labor Party, operating as a bulwark against communism, struggling in defensive wars against those Arab Soviet clients who were bent on destroying her.[10] So long as this synchronization lasted—essentially through 1977—Israelis could be virtually synonymous with their American heroic counterparts.

Arabs, because of their engagement in international terrorism, provided ideal foils for heroes in a genre that was daily growing more popular and financially lucrative. The decision made in 1968 by Fatah and later the PLO to use terrorism as a political tool, either working alone or with one of their communist backers across the globe, created more than a parochial threat to Israel and enough fictional fodder to sustain thriller plots for decades. Through the rest of the twentieth century, more than 150 spy novels and thrillers used the Arab-Israeli conflict as a plot theme. When the Arab-Israeli conflict plot was combined with international terrorism, the numbers of titles published rose even further.

Until the early 1980s, the Israeli fictional super-spy was everywhere either working in tandem with American heroes or operating alone and was as acceptable to an American reading public as British heroes were. In six out of the more than two hundred written-to-formula Nick Carter novels that appeared from the mid-1960s through the late 1980s that featured an Americanized James Bond agent who often worked with a pro-Western local to thwart conspiracies across the globe, the American hero works with Israeli operatives who resemble Americans.[11] Israeli agents were so respected that authors contrived fictional conspiracies either related to reality or even flights of fancy where he was called in as a consultant. In one novel, he was hired to find Soviet moles in British intelligence after the defection of Kim Philby, and, in another, to save members of the United Nations General Assembly from the maniacal designs of a mad messiah who used the biblical ten plagues in a plot designed to kill the pope.[12] There were Israelis in more than 40 American or British novels who rescued American and Israeli officials from terrorist hijackers or prevented the assassinations of Western heads of state and thwarted nuclear holocaust.[13]

10 Jonathan D. Sarna, "A Projection of America as It Ought to Be: Zion in the Mind's Eye of American Jews," in *Envisioning Israel: The Changing Ideals and Images of North American Jews*, ed. Allon Gal (Jerusalem: Magnes Press, 1996), 41–59.

11 Examples include Nick Carter [pseud.: Linda Stewart], *The Jerusalem File* (New York: Award, 1975); and [pseud.: Joseph Rosenberger], *Thunderstrike in Syria* (New York: Ace-Charter, 1979).

12 Examples include Barry Weil, *Dossier IX* (New York: Bobbs Merrill, 1969); and Sandor Frankel and Webster Mews, *The Aleph Solution* (New York: Stein and Day, 1978).

13 Examples include Paul Henissart, *Narrow Exit* (New York: Simon and Schuster, 1974); David S. Benedictus, *The Rabbi's Wife* (New York: M. Evans, 1976); Uri Dan and Peter Manor, *Ultimatum PU 94* (New York: Leisure, 1977); Jack Hoffenberg, *17 Ben Gurion* (New

Some authors made the Israeli more sympathetic by adding a trace of vulnerability to his persona. He had had a tragic love affair or was a Holocaust survivor who arrived in Israel only to spend a lifetime fighting Arabs first in wars and then in anti-terrorist units.[14] Authors used the resulting emotional numbness to excuse the violent, amoral means Israeli agents used in order to achieve the greater good. These fictional Israeli heroes mirrored American commandos in a thriller subgenre of "avenger" books that appeared in the late 1970s that combined James Bond and Rambo and drew upon American pulp fiction, the hardboiled detective novel, and the superhero comic book. They featured Israeli commandos who saved Israel and beat back the terrorists threatening the United States.[15] In these "Rambowitz" novels, the "tough Jews" are finally Superman unmasked, Western heroes who can fend for themselves and counter the stereotypical image of the diaspora Jew with a Jewish hero who negated the old Jewish caricatures and whose features clearly mirrored those deemed American. Thus, we have Dov Shalzar, the Jewish hero who had to "out-Gentile" the Gentiles.[16]

"Tough Jews," however, frightened American liberals.[17] This was not their American Zionism or Israel as the "Light unto the Nations." It became more complicated when the Likud came to power in 1977.

3 The Likud Government and Israeli Villains

Cracks in the Israeli heroic armor predated the replacement of Labor by the Likud government. British novels published in the United States questioned and critiqued Israeli policy. Although the Palestinian sharpshooter in Gerald Seymour's novel, *The Glory Boys* (1976),[18] is killed before he can assassinate the Israeli target, somehow the Israelis have become the real villains when the

York: Putnam, 1977); Nelson DeMille, *By the Rivers of Babylon* (New York: Harcourt, 1978); and Matti Golan, *The Geneva Crisis* (New York: A&W, 1981).

14 Examples include Ken Follet, *Triple* (New York: Arbor House, 1979). Note the continued success of Daniel Silva's Israeli art-restorer-assassin (*The Kill Artist* [New York: Random House, 2000]).

15 Examples: Harry Arvay, *Eleven Bullets for Mohammad* (New York: Bantam, 1975); Andrew Sugar's *Israeli Commandos: The Aswan Assignment* (New York: Manor, 1974).

16 Harry Brod, "Of Mice and Supermen: Images of Jewish Masculinity," in T. M. Rudavsky, ed., *Gender and Judaism: The Transformation of Tradition* (New York: New York University Press, 1995), 283.

17 Paul Breines, *Tough Jews: Political Fantasies and the Moral Dilemma of American Jewry* (New York: Basic Books, 1990).

18 Gerald Seymour, *The Glory Boys* (New York: Random House, 1976).

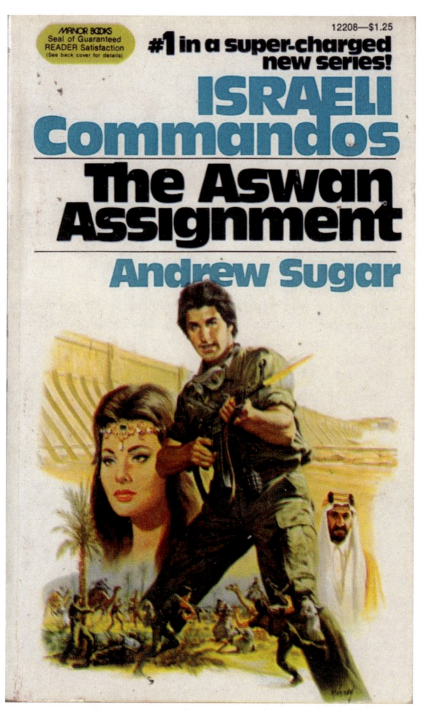

FIGURE 7.1 Cover art: Andrew Sugar, *The Aswan Assignment*
PHOTO BY AUTHOR

paunchy, 50-year old intended victim has a heart attack and dies on the airport tarmac. Israeli characters are smug. Knowing that the middle-aged scientist has a heart condition and has been targeted for assassination, they, nonetheless, send him to London and, ultimately, to an untimely death. Who, then, is the guilty one? During the 1970s, negative Israeli characters appeared in at least 14 novels; by the end of the century, there were more than 50 Israeli villains in American spy novels and thrillers.

American perceptions of Middle Easterners did not amount to a monolithic anti-Arab stereotype. During the late 1970s, the image of Egypt became more positive and Americans' view of Palestinians more ambivalent: there was sympathy for Palestinian refugees, but fear of terrorists.[19] Reflective of this perspective, subtle changes in the relationship between hero and villain came about to the point where some authors painted heroes and villains almost as mirror images of one another. Israeli agents were loners who joined the intelligence services because of their tragic past. Either they were Holocaust survivors, soldiers who had been severely wounded, or persons who had lost their wives or lovers to a terrorist attack. Palestinians joined terrorist organizations because they had been severely wounded or had lost close family members, wives, or lovers when Israeli bombs hit their refugee camps. Israelis were determined to avenge the deaths by combating terrorism; the Palestinians were determined to avenge deaths by destroying Israel, or later, by extension, the West.[20]

The combination of politics and publishing that were instrumental in creating the Israeli hero was soon to be the key to his eclipse. The Israeli election of 1977 that brought Menachem Begin and the Likud Party to power, the subsequent war in Lebanon (1982), and, later, the outbreak of the Intifada, projected negative images of Israelis and did not augur well for fictional Israeli heroes. Prime Minister Begin represented nationalism and religion, and was labeled by the American press as a terrorist, superhawk, and "strong-willed little Polish immigrant," whose name it crossly noted, "rhymes with Fagin."[21] His Yiddish-accented English and frequent biblical and Holocaust references made many American Jews uneasy as they resurrected the "old country"

19 Shelley Slade, "The Image of the Arab in America: Analysis of a Poll on American Attitudes," *Middle East Journal* 35, no. 2 (1981), 150.
20 Examples include John Le Carré, *The Little Drummer Girl* (New York: Knopf, 1983); and Seymour, *The Glory Boys*.
21 *Time Magazine* (May 23, 1977, 45; May 30, 1977, 22–23, 27) quoted in Jerold S. Auerbach, "Are We One? Menachem Begin and the Long Shadow of 1977," in *Envisioning Israel: The Changing Ideals and Images of North American Jews*, ed. Allon Gal (Jerusalem: Magnes Press, 1996), 341–342.

stereotypes these Jews thought they had left behind. They were supportive of a Zionist ideology that spoke to liberal universalism and were hardly pleased with Begin's narrow view of religious nationalism.[22]

Authors incorporated Israeli villains into their spy novels and thrillers, and, as American and British heroes returned in print during the 1980s, the shift in the Israeli image illustrated a growing political quandary: how could Americans accept an Israeli nationalist government that smacked of Europe and the Middle East, not America? During fictional lulls between real terrorist outrages in the Middle East, novels appeared with Israeli characters portrayed as extremist, nationalist fanatics. As Arabs began to be portrayed on television as victims rather than as terrorists, and as media coverage of Israeli policy became more critical, a new tarnished Israeli image followed in fiction: a fanatical Israeli right-wing group bombs Cairo, co-opts a disingenuous Jewish American scientist, and is as vicious as its Palestinian terrorist counterpart.[23] Americans are even called in to find Arab moles in the Israeli secret service. But when the American ex-CIA officer (who is their ally) discovers the identity of the traitor in Sean Flannery's *The Hollow Men* (1982),[24] Mossad agents ruthlessly kill him because he knows too much. Other plots have Israelis attempt to bomb the Aswan Dam, to initiate the Apocalypse, or to assassinate their own leaders.[25] And there was even a novel about a perfidious Israeli minister who uses the pretext of an assassinated diplomat to orchestrate an invasion of the country north of Israel where he misleads the Israeli people and double-crosses his Armenian allies.[26]

The shift in the Israeli image in fiction represented a growing uneasiness that many liberal American Jews felt about the Israeli right especially after the 1982 war in Lebanon. For them, Menachem Begin represented a Zionism that was uncomfortable for most Conservative and Reform Jews, one that negated the diaspora and its perceived prophetic egalitarian values and that idealized historic periods of Jewish sovereignty over the entire Land of Israel. It had strains of messianism and hinted of the Apocalypse.

22 Auerbach, "Are We One?," 342.
23 John Rowe, *The Aswan Solution* (Garden City, NY: Doubleday, 1979).
24 Sean Flannery, *The Hollow Men* (NP: Ace Books, 1982).
25 Examples include Russell Rhodes, *The Herod Conspiracy* (New York: Dodd Mead, 1980); and Roger Simon, *Raising the Dead* (New York: Villard Books, 1988).
26 Peter Delacorte, *Levantine* (New York: Norton, 1985). Despite Delacorte's disclaimer at the beginning of the novel that "Levantine is not Lebanon," we know that the villain who had the Israeli diplomat assassinated and who orchestrated the invasion northward has a remarkable resemblance to the Israeli general who was Minister of Defense in 1982.

4 The Oslo Interlude and Christian Evangelicals

Fewer thrillers that dealt with Israel were published during the 1990s, a decade reflecting both the hope of the Oslo Accords and apprehension at the quickly approaching millennium. Authors who took a pro-Oslo perspective used the genre to warn their readers of the danger to the Jewish state from right-wing religious fanaticism. Introducing his novel, *House of Guilt* (1996) Robert Rosenberg reminds his readers that, although his is a work of fiction, life in Israel was about "the gap between Jerusalem and Tel Aviv"—between absolute faith and reality.[27] This view was reiterated in mysteries and thrillers published during the brief interlude of the peace process and the Oslo agreement of the 1990s as authors have their heroes save Israel from what they saw as political and physical suicide. The fictional Israeli operatives of the James Bond era were no longer reliable, so American agents had to be used. There was also little faith that the parties themselves could solve the conflict, leading some authors to consider that a dose of American pragmatism brought to the conflict by Americanized Arabs might just solve the problem—a synchronization of the American self-view and an American liberal Zionist ideology. Authors projected the utopian vision of Oslo and introduced new heroic teams that combined liberal, secular Israelis and Palestinian Americans summoned to combat the religious fanatics on both sides who would destroy the chance for peace.[28]

By the end of the decade, marked by the outbreak of the Second Intifada and the end of the halcyon days of Oslo, other thriller writers combined an American religious revivalism with the Israeli right to produce books that took on an apocalyptic tinge of the "End of Days" incorporating Israel in a decidedly Christian approach to the Apocalypse.

Writing and preaching about the end of time in the newly developing mega-churches and on Cable TV, Bible teachers were watching the growth of political Islam as the Ayatollah Khomeini took power in Iran and as the *jihad* in Afghanistan proved instrumental in the fall of the Soviet Union. It would not be long until Russia as the "Evil Empire" shifted to Islam as the "Axis of Evil" whose extremists declared war on the West.[29] Events unfolding on the ground—the establishment of the State of Israel, the return of Jerusalem to Jewish rule, and

27 Robert Rosenberg, *House of Guilt* (New York: Simon & Schuster, 1996).
28 Examples include Jon Land, *The Walls of Jericho* (New York: Tom Doherty, 1997); Barbara Sofer, *The Thirteenth Hour* (New York: Dutton, 1996); and Zev Chafets, *Hang Time* (New York: Time Warner, 1996).
29 Timothy P. Weber, *On the Road to Armageddon: How Evangelicals Became Israel's Friend*. (Grand Rapids, MI: Baker Academic, 2004), 207–208. See also Michael Barkun, *The*

the end of the Cold War in 1979—were seen as prophetic indicators both to millennial Christians and messianic Jews. When, three years after Menachem Begin became the Israeli prime minister, Ronald Reagan was elected as the president of the United States, an unlikely alliance was formed. To many fundamentalist Christians, Begin was the embodiment of the religious nationalist who walked and talked the Bible and Reagan was a believer in prophecy and the "End of Days" who had close ties with the American Christian Moral Majority.[30] As a politically threatening "Islam" entered the American consciousness, the run-up to the millennium produced a religious revivalism with an apocalyptic belief that united the Israeli right with the Moral Majority that had become politicized during the presidency of Ronald Reagan.

Protestant Evangelical Christians were already using thrillers to explain Scripture as the declining Cold War ushered in a new era of American interest in mysticism, the occult, and conspiracy. Hal Lindsey's *The Late Great Planet Earth*, which suggested that the countdown to Armageddon was already in process, was a best-selling nonfiction book, and Bible prophecy was big business.[31] Secular and religious conspiracy theories developing on separate tracks in fiction now converged and were packaged in spy novel and thriller format.

When the first novels appeared, they were ignored not only because they were published by Christian publishing houses, but also because so-called "occult" books about the "End of Days" or the mysteries of Qumran (i.e., the Dead Sea Scrolls) were being turned out regularly during the run-up to the millennium and Y2K. But the extraordinary publishing success of Tim LaHaye and Jerry Jenkins's Left Behind series accompanying the political rise of the Moral Majority gave publishers pause. With more than 90 million copies of Left Behind books in print, Bantam, a mainstream trade publisher, signed contracts with the authors and was prepared to gamble on general audience reception.[32] In these "evangelical" thrillers, however, Israel is objectified and is merely the stage on which the final drama will be played. Heroes are Christian; Arabs are villains; and, Israelis and Jews are incidental unless they convert to Christianity.[33]

Culture of Conspiracy: Apocalyptic Visions in Contemporary America (Berkeley: University of California Press, 2003).

[30] Donald Wagner, "Reagan and Begin, Bibi and Jerry: The Theopolitical Alliance of the Likud Party with the American Christian 'Right,'" *Arab Studies Quarterly* 20, no. 4 (1998), 33–52.

[31] Hal Lindsey, *The Late Great Planet Earth* (Santa Ana, CA: Vision House, 1974).

[32] Allan Fisher, "Five Surprising Years for Evangelical-Christian Publishing: 1998 to 2002," *Publishing Research Quarterly* 19 (2003) 20–36.

[33] Examples include Frank Simon, *Veiled Threats* (Wheaton, IL: Good News, 1996); and Joel C. Rosenberg, *The Last Jihad* (New York: Tom Doherty, 2002).

5 The Gulf War and Loss of Israeli Agency

Despite the examples just cited, however, fewer spy novels about the Middle East and even fewer about the Arab-Israeli conflict were being published by the end of the 1990s. Critics decried the death of the genre. Perhaps readers were tiring of the sequence of first reading about terrorist events in the news and then seeing them unfold in fiction. In the early 1990s, authors and publishers had been primed for the First Gulf War, but none of the novels about the war made the hardcover bestseller list. Cable news and 24/7 war coverage of real-time heroics seemed to obviate the need for fiction. Publication data pointed to the fact that readers preferred domestic legal thrillers to international fare.

At the same time, the American victory in the First Gulf War erased the Vietnam War syndrome. It brought American heroes back to fiction, and illustrated Israeli loss of agency during the First Gulf War. The unexpected publishing success of Tom Clancy's *The Hunt for Red October* (1984)[34] and the creation of the military-tech or techno-thriller, many written by ex-US military, glorified American technology and featured American and British heroes in spy novels and thrillers as operators of ships and planes defeating terrorists in the Mediterranean and the Persian Gulf.[35]

If Israel appeared at all in novels, it was as a backdrop for American fictional exploits that, with international terrorism in the headlines, were moving away from the Arab-Israeli conflict. In almost a reversal of the plots of the Vietnam era, authors have Americans help the Israelis sunk in a Lebanese quagmire and advise a government that is as militarily inept as were those Western governments that had once called in the Israelis for aid. That same Israeli intelligence so vaunted in the 1970s is no longer able to defend Israel and must appeal to the CIA for assistance in finding Arab spies operating in the Mossad. Moreover, the Israeli military is also in trouble. Written just before the First Gulf War (1990–1991), Rich Herman's novel, *Firebreak*,[36] has Americans come to Israel's aid because Israeli planes are incapable of getting through to Baghdad to stop Saddam Hussein from firing SCUDs at Tel Aviv.[37] Not only are there Israeli villains in more than a few novels published during the 1990s, but thrillers depict Israel as too weak to defend itself both from external threat and from the internal corrosion brought about as a result of policies of the Likud government. Instead of the celebratory heroics that greeted the Israeli victory in 1967, liberal

[34] Tom Clancy, *The Hunt for Red October* (Annapolis, MD: Naval Institute Press, 1984).
[35] Examples include David Poyer, *The Gulf* (New York: St. Martin's Press, 1990); and Jack Merek, *Target Stealth* (New York: Warner, 1989).
[36] Rich Herman, *Firebreak* (New York: William Morrow, 1991).
[37] Examples include Herman, *Firebreak*; and Robert Cullen, *Cover Story* (New York: Simon and Schuster, 1994).

American jeremiads invested their increasingly atypical Israeli heroes with cautionary sensibilities and preached against impending political and millennial doom.

The days had passed when an Israeli diplomat could stare down an American president and real events were bypassing the Arab-Israeli conflict. After 9/11 and the onset of the Iraq War, spy novels and thrillers followed the news to Iraq and threats of international terrorism. Today, authors whose novels starred Israelis in the 1970s are writing about the Middle East again, but their heroes are British and American Special Forces operatives and New York City cops.[38] That same combination of political and publishing phenomena that created the Israeli hero in the 1970s has left him behind at the beginning of the twenty-first century.

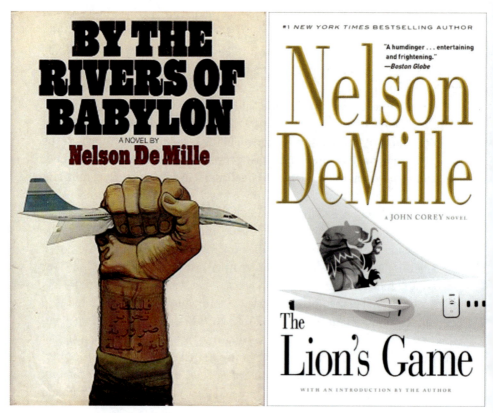

FIGURE 7.2 Cover art: books by Nelson DeMille published in 1979 and 2000
PHOTO BY AUTHOR

38 Examples include DeMille, *By the Rivers of Babylon*; and *The Lion's Game* (New York: Warner Books, 2000).

Bibliography

Agnew, Spiro T. *The Canfield Decision*. New York: Playboy, 1976.

Arvay, Harry. *Eleven Bullets for Mohammad*. New York: Bantam, 1975.

Auerbach, Jerold S. "Are We One? Menachem Begin and the Long Shadow of 1977." In *Envisioning Israel: The Changing Ideals and Images of North American Jews*. Edited by Allon Gal, 335–351. Jerusalem: Magnes Press, 1996.

Bar Zohar, Michael [pseud.: Michael Barak]. *The Secret List of Heinrich Roehm*. New York: William Morrow, 1976.

Barkun, Michael. *The Culture of Conspiracy: Apocalyptic Visions in Contemporary America*. Berkeley: University of California Press, 2003.

Benedictus, David. *The Rabbi's Wife*. New York: M. Evans, 1976.

Breines, Paul. *Tough Jews: Political Fantasies and the Moral Dilemma of American Jewry*. New York: Basic Books, 1990.

Brod, Harry. 1995. "Of Mice and Supermen: Images of Jewish Masculinity." In *Gender and Judaism: The Transformation of Tradition*. Edited by T. M. Rudavsky, 279–293. New York: New York University Press.

Carter, Nick [pseud.: Joseph Rosenberger]. *Thunderstrike in Syria*. New York: Ace-Charter, 1979.

Carter, Nick [pseud.: Linda Stewart]. *The Jerusalem File*. New York: Award, 1975.

Chafets, Zev. *Hang Time*. New York: Time Warner, 1996.

Clancy, Tom. *The Hunt for Red October*. Annapolis, MD: Naval Institute Press, 1984.

Cullen, Robert. *Cover Story*. New York: Simon and Schuster, 1994.

Dan, Uri, and Peter Manor. *Ultimatum PU 94*. New York: Leisure, 1977.

Delacorte, Peter. *Levantine*. New York: Norton, 1985.

DeMille, Nelson. *By the Rivers of Babylon*. New York: Harcourt, 1978.

DeMille, Nelson. *The Lion's Game*. New York: Warner Books, 2000.

Fisher, Allan. "Five Surprising Years for Evangelical-Christian Publishing: 1998 to 2002." *Publishing Research Quarterly* 19 (2003): 20–36.

Follet, Ken. *Triple*. New York: Arbor House, 1979.

Frankel, Sandor, and Webster Mews. *The Aleph Solution*. New York: Stein and Day, 1978.

Golan, Matti. *The Geneva Crisis*. New York: A&W, 1981.

Harris, Leonard. *The Masada Plan*. New York: Crown, 1976.

Henissart, Paul. *Narrow Exit*. New York: Simon and Schuster, 1974.

Herman, Rich. *Firebreak*. New York: William Morrow, 1991.

Hoffenberg, Jack. *17 Ben Gurion*. New York: Putnam, 1977.

Hunt, E. Howard. *The Gaza Intercept*. New York: Stein and Day, 1981.

Kalb, Marvin, and Ted Koppel. *In the National Interest*. New York: Simon and Schuster, 1977.

LaCapra, Dominick. *History, Politics, and the Novel*. Ithaca, NY: Cornell University Press, 1987.

Land, Jon. *The Walls of Jericho*. New York: Tom Doherty, 1997.
Le Carré, John. *The Little Drummer Girl*. New York: Knopf, 1983.
Lindsey, Hal. *The Late Great Planet Earth*. Santa Ana, CA: Vision House, 1974.
Mart, Michelle. "Tough Guys and American Cold War Policy: Images of Israel 1948–1960." *Diplomatic History* 20, no. 3 (1996): 357–380.
Mason, F. van Wyck. *The Cairo Garter Murders*. Garden City, NY: Doubleday, 1938.
Merek, Jack. *Target Stealth*. New York: Warner, 1989.
Moore, Deborah Dash. "From David to Goliath: American Representations of Jews around the Six-Day War." In *The Six-Day War and World Jewry*. Edited by Eli Lederhendler, 69–80. Bethesda: University Press of Maryland, 2000.
Poyer, David. *The Gulf*. New York: St. Martin's Press, 1990.
Rhodes, Russell. *The Herod Conspiracy*. New York: Dodd Mead, 1980.
Rosenberg, Joel C. *The Last Jihad*. New York: Tom Doherty, 2002.
Rosenberg, Robert. *House of Guilt*. New York: Simon & Schuster, 1996.
Rowe, John. *The Aswan Solution*. Garden City, NY: Doubleday, 1979.
Sachar, Howard M. *The Man on the Camel*. New York: Times Books, 1981.
Sarna, Jonathan D. "A Projection of America as It Ought to Be: Zion in the Mind's Eye of American Jews." In *Envisioning Israel: The Changing Ideals and Images of North American Jews*. Edited by Allon Gal, 41–59. Detroit: Wayne State University Press, 1996.
Seymour, Gerald. *The Glory Boys*. New York: Random House, 1976.
Silva, Daniel. *The Kill Artist*. New York: Random House, 2000.
Simon, Frank. *Veiled Threats*. Wheaton, IL: Good News, 1996.
Simon, Reeva Spector. *Spies and Holy Wars: The Middle East in 20th Century Crime Fiction*. Austin: University of Texas Press, 2010.
Simon, Roger. *Raising the Dead*. New York: Villard Books, 1988.
Slade, Shelley. "The Image of the Arab in America: Analysis of a Poll on American Attitudes." *Middle East Journal* 35, no. 2 (1981): 143–162.
Sofer, Barbara. *The Thirteenth Hour*. New York: Dutton, 1996.
Sugar, Andrew. *Israeli Commandos: The Aswan Assignment*. New York: Manor, 1974.
Uris, Leon. *Exodus*. New York: Bantam, 1958.
Wagner, Donald. "Reagan and Begin, Bibi and Jerry: The Theopolitical Alliance of the Likud Party with the American Christian 'Right.'" *Arab Studies Quarterly* 20, no. 4 (1998): 33–52.
Weber, Timothy P. *On the Road to Armageddon: How Evangelicals Became Israel's Friend*. Grand Rapids, MI: Baker Academic, 2004.
Weil, Barry. *Dossier IX*. New York: Bobbs Merrill, 1969.

CHAPTER 8

Israel through the Viewfinder: Claude Lanzmann and Susan Sontag Film the Jewish State

Rocco Giansante

> The novelist Amos Oz observed to me that Israel contains more different visions of Heaven than any outsider can imagine. Everyone who came over brought his own dream of Paradise with him.
> SAUL BELLOW, *To Jerusalem and Back*[1]

∵

This chapter argues that cinema has the possibility of acting as a symbolic place in which Israeli and diaspora Jews can interact with one another to discuss their, at times, divergent interpretations of Jewish identity, statehood, and universalism. In a time when the issue of the increasing distance between Israel and American Jews dominates the debate in the Jewish media[2] and the social sphere—attracting, in passing, also the interest of academia[3]—this chapter suggests that cinema can foster the conditions under which a healthy dialogue on these issues can take place.

1 Israeli Cinema: a Maker of National Narratives

In recent years, film industry professionals, critics, and audiences around the world have followed with interest and curiosity the developments inside Israeli

1 Saul Bellow, *To Jerusalem and Back* (New York: Viking Press, 1976), 30.
2 The Israeli broadcaster Kan aired a series showing the many kinds of American Judaism to Israelis. The show moves beyond the alarms about assimilation and decadence, to create a fascinating portrait of the way Jews in America give meaning to Judaism. The title of the show, *The New Jew*, suggests that American Jews are renegotiating the components of Jewish identity in the same way that the Zionists did in the first half of the twentieth century.
3 See, for example, Dov Waxman, *Trouble in the Tribe: The American Jewish Conflict over Israel* (Princeton, NJ: Princeton University Press, 2016).

cinema, which has shown a vivacity and creative energy difficult to ignore. Aside from its entertainment value, the success of Israeli cinema can be traced back to its topics dealing with universal themes like identity, memory, belonging, community, multiculturalism, migration, and one's relationship with the "other." In these areas, Israel functions as a sort of laboratory attempting to engineer solutions to issues relating to the present era defined by globalization and its socioecological by-products: the challenges stemming from phenomena like post-national liberalism and ethno-religious traditionalism, and cosmopolitanism and tribalism, or from events like the various current ecological, refugee, and sanitary crises.[4] Moreover, the creativity and popularity of Israeli cinema may be the result of the films serving as a locus where the nation's narrative can be constructed or renegotiated by making visible—on the screen—individuals and locations that have, for the most part, been invisible. Consequently, the act of filmmaking can be understood as the "configuration of experience that create[s] new modes of sense perception and induce[s] novel forms of political subjectivity."[5]

Thus, during the course of its history Israeli cinema has functioned as the transmitter of national narratives that uphold or oppose the contemporary established one: political and ethnic minorities, women, anti-Zionists, migrants, Haredim ("Ultra-Orthodox") have, in succession, conquered visibility on the screen and participated, with more or less success, in the process of renegotiating the national narrative and the representations of the country. The cinematic screen in Israel, thus, serves as a safe space in which the narratives of Israeli society can be deconstructed and renegotiated and, more importantly, where the different tribes[6] that make up the state can meet and interact with each other—thus overcoming, at least for the duration of a film, the divisions and tensions that are weakening the societal fabric.

While it is clear that a national cinema reinterprets the internal affairs of its country—becoming a space that affords its various group the chance to reflect on the past and to build a vision of the future—national cinema also "look[s] out across its borders, asserting its difference from other national cinemas,

4 Uri Ram, *The Globalization of Israel: McWorld in Tel Aviv, Jihad in Jerusalem* (London: Routledge, 2008).
5 Jacques Rancière, *The Politics of Aesthetics: The Distribution of the Sensible* (New York: Continuum, 2004), 9.
6 Former President of Israel Reuven Rivlin described the sectors that make up Israel as tribes: Arab, Ultra-Orthodox, national religious, and secular. See Reichmann University, "The Four Tribes Initiatives," December 9, 2021, https://www.idc.ac.il/en/research/ips/pages/4tribes.aspx.

proclaiming its sense of otherness."[7] This tension between the nation and the "other," the inside and the outside, enriches the meaning of national identity and complicates Benedict Anderson's celebrated definition of the nation as "an imagined community" anchored to a precisely mapped geopolitical space. National identity, in fact, "is not of course dependent on actually living within the geo-political space of the nation, as the émigré experience confirms. Thus, some diasporic communities, uprooted from the specific geo-political space of the nation or the homeland, still share a common sense of belonging, despite—or even because of—their transnational dispersal."[8] Cinema, then, not only formulates the narrative of a nation—reflecting on its past and building visions for its future—it also builds a network that, linking immigrants, diasporas, and the "other," gives the national discourse a universalist projection.

The complex relationship between the inside and outside of a nation is manifested by the fact that the image of a country is created and spread not only by the films produced in said country: in fact, films can participate in the process of image-building of a nation other than the one in which they were produced.

On the screen, the image(s) of Israel presented by the products of Israel's national cinema (that is, films produced in Israel) stand next to a number of filmic works about Israel produced by non-Israelis—for example, *Third Side of the Coin* (*Description d'un combat*, 1960) by Chris Marker or *Survival 1967* (*La guerre amère*, 1968) by Jules Dassin.[9] Among these, there are some made by diaspora Jews like Chantal Akerman's *Down There* (Là-Bas, 2006).[10] The latter are of interest because they evoke, through images, a difference between the Israel imagined by Israeli artists and the one created by diaspora Jews, a difference that points, depending on the times, to the convergence or divergence characterizing the discourse about Israel among Jews in the diaspora and Israeli Jews. Israeli sociologist Shmuel Eisenstadt describes a certain aspect of the relation between Jews and Israel that generates images based on visions, prophecies, and cultural tropes: "Many Jews search in Israel for the manifestation of those dimensions of Jewish existence and themes of Jewish civilization for which they longed; not only those of political and military strength and collective identity, but also those of social justice, full religious fulfillment, or

[7] Mette Hjort and Scott MacKenzie (eds.), *Cinema and Nation* (London: Routledge, 2000), 61.
[8] Hjort and MacKenzie, *Cinema and Nation*, 58.
[9] Dassin, Jules, dir. *La guerre amère* [Survival 1967]. 1968; Israel/United States/France: Les Artistes Associés. 1 hr., 10 min.
[10] Chantal Akerman, dir. *Là-Bas* [Down there]. 2006; France: Amip. 1 hr., 18 min.

for some great civilizationary vision, as well as those of 'simple' communal-familial Jewish solidarity."[11]

It can be said, then, that Israel on screen functions as a double mirror that, on one side, reflects the multiplicity of Israeli society (and its many interpretations) and that, on the other, supports the projections that the Jewish diaspora imagines for Israel. The screen becomes a place where these major forces of contemporary Jewish life can meet in the same way as, internally, the Israeli film allows the meeting with the "other," whether it be Orthodox, secular, straight, gay, Palestinian, initiating a dialogue that can potentially spill off the screen into society: the new subjectivities reflected on the screen, in fact, can help renegotiate the terms of the discourse between Israel and the diaspora.

This chapter considers the films created by two prominent Jewish intellectuals of the diaspora—Claude Lanzmann and Susan Sontag—and dedicated to Israel. Although focusing on the Jewish state, both films reveal many elements about the communities of origin of the filmmakers. Lanzmann's film is imbued with the experience of the Holocaust, which had greatly affected his personal story and his French community, while Susan Sontag composed an anti-war text that finds its roots in her American liberal milieu.

The values, anxieties, and stories of the diaspora are inserted into the Israeli landscape: seen on screen, the differences between the diaspora and Israel can be mediated and made into a new narrative that, in turn, has the potential to be shared by many.

2 Cinema and the Image of a Nation

How do we imagine places? In *City on a Hilltop*—Sara Yael Hirschhorn's study on American settlers in the Occupied Territories[12]—an *olah hadasha* ("a new immigrant") describes the encounter, upon her arrival in Israel, between the reality on the ground and the Israel that she had imagined back home in the United States. The real, physical Israel turned out to be not the place she had constructed in her mind: this realization had activated a painful process of recognition that had made her integration into the new country difficult to accomplish. What feeds this imagination? How is the representation of a nation generated?

11 Shmuel Eisenstadt, *Jewish Civilization: The Jewish Historical Experience in a Comparative Perspective* (Albany: State University of New York Press, 1992), 269.
12 Sara Yael Hirschhorn, *City on a Hilltop: American Jews and the Israeli Settler Movement* (Cambridge, MA: Harvard University Press, 2017).

The construction of the image of a nation is a complex process in which the film medium plays a leading role. For example, in the years following World War II, Italian neorealism was instrumental in creating the democratic image of post-fascist Italy and thus in contributing to the "self-redeeming" process that exonerated the Italian people from their historical responsibilities.[13]

In a similar way, in the 1960s, the Nouvelle Vague constructed a representation of France that was in tune with the social and cultural trends that were modifying French society's fundamental values. In fact, this new generation of filmmakers was immersed in a changing political landscape marked by the war in Algeria and the new constitutional asset of the Fifth Republic. Moreover, on a sociological level, the robust economic growth generated by the country brought into being phenomena like urbanization and mass entertainment.[14] According to Jean-Michel Frodon, at this point "lifestyles and costumes are evolving at great speed (even if we will have to wait for 1967 for the legalization of the contraceptive pill), under the banner of the 'consumerist society.'"[15]

The filmmakers of the Cinema Novo in 1960s Portugal were making films that differed quite significantly from contemporary filmic production, and registered the malaise of Portuguese society in regards to the stifling authoritarian stance of António de Salazar's regime, the severe economic situation, and the wars that the country was waging in Africa to retain control of its colonies.

In Israel, in the years following the establishment of the state, cinema served the nation-building project, creating stories infused by Zionist values and a nationalist outlook. From the 1960s to the 1970s, filmmakers of the so-called "New Sensibility"[16] movement adopted tropes of the Nouvelle Vague and formulas of modernist European cinema to create on the screen an image of the country that was at odds with its official representation. Rejecting militarism and nationalism, filmmakers like Uri Zohar and Dan Wolman focused

13 Lorenzo Fabbri, "Neorealism as Ideology: Bazin, Deleuze and the Avoidance of Fascism," *The Italianist* 35, no. 2 (2015): 182–201.

14 Also, cultural life was undergoing major shifts: authors like Claude Lévi-Strauss, Albert Camus, Jean-Paul Sartre, and Roland Barthes published groundbreaking works in the fields of anthropology, philosophy, literature, and cultural studies. An air of novelty crossed the arts with the adjective *nouveau* ("new") used to describe literary experimentations—the "Nouveau Roman" of Alain Robbe-Grillet, Marguerite Duras, and Françoise Sagan—or the visual arts group of the "Nouveaux Réaliste." Such was the effervescence that animated the cultural life in France that in 1959 a Ministry of Cultural Affairs was created and headed by the renowned novelist André Malraux.

15 Jean-Michel Frodon, *Le Cinéma français: De la Nouvelle Vague à nos jours* (Paris: Cahiers du Cinema, 2010), 13.

16 Judd Ne'eman, "The Lady and the Death Mask," in *Israeli Cinema: Identities in Motion*, ed. Miri Talmon and Yaron Peleg (Austin: University of Texas Press, 2011), 70–83.

their cameras on the personal and intimate lives of individuals standing on the margins, people untouched by the collective intoxication that took hold of the country after the 1967 War. In many ways, it can be stated that this new Israeli cinema was witnessing and documenting the demise of a societal structure built on the left-wing Mapai's political and cultural hegemony and announcing the Ma'apach (the "Revolution"), which brought the Likud to power in 1977.

Israeli cinema's new incarnation, opposing the form that preceded it and that had been born within the frame of the Zionist ideology that had created the state, brought to the screen a representation of the country that elaborated on the ongoing crisis of its foundational narrative.

Around that time, a few months before the breakout of the Yom Kippur War in 1973, Claude Lanzmann traveled to Israel with the intention of filming the Jewish state. Bringing together the elements that had constituted the representation of Israel on screen, Lanzmann reassembled them in an attempt to describe the intensity of that historical period.

3 Claude Lanzmann's Israel

It took Claude Lanzmann three years to complete *Why Israel* (*Pourquoi Israël*) (France, 1973), his first feature film, which contains, as it is often the case, all the ones that followed. The title is written without a question mark: Lanzmann did not come to Israel to find a reason for its existence, nor to question it. The purpose of the film was to investigate and show the normality of the country that Lanzmann, paradoxically, saw as abnormal[17] because it incorporated the particularity of the Jewish historical experience.

Similar to what Roland Barthes did when writing about Japan in *The Empire of Signs* (1970),[18] Lanzmann collected "a certain number of features" that he then put together to create a system that he called "Israel." Traveling across

17 "But I set myself to work and produced seventy pages distilling my essential thoughts about the normality of Israel, which for me was in fact the abnormality." See Claude Lanzmann, *The Patagonian Hare: A Memoir* (London: Atlantic Books, 2012), 579.
18 "If I want to imagine a fictive nation, I can give it an invented name, treat it declaratively as a novelistic object, create a new Garabagne, so as to compromise no real country by my fantasy.... I can also—though in no way claiming to represent or to analyze reality itself— isolate somewhere in the world (far away) a certain number of features (a term employed in linguistics), and out of these features deliberately form a system. It is this system which I shall call: Japan." See Roland Barthes, *Empire of Signs* (New York: Hill and Wang, 1987), 3.

the land, Lanzmann encountered the reality of Israel and captured it on the camera: he stood in front of the flux of the real and filmed the reflections of his idea of Israel in it. He traveled from south to north, in order to explore locations and record the stories of the people living there: Holocaust survivors, the *kibbutzniks*, the Mizrachi Jews working in the port of Ashdod or living in Dimona, the Ultra-Orthodox, the settlers in Hebron, the secular and the religious, the *yekkes*, the German Jews nostalgically stuck in Europe, and the new immigrants from the Soviet Union who had just reached the country.

The style of filmmaking is simple: shooting with a handheld camera in a way that is marked by the absence of voiceover and archival material and by the ample space given to oral testimony. In this film, Lanzmann inaugurated the mode of filmmaking that he will famously employ hereafter in his masterpiece, *Shoah* (France, 1985).[19] The result is a film based on the empathy of its director with the subject, a film that is in tune with the reality that it was capturing. For film critic Serge Toubiana, empathy in a filmmaker is "to be the first witness of what is born, of what happens."[20] After watching the film, Gershom Scholem exclaimed: "Never was anything like this seen before."[21] There is a raw quality in the images that connect the spectator directly with that part of reality that is Lanzmann's Israel.

The film opens on the image of a yellow Star of David, which is followed by a sequence shot at the Yad Vashem memorial.[22] The camera tails a group of students as they visit the exhibition, lingering on their young faces as they look at the historical photos documenting the extermination of the Jews by the Nazis. The Shoah is central to *Why Israel*: its memory is felt throughout the entire

19 *Why Israel* and *Shoah* share not only a filmmaking style, but also the crew members: the cinematographer William Lubtchansky and the editor Ziva Postec worked on both projects. See Claude Lanzmann, dir., *Why Israel*. 1973; France: Why Not Productions, 2007. 3 hrs., 12 min.; and Claude Lanzmann, dir., *Shoah*. 1985; France: Les Films Aleph, 9 hrs., 30 min.

20 *Serge Toubiana et Claude Lanzmann parlent de Pourquoi Israël* (2006, France), 5:55–06:10. This is a supplement to *Why Israel*.

21 "Gershom Scholem's comment, when he rose to his feet after the three hours and twenty minutes of the screening, turned to the audience and shouted, 'We've never seen anything like it!,' was, for me, the ultimate accolade, the greatest joy." See Lanzmann *The Patagonian Hare*, 588.

22 "The old, simple, unassuming and poignant Yad Vashem that appears in *Pourquoi Israël*, not the more recent creation, a gigantic Americanised stone city, a triumph of the museum-builders' art, the result of an arrogant competition between architects from around the world, a multimedia confection that promotes forgetfulness rather than memory." See Lanzmann, Ibid., 591.

film, not just in the sequences where it is directly referenced like the interview in which the policeman Shmuel Bogler retells his experiences in Auschwitz.[23]

For Lanzmann, the State of Israel cannot be seen as a consequence of the Shoah,[24] a reparation that the world accorded to the Jewish people, but he does write that "a complex and deep causal relationship connects these two key events in the history of the twentieth century, and that a core of Israel's population is made up of survivors and refugees weary of suffering."

The resistant Lanzmann, a survivor, sees in Israel the moment in history when, following near total annihilation, the Jews were able to reappropriate to themselves violence and power, and thereby the capacity to defend themselves. If the search for the manifestations of the normality of the Jewish state (along the lines of David Ben Gurion's[25] famous statement "We will know we have become a normal country when Jewish thieves and Jewish prostitutes conduct their business in Hebrew") leads to the discovery of Israel's Jewish abnormality, Lanzmann, nonetheless, recognizes that it is this reappropriation of violence that guarantees the existence of the state. As he writes in the opening titles of his film *Tsahal* (France, 1994): "Without Tsahal [the Israeli Army], the question of peace between Israel and her former enemies would never have been raised. Israel would no longer exist."[26] And it is here, in the possibility of defending oneself, that lies the normality[27] that exists at the center of the Israeli abnormality.

Claude Lanzmann's Israel is a laboratory of nation-building: basic questions about the essence of the state are continuously discussed. We are in the years

23 The film is dedicated to Angelika Schrobsdorff (a German Holocaust survivor), "and the key scenes are peopled by the German Jews that I met through her. Gert Granach, whose contributions open and close the film and whose deeply moving Spartacist songs, accompanied by his accordion, punctuate it, is a close friend of Angelika's." See Ibid., 581.

24 "Let me be clearly understood: I never considered Israel as the redemption for the Shoah, the idea that six million Jews gave their lives so that Israel might exist; such a teleological argument whether explicit or implicit is absurd and obscene." See Ibid., 556–557.

25 Joel Braunold, "Jewish Prostitutes, Jewish Thieves and Jewish Supremacists," *Haaretz*, May 15, 2014, https://www.haaretz.com/jewish/2014-05-15/ty-article/.premium/targeting-jewish-supremacists/0000017f-e854-dc7e-adff-f8fd34250000.

26 Claude Lanzmann, dir. *Tsahal*. 1994; France: Why Not Productions, 2008, opening text.

27 Reflecting on the concept of normality, the writer A. B. Yehoshua said: "What is a normal country? One that is master of its fate. When speaking of the normalization of the Jews, the intent was that the Jews would be responsible for their actions, masters of their fate, directing themselves, and not dependent upon others. This is the only normality. Normality is not about the character or history of a country, but rather about the existence of a sovereign political framework. In this sense, Israel is a normal country, like any other." See A. B. Yehoshua, "A. B. Yehoshua," *Azure* (Winter 1999): 226–232, here 231, https://azure.org.il/download/magazine/1737az6_Sym_A.B.Yehoshua.pdf.

after the Six Day War, a period marked by major rethinking, which "reopened the problems of the overall structure of the country's collective boundaries and symbols and of the major institutional formats of Israeli society."[28] Who is a Jew? What should the nature of the relation between state and synagogue be? How do you integrate new immigrants? What is the role of the army in society? What are the symbols of the nation? These and other questions are inserted inside a system of images that constitutes, for the filmmaker, everyday Israel: Jewish prisons, with Jewish guards and Jewish prisoners, Jewish supermarkets selling Jewish products to Jewish (American) tourists, new Jewish towns (built in the desert with great pain by North African Jews), Jewish policemen confronting Jewish protesters, a Jewish army, Jewish communities, a Jewish Jerusalem (opening itself to the Jewish world to fulfill its role as spiritual center), but also a Jewish diaspora (with the nostalgic Spartacist tunes of Gad Granach) and Jewish occupation (Gaza). Confronted with this Jewish totality, Lanzmann cannot but be struck and marvel at the ontological character of the state and celebrate its liberating effect (pushing him to critically reconsider Jean-Paul Sartre's reflections on the Jew as a creation of the anti-Semitic gaze: in Israel, the Jew exists independently).[29]

In parallel to the investigation of the nation's essence, Lanzmann's construction of Israel's image passes also through the demarcation of its geographical borders: the camera captures the landscapes of the country as it reaches its limits, registering the Israeli presence from the southern sands of Sharm El-Sheikh up to the North, to the snow-capped Mount Hermon, filming the barbed wires of the minefields at the border with Jordan in the East and photographing the blue line of the Mediterranean in the West, thus territorializing the idea of the nation.

The film has a circular structure: starting and ending at Yad Vashem, it returns to characters and locations during the course of its duration (mini-cycles composing the major one). In many ways, this complex temporal structure exemplifies the nation-building process, which consists in selecting elements of the past and engaging with them in the present in a continuous movement between now and then. Cultural theorist Homi Bhabha, elaborating Benedict Anderson's argument that the nation is "an imagined political

28 Eisenstadt, *Jewish Civilization*, 192.
29 For Lanzmann, the Jewish state was a revelation because it pushed him to critically reconsider Sartre's *Réflexions sur la question Juive* (trans. *Anti-Semite and Jew*), which had a great influence on a young Lanzmann dealing, after the war, with the discovery of the Holocaust. The Jew was not a creation of the anti-Semite. See Jean-Paul Sartre, *Réflexions sur la question Juive* (Paris: Paul Morihien, 1946); *Anti-Semite and Jew* (New York: Schocken Books, 1995).

community," argued that, in fact, the nation is narrated in double time: there is the straight progression of the temporal axis connecting the nation to its past (a connection that gives legitimacy to the nation, because it turns the present into a continuation of the past—the nation intended as the product of a teleological sequence of events) and the time in the present during which elements of the past are selected to become part of the national narrative. Thus, it is in the present that the past is built. In the present, in fact, the rhetorical figures of the nation are chosen, exchanged, discussed, and renewed in a performative rethinking of the past in the present that reworks national identity. This intercrossing between past and present can be easily achieved in film, thanks to the medium's possibilities of manipulating time (through editing). In *Why Israel*, the sense of history is very strong: while the creation of Israel and its development are inserted in the timeline of history, Lanzmann uses the film to show how events in history are remembered and became the basis for a national narrative and iconography (for example, the Shoah and Yad Vashem, the memorialization of the wars, and the religious ceremonies connecting the community to a near-mythological past).

This relation between past and present (the linear trajectory versus the constant performative rethinking of the past in the present—namely, which elements of the past to retain and which elements to forget), in the case of Israel, and Lanzmann's film is a clear example of it, is complicated by the proximity of the present (the time of the elaboration of the nation) with the historical events, especially if one considers the Holocaust. Idith Zertal in *Death and the Nation*[30] writes about the "short Zionist century" in which dwell both the acts of remembering/forgetting and the actual occurrence of what was remembered/forgotten. Lanzmann enters in direct contact with the historical events that sustain his idea of Israel. Moreover, the chronological proximity between present and past events renders the process of ideological appropriation of the past transparent, thus making it easy to critique the choice of which rhetorical figures or events from the past should constitute the nation's origin.

Why Israel is a document that reflects a popular attitude of the Jewish diaspora toward Israel in the intense years immediately following the Six Day War. This was an attitude characterized by an attachment to Israel,[31] an attachment

30 Idith Zertal, *Ha-Umma veHa-Mavet: Historia, Zikaron, Politika* [Death and the nation: History, memory, politics] (Tel Aviv: Dvir, 2000).
31 "In many Jewish communities, especially in the United States in the 1950s and 1960s, Israel constituted a central, in the beginning, a very new and potent, component of their Jewish 'civic religion.' It became the natural meeting place for most Jewish organizations; a sort of natural place for family gatherings and events, and by now very few

that came about as a consequence of the historical experience of the Holocaust. And it is to this experience which the film affords a central place in the identity-making of the Jews at a time of progressive weakening of the halakhic bond.

With *Why Israel*, Lanzmann builds a discourse that celebrates the successful establishment of the Jewish state, connecting it to the reconstruction of the Jewish civilization after the war. The creation of Israel, giving to the Jews control over their destiny, sanctions their "re-entry into History."[32]

4 Israel by Susan Sontag

A few months after Lanzmann, right at the end of the Yom Kippur War, Susan Sontag arrived in Israel to shoot *Promised Lands* (United States, 1974).[33] The film carries the heavy atmosphere of defeat and mourning that enveloped the country after the traumatic outcome of the conflict. In the words of Sontag: "What I wanted people to think about is how serious war is, that it is more horrible than any kind of pictures can convey."[34] These *promised lands* are the spaces of a permanent conflict, where cycles of violence occur continuously producing a never-ending number of dead.

Promised Lands is a text that looks with favor at the Jewish national project. In an interview given in Jerusalem during its filming, Sontag declared: "Why should I be anti-Israel? ... I would find it very, very difficult to take a position against this country. I'm proud to be a Jew, I identify very much with other Jews, and by temperament, I'm predisposed to Israel."[35] At the same time, the film carries a critique of post-1967 Israel: propelled by the economic boom that

organizations of Jewish communal life are not connected in some way or another with Israel." See Eisenstadt, *Jewish Civilization*, 269.

32 Ibid., 277–285.
33 "*Promised Lands*, that would stand as the best Susan ever made. Even today, after all the shifts the Arab-Israeli conflict has undergone, the film remains an indispensable guide to that conflict. It brought Susan's analytical mind to a highly emotional situation and showed the conflict's hideous toll on individual lives while avoiding clichés and propaganda." See Benjamin Moser, *Sontag: Her Life and Work* (New York: Ecco Press, 2019), 542.
34 Susan Sontag recounts her experience of filming in Israel: "I arrived in Israel with a small crew during the recent Arab-Israeli war to make a so-called 'documentary.' ... Being rather tuned into sadness, to the tears of things, I put a lot of that in the film. [...] What I want people to think about is how serious war is. It is more horrible than any kind of pictures could convey, and maybe one of the most horrible parts of it is that it becomes a normality. There is a culture of war." See Nancy D. Kates, dir., *Regarding Susan Sontag*. 2014; United States: HBO, 1 hr., 40 min.
35 Moser, *Sontag*, 543.

followed the war, a capitalist and individualist ethos started to take hold of the country. The intellectual Yoram Kaniuk, one of the protagonists of Sontag's film, declares:

> Until the 1967 war Israel had been a scrappy society whose main concern was survival and whose highest values were equality and solidarity. But victory brought money—"People started building villas"—and the moral degeneration abetted by imperial fantasies: Israel "became very unconcerned about other people's suffering, other people's plights."[36]

The film thus registers the pain of Israelis fighting a war while it denounces at the same time the violence that victims can commit in a moment of blindness when they momentarily have a lack of empathy for the "other."

Proceeding by visual and aural associations, like a poem on screen, Sontag opens her film with images of the Christian Quarter in Jerusalem's Old City followed by a sequence filmed in a biblical landscape in which an Arab shepherd is tending to his flock. Examples of ancient devotion and practice, these scenes lead to a commemoration of World War I fallen soldiers at a military British cemetery on Mount Scopus. Here religion, at the service of national politics, is used to give a meaning to the sacrifice of young men: the priests and the soldiers participate in a rite that, although it commemorates the memory of the fallen, perpetuates the ideology of war.

The messages of peace engraved on the headstone of the fallen have no meaning when a war has just been fought. Sontag, in fact, edits the images of the cemetery with the shots of a burned military vehicle abandoned in the Sinai Desert along with the featureless corpse of a soldier: from the buried bodies of World War I to the bodies yet to be buried of the Yom Kippur War, the violence of war crosses time zones and locations.

Sontag's camera traces the aftermaths of violence and war, guided by the belief that violence generates only more violence. The sequences of the shell-shocked veteran undergoing treatment hit the viewer by testifying the way in which war and its violence affect the souls and bodies well after its end. The young soldier burying his head under the cushion, while lying on his hospital bed, may well express the refusal to face yet another war.

"No more wars" recites a headstone in the British cemetery while Kaniuk, interviewed at length during the course of the film together with physicist Yuval Ne'eman, expresses his pessimism:

36 Ibid.

The Jews know drama. They don't know tragedy. Tragedy is when right is opposed to another right. And here are two rights. The Palestinians have full rights to Palestine. And the Jews have full rights to Palestine. Don't ask me why. But they have. There is no solution to a tragedy, and this is a tragic situation here.

But despite this pessimism, *Promised Lands* is full of sequences of Palestinians and Israeli Jews standing side by side, forcibly sharing a space. While the harrowing sequence of mourners at the Israeli military ceremony is marked by the absence of the ones who died, the shots at the marketplace, for example, offer an example of completeness that translates into a possibility of coexistence between the two peoples.

If Lanzmann celebrates in his film the Jews' reappropriation of violence, Sontag instead invites the viewer to consider the deadly mechanism of violence that produces more violence in a tragic crescendo that is difficult to halt. Sontag's critical opposition to the culture of war can be seen as an anticipation of a contemporary trend growing inside the Jewish diaspora that is critical vis-à-vis Israel's security policy and increasingly sensitive to the fate of the Palestinian nation. In this sense, the plural in the title of the film suggests the possibility of other modes of fulfilling the promise of the land, which can be shared by more than one people. From the post-Holocaust image of the resistant Lanzmann to the traumatized image of Sontag, up to more recent representations, Israel on screen functions as a board on which the diaspora can sketch its ideas (and hopes) for the Jewish state while, in parallel, the Israelis can renegotiate the components of their national story.

Bibliography

Akerman, Chantal, dir. *Là-Bas* [Down there]. 2006; France: Amip. 1 hr., 18 min.
Alfi, Guri; Cohen, Dudi; Nawi, Assaf, dir. *The New Jew*. 2021: "The Choice," KAN. 45 min. https://www.kan.org.il/program/?catid=1841.
Barthes, Roland. *Empire of Signs*. New York: Hill and Wang, 1987.
Bellow, Saul. *To Jerusalem and Back*. New York: Viking Press, 1976.
Braunold, Joel. "Jewish Prostitutes, Jewish Thieves and Jewish Supremacists." *Haaretz*. May 15, 2014. https://www.haaretz.com/jewish/2014-05-15/ty-article/.premium/targeting-jewish-supremacists/0000017f-e854-dc7e-adff-f8fd34250000.
Dassin, Jules, dir. *La guerre amère* [Survival 1967]. 1968; France: Les Artistes Associés. 1 hr., 10 min.

Eisenstadt, Shmuel. *Jewish Civilization: The Jewish Historical Experience in a Comparative Perspective*. Albany, NY: State University of New York Press, 1992.

Fabbri, Lorenzo. "Neorealism as Ideology: Bazin, Deleuze and the Avoidance of Fascism." *The Italianist* 35, no. 2 (2015): 182–201.

Frodon, Jean-Michel. *Le Cinéma français: De la Nouvelle Vague à nos jours*. Paris: Cahiers du Cinéma, 2010.

Hirshhorn, Sara Yael. *City on a Hilltop: American Jews and the Israeli Settler Movement*. Cambridge, MA: Harvard University Press, 2017.

Hjort, Mette, and Scott MacKenzie, eds. *Cinema and Nation*. London: Routledge, 2000.

Kates, Nancy D., dir. *Regarding Susan Sontag*. 2014; United States: HBO, 1 hr., 40 min.

Lanzmann, Claude. *The Patagonian Hare: A Memoir*. London: Atlantic Books, 2012.

Lanzmann, Claude, dir. *Shoah*. 1985; France: Les Films Aleph. 9 hrs., 30 min.

Lanzmann, Claude, dir. *Tsahal*. 1994; France: Why Not Productions, 2008. 4 hrs., 50 min.

Lanzmann, Claude, dir. *Why Israel*. 1973; France: Why Not Productions, 2007. 3 hrs., 12 min.

Moser, Benjamin. *Sontag: Her Life and Work*. New York: Ecco Press, 2019.

Ne'eman, Judd. "The Lady and the Death Mask." In *Israeli Cinema: Identities in Motion*. Edited by Miri Talmon and Yaron Peleg, 70–83. Austin: University of Texas Press, 2011.

Ram, Uri. *The Globalization of Israel: McWorld in Tel Aviv, Jihad in Jerusalem*. London: Routledge, 2008.

Rancière, Jacques. *The Politics of Aesthetics: The Distribution of the Sensitive*. London: Continuum, 2004.

Reichmann University. "The Four Tribes Initiatives." December 9, 2021. https://www.idc.ac.il/en/research/ips/pages/4tribes.aspx.

Sartre, Jean-Paul. *Anti-Semite and Jew*. New York: Schocken Books, 1995.

Sartre, Jean-Paul. *Réflexions sur la question Juive*. Paris: Paul Morihien, 1946.

Sontag, Susan, dir. *Promised Lands*. 1974; France: Gaumont. 1 hr., 27 min. https://www.youtube.com/watch?v=4NnHLJkcxrE&t=3s.

Waxman, Dov. *Trouble in the Tribe: The American Jewish Conflict over Israel*. Princeton, NJ: Princeton University Press, 2016.

Yehoshua, A. B. "A. B. Yehoshua." *Azure* (Winter 1999): 226–232, here 231, https://azure.org.il/download/magazine/1737az6_Sym_A.B.Yehoshua.pdf.

Zertal, Idith. *Ha-Umma veHa-Mavet: Historia, Zikaron, Politika* [Death and the nation: History memory, politics]. Tel Aviv: Dvir, 2000.

PART 3

Within, without: Becoming Glocal

CHAPTER 9

Tarnishing History through Matter: Gal Weinstein's *Sun Stand Still* at the Israeli Pavilion in Venice

Luna Goldberg

> The identity of place is always embedded in the histories which people tell of them, and, most fundamentally, in the way in which those histories were originally constituted … Whenever we talk about places, what is at issue, whether we acknowledge it or not, are competing versions of the histories in the process of which the present of those places came into being. Whenever we speak about the identity of a place, therefore, we run the danger of imputing to that place a false 'essence,' by abstracting it from the history of the place itself.
>
> PAUL CONNERTON, *How Modernity Forgets*[1]

∴

In his book *How Modernity Forgets*, Paul Connerton writes about the process through which histories are altered with time, how elements and narratives that characterize a place are sometimes forgotten or obscured from their overarching histories. Michel-Rolph Trouillot echoes Connerton in *Silencing the Past: Power and the Production of History* by posing the question of why certain narratives become "powerful enough to pass as accepted history, if not historicity itself" while others do not.[2] Referencing the construction of national histories, Trouillot notes that history is often written by those "who won" and manipulated to serve the interests of those in power. The specific historical "truths" or national narratives recounted thus become fictions among others.

In his practice, Israeli artist Gal Weinstein challenges the construction of national historiography in Israel. Relying on iconic imagery and symbolic

1 Paul Connerton, *How Modernity Forgets* (Cambridge: Cambridge University Press, 2009), 50.
2 Michel-Rolph Trouillot, *Silencing the Past: Power and the Production of History* (Boston, MA: Beacon Press, 1995), 6.

landscapes within Israel, Weinstein plays with the deconstruction of Zionist myths and narratives fixed in Israeli historiography through his immersive installations. His works often reconstruct imagery ingrained within Israeli collective memory through the use of synthetic and nontraditional materials, which themselves function as a critique of the subjects he chooses. At the core of his practice is also a preoccupation with the evolution of the image. Drawn from biblical narratives and iconic, romanticized landscapes and symbols in Zionist historiography, the images he takes as subjects are ones so embedded within Israeli society that they have become untouchable. The deconstruction of such symbolic imagery and landscapes through their reinvention in materials of poor quality, for Weinstein, functions as a means of reactivating them, "making the untouchable, touchable again" by the very use of the frame from which they originated.[3] By reproducing the image in nontraditional synthetic materials, Weinstein dilutes the charged nature of his subjects, making the works and the histories they encompass tangible to their viewers and allowing them to reimagine the narratives ingrained within them.

In 2016, Weinstein was selected to represent Israel at the 57th Venice Biennale. His exhibition, *Sun Stand Still*, served as an extension of his practice, challenging the construction of national historiography as it related to the Israeli Pavilion, a building whose history and architecture can be tied to nation-building for the Jewish state in its early years. Specifically, Weinstein's work in Venice references and criticizes the history of Bauhaus architecture in Tel Aviv and how this narrative and its legacy was retroactively historicized and reshaped into the greater architectural history of the state. In *Sun Stand Still*, Weinstein reflects on the Pavilion as a site that has denied the passage of time with its pristine untouched façade. He positions the building as a utopic space, one that could only exist outside of Israel, as the majority of Bauhaus buildings in Israel (unlike the one in Venice) have not been well preserved over the years. Using the history and structure of the Pavilion as a frame, Weinstein's exhibition collectively challenges the building's denial of the passage of time and the image the state sought to promote through its construction. His critical exploration of mythological, iconic, and romantic images and symbols of the early Zionist enterprise further serve as a means of undoing or questioning the foundations on which the nation was built, his works pointing to the space between the symbolic and the concrete, the real and the simulated, through his use of synthetic and organic materials.

The following chapter will take *Sun Stand Still* as a case study, examining how Weinstein uses materiality and installations disrupting the modernist

3 Author interview with Gal Weinstein, January 5, 2016, in Tel Aviv.

architecture and functionalist aesthetic of the Israeli Pavilion as a means of critiquing how the nation forged its image on a global stage while simultaneously reflecting on the current state of the country. In reconstructing installations drawn from iconic imagery, biblical references, and symbolic landscapes, the exhibition seeks to spoil the utopic image of the state, revealing dark or obscured portions of its history. The centerpiece of the exhibition—an installation of molding growths spread throughout the building that actively age and decay the interior of the structure—serves as an allegory for the nation, Weinstein's manipulation of the interior of the Pavilion functioning as a metaphorical critique of the state. I will begin with a segment on the history of the Pavilion and how it served as a means of nation-building for the Jewish state in its early years, prior to delving into two specific works in the exhibition. Drawing on the building's history and relation to the Bauhaus in Israel, the exhibition demystifies certain fixtures within Israeli historiography, exposing the fabricated nature of national narratives and myths. Focusing on select works, I then hope to trace how the materiality in Weinstein's practice—specifically his work in Venice—serves as a means of critiquing the historical and present context of the Pavilion as well as the nation. The Pavilion thus becomes a stage or screen through which Weinstein is able to deconstruct romanticized myths and pillars on which the state was built, exposing darker aspects of Zionism and their repercussions on the present realities of the nation.

1 Zeev Rechter's Modernist Pavilion: Nation Building and the Bauhaus in Israeli Historiography

In 1946, two years prior to the founding of Israel, an initial query about the construction of an Israeli Pavilion was submitted to the mayor of Venice.[4] Five years later, Zeev Rechter was appointed as the architect for the Biennale project. Built in a style characterizing pre-state construction in Israel and completed in 1952 (only four years after the founding of the State of Israel in May 1948), the Pavilion and its architecture played an important and symbolic role in the construction of national identity at a time when the "newly founded Israeli state faced the challenge of uniting its heterogeneous population into a national community."[5] Much like the city of Tel Aviv, which would become the "White City" in the mid-1980s and 1990s as the state redefined and

4 Tami Katz-Freiman, Anne Ellegood, Sabine Schaschl, Ofra Eschel, and Yair Zakovitch, *Gal Weinstein: Sun Stand Still* (Tel Aviv: Magen Halutz, 2017), 109.
5 Ibid.

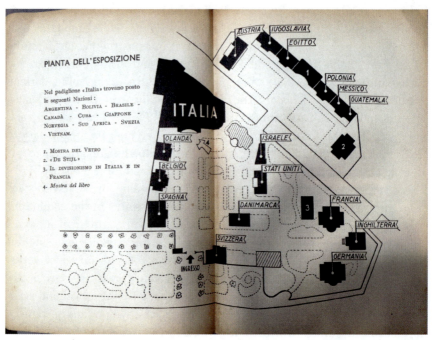

FIGURE 9.1　Map of the Giardini
26TH VENICE BIENNALE CATALOGUE, PUBLISHED JUNE 14, 1952

reconstructed its relationship to the Bauhaus and International Style, the Pavilion in Venice and its modernist style offered the state a space among other leading Western nations as the first non-European pavilion in the Giardini.[6] Its placement directly alongside the American Pavilion also served as a means of aligning Israel with the West (Fig. 9.1).

The integration of modernist, International Style, and Bauhaus constructions in Tel Aviv represented not only a Zionist gaze toward the West, but a yearning for European modernism.[7] Though it was not until the 1990s that architectural historians began to historicize and reconstruct the discourse around the Bauhaus in Tel Aviv, references to Tel Aviv as the "White City" started to appear in Hebrew literature as early as in 1915, even prior to the

6　Sigalit Landau, Jean de Loisy, and Ilan Wizgan, *Sigalit Landau: One Man's Floor Is Another Man's Feelings* (Paris: Kamel Mennour, 2011), 160.
7　Sharon Rotbard, *White City, Black City: Architecture and War in Tel Aviv and Jaffa* (London: Pluto Press, 2015), 6.

International Style's arrival in Tel Aviv (in the 1930s).[8] When the architectural legend of the "White City" began to spread into official state narratives in the 1990s, it further sought to place the country among other developed nations. As Sharon Rotbard notes in his book, *White City, Black City: Architecture and War in Tel Aviv and Jaffa*:

> The city's local International Style was seen as a means of propelling the country's integration into an increasingly globalized world. In 1994, the "Bauhaus in Tel Aviv" festival signaled the beginning of a series of daring attempts to push this narrative into the international canon of modern architecture. It was allotted this crucial role in the national rebranding because in order to fully participate in the globalization process at hand, to become the next stop on David Bowie's or Madonna's world concert tour and to entice wealthy investors and tourists from abroad, it was necessary to transform Tel Aviv into a "global city."[9]

Though this rebranding project and the transformation of the city's architectural history was pushed forward only in the 1990s (the shift in the conception of the city often attributed to and having been triggered by Michael Levin's seminal exhibition, *The White City: International Style Architecture in Israel, A Portrait of an Era* at the Tel Aviv Museum of Art), the influence of European modernism in Israeli architecture preceded the state.

It was in the early 1930s that Jewish architects like Aryeh Sharon, who had fled Germany, began to build in International Style or Bauhaus structures in Tel Aviv.[10] Sharon was one of three Bauhaus graduates who was active in Israel during that time, and was later appointed to design the first master plan for the state in 1948 as the head of the national urban planning office.[11] The ideals and ethos of the Bauhaus lent themselves well to the Jewish state in its early years, as it struggled to settle waves of immigrants who arrived shortly after its declaration. Among Sharon's most significant architectural contributions to the city were the workers' communal housing developments, which embraced

8 Ibid., 6.
9 Ibid., 15.
10 It has been noted that in the 1920s, prior to their arrival, architects such as Erich Mendelsohn, Zeev Rechter, Leopold Krakauer, Joseph Berlin, and Yohanan Retner had already begun to build according to the principles of modern architecture. See Bracha Kunda, "Sources of Inspiration for International style architects in Eretz—Israel," *Artlog*, August 5, 2017, http://www.artlog.co.il/oldartlog/telaviv/source.html.
11 Ibid.

the Bauhaus emphasis on social reform through simple and functionalist design.[12]

Other key modernist architects and central figures in Israeli architecture included Dov Karmi and Zeev Rechter, who, despite not having studied at the Bauhaus in Dessau, had each studied in Europe. As Sharon writes in *Kibbutz + Bauhaus: An Architect's Way in a New Land*, in the early 1930s young architects who had returned from progressive schools in Europe began to reshape the city of Tel Aviv. He notes:

> Within a relatively short time, we succeeded in infiltrating into the well-established architects' and engineers' association, in introducing and organizing competitions for public buildings and housing estates, in establishing architectural committees ... The time was ripe for an architectural revolt. Thousands of Jewish immigrants ... had already been imbued in Europe with new progressive ideas in art and architecture. The economic situation in Israel improved ... the impact of the new architectural circle was felt immediately.[13]

Together, the "Tel Aviv Circle," as they called themselves, transformed the city by bringing modernist constructions to the non-Western world, though it wasn't until after Levin's seminal exhibition *The White City: International Style Architecture in Israel, A Portrait of an Era*, that the city was rebranded as such.

It comes as no surprise that the young Jewish state selected Rechter, one of the key modernist architects in Israel at the time, to design its pavilion in Venice. As Sibel Bozdoğan notes in his article critiquing the importation of modernism into the East: "Modernist forms in the non-western world ... have been adopted as part of official cultural agendas engineered and enforced by nationalist elites who perceived themselves as agents of civilization."[14] The construction of a modernist building in Venice would serve as a means of positioning Israel as an extension of the West, much like it did in Tel Aviv. According to Levin, the arrival of the Tel Aviv Circle architects and "the absence of building tradition greatly facilitated the absorption of modern architecture in Israel ... The International Style was perceived as an expression of the link

12 Panayotis Tournikiotis, *The Historiography of Modern Architecture* (Cambridge, MA: MIT Press, 2001).
13 Aryeh Sharon, *Kibbutz Bauhaus: An Architect's Way in a New Land* (Stuttgart: Karl Krämer, 1976), 48.
14 Sibel Bozdoğan, "Modern Architecture in the Non-Western World," *Thresholds* 4 (1992): 4.

to Western culture, and many of the architects spared no effort to maintain contacts with Europe."[15]

While the state's initial query into the Pavilion preceded its founding, it wasn't until 1948–1949 that the Italian government would respond.[16] In her essay "Space—Movement—Light: Israeli Pavilion in Venice," Matanya Sack addresses a history of the Pavilion preceding Rechter and his design for the structure, and instead focuses on the building's prehistory and the initial proposal for the Israeli Pavilion, a 1949 design by an Italian architect. Found within Rechter's archive, the Italian plan proposed a structure divided into two galleries. Sack describes it as follows:

> Both galleries, one a bit larger than the other, are designed in the shape of simple boxes with upper ribbon windows to let in the light. According to classical tradition, the entrance to a building is in the center, slightly elevated, and has a wide staircase. The entry level is also a passage, or crossing to a secondary path in the garden.[17]

Two years later, in 1951, a letter was sent to the Ministry of Education and Culture in Israel on behalf of the President of the Arts Biennale, stating that the Pavilion could be designed as the architect saw fit, so long as it did not deviate from the building lines or interrupt existing flowerbeds and trees.[18]

Rechter's plan and final design for the Pavilion greatly deviated from the Italians' initial proposal (Fig. 9.2). The building took the form of a self-enclosed trapezoidal structure devoid of windows or decorative elements. Its white concrete façade hovers above the ground and is interrupted solely by the entrance, accentuated by two columns and floor-to-ceiling glass pane windows, meeting at an angle and receding away from the columns to create a covered entrance lobby to the space. Designed on three levels, two staircases create a circular path in the Pavilion, connecting the half-height intermediate level and upper

15 It is necessary to acknowledge that other architectural styles of building were present in Tel Aviv at the time, though these histories (including the spread of brutalism in Israel starting in 1948) are often overshadowed by the overarching narrative of the Bauhaus. See Michael D. Levin, *White City: International Style Architecture in Israel: A Portrait of an Era* (Tel Aviv: Tel Aviv Museum, 1984), 10.
16 The official date and year that the Italian government approved Israel's query is one I have not been able to locate documentation for, though the first plans for the Pavilion sent by the Italian architects are dated 1949. Zeev Rechter's grandson Amnon Rechter has also suggested that the official approval and invitation to build an Israeli pavilion came in 1948, preceding the plan.
17 Landau et al., *Sigalit Landau*, 170.
18 Author interview with Amnon Rechter, December 5, 2017, via phone.

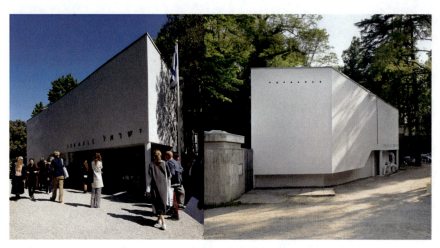

FIGURE 9.2 Exterior of the Israeli Pavilion, designed by Zeev Rechter, 1952
PHOTO BY AUTHOR

level to the ground floor and courtyard, a 1960s addition by a local architect.[19] According to his grandson Amnon Rechter, "the neoclassical traditionalist design that the Italian architects designed was obviously not representative of anything that had to do with the young Israel or with the older Israel for that matter, and once the decision was to take a great Modernist, the result would be quite naturally a Modernist building."[20]

Having immigrated from the Ukraine to Palestine in 1919, Rechter studied in Paris at the École Nationale des Ponts et des Chaussées under Le Corbusier from 1929 to 1932 and was highly influenced by his ideas on modernist architecture, functionality, and efficiency.[21] Le Corbusier's influence is visible in Rechter's design for the Israeli Pavilion, which could be characterized as a hybrid between Bauhaus architecture and brutalism, with integrated architectural features and elements particular to Le Corbusier such as the building's pilotis, free façade, and free plan. The building was designed as a kind of Corbusian villa reminiscent of Villa La Roche, though at the time Rechter's office had already been working with brutalist elements, such as exposed concrete, for other projects (perhaps accounting for the hybrid design of the structure). The use of columns, particular to Le Corbusier, had become an integrated and prominent feature of Bauhaus architecture in Tel Aviv and the construction of three levels with long windowless walls allowed for maximal use of the space

19 Landau et al., *Sigalit Landau*, 171.
20 Author interview with Amnon Rechter, December 5, 2017, via phone.
21 Katz-Freiman et al., *Gal Weinstein*, 109.

within the oddly shaped structure. The Pavilion's simple design and integration of different architectural styles and elements ultimately functioned as an adaptation to the site, maximizing available space within the footprint that had been allotted the country (given the project's budgetary limitations) while simultaneously incorporating the architectural properties and characteristics promoted or embodied by the state at the time.

2 Gal Weinstein's *Sun Stand Still*

In July 2003, UNESCO's World Heritage Committee designated Tel Aviv as one of its World Heritage Sites. The official text accompanying the declaration proclaimed "the White City of Tel Aviv" "a synthesis of outstanding significance of the various trends of the Modern Movement in architecture and town planning in the early part of the 20th century."[22] UNESCO's designation served as a means of reinforcing the construction of a particular architectural (and to a certain extent, political) history of the city. Following the declaration, the city organized a series of events, exhibitions, and ceremonies celebrating the UNESCO proclamation and its significance for the country. The "White City" it sought to recognize, however, was far from white, many of its buildings having been neglected and fallen into disrepair. Despite the state's long-term efforts and campaign to promote Tel Aviv as the "White City," a large majority of its International Style and Bauhaus structures have not been maintained over time. Because a significant number of these buildings were built to accommodate waves of immigrants who moved to the country in its early years, many of these constructions were built rapidly and not meant to last. It was only in the 1990s that Nitza Szmuk, an architect invested in the conservation of International Style buildings in Tel Aviv, began to draft the city's conservation plan designating some 1,600 buildings as historical.[23] Still, while the plan prohibited such buildings from being demolished, the enforcement of their renovation proved more complicated, particularly given the percentage of privately owned architectural landmarks.[24] To this day, a significant number of the International Style and Bauhaus buildings remain in poor condition.

22 UNESCO World Heritage Centre, "White City of Tel Aviv—The Modern Movement," December 11, 2017, http://whc.unesco.org/en/list/1096/.
23 Rotbard, *White City*, 9.
24 The government has initiated a number of incentives in order to motivate historic building owners to restore their properties, yet the costs are often a deterring factor. Among more successful initiatives was National Master Plan 38, for instance, which has allowed for the enlargement of certain apartment buildings in exchange for adding structural reinforcement against earthquakes. Both the addition of apartment units to such residential buildings and prospective profits have served as incentives to private building owners.

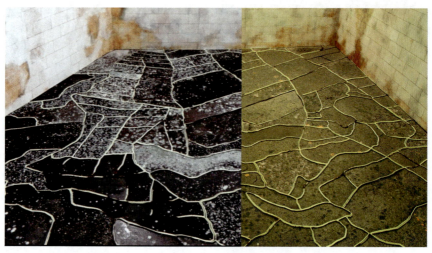

FIGURE 9.3 *Jezreel Valley in the Dark, Sun Stand Still*, Gal Weinstein, 2017
Coffee, polyurethane, metallic wool, felt, and plywood, Israel Pavilion, Venice Biennale, 2017
IMAGES BY LUNA GOLDBERG (LEFT), CLAUDIO FRANZINI (RIGHT)

In his 2017 exhibition at the Venice Biennale, *Sun Stand Still*, Weinstein uses the Pavilion and its modernist structure as a frame through which to address the disjunction between how the state sought to present itself on a global stage and how it exists in reality. The main installation in the exhibit is one which directly engages the Pavilion and its charged position as a site representative of the image Israel hoped to disseminate in its early years. Yet over 60 years later, the building, unlike those in Israel built in a similar style, has not aged. Literally and metaphorically, Weinstein's critique extends both to Israel's inability to live up to its image and to the notion that the image it sought to promote has in fact expired or been outgrown by the state.

Upon entering the Pavilion, one is immediately struck by the pungent scent of coffee that fills the space. The source of the scent is an installation on the intermediate floor of the structure, *Jezreel Valley in the Dark* (Fig. 9.4). From afar, one can recognize what appears to be an aerial landscape, that of Jezreel Valley, "one of the emblems of the agricultural settlements founded by Zionist pioneers [which] has acquired the status of a mythological landscape in Israeli collective memory."[25] Up close, however, the landscape comes apart, exposing the material that reconstructs it—mold spores of different tones and shades growing from Turkish coffee shaped by polyurethane molds invisible to the eye

25 Katz-Freiman et al., *Gal Weinstein*, 44.

TARNISHING HISTORY THROUGH MATTER 171

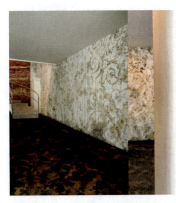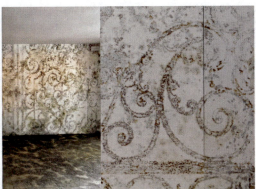

FIGURE 9.4 Installation and detail shots of *Ornament, Sun Stand Still*, Gal Weinstein, 2017
Metallic wool and plywood, Israel Pavilion, Venice Biennale, 2017
IMAGES BY LEE BARBU

yet which keep the form of the landscape. While to a certain extent, the work is contained by the landscape it recreates, the installation also spills out of the molds and onto the walls and floors of the Pavilion's entry level into a work called *Persistent, Durable, and Invisible*.

Beyond the clear glass doors and concrete walls of the structure, an aged and decaying space awaits the viewers, betraying the building's pristine white façade. The interior bears traces of a site that has been abandoned or neglected over time, tainted with the growth of both organic and synthetic mold spores. Stretching across the first level, darkened stains form patches along its walls and floors, their shades subtly changing based on the scale of the masses they produce. Despite their appearance as mold, upon further examination one can see that the growths infesting the walls are in fact patches of steel wool that have been colored and shaped to resemble mold spores. The growths spread into the corners of the Pavilion and climb up its columns, gnawing at the interior of the structure like termites on wood. The traces they leave behind form patterns, in some cases refined moments referencing another point in time while in others they represent the pure remnants of decay. Within this space, other installations are embedded, rendering the molding growths both an addition to and part of the vessel that contains the work—the Pavilion itself.

Along one of the walls, the spores take the shape of ornamental patterns embellishing the Pavilion's long uninterrupted white wall. Here, that which tarnishes also becomes an ornament, carving out faded spirals through the veil of murkier stains resembling flood marks (Fig. 9.3). The work, titled *Ornament*, playfully engages with the modernist architecture of the Pavilion and its functionalist aesthetic, the artist reinscribing ornamental elements and patterns reminiscent of the nineteenth-century décor into the streamlined minimalist

building. What has been inserted is that which the very structure—by virtue of its functionalist design—rejects, the ornament. The insertion of mold and the ornament disrupt Rechter's transparent and timeless design for the Pavilion, undermining its position as representative of modernity and progress. The Pavilion, a space that Weinstein critiques as not having aged, thus falls victim to the influence and wear of time, his installation signaling that time has in fact "caught up" with the structure.

The ornament too functions as a means of disillusioning the mirage behind the building's ageless face. Its insertion reveals stagnation in the image that the structure represents and, by extension, that which the nation sought to promote through its construction. In his essay "Ornament and Crime," Adolf Loos argues that "the evolution of culture is synonymous with the removal of ornament from utilitarian objects."[26] For Loos, ornamentation causes an object to expire or go out of style. It represents the lack of modernity or rather functions as a means of hindering a society's progress. "Freedom from ornament," he notes "is a sign of spiritual strength."[27] Weinstein's ornamentation of the space can thereby be read as a greater critique on the ruin of culture. Unlike the modern image the Pavilion embodies, the installation and insertion of the ornament reflects a nation that has been stunted, one that is not capable of developing. In the context of the Venice Biennale, the utopic site that the building portrays has "expired," the ornamentation of its interior and its materiality physically manifesting the building's symbolically worn and outdated state.

With *Ornament* and *Persistent, Durable, and Invisible*, Weinstein addresses the disjunction between the Israeli Pavilion in Venice and the society it seeks to represent in Israel. The modern structure, with its pristine white walls, becomes representative of a utopic era in Israel that has passed, leaving behind only remnants of its existence, crumbling grey buildings that comprise the "White City" of Tel Aviv. Through his transformation of the Pavilion's interior, Weinstein reconstructs a decaying, abandoned site, reminiscent of those International Style buildings that have undergone the wear of time in Tel Aviv. As a result, Weinstein's installation in Venice restores a bleak continuity between the Pavilion and the nation it seeks to represent, imbuing within it dark and critical commentary about Israel's past and the image it constructed for itself, as well as its current state of stagnation.

26 Adolf Loos, "Ornament and Crime" (1908), in *The Theory of Decorative Art: An anthology of European and American Writings 1750–1940*, ed. Isabelle Frank (New Haven, CT: Yale University Press, 2000), 288–294, here 289.
27 Ibid., 294.

While the works on the entry level enact a metaphorical critique of the nation through the use of steel wool mimicking mold, *Jezreel Valley in the Dark* reconstructs a landscape rooted within the Israeli imaginary to similarly address the construction of Zionist myths and narratives on which the nation was built. The installation, unlike that which stretches along the walls and floors of the Pavilion, is the only work in the exhibition made of organic material—mold spores cast in the form of the landscape that grow and evolve over the course of the exhibit. Weinstein's use of both synthetic and organic materials acts as a key to reading his works. The materials he chooses reveal an intentionality in relation to his subjects. In *Persistent, Durable, and Invisible* and in *Ornament*, Weinstein uses steel wool as a means of feigning the organic. His transformation of the material and its coloring by dipping the steel wool into chemicals and products as banal as Coca Cola or vinegar disguise its natural essence as an abrasive material typically used to clean surfaces. Here, instead, it becomes a substance that soils or tarnishes the structure, mimicking the mold spores that grow in *Jezreel Valley in the Dark*.

Weinstein's practice is one which evolves over time, referencing past iterations of work while simultaneously building upon them. Whereas in previous installations he actively sought to use poor-quality synthetic materials such as MDF board or carpeting to reconstruct charged visual imagery and symbols tied to the Zionist enterprise, in *Jezreel Valley in the Dark* Weinstein relies on actual organic material, the latter being among the first exhibitions in which he chooses to do so. In a 2002 iteration titled *The Valley of Jezreel* at the Herzliya Museum of Contemporary Art, Weinstein built a large-scale floor installation out of cheap synthetic carpets, thereby rendering the aerial landscape of the agricultural fields into a patchwork of vibrant greens, browns, and yellows mimicking a jigsaw puzzle. Through his use of synthetic materials, the artist is able to dismantle or expose the fabricated and charged nature of Zionist narratives. His reconstruction of these iconic symbols and landscapes from artificial materials, ones that "have no identity, no memory, no past," for Weinstein further acts as a means of distancing viewers from their association to his subjects.[28] The act of reconstructing this culturally embedded landscape from industrially processed materials devoid of aura reveals an inherent contradiction within the work, as the subject Weinstein represents is diluted, camouflaged by the materials that recreate it. What remains is a work existing between the real and the simulated, the symbolic and the concrete.

28 Author interview with Gal Weinstein, January 5, 2016, in Tel Aviv.

In the case of Jezreel Valley, Weinstein's reconstruction of the area's landscape at the Pavilion, this time out of molding coffee dregs, plays with the notion of growth and decay, progress and destruction. Located in the north of Israel, and circumscribed by mountains on all but one side, the valley was the site of several victories and losses for the Israelites, according the Bible. More pertinent to Weinstein's work, however, was the transformation of the infested swampy lands that the valley was made up of into a "fertile, fruit-bearing plain" by Zionist settlers in the early 1920s. Upon acquiring the land in 1921, the pioneers drained the swamps, revealing "some of the most fertile farmland in Israel."[29] In the context of the Pavilion, Weinstein's recreation of Jezreel Valley suggests a return to the valley as it existed when it was first discovered by the early Zionists. While *Jezreel Valley in the Dark* maintains the form of agricultural fields, they are composed of murky dark coffee, reminiscent of swamplands. The mold spores that proliferate from the coffee, while designating a rottenness, also denote a rebirth—the ability to grow and sustain a living material from rot and decay. Weinstein's use of organic matter at the Venice Biennale thus signals not the death or stagnation of a society, but rather its ability to evolve even under hazardous conditions.

Through his use of both synthetic and organic materials in *Sun Stand Still*, Weinstein's work seeks to demystify the pillars on which the Jewish state was founded, for these symbols, narratives, and culturally embedded landscapes that stand so tall in the minds of those who know them become the very elements that impede a nation's progress. His reconstruction of such imagery in lowly materials familiar to most viewers functions as a means of diluting the image, and making it "touchable" again, as it is only through critically reflecting upon the origins of such narratives and histories that one can continue to build upon them. Weinstein's engagement with the Pavilion and its history becomes a frame through which to examine and criticize the nation and how it sought to present itself on a global stage, with the construction of an elegant white modernist structure. Years later, however, the Pavilion continues to exist as a utopic space frozen in time, while the country and "White City" architecture it was built in the image of has fallen into disrepair and faded to grey. Using the Pavilion as a backdrop, *Sun Stand Still* addresses these gaps between representation and reality, the simulated and real, and the symbolic and concrete, all while exposing darker aspects of Zionism and their repercussions on the present realities of the nation.

29 Jewish Virtual Library, "Via Maris," December 12, 2017, https://www.jewishvirtuallibrary.org/via-maris.

Bibliography

Bozdoğan, Sibel. "Modern Architecture in the Non-Western World." *Thresholds* 4 (1992): 4.

Connerton, Paul. *How Modernity Forgets*. Cambridge: Cambridge University Press, 2009.

Jewish Virtual Library. "Via Maris." December 12, 2017. https://www.jewishvirtuallibrary.org/via-maris.

Katz-Freiman, Tami, Anne Ellegood, Sabine Schaschl, Ofra Eschel, and Yair Zakovitch. *Gal Weinstein: Sun Stand Still*. Tel Aviv: Magen Halutz, 2017.

Kunda, Bracha. "Sources of Inspiration for International style architects in Erezt—Israel." *Artlog*. August 5, 2017. http://www.artlog.co.il/oldartlog/telaviv/source.html.

Landau, Sigalit, de Loisy, Jean, and Ilan Wizgan. *Sigalit Landau: One Man's Floor Is Another Man's Feelings*. Paris: Kamel Mennour, 2011.

Levin, Michael D. *White City: International Style Architecture in Israel: A Portrait of an Era*. Tel Aviv: Tel Aviv Museum, 1984.

Loos, Adolf. "Ornament and Crime" (1908). In *The Theory of Decorative Art: An anthology of European and American Writings 1750–1940*. Edited by Isabelle Frank, 288–294. New Haven, CT: Yale University Press, 2000.

Rotbard, Sharon. *White City, Black City: Architecture and War in Tel Aviv and Jaffa*. London: Pluto Press, 2015.

Sharon, Aryeh. *Kibbutz Bauhaus: An Architect's Way in a New Land*. Stuttgart: Karl Krämer, 1976.

Tournikiotis, Panayotis. *The Historiography of Modern Architecture*. Cambridge, MA: MIT, 2001.

Trouillot, Michel-Rolph. *Silencing the Past: Power and the Production of History*. Boston, MA: Beacon Press, 1995.

UNESCO World Heritage Centre. "White City of Tel Aviv—The Modern Movement." December 11, 2017. http://whc.unesco.org/en/list/1096/.

CHAPTER 10

Contemporizing (Yemenite) Ethnicity: Hybrid Folklore in Mor Shani's "Three Suggestions for Dealing with Time" Dance Trilogy for Inbal Dance Theater

Idit Suslik

In 2016, Inbal Dance Theater premiered choreographer Mor Shani's *Simple Dance*, a folklore-inspired contemporary dance work, which was later followed by *While the Fireflies Disappear* (2018) and *Lechet* (2020), the three performances eventually becoming a trilogy entitled "Three Suggestions for Dealing with Time." The trilogy explores notions of ethnicity, tradition, and legacy in response to the canonical choreographic style identified with Inbal from its inception, commonly termed the "Inbalite" language, and the company's complex history.

Established in 1949 by Sara Levi-Tanai, Inbal Dance Theater presented a unique cultural and artistic integration of Eastern and Western influences.[1] Levi-Tanai achieved this by combining movement and musical ethnic elements, mostly Yemenite, with modern dance and theater modes. The company, however, was labeled as representative of Yemenite ethnicity, which did not conform to the image of "Israeliness" displayed and constructed through Israeli folk dances.[2] This resonated with the ambiguous social attitude of the newly formed Israeli state toward Yemenite culture in general. It was praised as a symbol of continuity between the traditional Jewish past and the forming national present, but ultimately rejected as an expression of Mizrachi exoticism that contrasted with the Hebrew-Zionist-Ashkenazi-secular-Sabra identity or body.[3]

1 Gila Toledano, *A Story of a Company: Sara Levi-Tanai and Inbal Dance-Theatre* [Hebrew] (Tel Aviv: Resling, 2005).
2 The Israeli folk dances displayed corporeal qualities such as youthfulness, vitality, and physical strength, which molded the idealized vision of the "new" Israeliness. See Zvi Friedhaber, "Folk Dance in Israel: 100 Years of Zionism in Dance" [Hebrew], *Folk Dance Supplement 4* of *Israel Dance Quarterly* 10 (1997): 3–16.
3 In the politics of Israeli Jewish cultural identity, the terms "Ashkenazi" and "Mizrachi" serve to define ethnic origin. "Ashkenazi" refers to Jews of Eastern and Central European descent,

Interestingly, Inbal Dance Theater's stylistic innovation received significant recognition abroad, but further complicated the public debate in Israel surrounding the company's cultural and artistic identity. This highlighted a consistent tension in Israeli society between Yemenite and Israeli, ethnic and national, exotic and innovative, art and folklore.[4] Inbal's position in the Israeli dance field became more marginalized from the mid-1960s onward with the establishment of other, more modern dance companies. It remained so up until the current millennium, though its status has significantly shifted through the works of Shani.

This chapter therefore analyzes "Three Suggestions for Dealing with Time" as a choreographic practice of contemporizing the Yemenite ethnicity that has defined Inbal from its beginning. I argue that Shani's works explicitly comment on Inbal's cultural-artistic identity and controversial position throughout the years, for the purpose of affirming Levi-Tanai's legacy as a source of the company's contemporaneity. Moreover, by expanding Levi-Tanai's unique stylistic integration, Shani thus realizes Inbal Dance Theater's potential as a *third space* (Bhabha [1995] 2006) through which the "Inbalite language" is updated and included in the choreographic present.[5]

1 **Yemenite *and* Israeli: Cultural Pluralism as Artistic Motivation in the Work of Sara Levi-Tanai**

Inbal Dance Theater was established in 1949 by Levi-Tanai (1910–2005) as a company that expressed Yemenite cultural heritage through Western theatrical and choreographic forms. Meanwhile, the collective Israeli identity, defined as Ashkenazi in nature, was constructed and promoted through folk dances that

whereas "Mizrachi" refers to Jews of Arab/Islamic or Oriental/Asian descent. In this context, the term "Sabra" (in Hebrew, *tzabar*—"cactus") is associated with the native-born (Ashkenazi) Israeli, but mostly symbolizes the constructed mythic image of the "new Jew." See Oz Almog, *The Sabra: The Creation of the New Jew* (1997; repr. Berkeley: University of California Press, 2000); and Dina Roginsky, "The National, the Ethnic and in-Between: Sociological Analysis of the Interrelations between Folk, Ethnic and Minority Dances in Israel," in *Dance Discourse in Israel* [Hebrew], ed. Henia Rottenberg and Dina Roginsky (Tel Aviv: Resling, 2009), 95–125.

4 Dina Roginsky, "Orientalism, the Body, and Cultural Politics in Israel: Sara Levi Tanai and the Inbal Dance Theater," *Nashim: A Journal of Jewish Women's Studies & Gender Issues* 11 (2006): 164–197.

5 Homi K. Bhabha, "Cultural Diversity and Cultural Differences," in *The Post-Colonial Studies Reader*, ed. Bill Ashcroft, Gareth Griffiths, and Helen Tiffin (1995; repr. New York: Routledge, 2006), 155–157.

began to develop during the 1930s and 1940s within the defining communal practice of the Yishuv known as the *masekhet*. This term stood for a multidisciplinary theatrical performance that presented narratives and imagery from the biblical past and the new rural, secular life in the *kibbutzim*.[6]

Dan Ronen explains that these dances were "an expression of Israeli vitality, the great diversity of the Israeli society and ... the will ... to create a new ... Hebrew nation in Israel ... that is not a differentiating religious ethnicity, but part of the historical and geographical space we belong to."[7] In practice, however, the representations promoted through the "original Israeli" folk dances stylized the features of the ideal Hebrew-Ashkenazi-secular-Sabra bodily model. As such, they functioned as a sign of exclusion, actively disembodying, as Meira Weiss argues, "'the Other within us,' namely, Arabs and Palestinians, but also Sephardim, Ethiopians, Russians, Yemenis, the disabled, the bereaved, lesbians and gays, and so forth."[8]

The mass immigration of Oriental and/or Mizrachi Jews to the newly founded Israeli state from the late 1940s onward was addressed by the establishment with social policies such as the "melting pot," the rejection of the diaspora through assimilation to a "standard model Israeli."[9] Accordingly, the immigrant cultures were required to abandon their distinct ethnicities and conform to the collective-unified Israeli culture, which was molded after the idealized Sabra. This agenda translated into an Orientalist-paternalistic attitude that reflected "a cultural superiority towards the 'primitive East' and a will to cultivate it, alongside a passion for what was perceived as a primal, rooted and indigenous sensuality."[10] This was also evident in the institutionalized folk dance field's treatment of the wide range of ethnic (Oriental) and minority (Arab) dances from the 1950s onward. Alongside initiatives aimed at preserving these traditions—thus framing them in need of "higher" cultural assistance[11]—the Israeli folk dance repertoire codified the "Yemenite step" and the Arab *dabke* as its basic elements[12] through a process of stylistic appropriation. Consequently, the dances were disconnected from their original cultural

6 The *kibbutz* was the first collective agricultural community established in the Yishuv and was based on the socialist-Zionist ethos. See Friedhaber, "Folk Dance in Israel," 3; and Almog, *The Sabra*, 226.
7 Dan Ronen, "Dreaming and Dancing: About Gurit Kadman" [Hebrew], *Folk dance Supplement 5*, of *Israel Dance Quarterly* 11 (1997): 10–14, here 13. The translations from Hebrew to English here and throughout the chapter were translated by the author.
8 Meira Weiss, *The Chosen Body: The Politics of the Body in Israeli Society* (Stanford, CA: Stanford University Press, 2002), 16.
9 Almog, *The Sabra*, 90.
10 Roginsky, "The National, the Ethnic and in-Between," 118.
11 Ibid., 106–108.
12 Gurit Kadman, *Ethnic Dance in Israel* [Hebrew] (Tel Aviv Masada, 1982).

roots and aesthetically altered, eventually being transformed into choreographic markers of the newly constructed national Israeli-Ashkenazi identity.[13]

In contrast, Inbal Dance Theater was characterized by a deliberate integration of sources, an approach that originated from Levi-Tanai's culturally diverse biography. And this approach is nowhere more evident than in a statement she made in 1981: "I grew up here; all of you know that I am an absolute Yemenite. However, my teachers were the true pioneers who came to Eretz Israel (Palestine) many years ago … I so much enjoyed drinking from their European springs."[14] Accordingly, she translated her multicultural background into an artistic language that manifested the movement across identities and stylistic influences in four distinct features of Inbal Dance Theater.

The first is form—a "total theater" composed of song, dance, music, acting, and text, based on the *masekhtot* she created in the *kibbutzim* before establishing Inbal and those created by her European-born colleagues, which displayed aesthetic features of German expressionist dance (*Ausdruckstanz*).[15] The second is the "Inbalite" movement language—an integration of ethnic sources (mostly Yemenite) with modern dance and theater "rooted in the belief that the ancient fundamentals of Eastern and Western Jewish folklore will blend in the future into a modern Israeli style."[16] The third is the "Inbalite" bodies—nonprofessional dancers who expressed performative artistry through an authentic articulation of Yemenite movement and gestures combined with choreographic forms and bodily postures associated with modern dance.[17] And the last consisted of the themes of the works—a combination of Yemenite sources, the Bible and Jewish tradition, the Eastern landscape, and the newly evolving Israel, which was reconstructed for the stage "to bring the unique spiritual treasures of the Yemenite Jewish congregation to the wide public and not leave them hidden for folklore lovers alone."[18]

The innovation of Levi-Tanai's artistic language thus lay in the unique form of multidisciplinarity that generated "organic transitions" between the various

13 Dina Roginsky, "Double Dance: Folk and Ethnic Dancing in Israel," *Dance Today* 3 (2000): 18–23, here 21.
14 Sara Levi-Tanai, "Sara Levi-Tanai Talks about Her Work" (1981) [Hebrew], *Dance Today* 20 (2011): 14–15, here 15.
15 Giora Manor, "And Sara Levi-Tanai Created the Multimedia: 35 Years of Inbal Dance Theatre" [Hebrew], *Israel Dance Annual* (1985): 26–28; Roginsky, "Orientalism," 170.
16 Levi-Tanai quoted in Toledano, *A Story of a Company*, 36.
17 Henia Rottenberg, "The Inbalite Language: The Creation of Sara Levi-Tanai," in *Sara Levi-Tanai: A Life of Creation* [Hebrew], ed. Henia Rottenberg and Dina Roginsky (Tel Aviv: Resling, 2015), 251–280.
18 Levi-Tanai quoted in Toledano, *A Story of a Company*, 39.

elements of the performance.[19] From a cultural perspective, Dina Roginsky stresses that Levi-Tanai "sought a harmonious, equal-status blend of all cultural Israeli sources."[20] In doing so, she displayed a recognition of the cultural diversity embedded within Israel, which therefore preceded the official transition from the "melting pot" agenda to the idea of cultural pluralism applied during the 1970s and defined by the "ingathering of the exiles" (*mizug galuyot*).[21]

2 Exotic or Innovative? The Reception of Inbal Dance Theater in Israel and Abroad

Inbal Dance Theater was the first modern institutionalized company supported by the State of Israel,[22] and the first to embark on an international tour. However, the company's formative years were accompanied by its evident move across inclusion in and exclusion from the dance field in Israel and abroad. Liora Malka Yellin argues that, because the internal discourse located the "ethnic" against the "Israeli" and the "national," the Israeli categorization of Levi-Tanai's work as the former embodied "a double negation," both social and artistic, and therefore undermined "the identification of Levi-Tanai as an artist who creates Israeli dance."[23]

Like the issue of Inbal's cultural identity, the question of whether Levi-Tanai's movement language represents (high) art or (low) folklore was constantly present in references to the company's works. For Levi-Tanai herself, Inbal Dance Theater represented "a new and modern Israeli theater" that exceeded the limits of folklore, because its works "strive for artistic expression."[24] This perception was supported by two significant figures of dance: American choreographers Jerome Robbins and Anna Sokolow, who discovered Inbal during subsequent, but related, visits to Israel at the beginning of the 1950s. In a report Sokolow prepared for the America-Israel Cultural Foundation, she stated that the company was "by far the most impressive in the dance in

19 Toledano, *A Story of a Company*, 31; Manor, "And Sara Levi-Tanai Created the Multimedia," 28.
20 Roginsky, "Orientalism," 186.
21 Shlomo Deshen, "From the 'Mizrachi Ethnicities' to Half the Nation," in *Half the Nation* [Hebrew], ed. Shlomo Deshen (Ramat Gan, Israel: Bar-Ilan University Press, 1986), 7–17.
22 Rottenberg, "The Inbalite Language."
23 Liora Malka Yellin, "A Stranger within Us: Choreography as Defiance in *The Story of Ruth*," in *Sara Levi-Tanai: A Life of Creation* [Hebrew], ed. Henia Rottenberg and Dina Roginsky (Tel Aviv: Resling, 2015), 183–209, here 183.
24 Sara Levi-Tanai, "Why Inbal?" [Hebrew], 1967, Inbal Archive, Israeli Dance Library Archive, Reference Code: 121.78.3.5.2, 1–8, here 1.

Israel" and praised Levi-Tanai's "creative ability and her sense of choreography and form."[25]

Inbal Dance Theater's scheduled first tour to Europe, America, and Canada (1957–1958) exposed the gap between the success it had gained abroad and its reception by the Israeli public. Gila Toledano mentions that the first newspaper coverage that acknowledged Inbal's existence focused on the tour but displayed "a general tone of astonishment and shock" from the possibility that Inbal would be recognized as representing the culture of Israel.[26] Moshe Wallin, a leading impresario at the time, stated: "The ministry of education should impose strict supervision over an export such as this and ban the exit of classless artists abroad."[27] By contrast, John Martin, dance critic for the *New York Times*, referred to Inbal as "The Dance Theater of Israel,"[28] and Abba Eban, Israel's ambassador to the United States at the time, wrote in a letter to the Ministry of Foreign Affairs that "every member of the INBAL group, and the Dance Theatre as a whole, have been ambassadors of good-will and understanding for Israel."[29] This demonstrates that Inbal Dance Theater was situated between two conflicting cultural gazes: it was perceived as a low folkloric "other from within" in Israel, but acknowledged abroad as an innovative artistic-cultural expression of the "New Israel."

Interestingly, the company's international success and professionalization seemed to complicate the public debate in Israel surrounding its cultural and artistic identity. Some reviews praised the technical progress of the dancers, noting that "the instruments have improved—crystalized,"[30] while others argued that Inbal "has lost much of its naivety and innocence."[31] Moreover, the establishment of the professional companies in Israel between the mid-1960s

25 Anna Sokolow, "Report on 'Inbal' Yemenite Dance Ensemble," in *Sara's Way: Sara Levi-Tanai and Her Choreography*, ed. Giora Manor (1954; repr. Tel Aviv: Inbal Dance Theater, 2002), 43.
26 Toledano, *A Story of a Company*, 89.
27 Moshe Wallin quoted in Edna Sharon, "Israeli Impresario on the Matter of 'Inbal'" [Hebrew], *LaIsha*, July 21, 1954, Inbal Archive, Israeli Dance Library Archive, Reference Code: 111.4.2.2.
28 John Martin, "Dance: Israeli Troupe," *New York Times*, January 7, 1958, Inbal Archive, Israeli Dance Library Archive, Reference Code: 111.4.3.1c.2.
29 Abba Eban, *Letter to the Ministry of Foreign Affairs*, 1958, Inbal Archive, Israeli Dance Library Archive, Reference Code: 111.4.3.1c5.
30 Ezra Zussman, "A New Show by 'Inbal'" [Hebrew], *Davar*, January 28, 1955, Inbal Archive, Israeli Dance Library Archive, Reference Code: 111.4.2.2.
31 Azaria Rapaport, "'Inbal' Company in the Program 'Canaan'" [Hebrew]. *Maariv*, March 7, 1955, Inbal Archive, Israeli Dance Library Archive, Reference Code: 111.4.2.2.

and 1970s further marginalized Inbal Dance Theater in the local dance field, coinciding with additional difficulties the company encountered due to financial issues and Levi-Tanai's reluctance to open Inbal's gates to other choreographers.[32] Ruth Eshel explains that "it was not a folklore company that could address the wide audiences of folk dances and ethnic dances, and in the eyes of the modern dance seeking audience it was perceived as an exotic company intended for tourists and tours abroad."[33]

In the decades that followed, Inbal Dance Theater experienced significant organizational and artistic turmoil.[34] However, all the choreographers who were assigned or chosen to create for the company, before and after Levi-Tanai's (more or less forced) resignation in 1991, attempted to maintain the "Inbalite" heritage. They did so either through new creations, revivals of the iconic repertoire, or contemporary dance works that aspired to correspond with Levi-Tanai's stylistic and ethnic approach.

3 "Three Suggestions for Dealing with Time": a Contemporary "Inbalite" *Third Space*

The most recent and constitutive example for a dialogue with the "Inbalite" language is Shani's dance trilogy, "Three Suggestions for Dealing with Time," which was created between 2016 and 2020. Shani's choreographic research took as its starting point the two central features of Levi-Tanai's unique artistic approach: stylistic integration and cultural pluralism. In the trilogy, he addresses these concepts from the perspective of Inbal Dance Theater's present, creating new manifestations of the company's defining movement and scenic language. These demonstrate key postmodern and contemporary features, such as globalism, transculturation, and hybridity, reflecting the blurring of cultural and national boundaries, stylistic eclecticism, and a critical reflection on tradition and time.[35] André Lepecki defines the "turning and returning"

32 The companies are Bat-Sheva Dance Company (1964), Bat-Dor (1967), The Israeli Ballet (1968), Kibbutz Contemporary Dance Company (1971), and Kol Demama (1975).

33 Ruth Eshel, *Dance Spreads Its Wings: Israeli Concert Dance 1920–2000* [Hebrew] (Tel Aviv: Israeli Dance Diaries, 2016), 514.

34 Zohar Burshtein, "Founder's Syndrome in Dance Companies: The Case of Bat-Dor and Inbal Dance Theatre," [Hebrew], *Dance Today* 22 (2012): 58–61.

35 Roland Robertson. "Glocalization: Time-Space and Homogeneity-Heterogeneity," in *Global Modernities*, ed. Mike Featherstone, Scott Lash, and Roland Robertson (London: SAGE Publications, 1995), 25–44; Charles Jencks, *The Language of Post-Modern Architecture* (1977; repr. London: Academy Editions, 1991).

to the past as "one of the most significant marks of contemporary experimental choreography,"[36] while Mark Franko points to the "power of recall" as the claim of dance on its historicity, placing the body as an archive that also generates new positions through the act of dancing.[37] In the following analysis of "Three Suggestions for Dealing with Time," I will show that Shani's process of commenting on Levi-Tanai's movement language was not aimed at recovering or preserving the past, as do artistic practices such as reconstruction, revival, and restaging.[38] Rather, it *relocates* the "Inbalite" language and legacy within the contemporary in such a way that "the same signs" are "appropriated, translated, re-historicized, and read anew."[39] Considering this perspective, I will demonstrate how the trilogy unfolds as a choreographic realization of what Homi Bhabha defines as a *third space*: an exploratory movement that positions culture in an "in-between" space of intervention that negotiates and redefines the cultural borders and social identities of "the Now."[40]

4 *Simple Dance*: Choreographing the Global "Melting Pot"

Simple Dance premiered at the 2016 Diver Festival: Contemporary Dance in Tel Aviv-Jaffa. Inbal Dance Theater's participation in the festival was not taken lightly by the local dance community. Since 2012, the Diver Festival had established itself as a leading Israeli dance platform showcasing cutting-edge choreographic practices, while Inbal was in many ways still haunted by "the distinct historical context it carried and its being a 'heritage center' and not only a dance company."[41] The theme chosen for the Diver Festival that year—"trad(e)ition"—invited a critical and reflective look at ethnicity and the

36 André Lepecki, "The Body as Archive: Will to Re-Enact and the Afterlives of Dances," *Dance Research Journal* 42, no. 2 (Winter 2010): 28–48, here 29.
37 Mark Franko, "Introduction: The Power of Recall in a Post-Ephemeral Era," in *The Oxford Handbook of Dance and Reenactment*, ed. Mark Franko (New York: Oxford University Press, 2018), 1–15, here 1, 4.
38 Roger Copeland, "Reflections on Revival and Reconstruction," *Dance Theatre Journal* 11, no. 3 (1994): 18–20; Deborah Friedes Galili, "Reframing the Recent Past: Issues of Reconstruction in Contemporary Israeli Dance," in *Dance on Its own Terms: Histories and Methodologies*, ed. Melanie Bales and Karen Eliot (New York: Oxford University Press, 2013), 65–96.
39 Bhabha, "Cultural Diversity and Cultural Differences," 157.
40 Homi Bhabha, *The Location of Culture* (London: Routledge, 1994), 1, 7.
41 Mor Shani, "Mor Shani's 'Simple Dance' in Inbal Dance Theater" [Hebrew], *Dance Today* 31 (2017): 42–46, here 42.

excluded Mizrachi culture.[42] Accordingly, Shani presented a folklore-inspired contemporary dance work that reframed ethnic dance to explore "what the folk dance of tomorrow will look like" and "what is the place of ethnic dance in Israel today."[43]

Considering Inbal's distinct cultural and artistic identity, *Simple Dance* opens with a surprising visual image of ethnic neutrality: the stage is white, bare, and empty, and the dancers are dressed in ordinary clothes. As the work develops, the main feature of the evolving dance is its lack of a distinct technique or recognizable cultural source. The choreography seems to intertwine diverse movement fragments that have been extracted from their original contexts: the Israeli *hora*, Irish dance, Argentinian tango, ballroom dancing, and even hip-hop. Moreover, this cluster of materials is performed by bodies that display what Valerie Briginshaw describes as "fleshy corporeality,"[44] the enhanced physicality and corporeal materiality identified with postmodern and contemporary dance.

In a text discussing the creative process of *Simple Dance*, Shani explains that his aesthetic approach for the piece was based on minimalism, because "folk dances are minimal in nature, since they are supposed to be danced by the people and not by professional dancers."[45] Considering this statement, I argue that the implementation of minimalism through abstraction together with stylistic integration enabled Shani to formulate his vision for "a kind of new global folklore"[46]—one that reflects the fluidity of cultural distinctions and aesthetic classifications in accordance with contemporary processes such as hybridity and transculturation.[47] As such, and much like the traditional "Inbalite" language, Shani's choreography displays the apparent simplicity of folk movement but embodies the complexity of interweaving various cultural influences and dance styles together.

Shani's sensitivity to the function of folklore as the crystalized expression of a people demonstrates through the choreographic score the essence of transculturation as a state that "transcends particular cultures on behalf of a universality of the human condition."[48] In the first part of the work, the

42 See official site: https://www.diverfestival.com/wp-content/uploads/2022/05/2016.pdf.
43 Shani, "Simple Dance," 44.
44 Valerie Briginshaw, *Dance, Space and Subjectivity* (New York: Palgrave, 2001), 139.
45 Shani, "Simple Dance," 45.
46 Ibid.
47 Roger Copeland, "Postmodern Dance, Postmodern Architecture, Postmodernism," *Performing Arts Journal* 7, no. 1 (1983): 27–43; Jésus Martín-Barbero, "The Processes: From Nationalisms to Transnationalisms," in *Media and Cultural Studies: Keyworks*, ed. Meenakshi Gigi Durham and Douglas M. Kellner (Malden, MA: Blackwell, 2006), 626–657.
48 Patrice Pavis, ed., "Introduction: Towards a Theory of Interculturalism in Theatre?" in *The Intercultural Performance Reader*, ed. Patrice Pavis (London: Routledge, 1996), 1–21, here 6.

rhythmic synchronization between the dancers and the corporeal unity of the collective movement realize the traditional function of folk dance and construct an image of a people that "speaks" a shared movement "language." Later, these formal choreographic patterns dissolve into the slow movement of individual bodies that gradually assemble again—either by will or necessity—through an intensive physical interaction that returns to the primal experience of humaneness: presence, touch, and intimacy.

Through these images, *Simple Dance* relocates Levi-Tanai's pioneering social-artistic vision within the context of global culture and contemporary Israel. As mentioned above, the implementation of cultural pluralism served as a mode of resisting the ethnic assimilation promoted through the "melting pot" agenda in Levi-Tanai's time. Quite similarly, Shani utilizes abstraction *and* hybridity to reflect upon "a world where nations and communities repeatedly disperse to the global village and yet constantly try to formulate a renewed self-definition."[49] As a possible answer, he presents folklore as a unifying—not erasing—practice, which can resolve the still-present "contemporary-Israeli ethnic conflict"[50] through assembling bodies in recognizable and new movement patterns.

5 *While the Fireflies Disappear*: Reimagining the Hybrid "Inbalite" Bodies

In 2018, Inbal Dance Theater was invited to premiere a new work at the prestigious Israel Festival – Jerusalem. Shani created *While the Fireflies Disappear* in honor of the company's upcoming 70th anniversary, describing it as "an attempt to reimagine Levi-Tanai's work in a contemporary context ... while preserving the gentle, flickering quality of Inbal Dance Theater's vanishing dances."[51]

While *Simple Dance* displayed a global vision of ethnicity and folklore, *While the Fireflies Disappear* returns to the distinct Yemenite culture and iconic elements of Levi-Tanai's unique movement language (Fig. 10.1). These include the *walnut*-shaped hand posture;[52] facial expressions of inward convergence

49 Mor Shani, *Simple Dance* [Program], 2016.
50 Shani, "Simple Dance," 42.
51 Mor Shani, *While the Fireflies Disappear* [Program], 2018.
52 Naomi Bahat-Ratzon and Avner Bahat, "The Creation of Sara Levi-Tanai in Text, Melody, Movement and Dance in Hebrew Culture," in *Sara Levi-Tanai: A Life of Creation* [Hebrew], ed. Henia Rottenberg and Dina Roginsky (Tel Aviv: Resling, 2015), 29–58, here 38.

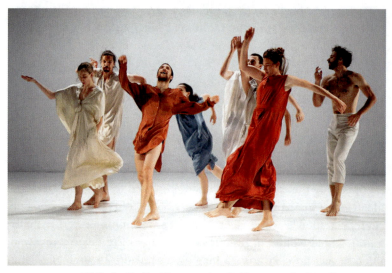

FIGURE 10.1 *While the Fireflies Disappear* (2018). Choreography: Mor Shani.
Performed by Inbal Dance Theater
PHOTO BY EFRAT MAZOR

simulating prayer;[53] stylized movement patterns such as squat-walking;[54] and codified dance steps like the *dassah* that Levi-Tanai perceived as reflecting "the desert ... the far horizon ... as well as the gracefulness of the camel's walk."[55]

Shani incorporates this traditional material in his work through artistic practices of aesthetic "citation," such as pastiche and intertextuality, creating sequences of choreographic and visual quotes from Inbal's dance heritage.[56]

At the same time, Levi-Tanai's signature language is also expanded and updated through acceleration and slow motion, or combined with contemporary floor work, lifts, and turns. Moreover, the dance is accompanied by computer-generated music that includes musical fragments from canonical songs like *Im Nin'alu* from the seventeenth century. This aesthetic approach is also applied to the costumes: the dancers perform in various robes inspired by traditional Yemenite *galabias* designed by Maskit—Israel's first high fashion house established in 1954 and internationally acclaimed for its "desert chic"

53 Rottenberg, "The Inbalite Language," 273.
54 Ibid., 266.
55 Sara Levi-Tanai, *Dassah* [Program], 1959, Inbal Archive, Israeli Dance Library Archive, Reference Code: 111.4.3.2b.1.
56 Sally Banes, *Writing Dancing in the Age of Postmodernism* (Hanover, NH: Wesleyan University Press, 1994).

style[57]—or, alternatively, in a contemporary and visually neutral look composed of black pants, black bras for the women, and no shirts for the men.

I wish to stress here that Shani's evident reflexivity toward the past not only stimulates an enjoyable experience of *déjà vu* from the (re)encounter with the recognizable "Inbalite" iconography,[58] but also comments on the company's complex history and position between exotic folklore and innovative art. This is expressed in two related scenes that point to an Ashkenazi-Sabra "gaze" that still dominates the politics of ethnic identity in Israeli society. At the beginning of the work, one dancer performs a series of "Inbalite" movements while holding sunglasses. Upon putting them on, his bodily attitude and facial expressions become exaggeratedly festive, simulating the Orientalist (Ashkenazi) look on Yemenite folklore as a primal, even indigenous, ethnic form of movement that has not been properly cultivated. Toward the end of the performance, the dancers slowly progress on stage in a squat-walk, and finally situate themselves on its edge. They take off their sunglasses, place them by their side, and observe the audience, thus acknowledging, and resisting, the potential paternalistic gaze that still exists in Israeli society toward expressions of ethnic dance and folklore.

While the Fireflies Disappear moves between past and present, tradition and innovation, presenting a contemporary model for a hybrid "Inbalite" body. In doing so, Shani resonates with Levi-Tanai's initial vision of her unique movement technique as a "permanent treasury of movements" that would function as "a method—that can be taught,"[59] and one that is composed of "a mixture of the original movement language and the free-personal-modern language."[60] Quite similarly, the dancing bodies in Shani's work emerge as a *transformational hybrid*[61] through the integration of distinctive "Inbalite" elements with the aesthetic of contemporary dance. Consequently, they become contemporary

57 Maskit designed costumes and jewelry for Sara Levi-Tanai's *A Wedding in Yemen* performed by Inbal Dance Theater in 1956. See official site: https://maskit.com/about/.
58 Umberto Eco, "*Casablanca*: Cult Movies and Intertextual Collage," *Substance* 14, no. 2 (1985): 3–12.
59 Levi-Tanai quoted in Dunevich "Sara Levi on the Programs of 'Inbal,'" [Hebrew] *Haaretz*, June 29, 1956, Inbal Archive, Israeli Dance Library Archive, Reference Code: 121.78.3.4.
60 Sara Levi-Tanai, "The Experience of Jewish-Yemenite Dance Positioned Against the Art of Yemenite Jews," in *Judaism and Art* [Hebrew], ed. David Cassuto (Ramat Gan: The Kotar Institute for Judaism and Contemporary Thought, 1989), 377–396, here 384.
61 As Jerrold Levinson explains, in a transformational hybrid art form object A incorporates defining features of object B, and is thus "transformed in a B-ish direction." See Jerrold Levinson, "Hybrid Art Forms," *Journal of Aesthetic Education* 18, no. 4 (1984): 5–13, here 10.

folklore, thus expressing a *bodily bilingualism*[62] that succeeds in cutting across the binding ethnic classifications and social categories previously used to locate Inbal in the Israeli dance field.

6 *Lechet*: Celebrating Ethnicity as a Contemporary Body Technique

In 2020, amid the COVID-19 pandemic, Shani created *Lechet*, which was inspired by "the landscape of the city emptying from its movement and leaving its streets to the walkers towards nowhere, to the runners in circles, to the people who have lost their destinations" (Fig. 10.2).[63] After specifically referring to the "Inbalite" movement language in *While the Fireflies Disappear*, Shani returns to the more global approach to folklore presented in *Simple Dance*, affirming ethnic dance as an organic part of Western urban culture and contemporary dance.

As its title suggests, *Lechet*—a Hebrew word signifying walking as an ongoing state—opens with repetitive, frantic, running sequences across the stage. They gradually transform into stylized and synchronized patterns of walking or skipping "decorated" by abstract ethnic "ornaments"—small hops sideways, foot cross-over patterns, and hip-swaying. As the dancers' projected energy changes, so do their movements, and the initial chaos turns into what seems to be the *joie de vivre* of dance, movement, and persistent existence.

Through this choreographic occurrence, Shani explores the codified human form of moving through two separate, but related, prisms. The first is the bodily mechanics of walking displayed through the various developments of the initial step and its changing qualities—mundane or stylized, fast or slow. In doing so, he resonates with the "Inbalite" technique's reliance on two fundamental patterns of steps, the Yemenite step and the *dassah*, the latter described by Manor as "the brick from which she [Levi-Tanai] builds the movement."[64] The second prism evolves from Shani's approach to walking as a sociality, a contemporary communal practice grounded in a shared history. This becomes evident in the flow between choreographic patterns that simulate walking on the streets and moments of stylized dancing—either ethnic or urban in nature

62 The integration of two distinct dance styles within one body can result in the body "speaking" the different languages through its aesthetic features and movement qualities. See Jane C. Desmond, "Embodying Difference: Issues in Dance and Cultural Studies," *Cultural Critique* 26 (1993): 33–63, here 46.
63 Mor Shani, *Lechet* [Hebrew] [Program], 2020.
64 Giora Manor, *Sara's Way: Sara Levi-Tanai and Her Choreography* [Hebrew](Tel Aviv: Inbal Dance Theater, 2002), 52.

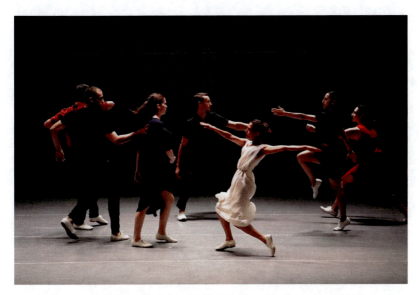

FIGURE 10.2 *Lechet* (2020). Choreography: Mor Shani. Performed by Inbal Dance Theater
PHOTO BY EFRAT MAZOR

(like a street dance "jam"). These emphasize the notion of bodily motion as the articulation, production, and preservation of social memory,[65] and therefore as "capable of formulating a kind of trace."[66]

The various forms of walking are therefore experienced as what Marcel Mauss defined as a *technique* of the body, stressing that "there is no technique and no transmission in the absence of tradition,"[67] or, similarly, as the bodily expression of Pierre Bourdieu's concept of *habitus* as "internalized as a second nature" and thus an "active presence of the whole past of which it is the product."[68] As such, they form a type of urban folklore, alternately shifting between an edgy and controlled quality of motion and "embodied traces" of ethnicity that manifest as humane, spontaneous energy. Through these distinct physical states, Shani creates a bodily whole, which in many ways constitutes a contemporary expression of Levi-Tanai's integrative approach, which

65 Paul Connerton, *How Societies Remember* (Cambridge: Cambridge University Press, 1989).
66 Susan Foster, "Walking and Other Choreographic Tactics: Danced Inventions of Theatricality and Performativity," *Substance* 31, no. 2–3 (2002): 125–146, here 131.
67 Marcel Mauss, "Techniques of the Body," in *Incorporations*, ed. Jonathan Crary and Sanford Kwinter (1934; repr. New York: Zone, 1992), 455–477, here 461.
68 Pierre Bourdieu, *The Logic of Practice*, trans. Richard Nice (1980; repr. Stanford, CA: Stanford University Press, 1990), 56.

is aimed at "expanding and diversifying" Yemenite folklore while attempting to "stay true to our sources and ourselves."[69] Quite similarly, Shani's "truth"—to paraphrase Levi-Tanai—is composed of tradition and contemporaneity, each of them equally enriching and deepening for the other.

In its choreography of tracing and *retracing*, *Lechet* seems to realize Shani's central motivation for *Simple Dance*, which he describes as a dare "not to lean on invention and innovation, but on the natural grace of the movements and the people."[70] In a sense, this vision coincides with Levi-Tanai's initial insistence on working with non-professional Yemenite dancers: "For our fundamental movement element, the movement treasure of the dances of Yemen, there was no conscious school. In the beginning it was a natural theater."[71] Like Levi-Tanai's reliance on the authentic Yemenite body knowledge and her perception of the ethnic tradition as artistically valuable, Shani's *Lechet* maintains the notion of folklore as a corporeal intelligence that guides the contemporary dancing body's journey through the present.

7 Conclusion: *Reaffirming* Ethnicity as Artistic Ethics

Reflecting on the creative process of *Simple Dance*, Shani asks whether ethnic dance can be "more than a monument for a past culture" and "exceed the realm of legacy, nostalgia, and entertainment."[72] In many ways, the dance trilogy "Three Suggestions for Dealing with Time" embodies the answer to this question for folklore in general, but more specifically in relation to Inbal Dance Theater. It acknowledges the company as a still-evolving entity moving back and forth from heritage to contemporaneity as its "'past-present' becomes part of the necessity, not the nostalgia of living."[73] Accordingly, the dancing bodies of Inbal today display a connection to the past, but mostly perform an awareness of time—that which has passed and that which still lingers in Inbal Dance Theater's present as a dance company, one that is a cultural institution and a Mizrachi-ethnic-Yemenite icon.

69 Sara Levi-Tanai, *Se'u Zimra* [Hebrew] [Program], 1952, Inbal Archive, Israeli Dance Library Archive, Reference Code: 111.4.2.1.
70 Shani, "Simple Dance," 46.
71 Levi-Tanai, "Why Inbal?," 2.
72 Shani, "Simple Dance," 44.
73 Bhabha, *The Location of Culture*, 7.

Because dance "lies at the point at which reflection and embodiment meet,"[74] the reflexive presence of time and historicity in the contemporary "Inbalite" bodies demonstrates how Shani's trilogy challenges the limiting discourse on ethnicity that has been accompanying Inbal Dance Theater from its beginning, while validating the significance of Levi-Tanai's movement language for the company's present. In doing so, Shani renegotiates Inbal's position in the Israeli dance scene, affirming its artistic identity as a contemporary dance company without erasing its ethnic roots.

During the years Levi-Tanai led Inbal Dance Theater, she consistently equated her artistic practice of stylistic integration with the social agenda of cultural pluralism, viewing both concepts as crucial for the creation of a (national) Israeli dance that would reflect and embody the country's ethnic diversity. This is evident in her following statement from 1981, in a seminar on dance at Tel Aviv Museum:

> Only when the gap between us will decrease, when we will all see the richness embodied in our language, in our old and new landscape, in the universal-Jewish heritage and the culture of the various ethnicities within us that also includes ethnic dance ... only then a true Israeli dance will rise for us.[75]

Upon beginning his work on the trilogy, Shani wrote that "the creation process itself should realize an ethical wish before upholding an aesthetic wish."[76] This artistic and humane position was articulated in his vision of *Simple Dance* as "an invitation to look through fresh eyes at banalities."[77] It was further developed in *While the Fireflies Disappear* and *Lechet* through the act of reimagining and celebrating Yemenite ethnicity—and ethnicity in general—therefore rejecting the common, banal perception of the ethnic as "exotic other" so deeply rooted in Israeli (Ashkenazi) society and its attitude toward Mizrachi culture. This way, Shani continues, and updates, Levi-Tanai's inclusive agenda, which acknowledged ethnicity and Israeliness as complementary components of a cultural and artistic whole, and not as contradictory identities. In doing so, he envisions Inbal Dance Theater as the *third space* in which this genuine integration can be realized and serve as a guiding model for Israeli society and art.

74 Randy Martin, *Critical Moves: Dance Studies in Theory and Politics* (Durham, NC: Duke University Press), 1.
75 Levi-Tanai, "Sara Levi-Tanai Talks about Her Work," 15
76 Shani "Simple Dance," 44.
77 Shani, "Simple Dance."

Bibliography

Almog, Oz. *The Sabra: The Creation of the New Jew*. 1997. Berkeley: University of California Press, 2000.

Bahat-Ratzon, Naomi, and Avner Bahat. "The Creation of Sara Levi-Tanai in Text, Melody, Movement and Dance in Hebrew Culture." In *Sara Levi-Tanai: A Life of Creation* [Hebrew]. Edited by Henia Rottenberg and Dina Roginsky, 29–58. Tel Aviv: Resling, 2015.

Banes, Sally. *Writing Dancing in the Age of Postmodernism*. Hanover, NH: Wesleyan University Press, 1994.

Bhabha, Homi K. "Cultural Diversity and Cultural Differences." 1995. In *The Post-Colonial Studies Reader*. Edited by Bill Ashcroft, Gareth Griffiths, and Helen Tiffin, 155–157. New York: Routledge, 2006.

Bhabha, Homi K. *The Location of Culture*. London: Routledge, 1994.

Bourdieu, Pierre. *The Logic of Practice*. 1980. Translated by Richard Nice. Stanford, CA: Stanford University Press, 1990.

Briginshaw, Valerie. *Dance, Space and Subjectivity*. New York: Palgrave, 2001.

Burshtein, Zohar. "Founder's Syndrome in Dance Companies: The Case of Bat-Dor and Inbal Dance Theatre" [Hebrew]. *Dance Today* 22 (2012): 58–61.

Connerton, Paul. *How Societies Remember*. Cambridge: Cambridge University Press, 1989.

Copeland, Roger. "Postmodern Dance, Postmodern Architecture, Postmodernism." *Performing Arts Journal* 7, no. 1 (1983): 27–43.

Copeland, Roger. "Reflections on Revival and Reconstruction." *Dance Theatre Journal* 11, no. 3 (1993): 18–20.

Deshen, Shlomo. "From the 'Mizrachi Ethnicities' to Half the Nation." In *Half the Nation* [Hebrew]. Edited by Shlomo Deshen, 7–17. Ramat Gan, Israel: Bar-Ilan University Press, 1986.

Desmond, Jane C. "Embodying Difference: Issues in Dance and Cultural Studies." *Cultural Critique* 26 (1993): 33–63.

Dunevich, Nathan. "Sara Levi on the Programs of 'Inbal'" [Hebrew]. *Haaretz*, June 29, 1956. Inbal Archive. Israeli Dance Library Archive. Reference Code: 121.78.3.4.

Eban, Abba. *Letter to the Ministry of Foreign Affairs*, 1958. Inbal Archive. Israeli Dance Library Archive. Reference Code: 111.4.3.1c5.

Eco, Umberto. "*Casablanca*: Cult Movies and Intertextual Collage." *Substance* 14, no. 2 (1985): 3–12.

Eshel, Ruth. *Dance Spreads Its Wings: Israeli Concert Dance 1920–2000* [Hebrew]. Tel Aviv: Israeli Dance Diaries, 2016.

Foster, Susan. "Walking and Other Choreographic Tactics: Danced Inventions of Theatricality and Performativity." *Substance* 31, no. 2–3 (2002): 125–146.

Franko, Mark. "Introduction: The Power of Recall in a Post-Ephemeral Era." In *The Oxford Handbook of Dance and Reenactment*, 1–15. New York: Oxford University Press, 2018.

Friedes Galili, Deborah. "Reframing the Recent Past: Issues of Reconstruction in Contemporary Israeli Dance." In *Dance on Its Own Terms: Histories and Methodologies*. Edited by Melanie Bales and Karen Eliot, 65–96. New York: Oxford University Press, 2013.

Friedhaber, Zvi. "Folk Dance in Israel: 100 Years of Zionism in Dance" [Hebrew]. *Folk Dance Supplement 4* of *Israel Dance Quarterly* 4 (1997): 3–16.

Jencks, Charles. *The Language of Post-Modern Architecture*. 1977. London: Academy Editions, 1991.

Kadman, Gurit. *Ethnic Dance in Israel* [Hebrew]. Tel Aviv: Masada, 1982.

Lepecki, André. "The Body as Archive: Will to Re-Enact and the Afterlives of Dances." *Dance Research Journal* 42, no. 2 (2010): 28–48.

Levi-Tanai, Sara. *Dassah* [Program]. 1959. Inbal Archive. Israeli Dance Library Archive. Reference Code: 111.4.3.2b.1.

Levi-Tanai, Sara. "Sara Levi-Tanai Talks about Her Work." 1981. [Hebrew]. *Dance Today* 20 (2011): 14–15.

Levi-Tanai, Sara. *Se'u Zimra* [Hebrew] [Program], 1952. Inbal Archive. Israeli Dance Library Archive. Reference Code: 111.4.2.1.

Levi-Tanai, Sara. "The Experience of Jewish-Yemenite Dance Positioned against the Art of Yemenite Jews." In *Judaism and Art* [Hebrew]. Edited by David Cassuto, 377–396. Ramat Gan: The Kotar Institute for Judaism and Contemporary Thought, 1989.

Levi-Tanai, Sara. "Why Inbal?" [Hebrew], 1967. 1–8. Inbal Archive. Israeli Dance Library Archive. Reference Code: 121.78.3.5.2.

Levinson, Jerrold. "Hybrid Art Forms." *Journal of Aesthetic Education* 18, no .4 (1984): 5–13.

Malka Yellin, Liora. "A Stranger within Us: Choreography as Defiance in *The Story of Ruth*." In *Sara Levi-Tanai: A Life of Creation* [Hebrew]. Edited by Henia Rottenberg and Dina Roginsky, 183–209. Tel Aviv: Resling, 2015.

Manor, Giora. "And Sara Levi-Tanai Created the Multimedia: 35 Years of Inbal Dance Theatre" [Hebrew]. *Israel Dance Annual* (1985): 26–28.

Manor, Giora. *Sara's Way: Sara Levi-Tanai and Her Choreography* [Hebrew]. Tel Aviv: Inbal Dance Theater, 2002.

Martin, John. "Dance: Israeli Troup." *New York Times*, January 7, 1958. Inbal Archive. Israeli Dance Library Archive. Reference Code: 111.4.3.1c.2.

Martin, Randy. *Critical Moves: Dance Studies in Theory and Politics*. Durham, NC: Duke University Press, 1998.

Martín-Barbero, Jésus. "The Processes: From Nationalisms to Transnationalisms." In *Media and Cultural Studies: Keyworks*. Edited by Meenakshi Gigi Durham and Douglas M. Kellner, 626–657. Malden, MA: Blackwell, 2006.

Mauss, Marcel. "Techniques of the Body." 1932. In *Incorporations*. Edited by Jonathan Crary and Sanford Kwinter, 455–477. New York: Zone, 1992.

Pavis, Patrice, ed. "Introduction: Towards a Theory of Interculturalism in Theatre?" In *The Intercultural Performance Reader*. Edited by Patrice Pavis, 1–21. London: Routledge, 1996.

Rapaport, Azaria. "'Inbal' Company in the Program 'Canaan'" [Hebrew]. *Maariv*, March 7, 1955. Inbal Archive. Israeli Dance Library Archive. Reference Code: 111.4.2.2.

Robertson, Roland. "Glocalization: Time-Space and Homogeneity-Heterogeneity." In *Global Modernities*. Edited by Mike Featherstone, Scott Lash, and Roland Robertson, 25–44. London: SAGE Publications, 1995.

Roginsky, Dina. "Double Dance: Folk and Ethnic Dancing in Israel" [Hebrew]. *Dance Today* 3 (2000): 18–23.

Roginsky, Dina. "Orientalism, the Body, and Cultural Politics in Israel: Sara Levi Tanai and the Inbal Dance Theater." *Nashim: A Journal of Jewish Women's Studies & Gender Issues* 11 (2006): 164–197.

Roginsky, Dina. "The National, the Ethnic and in-Between: Sociological Analysis of the Interrelations between Folk, Ethnic and Minority Dances in Israel." In *Dance Discourse in Israel* [Hebrew]. Edited by Henia Rottenberg and Dina Roginsky, 95–125. Tel Aviv: Resling, 2009.

Ronen, Dan. "Dreaming and Dancing: About Gurit Kadman" [Hebrew]. *Folk Dance Supplement 5* of *Israel Dance Quarterly* 11 (1997): 10–14.

Rottenberg, Henia. "The Inbalite Language: The Creation of Sara Levi-Tanai." In *Sara Levi-Tanai: A Life of Creation* [Hebrew]. Edited by Henia Rottenberg and Dina Roginsky, 251–280. Tel Aviv: Resling, 2015.

Shani, Mor. *Lechet* [Hebrew] [Program], 2020.

Shani, Mor. "Mor Shani's 'Simple Dance' in Inbal Dance Theater" [Hebrew]. *Dance Today* 31 (2017): 42–46.

Shani, Mor. *Simple Dance* [Program], 2016.

Shani, Mor. *While the Fireflies Disappear* [Program], 2018.

Sharon, Edna. "Israeli Impresario on the Matter of 'Inbal'" [Hebrew]. *LaIsha*, July 21, 1954. Inbal Archive. Israeli Dance Library Archive. Reference Code: 111.4.2.2.

Sokolow, Anna. "Report on 'Inbal' Yemenite Dance Ensemble." 1954. In *Sara's Way: Sara Levi-Tanai and Her Choreography*. Edited by Giora Manor, 43–45. Tel-Aviv: Inbal Dance Theater, 2002.

Toledano, Gila. *A Story of a Company: Sara Levi-Tanai and Inbal Dance-Theatre* [Hebrew]. Tel-Aviv: Resling, 2005.

Weiss, Meira. *The Chosen Body: The Politics of the Body in Israeli Society*. Stanford, CA: Stanford University Press, 2002.

Zussman, Ezra. "A New Show by 'Inbal'" [Hebrew]. *Davar*, January 28, 1955. Inbal Archive. Israeli Dance Library Archive. Reference Code: 111.4.2.2.

Works of the "Three Suggestions for Dealing Time" Trilogy

Lechet (2020). Choreography: Mor Shani. Performed by: Inbal Dance Theater. Stage and Light Design: Ofer Laufer. Costume Design: Omri Alvo. Music: Asid Arab live in Paris. Premiered at Inbal Theater, Suzanne Dellal Centre, April 2021. Trailer: https://www.youtube.com/watch?v=bd4MfQlMjSY.

Simple Dance (2016). Choreography: Mor Shani. Performed by: Inbal Dance Theater. Light Design: Yair Vardi. Costume Design: Yfat Kanfi. Music and Sound: Jaap Van Keulen, "Al Na Telech"—Shlomo Gronich and Matti Caspi (from "Behind the Sounds"). Premiered at Diver Festival—Contemporary Dance in Tel Aviv-Jaffa, Inbal Theater, Suzanne Dellal Centre, September 7, 2016. Trailer: https://www.youtube.com/watch?v=xz-4fii2mjo.

While the Fireflies Disappear (2018). Choreography: Mor Shani. Performed by: Inbal Dance Theater. Light Design: Omer Sheizaf. Costume Design: Maskit Fashion House. Music: "Itamar Gross (Including the song "Vatiur"—performed by Lea Avraham to music and lyrics by Shama'a Avraham). Premiered at Israel Festival – Jerusalem, The Jerusalem Theater, June 2, 2018. Trailer: https://www.youtube.com/watch?v=OcrSDa-zy-s.

CHAPTER 11

A Rough, Country Face: an Iranian Intellectual Retells the Holocaust

Samuel Thrope

In 1963, two of Iran's leading intellectuals, the writers Jalal Al-e Ahmad and his wife Simin Daneshvar, were invited on an official two-week trip to Israel. In the context of today's enmity between the Jewish state and the Islamic republic, such a visit seems nearly unimaginable. Indeed, the cognitive dissonance between now and then has attracted no little attention to Al-e Ahmad's written response to his journey to Israel. This attention has been compounded by the fact that in his work Al-e Ahmad depicts Israel, using a particularly Shia Muslim religious language, as an ideal state.[1]

But Al-e Ahmad's Israel book is not only a political tract. An author who came to prominence for his celebrated novels and short stories, Al-e Ahmad also applied the tools of storytelling to his nonfiction writing, and *The Israeli Republic* is no exception.[2] This chapter will discuss how Al-e Ahmad depicts Israel in narrative terms, focusing on a key passage in *The Israeli Republic*: Al-e Ahmad's visit to the Holocaust Memorial Yad Vashem. Before turning to this aspect of the text, however, it is necessary to set Al-e Ahmad's work in its historical and biographical contexts.

Born in Tehran in 1923, Al-e Ahmad was one of the leading activist intellectuals of twentieth-century Iran. His prolific literary output included novels, short stories, essays, translations, reportage, travelogues, and ethnography, but he is best known today for his most influential work, a 1962 critique of

1 See, most recently, Eskandar Sadeghi-Boroujerdi and Yaacov Yadgar, "Jalal's Angels of Deliverance and Destruction: Genealogies of Theo-Politics, Sovereignty and Coloniality in Iran and Israel," *Modern Intellectual History* 18, no. 1 (2019): 223–247, and the earlier literature quoted there.
2 Al-e Ahmad's Israel book only appeared in full, in a version edited by his brother Shams Al-e Ahmad, in 1984, 15 years after the author's death. Shams Al-e Ahmad titled his version of the book *Safar beh Velayat-e Ezra'il* (*Journey to the Land of the Angel of Death*), a pun on the title *Safar be Velayat-e Isra'el* (*Journey to the Land of Israel*) that Jalal Al-e Ahmad had given to the first two chapters when they appeared as a stand-alone essay in the left-leaning magazine *Andisheh va Honar* (*Thought and Art*) in 1964. As it remains unclear what title Jalal Al-e Ahmad himself would have given to the work had he succeeded in publishing it before his death, the English translation was given the title *The Israeli Republic*. For more details, see Jalal Al-e Ahmad, *The Israeli Republic*, trans. Samuel Thrope (New York: Restless Books, 2017).

Westernization in his home country that extolled Shia Islam as the foundation for an authentic Iranian culture. The book, entitled *Gharbzadegi*, was widely read and revered by activists opposed to the regime of Shah Mohammad Reza Pahlavi. This included future Supreme Leader Ayatollah Ruhallah Khomeini, who would rise to power in the wake of the 1979 Islamic Revolution. *Gharbzadegi*, literally meaning "the state of being stricken by the West," became a watchword of Iranian revolutionary politics, and Al-e Ahmad himself, who passed away unexpectedly in 1969, came to be considered one of the Revolution's intellectual forebears.[3]

Al-e Ahmad first became interested in Israel in 1948, when he and other left-leaning intellectuals had split from Iran's communist Tudeh Party and were seeking an alternative to both Western capitalism and Stalinism; the Zionist agricultural collective, the *kibbutz*, provided just such a model.[4] In the early 1960s, in the wake of ever-closer ties between Israel and Shah Mohammad Reza Pahlavi's Iran, opportunities arose for further contact with Israel and Israelis.[5] Israeli diplomats in Tehran brought artists, musicians, and others to Iran; they participated in cultural and intellectual life in the capital; and likewise arranged tours in Israel for several Iranian writers, painters, politicians, and cultural figures, Al-e Ahmad included.[6]

Al-e Ahmad and Daneshvar spent one week in Israel in February of 1963. The couple visited Tel-Aviv, Acre, Haifa, Jerusalem, and Nazareth, stayed at Kibbutz Ayelet Hashahar, met other writers, and participated in an archeological dig. Daneshvar also delivered two lectures at the Hebrew University in Jerusalem.

This was more or less the standard itinerary for Iranian visitors.[7] But Al-e Ahmad's literary response was anything but a standard travelogue.[8] Al-e Ahmad uses his Israel journey as a springboard for a wide-ranging meditation on

[3] *Gharbzadegi* has been variously translated as "Weststruckness," "Euromania," "Occidentosis," and "Westoxification." For a further discussion of the book and its significance, see Hamid Algar's introduction to Jalal Al-e Ahmad, *Occidentosis: A Plague from the West*, trans. R. Campbell (Berkeley: Mizan Press, 1984); and Roy Mottahedeh, *The Mantle of the Prophet* (New York: Pantheon, 1985), 287–336. For a biography of Al-e Ahmad, see Hamid Dabashi, *The Last Muslim Intellectual: The Life and Legacy of Jalal Al-e Ahmad* (Edinburgh: Edinburgh University Press, 2021).

[4] Al-e Ahmad, *Israeli Republic*, 62–64.

[5] See Lior B. Sternfeld, *Between Iran and Zion: Jewish Histories of Twentieth Century Iran* (Stanford, CA: Stanford University Press, 2019), in particular chapter three.

[6] Travelogues by writer Dariush Ashouri and politician Khalil Maleki are compared with Al-e Ahmad's own in Sadeghi-Boroujerdi and Yadgar, "Jalal's Angels." The first president of the Islamic Republic of Iran, Abolhassan Banisadr, also visited Israel as a student in 1962. See Sternfeld, *Between Iran and Zion*, 84–85.

[7] Al-e Ahmad, *Israeli Republic*, 25. Unfortunately, I have found neither a detailed itinerary for Al-e Ahmad and Daneshvar's trip, nor the topics of Daneshvar's lecture in Israeli archives.

[8] This is due, in no small part, to the text's punctuated publishing history, on which see note 2.

political theology, education, ethnicity, colonialism, and—the theme that drives much of his work—the divide between East and West. In turns admiring and excoriating, Al-e Ahmad both celebrates Israel as "a base of power, a first step, the herald of a future not too far off,"[9] and, in the final chapter written in the wake of the 1967 Six Day War, invokes anti-Semitic tropes to condemn Israeli aggression and blame French intellectuals' support for Israel on Jews' secret control of media, finance, and the state.[10]

In their readings of *The Israeli Republic*, earlier studies have rightly concentrated on Al-e Ahmad's ambiguous adoption of Zionism as a political theology precisely suited for the Iran of his day. In the most provocative portion of his Israel book, Al-e Ahmad claims that Israel is not like any other country, but is in fact a *velayat*, that is, a "guardianship state." The term *velayat* is drawn from Shia theology and, in this context, refers to a polity in which divinely inspired guardians—less than prophets but more than politicians—rule. As Al-e Ahmad writes:

> Ben-Gurion is no less than Enoch, and Moshe Dayan no less than Joab: these new guardians, each one with his own prophecies or—at least— clear-vision, built a guardianship state [*velayat*] in the land of Palestine and called to it all the Children of Israel ... like it or not, [the guardianship state of Israel] now governs and acts in the name of all the twelve million Jews scattered around the world.[11]

Here, as in *Gharbzadegi* and other work, Al-e Ahmad is evocative rather than programmatic; he never precisely spells out what the implications of Israel's status as a *velayat* might be for the East, nor how Israel should and could serve as a model for Iran. This is, though, entirely in keeping with his stated goals, namely, "that you come to know the disposition, the words, and the 'yes, buts' of a penman from this corner of the world—and a Persian speaker—faced with the reality of the Children of Israel's new country in this corner of the East."[12] In other words, the author declares his intention to be equivocal, and leaves for the reader the task of teasing out his theory of politics.

A straightforwardly political interpretation of *The Israeli Republic*, though, leaves the book's narrative aspects unconsidered. While the first chapter of

9 Al-e Ahmad, *Israeli Republic*, 56–57.
10 This final chapter, however, is more nuanced than it appears at first glance. See the further discussion in Al-e Ahmad, *Israeli Republic*, 14; and Sadeghi-Boroujerdi and Yadgar, "Jalal's Angels," 21–24.
11 Al-e Ahmad, *Israeli Republic*, 54.
12 Ibid., 57.

The Israeli Republic, which contains Al-e Ahmad's identification of Israel as a *velayat*, functions as an introduction to and justification for his trip and the work as a whole, chapters two, three, and four open with short depictions of events that took place on the couple's journey. In each of these three cases, the narratives could be dismissed as attempts to draw the reader in and make them more receptive to the didactic material that follows. In contrast, though, I believe that the narrative sections are in fact central to *The Israeli Republic*.

We will focus on the opening section of the second chapter, which is entitled "The First Calling." The chapter begins with an account of the couple's visit to the Yad Vashem Holocaust memorial in Jerusalem, which is located near the national cemetery on Mount Herzl.

Al-e Ahmad opens with a description of the site's Hall of Remembrance ("A huge granite edifice of four walls ... a thick one-piece ceiling laid on top of these four walls. A large, rough, black door of leaves of scrap iron") and then briefly mentions the museum and how the tour of its exhibitions brought him and his wife to tears.[13] The passage that follows is worth quoting in full:

> That same day a Dutch family, in whose honor a ceremony was held, had come for a visit. Under the broad and hushed vault that resembled a mausoleum, a group of elementary school children sang a hymn, a rabbi prayed, they gave the family medals, and they thanked the father of the family, who during the war had sheltered fifteen or twenty Jews and saved them from Hell.
>
> The person who received this honor was a tradesman, or some such type, with a rough, country face. But in order to be noble, it is not necessary that you be a philosopher or have an aristocratic mind. He must have been a man of feeling and compassionate for the fate of God's creation and, able to do so, hid some of the Children of Israel between the crates of a ship and spared them. I mean, so he said in the short speech he gave in response to the round of thanks of the organizers of the ceremony. And he added that, in his own small deed, he had no other goal but to answer the calling he felt in the face of this self-sacrifice, martyrdom, and suffering.[14]

This passage is typical of Al-e Ahmad's characteristic style of short, staccato sentences and minimal details, a departure from what had been an earlier canonical style of often-effusive Persian prose. He does not provide the

13 Ibid., 61.
14 Ibid., 62.

name of the Dutch rescuer[15] or any further context to aid the understanding of Iranian readers, who are necessarily unfamiliar with Yad Vashem and Israeli Holocaust commemoration overall. Interestingly, though it likewise goes unmentioned, Al-e Ahmad and Daneshvar witnessed one of the first ceremonies honoring Righteous Among the Nations, non-Jews who saved Jews during the Holocaust.[16]

The power of the passage lies precisely in this sparseness. The scene takes place in a "hushed" space that might as well be beyond the grave, the province of specters and wraiths. The vague description of the ceremony, in which an unspecified group of children sing an unnamed song, the rabbi intones an unknown prayer, and the speech awarding the rescuer his medal goes entirely unspoken, seems mysterious and foreign, unapproachable. It is unclear whether the narrator's distance from the events is due to overwhelming, disabling emotion; to the necessary estrangement of unknown language; or to some other factor.[17]

But against this backdrop, the rough-faced, plainspoken Dutch rescuer shines as if in a spotlight. His motives in risking his own life are depicted as simple: to answer a calling and to respond to his own compassion for God's creation. The rescuer comes across as humble and uncomplicated, a figure whom the reader can emulate and with whom they can identify.

Al-e Ahmad's decision to include this passage as the reader's first glimpse into Israeli reality, though, is anything but uncomplicated. In part, this choice is a reflection of the important role that the Holocaust plays throughout *The Israeli Republic*. The Israeli capture and trial of Adolf Eichmann, undertaken "in the name of six million Jews who were slaughtered in the crematoria of a Europe leprous with Fascism, before the establishment of Israel," in other words, not in the name of the country's own citizens, is cited as the prime example of Israel's exceptional status as a "guardianship state."[18] At the same

15 I have not yet been able to identify this individual.
16 For the history of the Righteous Among the Nations program, inaugurated in 1962, see https://www.yadvashem.org/righteous/about-the-program/program-history.html, accessed January 18, 2022. Interestingly, Al-e Ahmad does not mention that a tree was planted in the rescuer's honor, a regular feature of ceremonies at that time. See further Irena Steinfeldt, "Commemorating the Righteous Among the Nations at Yad Vashem: The History of a Unique Program," *Diasporas* 21 (2013): 82–90.
17 Al-e Ahmad spoke and read French as well as English, and translated French literature into Persian. The couple's guide in Israel was a French-speaking Belgian Jew who likely interpreted the ceremony for them. See *Israeli Republic*, 73.
18 Al-e Ahmad, *Israeli Republic*, 54–55. For a further discussion of this passage and Hannah Arendt's concept of the "banality of evil," see Sadeghi-Boroujerdi and Yadgar, "Jalal's Angels," 16 n. 83.

time, Al-e Ahmad argues that the Jewish state is "a coarsely realized indemnity for the Fascists' sins in Dachau, Buchenwald, and the other death camps during the war. Pay close attention: that is the West's sin and I, an Easterner, am paying the price."[19] Al-e Ahmad wavers throughout between the positions staked out by these almost-congruent passages: Israel, in the wake of the Shoah, as an admirable state of exception and Israel as a cynical capitalization by the West on the Holocaust for its own purposes.[20]

Even more important is how this passage constructs the position of the narrator himself. For the mention of the Dutch rescuer's response to a calling immediately brings to the narrator's mind his own earlier experience: "On that day I recalled the passion that called me ... to Israel on the eve of its foundation, but for a different reason."

As mentioned above, Al-e Ahmad was only one of several Iranian intellectuals who had begun to explore socialist alternatives to communism in the late 1940s. The context for this split in the left—prior to which almost all Iranian intellectuals identified with the communist Tudeh Party—was the Azerbaijan Crisis of 1946, which saw the Soviet Union refuse to relinquish control over territory in northern Iran that had been seized during the Allied occupation of the country in World War II. The Tudeh Party's support for the Soviets, and against Iranian interests, led leading Iranian socialist Khalil Maleki to break with the Tudeh; Al-e Ahmad was one of Maleki's leading disciples.[21]

In *The Israeli Republic*, following the quote cited above Al-e Ahmad describes how this group of renegade followers of Maleki investigated other parties, in India and Yugoslavia, that had similarly split with Moscow, and looked for a model of collective agriculture to replace the Soviet *kolkhoz*. He then relates the following narrative:

> There was a shop, and perhaps there still is, on Lalehzar Avenue. It was a textile shop and a tailor's called Melamed. It was also a distributor of Israeli publications and I, at that time, was renting Nader Naderpour's house on Nakissa Alley near Lalehzar. Every day I passed by that store. He put the publications in the display window so that people would see them. Then one day I also saw and bought and read and told Hossein

[19] Ibid., 57.
[20] To a degree, this is in line with Israel's own reaction to the Holocaust. See Tom Segev, *The Seventh Million: The Israelis and the Holocaust*, trans. Haim Watzman (New York: Hill and Wang, 1993).
[21] On Maleki and the Azerbaijan Crisis, see Homa Katouzian, *Khalil Maleki: The Human Face of Iranian Socialism* (London: Oneworld, 2018); and Sternfeld, *Between Iran and Zion*, 145–146 n. 18.

Malek, and things reached such a point that he and I became regular consumers of Israeli newspapers and magazines and pamphlets.[22]

The very short story told here seems, at first glance, to be worlds away from the somber Holocaust commemoration at Yad Vashem. In particular, the urban, Tehran setting,[23] populated by a cadre of excitable intellectuals, was no doubt familiar to Al-e Ahmad's readers.[24]

However, coming so close after the Yad Vashem narrative, and explicitly linked to it by the motif of responding to a "calling," the connections between the two short passages come to light. Like the Dutch man, here it is the narrator who is compelled to "rescue," that is, to buy, an Israeli publication from the tailor Melamed's shop. After this initial purchase, the narrator acquires more and more Israeli publications, so much so that he and Malek "became the transmitters of what reached this country as Israeli agricultural socialism."[25]

The juxtaposition of the two stories invites the reader to equate their two main characters: both simple, both noble, both driven to save. The Dutch rescuer, of course, is saving lives, and the narrator is only "saving" books. One might argue, though, that by aiding Iran, and the Iranian Left in particular, discover its own destiny, the life of a nation is at stake. In a larger frame, and in light of these narratives, this seems in fact to be the *The Israeli Republic*'s ultimate purpose: to rescue the idea of Israel from the tailor's shop window and to rescue it from the Jews themselves.

Nowhere is this point or this perspective made explicit in *The Israeli Republic*. However, a close reading of these two juxtaposed stories, and other of the books brief narratives that might be adduced, brings to light the book's primary goal, which is making use of the Israeli experiment—in cultural, political, religious, and especially educational terms—for the betterment of Iran.

22 Al-e Ahmad, *Israeli Republic*, 63.
23 Lalehzar Avenue was Tehran's first modern boulevard and a thriving cultural hub in the 1920s, 1930s, and 1940s.
24 Literary critic and poet Nader Naderpour was six years Al-e Ahmad's junior and had likewise split with the Tudeh Party under Maleki's leadership. See Houra Yavari, "Naderpour, Nader," *Encyclopaedia Iranica*, October 9, 2012, https://www.iranicaonline.org/articles/naderpour-nader. Hossein Malek, half-brother of Maleki, was a writer and prominent member of the Third Force. See Katouzian, *Khalil Maleki*.
25 Al-e Ahmad, *Israeli Republic*, 63.

Bibliography

Al-e Ahmad, Jalal. *The Israeli Republic*. Translated by Samuel Thrope. New York: Restless Books, 2017.

Algar, Hamid. "Introduction." In *Occidentosis: A Plague from the West* by Jalal Al-e Ahmad. Translated by R. Campbell. Berkeley: Mizan Press, 1984.

Dabashi, Hamid. *The Last Muslim Intellectual: The Life and Legacy of Jalal Al-e Ahmad*. Edinburgh: Edinburgh University Press, 2021.

Katouzian, Homa. *Khalil Maleki: The Human Face of Iranian Socialism*. London: Oneworld, 2018.

Mottahedeh, Roy. *The Mantle of the Prophet*. New York: Pantheon, 1985.

Sadeghi-Boroujerdi, Eskandar, and Yaacov Yadgar. "Jalal's Angels of Deliverance and Destruction: Genealogies of Theo-Politics, Sovereignty and Coloniality in Iran and Israel." *Modern Intellectual History* 18, no. 1 (2019): 223–247.

Segev, Tom. *The Seventh Million: The Israelis and the Holocaust*. Translated by Haim Watzman. New York: Hill and Wang, 1993.

Steinfeldt, Irena. "Commemorating the Righteous Among the Nations at Yad Vashem: The History of a Unique Program." *Diasporas* 21 (2013): 82–90.

Sternfeld, Lior B. *Between Iran and Zion: Jewish Histories of Twentieth Century Iran*. Stanford, CA: Stanford University Press, 2019.

Yavari, Houra. "Naderpour, Nader." *Encyclopaedia Iranica*. October 9, 2012. https://www.iranicaonline.org/articles/naderpour-nader.

CHAPTER 12

Imagined Israel? Israel in Contemporary British Theater

Glenda Abramson

In 2017, a Jewish American online magazine asked why, with regard to Israel, "British theatre can only produce shrill anti-Israel agitprop." It answered that "British theatres think it is better to be self-righteous than carefully to explore both sides of complex conflicts."[1] Over the past 20 years, there have been a number of British plays implicitly or explicitly criticizing Israel. This led to a headline in the same magazine: "British Theatre Has an Enemy and Its Name is Israel." While this is exaggerated, there have been instances of critical judgment of Israel in British plays.

The question I ask in this chapter is whether four of these plays, *Via Dolorosa* by David Hare, *Seven Jewish Children* by Caryl Churchill, *A Land without People* by Brian Rotman, and *My Name Is Rachel Corrie* by Katharine Viner and Alan Rickman, present well-reasoned arguments or whether they can be classified as "shrill anti-Israel agitprop."

This chapter also considers the implications of a theatrical controversy that took place in late 2021. During the period of Jeremy Corbyn's leadership of the British Labour Party from 2015 to 2020, Corbyn and his followers—who remain active in the party—raised the problem of definition: of the terms "anti-Semitism," "anti-Israelism," and "anti-Zionism," the last two are rhetorical labels with multiple meanings. Discussion of the problem of Israel, Zionism, and the attitudes toward them is inappropriate in an article on theater, but one question can legitimately be asked: Is Israel being singled out for opprobrium in the arts? Is the mainstream British theater equally preoccupied with other nations or regimes? Is it true that, as the rather feverish headline put it, British theatre has an enemy, and its name is Israel? Jeffrey Goldberg, editor-in-chief of *The Atlantic* wrote of "a particular theater subculture in Great Britain

1 "British Theatre Has an Enemy, and Its Name Is Israel," *Mosaic*, September 1, 2017, https://mosaicmagazine.com/picks/israel-zionism/2017/09/british-theater-has-an-enemy-and-its-name-is-israel/. See also *Standpoint*, August 27, 2017 (this online magazine stopped being regularly published in 2020).

that demonizes Israel."[2] In this chapter, I attempt to discover whether this is accurate and whether criticism of Israel in British drama is exaggerated or disproportionate. I also mention a new and controversial play produced while this chapter was being written. I have to stress that I am expressing my arguments not from the theatrical events themselves but from the printed play-texts and therefore am obliged to ignore the visual signs.

Before the advent of social media, "Jewishness" was not a serious problem in British theater, but in recent years, and particularly since Israel's disastrous confrontations with Gaza from 2006, with sometimes direct attacks on civilians, Israel has become the focus of international censure reflected in the theater as well. A play about rising anti-Semitism in the United Kingdom became the target of much online anti-Semitic vilification. *One Jewish Boy* by Stephen Laughton (2018), an "urgent response to overt anti-Semitism"[3] focuses on the marriage of a Jewish man and a mixed-race, non-Jewish woman, their experiences of hatred and abuse, and the impact of these experiences on their marriage. From the time publicity for the play was launched, Laughton became the target of invective on social media, and posters for the production were defaced and torn down. Palestinian flags were posted online in response to mentions of the play,[4] placing it within the general "anti-Israel" discourse.

It was not only stage plays that reacted to the Israeli policy of settlement in the Occupied Territories and to the Gaza campaigns: in 2012, in an open letter, many prominent members of the United Kingdom's theater and film industries protested Israel's national theater Habima's planned run of *The Merchant of Venice* at the Globe to Globe Festival.[5] Demanding that the Globe Theatre withdraw the invitation, the signatories wrote of their "dismay and regret," citing Habima's willingness to perform in the settlements despite a refusal to do so by several Israeli theater professionals.

2 Jeffrey Goldberg, "Caryl Churchill: Gaza's Shakespeare, or Fetid Jew-Baiter?" *The Atlantic*, March 25, 2009, https://www.theatlantic.com/international/archive/2009/03/caryl-church ill-gaza-apos-s-shakespeare-or-fetid-jew-baiter/9823/.
3 See https://www.londontheatre1.com/reviews/play/one-jewish-boy-by-stephen-laughton-at -trafalgar-studios-review/, accessed November 1, 2021. The title of the play is a response to Caryl Churchill's *Seven Jewish Children*, which is discussed below.
4 Harriet Sherwood, "Life Imitates Art," *The Guardian*, December 9, 2018, https://www.theguard ian.com/news/2018/dec/09/one-jewish-boy-abuse-campaign-play-london-antisemitism.
5 Ido Balas, "Israeli Theater Must Be Removed from London Festival, Top U.K. Cultural Figures Say," *Haaretz*, April 1, 2012, https://www.haaretz.com/israel-news/culture/1.5210286.

In 2014, Indhu Rubasingham, artistic director of London's Tricycle Theatre, declared that due to the sensitivity of the ongoing Israel-Palestine conflict, the theater's board had decided not to host the UK Jewish Film Festival because it was to be partially funded by the Israeli embassy.[6] The Tricycle was supported by Nicholas Hytner, then director of the National Theatre, Harold Pinter, the producer Michael Kustow, and Arnold Wesker, all of whom were Jews and major figures in British theater and all vocal critics of Israel's treatment of the Palestinians.

Over the past 20 years, a number of plays have judged Israel with little subtlety, primarily, but not exclusively, in response to the Gaza campaigns, including *Via Dolorosa* by David Hare; *My Name Is Rachel Corrie* by Alan Rickman and Katherine Viner; Caryl Churchill's *Seven Jewish Children: A Play for Gaza*; Brian Rotman's *A Land without People*. An American play on the subject, *Oslo*, did not take sides but dealt with this difficult topic with noteworthy neutrality, and became a critical and popular success. David Herman notes that this play is "a far cry from the shrill agitprop" preferred by the British stage.[7] The four plays I discuss have common elements: they fail to make a clear distinction between Jews and Israel, and implicitly or explicitly indict world Jewry for the suffering of the Palestinians. Their documentary aspect overrides the need for "stories," avoiding metaphorical fictional characters.

The plays exemplify political theater, the definitions of which are wide and conflicting: on the one hand, all theater is regarded as political and, on the other, theater can be political in the narrow sense of discussing a particular political issue. The plays are set in a political space that, also according to one of many definitions, is a place in which politics and territory are related,[8] and they are clearly concerned with taking sides. It seems impossible for critics, reviewers, and scholars to provide unbiased, unpolarized discussions of a political play as a theatrical event. In all these plays, I have chosen to examine, political standards replace theatrical ones.

6 Dorian Lynskey, "Tricycle Theatre and Israel: The Politics of the Cultural Boycott," *The Guardian*, August 6, 2014, https://www.theguardian.com/culture/2014/aug/06/-sp-tricycle-theatre-row-is-cultural-isolation-ever-right.

7 "British Theatre Has an Enemy." Shelley Silas's *Eating Ice Cream on Gaza Beach*, Jonathan Lichtenstein's *Memory*, and Sonja Linden and Adah Kay's *Welcome to Ramallah* (all produced in London in 2008) portray Palestinian suffering at the hands of Israelis.

8 See Yale H. Ferguson and R. J. Barry Jones, eds, *Political Space: Frontiers of Change and Governance in a Globalizing World* (Albany: State University of New York Press, 2002).

1 David Hare's *Via Dolorosa* (1998)

David Hare's *Via Dolorosa*, performed at the Royal Court Theatre,[9] differs from the other plays in style but not always in substance. It is a 90-minute monologue rather than a play, and originally performed by the playwright and therefore unmediated by an actor. It is a form of memoir, and like most memoirs a collection of facts but with inevitable gaps between fact, memory, and interpretation. Hare declared that

> it had seemed important when writing the play not to waste time offering opinions, since here was a controversy already overloaded with opinion. It was far more valuable to attempt enlightenment. I wanted, above all, to explain the roots of some of the powerful feelings which informed the attitudes of those most concerned.[10]

In his article about his play, Brian Rotman made a similar disclaimer: "Though deeply disturbed by the onslaught on Gaza I saw little point in adding my two bits to the plethora of denunciations of Israel's actions. I instead decided to write a play, not about its contemporary actions but about the origin of the Israeli state itself."[11] In fact, while it is obvious that Hare struggled to be even-handed, to avoid partisanship, and even sympathize with Israel's multiple political dilemmas without offering opinions, the undertone of his memoir conveys his disapproval of Israeli intransigence in its settlement policy and its treatment of the Palestinians. He does not make the common mistake—shared by Jews and non-Jews alike—of conflating Israel as a political entity and Jews as a diverse multinational culture, in political discourse. Yet as if to seal the fact that his attitude to Israel was less than even-handed, in 2006, eight years later, he presented *Wall* (2009), which, according to a review, "will not make too many friends in Israel at the moment."[12] Overall, Hare is charmingly self-effacing in *Via Dolorosa*, more than once mentioning his "clumsiness" and being "out to sea, in the depths … and my feet no longer touch the bottom."[13]

9 This theater has been accused of a decades-long history of antisemitism, having staged plays that either blatantly or implicitly express anti-Jewish ideas.
10 "Via Dolorosa by David Hare," *The Guardian*, October 28, 2000, https://www.theguardian.com/books/2000/oct/28/books.israelandthepalestinians.
11 Ibid.
12 https://www.britishtheatreguide.info/reviews/wall-rev, accessed January 3, 2022.
13 David Hare, *Via Dolorosa and Where Shall We Live?* (London: Faber & Faber, 1998), 6, 18.

Hare begins by describing his visit to a West Bank Jewish family. Until then, he had encountered a few liberal Israelis, including the author David Grossman, most of whom were critical of their own society's responses. Another of them is Eran Baniel, an Israeli director, who is voluble in his political attitude:

> Most Israelis don't even notice the Palestinians ... They don't see them. In the settlements you have the obscene spectacle of Israelis sitting by their swimming pools while Palestinians carry their drinking water round in Jerry cans. He uses a phrase I've heard before: "It's un-Jewish, it's un-Jewish behaviour."[14]

Yet according to Hare in his follow-up play *Wall*, 84 percent of Israelis are actively in favor of the huge wall, which is known in Israel as the "fence," built at a time when terrorism was rampant. Hare's sample of Israeli liberal intellectuals is not therefore representative of Israeli society.

On his way to the West Bank, driving through the hills and olive groves, a thought comes to him unbidden: "The Jews do not belong here." It may be that he means the West Bank only, and perhaps he deliberately leaves it ambiguous, but he adds "for the first time I understand how odd, how egregious Israel must look to the Arab eye."[15] There is no way back from this, and the remainder of the play, however superficially impartial, rests on that subtext. This is scarcely the comment of a "disinterested party" as *Variety* terms Hare in its review of his performance.[16]

His next stop is, then, with the American couple Danny and Sarah Weiss, the parents of six children who live in an Orthodox Jewish settlement on the West Bank. Hare encounters an example of the Jewish imagination: there is no sense of historical time, the Bible being about the past and the present, and also eternal. The Weisses have little idea of present-day *Realpolitik*. For them, according to Hare, "the Oslo accord, the first ever peace accord between the Palestinians and the Jews is the great betrayal."[17] The basis of their stubborn justification is their sincere conviction that the Palestinians want to kill them. Hare liked the couple and was genuinely interested to hear their views but was baffled by their certainty, their fixation on the past, and their political blindness.

14 Ibid., 10.
15 Ibid., 10.
16 Charles Isherwood, "Via Dolorosa," *Variety*, March 18, 1999, https://variety.com/1999/legit/reviews/via-dolorosa-2-1200456948/#!.
17 Hare, *Via Dolorosa*, 17.

His next encounter through the filth and agony of Gaza is with anti-Arafat politician Haider Abdel Shafi and then the historian Albert Aghazerin at Birzeit University. Before then, Muna Khlefi, his official guide, asks him why he has come to the Middle East. His response is unconvincing and disingenuous: "It's an instinct. Playwrights are drawn to places without quite knowing why."[18] Israel is not simply a "place": as a political space, it is likely to draw more specific attention from artists and writers, and Hare will certainly have known why he had chosen Israel and Palestine. He hears Aghazerin's astute observation that "in some terrible way" the Israelis and Palestinians are bound together in their mutual unhappiness.[19] He then meets with George Ibrahim, a theater director in Ramallah. Ibrahim reiterates a claim already voiced by Palestinian intellectuals: "What is the State of Israel but the transformation of native Semitic culture into a terrible Western caricature?"[20]

Hare then goes back to Jerusalem and its holy sites including the Via Dolorosa, which fills him with a sense of loss—perhaps the sense of a lost fantasy. Of Jerusalem, he comments: "Myself, I would like Jerusalem more if it weren't so important."[21] After visiting Yad Vashem, Hare meets Shulamit Aloni, an eminent liberal Israeli politician.

Ultimately, conferring with a few intellectuals on both sides will not afford Hare a true picture of the situation on each side of the divide. Apart from the West Bank family, Hare does not report any conversations with "ordinary" people either in Israel or in the West Bank and Gaza. In fact, the professionals he met with were moderate in their views, the Israelis being somewhat more inclined to exculpation and the Palestinians less inclined to condemn.

Hare's monologue is a theatrical event rather than a play. Yet, as a reviewer observed, it is a work of art rather than a living newspaper.[22] It has a shape, a structure, and a momentum. The play, a compound of different voices, is an autobiographical account of the impact on an English liberal of one land possessed by "iron certainty"[23] and its shadow "other," by chaos and despair.

Is this an example of "shrill agitprop"? Inevitably protests against the play's critique of Israel followed its run, and even suggestions of anti-Semitism, which were unjustified. The end result of his visit was his attitude of impatience with

18 Ibid., 30.
19 Ibid., 31.
20 Ibid., 34. Ibrahim's Palestinian theater group, Al Kasaba, presented *Alive from Palestine: Stories under Occupation* at the Royal Court Theatre in 2001 and 2014.
21 Ibid., 37.
22 Michael Billington, "Via Dolorosa," *The Guardian*, July 19, 2002, https://www.theguardian.com/stage/2002/jul/19/theatre.artsfeatures.
23 Ibid.

the situation: a plague on both their houses. Perhaps the high emotion, hatred, violence, voluble political arguments and the terrible, intractable, fixation by both sides on homeland: *moledet* and *watan*, all centered on incomprehensible theologies, have taxed the endurance of a non-Jewish English playwright.

2 Caryl Churchill's *Seven Jewish Children* (2009)

This play is entirely different in substance and intention. I believe Hare set out with a purpose to clarify for himself a situation that has been defined by little more than attitude. Churchill set out to express and create outrage. Her work is a six-page, ten-minute play written in response to Israel's Operation Cast Lead (2008), and was first performed at the Royal Court Theatre in February 2009, a little over two weeks after Israel withdrew its troops in the midst of an international storm. Directed by Dominic Cooke, the play's narrative, written in seven poetic, page-long scenes, presents a group of Israeli adults, presumably parents, considering what to tell their daughters, a different one in each scene, seven in all, about recent Jewish and Israeli history. Each section begins "Tell her/Don't tell her." There are no stage directions, no cast of characters, and no identification of the speakers. The text encompasses East European pogroms, the Holocaust, the establishment of Israel, and its wars with Gaza. The text is unsubtle: "Don't tell her she doesn't belong here"; "Don't tell her anything about the army/Tell her, tell her about the army." The play ends: "Tell her we're the chosen people/tell her I look at one of their children covered in blood and what do I feel?/tell her all I feel is happy it's not her."

Plays that take political issues as their topics seem not to function within traditional structures but create new forms to contain their argument. Both Hare's and Churchill's works are dramatic structures built to express specific ideas. The question is, then, whether *Seven Jewish Children* should be evaluated by the accepted criteria of theater or literary criticism. Churchill herself declared: "It's a political event, not just a theatre event."[24] Following each performance, there was a collection for the people of Gaza, shifting the character of the event to a demonstration rather a play, and as such the sentiment buried in it should be viewed as an outcry rather than an example of political theater. According to Kate Leader, "the framing of the production leaves no doubt as to what we are all meant to feel upon witnessing the play. This in itself is not

24 Kate Leader, "'Tell Her to Be Careful': Caryl Churchill's *Seven Jewish Children: A Play for Gaza* at The Royal Court Theatre," *Platform* 4, no. 1 (2009): 133–136, here 134.

surprising in a piece of theatre specifically designed to raise funds for people in need."[25]

The controversy following this play is too vast and polarized to be summarized. The main points of difference among reviewers related to the lack of context and ideological balance and emotional focus. For example, for *The Guardian*, it was a "heartfelt lamentation"[26] while in a scathing review *The Times* found it "straitjacketed political orthodoxy."[27] The *Jewish Chronicle* deemed it anti-Semitic.[28] *The Atlantic* in the United States considered it a "drive-by polemic that's meant to demonize the Jewish state,"[29] while the CST, a British Jewish organization, also accused Churchill of anti-Semitism, stating: "The play ends with a monologue of genocidal racial hatred, culminating in that noxious mixture of Jews, children, death and blood."[30] Jacqueline Rose, an academic, contested Howard Jacobson's claim that the play repeated the blood libel[31] by pointing to its "precise and focused … criticism of Israel's policies, control of water, house demolitions, checkpoints and the destruction of olive trees."[32] Tony Kushner and critic Alisa Solomon urged production and discussion of the play "as widely as possible." They praised its incitement to speech and examination of silence and its attention to what can and cannot be said.[33] While sympathetic to those appalled by the Gaza catastrophe, including Churchill, they avoid judging the play by projecting opinions to "some" who may be troubled "by the play's blunt assertion that the Israeli-Palestinian

25 Ibid., 134. See also Rachel Clements, "Framing War, Staging Precarity: Caryl Churchill's *Seven Jewish Children* and the Spectres of Vulnerability." *Contemporary Theatre Review* 23, no. 3 (2013): 357–367.
26 Michael Billington, "Seven Jewish Children," *The Guardian*, February 11, 2009, https://www.theguardian.com/stage/2009/feb/11/seven-jewish-children.
27 Christopher Hart, "*The Stone* and *Seven Jewish Children: A Play for Gaza* at the Royal Court, SW1," *The Times*, February 15, 2009, https://www.thetimes.co.uk/article/the-stone-and-seven-jewish-children-a-play-for-gaza-at-the-royal-court-sw1-kx78rwrqzg8.
28 "Seven Jewish Children," *Jewish Chronicle*, February 12, 2009, https://www.thejc.com/news/all/review-seven-jewish-children-1.7642.
29 Goldberg, "Caryl Churchill."
30 "Lincoln's Blood Libel," *CST Blog*, January 20, 2011, https://cst.org.uk/news/blog/2011/01/20/lincolns-blood-libel-and-seven-jewish-children.
31 Howard Jacobson, "Let's See the 'Criticism' of Israel for What It Really Is," *The Independent*, February 18, 2009, https://www.independent.co.uk/voices/commentators/howard-jacobson/howard-jacobson-let-rsquo-s-see-the-criticism-of-israel-for-what-it-really-is-1624827.html.
32 Amelia Howe Kritzer, "Enough! Women Playwrights Confront the Israeli-Palestinian Conflict." *Theatre Journal* 62, no. 4 (2010): 611–626, here 615.
33 Ibid.

conflict is a Jewish-Palestinian conflict."[34] They were disturbed by certain lines in the play, including the stereotyping of Jews and "particularly in an ugly monologue near the play's conclusion, that [is] terribly painful to experience, especially for Jews." The BBC refused to commission the play due to issues of partisanship.

All reviews and scholarly articles fell into these polemical camps. Few of the reviews discussed this work as a theater event, but concentrated exclusively on its content. Some scholarly views were more outrageous than the media responses. For example, Michal Lachman writes: "The provocative power of the [play's] narrative springs from the fact that along with presenting the undoubted suffering of the Jews, it *reveals their moral hypocrisy* when it comes to describing the immoral deeds committed by the Jewish state in the postwar history of Europe."[35] Jews' moral hypocrisy is a given, only concealed, but Churchill's play reveals it.

The play, a gently styled polemic, is biased both against Israel and the Jews. It lacks the courage to name the political entity at which it is aimed, but focuses on the history of the people in whose name the entity was founded, which is confirmed by the plays' title and Churchill's vituperative failure to distinguish between the two. It reinforces the opinion that "some hard-core anti-Israel activists do not use the word 'Israel' but rather avoid it—as if the use of the name, in itself gives legitimacy to the state."[36]

Churchill's play was part of the general public discourse around Operation Cast Lead almost immediately after Israel's disastrous campaign, including attitudes toward the occupation. Even without this actual context, and evaluated as a piece of theater, the text itself is troubling. Kushner and Solomon argue that the Jewish history of persecution led to the founding of Israel, which claims to act on behalf of all Jews and that diaspora Jews have an impact upon its policies.[37] The corollary here is that all Jews are responsible for Israel's actions, a position that is the fuel that drives Churchill's play. This is not a

[34] Tony Kushner and Alisa Solomon, "'Tell Her the Truth': On Caryl Churchill's *Seven Jewish Children: A Play for Gaza*," The Nation, March 26, 2009, https://www.thenation.com/article/archive/tell-her-truth/.

[35] Michal Lachman, "Performing History: Caryl Churchill's Theatrical Historiography from *Light Shining in Buckinghamshire* to *Seven Jewish Children*," *Hungarian Journal of English and American Studies* 19, no. 2 (2013): 415–435, here 429. Italics are my own.

[36] David Collier, *Antisemitism in Ireland*, October 2021, https://david-collier.com/wp-content/uploads/2021/10/211007_-ireland_final_ed_online.pdf.

[37] Kushner and Solomon, "'Tell Her the Truth.'"

unique view: Jewish history (the Holocaust) and the Gaza offensive are linked, possibly without intention, even in scholarship about the play.[38]

Yet none of this is as knowingly offensive as an image from a play called *Go to Gaza Drink the Sea* (2003) by Justin Butcher and Ahmed Masoud—a heartfelt protest against the situation in Gaza—where the audience confronts a stage setting of Gaza constituted by huge mounds of rubble constructed out of shoes, perhaps the most anamnetic metonym of the Holocaust.

Churchill responded to Howard Jacobson's accusations of reviving the blood libel in a letter to *The Independent*: "Howard Jacobson writes as if there's something new about describing critics of Israel as anti-Semitic. But it's the usual tactic. We are not going to agree about politics … But we should be able to disagree without accusations of anti-Semitism."[39] Kushner and Solomon reinforce Churchill's response, rejecting the accusation of blood libel and justifying the last line of the play as a warning that we can't protect our children by being indifferent to the children of others.

In May, 2009, the city of Liverpool withdrew public funding from a theater festival that had scheduled a production of *Seven Jewish Children* after the producers refused to balance the political message of the Churchill play with Richard Stirling's *Seven Other Children*. Stirling called the producer's decision "at best incautious and at worst severely one-sided."[40]

3 Brian Rotman's *A Land without People* (The Courtyard Theatre, 2015)

In a review of Brian Rotman's 2015 history play, *A Land without People*, *The Jewish Chronicle* stated that "during the narrative's timeline of 1939 to 1948, Rotman appears to have taken care to represent the decade even-handedly."[41] This even-handedness is not borne out by Rotman's own stated reason for writing this play, a justifiably angry but also often tendentious response to Israel's deadly Protective Edge bombardment of Gaza in 2014. His comments were less an attack on Israel than on "murderous Zionist gangs" and "Zionism's

38 See Clements, "Framing War," 357.
39 Terri Judd, "Churchill Defends 'Anti-Semitic Play,'" *The Independent*, February 21, 2009, https://www.independent.co.uk/arts-entertainment/theatre-dance/news/churchill-defends-8216-antisemitic-8217-play-1628250.html.
40 Cnaan Liphshiz, "Liverpool Cuts Funding for Festival That Includes 'Anti-Semitic' Play," *Haaretz*, May 17, 2009, https://www.haaretz.com/1.5053311.
41 "Review: *A Land without People*," *The Jewish Chronicle*, July 16, 2015, https://www.thejc.com/culture/theatre/review-a-land-without-people-1.67693.

relentless, ferociously single-minded determination to claim the holy land as its own."[42] Rotman then decided to write the play about the origin of the Israeli state itself.

By and large the pre-Israel sections of this play are even-handed and attempt to provide all sides of the argument. Rotman explained: "I began to be aware of the hugely contentious thoughts concerning Israel but I was determined to stick to the historical truths, which I researched thoroughly making a genuine attempt on my part to say this is the true history. In a sense the majority of the play is to do with Britain. The British role was crucial."[43] However, Rotman failed to define a "true history." To this end, he selected certain documented speeches and incidents and omitted others. A writer can create any picture with a judicious selection of material. The play portrays the single-mindedness of the leading Zionists, David Ben-Gurion and Chaim Weizmann, who were unable to compromise, and it avoids placing Israel in any context that might arouse any sympathy for it. There is little global historical context, no Sykes-Picot Agreement indicating British treachery against the Arabs, and there was no indication that it was in Britain's interest to generate the Balfour Declaration.

Yet Rotman provides good historical continuity and a comparatively reasoned picture, with lip service to Jewish suffering, which in this context is irrelevant. The ideological parameters were established long before the Holocaust, amplified by Jewish suffering in World War I, about which comparatively little is recorded. As one reviewer wrote: "What this proves—more than whether this small play can illustrate it—is that there is no such thing as taking a neutral view on the Arab-Israeli conflict and that Rotman misleads his audience quite significantly by suggesting otherwise."[44]

Rotman quite graphically uncovers some of the less palatable early Israeli history relating to the murder and expulsion of Arab populations that left a deep scar in the Israeli psyche. Yet there are few dilemmas or nuances in this play, which becomes something of a history lesson, and nothing about the deep complexities of the situation. Ultimately, it is a superficial history, recalling the early Zionist activities in connection with the unfolding tragedy of Gaza. Rotman said in an interview that "I was determined to stick to the historical truths."[45] He should beware of the word "truth" when discussing this

42 Brian Rotman, "Why I Wrote a Play Charting Israel's Violent Birth," *Red Pepper*, July 17, 2015, https://www.redpepper.org.uk/why-i-wrote-a-play-charting-israels-violent-birth/.

43 Fiona Green, "*A Land without People*: An Israel State of Mind," *Jewish News*, June 23, 2015, https://www.jewishnews.co.uk/a-land-without-people-an-israel-state-of-mind/.

44 Fiona Green, "*A Land without People*: A Play without Principle," *Jewish News*, July 14, 2015, https://www.jewishnews.co.uk/a-land-without-people-a-play-without-principle/.

45 Green, "An Israel State of Mind."

complex, multifaceted history. In the rancorous cultural debates of our time, "truth" has become both relative and personalized.

An example of Rotman's selectivity is his inclusion of Khalil el Sakakini, the Christian Arab Palestinian activist, educator, and diarist whose declaration appears in Rotman's play: "I say two nations have fooled the world—the Jews and the British. Not so the Germans. Their eyes are wide open about the Jews. If the British go to war against Germany and are defeated then perhaps Hitler might help us rid our land of the Jewish invaders."[46] Sakakini indeed loathed the Zionists for their establishment of their independent nation at the expense of another and for their separation of the Arab geographical entity. Yet Rotman neglects to inform us that, notwithstanding his hostility to Zionism, Sakakini strictly differentiated between Zionism and Jews,[47] an attitude borne out by his diaries.

While the play can be labeled "anti-Zionist," this is in the historical sense of critiquing Zionism as a nationalist movement, unlike the present appropriation of the term, which lacks any historical context. It is important to stress that, unlike Churchill, Rotman does not indict Jews but the early Zionist leadership, and attempts to indicate the difference between the Haganah, which later became Israel's defence force, and the Irgun, which was a terrorist group, and he does not shrink from including Ben-Gurion's tacit involvement in the appalling story of Deir Yassin. In fact, both Ben-Gurion and Weizmann appear as heartless villains.

Yet Rotman, with his barely concealed bias, did attempt to give both sides of the history or at least indicated that there was another side. In Churchill's play, there is no nuance, no dialogue, and no discussion, only a display of fury in the performative shape of political demagoguery rather than art. Both Churchill and Rotman select events in the past that appear to explain events in later times. Churchill does so by implication and Rotman with greater historical evidence. They suggest a historical inevitability construed by a prefabricated line of continuity, for example from the persecution of the Jews in the Holocaust to Israel's persecution of the Palestinians. The exploitation of the Holocaust by these playwrights is scandalous but not unique: it has been used by political elements in Israel as well.[48]

46 https://brianrotman.wordpress.com/plays/a-land-without-people/, accessed November 2021. Play text. Rotman does not supply the source or context of this statement.
47 See Emanuel Beška, "Khalil al-Sakakini and Zionism before WWI," *Jerusalem Quarterly* 63–64 (2015): 40–53, here 47.
48 See, for example, Hagai El-Ad, "Netanyahu Exploits the Holocaust to Brutalize the Palestinians," *Haaretz*, January 23, 2020, https://www.haaretz.com/israel-news/.premium-netanyahu-exploits-the-holocaust-to-brutalize-the-palestinians-1.8437715.

It is ironic that since the production of these plays there was another Gaza-Israel battle (2021), which seems to have aroused less media opprobrium despite mass demonstrations in London and elsewhere, and a notable rise in British anti-Semitism. So far, no new plays about Israel have emerged.

4 Katherine Viner and Alan Rickman's *My Name Is Rachel Corrie* (2005)

Distilled by the late Alan Rickman and the *Guardian* editor Katherine Viner from a 184-page document that included Corrie's journals, letters, and emails from Gaza to her parents, the play opened at the Royal Court Theatre in London in 2005, and it was revived by the Young Vic in 2017. The original production was scheduled to open at the New York Theater Workshop in 2006, but the performances were postponed indefinitely, ostensibly because of Ariel Sharon's illness and Hamas's electoral success.[49] In defending the cancellation of the original New York production, artistic director James Nicola suggested the play should have been properly "contextualized."[50] The controversy spread to other theaters in the United States and Canada.

Rachel Corrie, a 23-year-old college student from Olympia, Washington, traveled to Palestine with the Palestine-led International Solidarity Movement (ISM).[51] She had possessed a sense of general injustice since childhood, and wanted nothing more than to "do something" to help. In March 2003, she died under an Israeli bulldozer in Rafah while protecting a Palestinian house marked by the Israel Defense Forces (IDF) for demolition. Controversy, still unresolved, followed her tragic death relating to the culpability of the bulldozer driver and to Rachel's presence close to the machine's tracks. No definitive verdict can be supplied about the circumstances. The only undisputed fact is that Corrie was killed in the Gaza Strip in March of 2003. According to the Jewish Virtual Library website—without quoting sources—the incident occurred while the IDF was removing shrubbery along the security road at Rafah to uncover explosive devices, and destroying tunnels used by Palestinian terrorists. There are numerous detailed eyewitness accounts that contradict this one. In an interview the day Corrie died, Thom Saffold, a founder of the ISM, said: "It's possible they [the protesters] were not as disciplined as we would have liked.

49 Tom Cantrell, *Acting in Documentary Theatre* (London: Palgrave Macmillan, 2013), 63.
50 George Contini, "My Name Is Rachel Corrie," *Theatre Journal* 59, no. 1 (2007): 116–117, here 116.
51 The ISM as human rights observers were engaged in nonviolent direct action in Gaza.

But we're like a peace army. Generals send young men and women off to operations, and some die."[52] The American Jewish *Mosaic* magazine, not averse to hyperbole and misinformation, claimed that "the play, which amounts to little more than crass anti-Israel propaganda, is based on the story of its title character, who died after *throwing herself* in front of an IDF bulldozer *at the behest of* the International Solidarity Movement, an organization *dedicated to providing cover for Hamas*."[53]

Corrie was perceived by Jewish communal leaders as an anti-Israel activist. During the play's revival in 2017, the Zionist Federation distributed leaflets outside the Young Vic in London, which attempted to redress what it saw as factual inaccuracies. Viner responded by declaring that the play is "a piece of art, not a piece of agitprop," a position with which the *Jewish Chronicle* agreed.[54] This play, once again, raised the question of suppression. Artists are understandably infuriated by automatic allegations of anti-Semitism whenever an artwork criticises Israel. Harold Pinter and others accused the theater of bending to pressure from hardline supporters of Israel. Similar charges were lodged at Toronto's CanStage company, which withdrew from producing the play. The cancellation of the play generated discussion about the possibility of censorship, artistic freedom, and free speech. American discourse around the Israeli-Palestinian conflict became increasingly vituperative and polarized.[55] Even London's *Jewish Chronicle* asked whether

> trying to shut down a play with a disagreeable political message is a moral or proportionate thing to do ... and it's disturbing that, without debate, [censorship] seems now to be part of our leadership's tool-kit. Last week this paper called the play "provocative"—wouldn't it be better if we just refused to be provoked?[56]

Rickman and Viner chose to portray Corrie primarily as an idealistic young American with her heart in the right place rather than an anti-Israel

52 The Haifa District Court delivered its findings in the Rachel Corrie case on August 28, 2012. See https://mfa.gov.il/MFA/ForeignPolicy/Issues/Pages/Behind_the_Headlines_Verdict_Rachel_Corrie_Aug_2012.aspx, accessed November 1, 2021.
53 David Herman quoted in "British Theatre Has an Enemy, and Its Name Is Israel." Italics are my own.
54 Ben Crowne, "Is Outrage the Right Response to a Play about Activism?," *Jewish Chronicle*, August 10, 2017, https://www.thejc.com/lets-talk/all/is-outrage-the-right-response-to-a-play-about-activism-1.442737.
55 Kushner and Solomon, "'Tell Her the Truth.'"
56 Crowne, "Is Outrage the Right Response?"

propagandist. Yet often their choice of excerpts is shot through with less than subtle antagonism toward Israel and statements that are scarcely neutral when, as the *London Times* characterized it, "an element of unvarnished propaganda comes to the fore."[57] Corrie writes of Israel's "collective punishment," "transfer," "wilful destruction,"[58] and many other evocative phrases of oppression. She comments, during a period of sustained terrorist attacks on Israeli civilian targets, "the vast majority of Palestinians right now, as far as I can tell, are engaging in Gandhian nonviolent resistance,"[59] leading the *Times* to comment: "Even the late Yassir Arafat might have blushed at that one."[60] The positive reviews more evocatively highlight Rachel's naïveté and disillusionment, her youthful idealism, and its first encounter with reality.[61] The play remains "a deeply moving human document and a portrait of a remarkable woman who tried to alleviate suffering."[62] Clearly, the Palestinians Rachel encounters, including the family that hosts her, are not terrorists but victims of Israeli military and political policy.

In her journals, Corrie was not writing a history or an objective study of the Israeli-Palestinian conflict or about Jews, and if there were factual inaccuracies, these emerged from her experience. In fact, in the play Rachel says: "The scariest thing for non-Jewish Americans in talking about Palestinian self-determination is the fear of being or sounding anti-Semitic." Caryl Churchill reveals a worldview in which *Jews* are a monolithic entity bent on destroying the Palestinians, a standpoint that has echoes in the other dramas. Yet Rachel, even in her youth and inexperience, writes about the distinctions between the policies of Israel as a state and the Jews as a people. "There is very strong pressure to conflate the two. I try to ask myself whose interest does it serve to identify Israeli policy with all Jewish people?"[63] Elsewhere, she writes: "I'm really new to talking about Israel-Palestine, so I don't always know the political implications of my words."[64] On the other hand, Rickman (who, according to *Salon*, had a firm commitment to progressive politics and to support for

57 Clive Davis, "My Name Is Rachel Corrie," *The Times*, April 18, 2005, https://www.thetimes.co.uk/article/my-name-is-rachel-corrie-hohpbfjhckw.
58 Katherine Viner and Alan Rickman, *My Name Is Rachel Corrie* (London: NHB Modern Plays, 2017), 47–48.
59 Ibid., 48.
60 Davis, "My Name Is Rachel Corrie."
61 Crowne, "Is Outrage the Right Response?"
62 Michael Billington, "My Name Is Rachel Corrie," *The Guardian*, April 14, 2005, https://www.theguardian.com/stage/2005/apr/14/theatre.politicaltheatre.
63 Entry for January 25.
64 Viner and Rickman, *My Name Is Rachel Corrie*, 45.

Palestinian rights in particular)[65] and Viner are aware that Corrie's words do indeed have political implications, and moreover that she and the ISM had chosen to be in one of the most controversial, dangerous, and incendiary places in the world. Even though she emerges as a courageous and sincere young woman who wanted nothing more than to do some good, the *play* is biased, with a thread of Israeli violence present on every page set in Gaza, and the Palestinians are absolved of all blame in the terrible situation.

The leafleting by representatives of Zionist federations, rabbinical groups, and Jewish communities, and protests against the make of bulldozer that killed Rachel, are extra-theatrical phenomena that have blurred the qualities of the play itself. One would expect from this uproar at least some form of "agitprop." Yet the play, which many critics accused of being static and untheatrical, is no more than a sometimes-cloying dramatic monologue about a young woman's early life in Olympia, which takes fire once she is in Rafah amid the rubble and fear. Her observations then become consequential and expressed in effective and eloquent lyrical passages. She relates to the Israeli army's mechanisms, tanks, curfew, checkpoints, machine guns, and rocket launchers with antipathy, which is only to be expected. Yet at no point does Rachel indicate any awareness of the complex geopolitical realities of the region, which may be appropriate for a personal journal, a subjective record of events, less for a play, which requires some framework, if nothing else for audiences who are not familiar with the location and its political realities. No passages are included, for instance, where Rachel explains why she chose Palestine. Rickman and Viner mention the ISM only obliquely. Perhaps the most sensible comment is provided by *Theatermania*, after criticizing the play's lack of context:

> Supporters of Corrie's activism are likely to continue to deem her a martyr, while those who believe that Corrie was aiding Palestinian terrorists will either fail to attend the show or dismiss it as propaganda. Those occupying a middle position may be moved by the words of this young, idealistic woman, but they won't get all the information they need from this play in order to make an informed decision.[66]

65 Ben Norton, "Remembering Alan Rickman's Pro-Palestinian Play about Rachel Corrie, American Activist Crushed by Israeli Bulldozer," *Salon*, January 14, 2016, www.shorturl.at /qyABT.
66 Dan Bacalzo, "My Name Is Rachel Corrie," *Theatermania*, October 15, 2006, https://www .theatermania.com/new-y.

The question is not why Rachel Corrie made the decisions she did, but why Rickman and Viner chose to present her diaries as a play and what prompted their selection of material. While it is clear that they wished to make a point about global injustice, they focused on a character whose quest for justice and humanitarianism is centered on Israel. Selecting from and arranging existing texts is a subjective process, as we have seen with Rotman's play.

My Name Is Rachel Corrie was produced in Jaffa in 2016. The reviews were split along political lines. Positive reviews highlighted Rachel's humanitarian ideology, her compassion, and her kindness, but there were also strongly negative voices. The Israeli Ministry of Culture threatened to withdraw funding for the production. The play's director, Ari Remez, expressed surprise and delight that even right-wing members of the audience who had anticipated a confrontation discovered the play to be non-threatening.[67] In an interview, he discussed the play in the context of Shovrim Shetikah ("Breaking the Silence"), an organization of veteran soldiers who have served in the Israeli military and who expose the Israeli public to the reality of everyday life in the Occupied Territories and the settlers' part in it.[68]

5 A Recent Controversy

Although in this chapter I have written about negative attitudes toward Israel, rather than anti-Semitism, in the theater, I am unable to ignore a very recent theatrical scandal, again at London's Royal Court Theatre. In November 2021, it presented a play, *Rare Earth Mettle* by British playwright Al Smith, which features a villainous, colonialist, egomaniacal billionaire character called Herschel Fink who plans global domination. Set in the Bolivian desert, the story is about a battle between two characters, Fink, head of Edison Motors, and Anna, a doctor and director of medical research. Both want to mine the rare metal, lithium, from the South American salt flats: Fink, for the batteries of his electric cars; the doctor, to put it in the UK water supply to calm the population and improve their mental health, while the local indigenous communities claim a right over their lithium-laden land.

Although the playwright insisted that Fink is not a Jew and that there are no Jews in the play, the name, which appears to be typically Jewish, caused outrage. Were Hershel Fink indeed a Jewish character, he would incorporate

67 I24NewsEnglish, "Play in Jaffa: My Name Is Rachel Corrie Created by Alan Rickman," January 20, 2016, *YouTube*, 15:36, https://www.youtube.com/watch?v=bLaPPgG7IWo.
68 https://www.breakingthesilence.org.il/about/organization, accessed November 1, 2021.

one of the oldest and ugliest anti-Semitic stereotypes: the wealthy Jew pulling the strings of the world and exploiting innocent indigenous labor. A review summarized the general anger: "Why are we indifferent to anti-Semitism? In the past few weeks the Royal Court, a proud citadel of wokeness, has been embroiled in an appalling case of prejudice by allowing a character, who is a really bad billionaire, in Al Smith's new play, *Rare Earth Mettle*, to be called Hershel Fink. Stereotype, or what?"[69]

The law firms Kirkland & Ellis and Weil, Gotshal & Manges immediately withdrew as financial sponsors for the Royal Court. Under fire, the theater issued a brief apology for the use of an anti-Semitic name, prompting the playwright Patrick Marber to tweet in response: "The name 'Hershel Fink' is not 'antisemitic.' But you are."[70] "It was a mistake, it shouldn't have happened," stated the Royal Court, followed by a commitment to "dismantle antisemitism internally."[71] This in itself is an outrageous admission of prejudice. Smith then changed the name of the character to Henry Finn, which is equally insidious given the tendency of British Jews to change their Jewish-sounding names.[72] The theater confessed that "unconscious bias" had prompted the use of the original name. Even worse, this suggests "a theatre community in which Jewish signifiers have become a natural shorthand to describe evil capitalists, 'unconsciously' indicating greed." David Baddiel reflects accurately that "unconscious" means "systemic."[73]

69 Aleks Sierz, "*Rare Earth Mettle*, Royal Court Review—One Long Unsatisfying Slog," *The Arts Desk*, November 19, 2021, https://www.theartsdesk.com/node/87401/view.

70 Kate Maltby, "The Inside Story of the Royal Court Theatre's Antisemitism," *The Times*, November 21, 2021, https://www.thetimes.co.uk/article/the-inside-story-of-the-royal-court-theatres-antisemitism-ggln3o6lf.

71 Alun Hood, "*Rare Earth Mettle* at the Royal Court—Review," *What's on Stage*, November, 21, 2021, https://www.whatsonstage.com/london-theatre/reviews/rare-earth-mettle-royal-court_55383.html.

72 In 2019, *Falsettos*, a musical, was put on in London. It was as one review put it "undeniably a Jewish story," with most of the characters Jews and featuring a bar mitzvah, a little Yiddish, and songs about Jewish angst. A major controversy followed the show, which was accused of cultural appropriation because the cast members and the director weren't Jewish. The playwright is an American, William Finn. Either this is Smith's unconscious association or it is a peculiar coincidence. See Lanre Bakare, "'Jewface' Row: West End Musical Accused of Cultural Appropriation," *The Guardian*, August 23, 2019, https://www.theguardian.com/stage/2019/aug/23/jewface-row-west-end-musical-falsettos-decried-for-cultural-appropriation; and Emma Jude Harris, "The Jews Are Tired: The Royal Court, Rare Earth Mettle, and Why Enough is Enough," *Exeunt*, November 2, 2021, http://exeuntmagazine.com/features/jews-tired-royal-court-rare-earth-mettle-enough-enough/.

73 David Baddiel, "Talking Is the Only Way through the Culture Wars," *The Times*, November 21, 2021, https://www.thetimes.co.uk/article/david-baddiel-talking-is-the-only-way-through-the-culture-wars-fcjlwlpgh. Baddiel is the author of a book entitled *Jews Don't Count*,

The Fink character was originally conceived as a Mexican, but he became "White" after the theater raised concerns about the racist implications of a wicked Mexican character being created by a White playwright. It seems that the Royal Court deems prejudice against Hispanic people to be abhorrent while over the years of development of Smith's play the question of anti-Jewish prejudice did not arise at the Royal Court and no one noticed the implications of the name in relation to the character. When Jewish actors pointed this out, they were ignored. Yet the Royal Court personnel subsequently claimed to be "devastated" to have caused such hurt.[74]

This controversy again raises the discussion about whether forcing a playwright to change elements of his play because of public response is a form of censorship. One review of *Rare Earth Mettle* states: "Jewishness turns out to be entirely irrelevant to a baggy, shapeless but appealingly acted play that seems to have drawn attention for all the wrong reasons."[75] Another writes: "Al Smith's sprawling, slapdash satire caused controversy before opening when it was revealed an autocratic American tech billionaire character had the stereotypically Jewish name Herschel Fink … It was a clumsy gaffe, clumsily addressed."[76] We see a phenomenon like those that accompanied the plays mentioned earlier in this chapter, that Jewish sensitivities, sometimes misplaced, force changes, cancel productions, or create outrage.[77] The question remains whether or not the playwright *intends* to offend, as I believe Caryl Churchill did, or whether offence is in the eye of the beholder. Something will

about the omission of Jews from all anti-racist discourse. Baddiel argues that anti-Semitic bias is the one prejudice that remains largely unpoliced in the "culture wars."

74 Maltby, "The Inside Story."
75 Matt Wolf, "'Rare Earth Mettle' Review—An Appealingly Acted Play that Deserves Consideration," *London Theatre*, November 23, 2021, https://www.londontheatre.co.uk/reviews/rare-earth-mettle-review-royal-court.
76 Nick Curtis, "Rare Earth Mettle Review: Anti-Semitic? No. Worth Seeing? No," *London Evening Standard*, November 17, 2021, https://www.standard.co.uk/culture/theatre/rare-earth-mettle-review-royal-court-b966627.html.
77 In 1987, when the Royal Court Theatre, together with its co-producer, the Manchester Library Theatre, announced its intention to mount *Perdition* by Jim Allen, it circulated copies of the text to certain members of the community and the press, as was its custom with all new works. Following the comments by two leading Anglo-Jewish historians, the Manchester Library Theatre withdrew and the Royal Court's artistic director, Max Stafford-Clark, canceled the production, claiming that he had been betrayed by the playwright's views. The furor this caused raised questions about freedom of expression and censorship. Allen and his director Ken Loach (expelled in 2021 from Keir Starmer's Labour Party for his views on anti-Semitism) complained to the press about a Zionist conspiracy to ban the play. See Glenda Abramson, "Anglicising the Holocaust," *Journal of Theatre and Drama* 7–8 (2006): 105–123.

always be in place to offend, particularly in our ultra-sensitive age, and the commonplace "everyone has the right to be offended" is itself an offensive mantra. In *Rare Earth Mettle*, there was no suggestion of Jewishness, other than the name. Perhaps it was indeed Smith's "unconscious bias" or he might have intended to create an amalgam of the global billionaires such as Musk, Jobs, Bezos, and Gates, none of whom is Jewish. He may not even be aware of the myth of Jewish financial power, although it seems improbable that after the five years of controversy over Corbyn and his party's entrenched anti-Semitism that anyone, particularly an artistic creator in tune with his cultural environment, could still be ignorant of anti-Semitic tropes.

6 Conclusion

There is certain justification for the argument that the British theatre reflects the general hostility of the non-Jewish British population to the State of Israel. Yet this "anti-Israel" attitude is primarily associated with only one London theater. The most recent controversy once again involves the Royal Court, this time regarding antisemitism rather than Israel.

Is British theater the "enemy of Israel?" Four of the plays I have discussed respond to a series of wars involving Gaza but range somewhat further than discussion of the wars themselves. Israel is seen in these plays—without distinction between nation and state—not as a democracy but exclusively as a military oppressor. They ignore any historical context and the enormous complexity of the present geopolitical reality. The question remains why Israel in particular is singled out for theatrical condemnation even though the answer is fairly obvious. One reason was offered by the *Wall Street Journal* in 2006: "Because Palestine is the new Cuba."[78] When British theater takes Israel as a topic and uniquely demonizes it without political context, British theater is indeed "anti-Israel."

The fifth play discussed is ambiguous but lends itself to an anti-Semitic interpretation. There is little doubt that anti-Jewish attitudes, often embodied in criticism of Israel, are more prevalent in the British theater than negative attitudes toward any other cultural or ethnic group. Yet *defining* British theater as "anti-Israel" or "anti-Semitic" is an expansive generalization that is difficult to prove.

78 "Bulldozed by Naïveté," *Wall Street Journal*, October 20, 2006, https://www.wsj.com/articles/SB116129439880998208.

Recently, the leading article in the *Times* questioned the Irish novelist Sally Rooney's much publicized statement that she will not allow the publication of her latest novel if translated into Hebrew by an Israeli publisher. "Is a Russian translation the cards thanks to the occupation of Ukraine and the persecution and murder of political dissidents?" asks the leader. "Arabic will be a problem what with Saudi Arabia's denial of basic freedoms to women. Turkish little better what with the Kurds. Perhaps [Rooney] will also object to a Hindu translation thanks to India's treatment of Kashmir and also an Urdu one thanks to Pakistan's ... Or is her concern solely with the perceived wrongdoing of the world's only Jewish state?"[79]

Bibliography

Abramson, Glenda. "Anglicising the Holocaust." *Journal of Theatre and Drama* 7–8 (2006): 105–123.

Abramson, Glenda. *Drama and Ideology on the Israeli Stage*. Cambridge: Cambridge University Press, 1998.

Bacalzo, Dan. "My Name Is Rachel Corrie." *Theatermania*, October 15, 2006. https://www.theatermania.com/new-y.

Baddiel, David. "Talking Is the Only Way through the Culture Wars." *The Times*, November 21, 2021. https://www.thetimes.co.uk/article/david-baddiel-talking-is-the-only-way-through-the-culture-wars-fcjlwlpgh.

Bakare, Lanre. "'Jewface' Row: West End Musical Accused of Cultural Appropriation." *The Guardian*, August 23, 2019. https://www.theguardian.com/stage/2019/aug/23/jewface-row-west-end-musical-falsettos-decried-for-cultural-appropriation.

Balas, Ido. "Israeli Theater Must Be Removed from London Festival, Top U.K. Cultural Figures Say." *Haaretz*, April 1, 2012. https://www.haaretz.com/israel-news/culture/1.5210286.

Beška, Emanuel. "Khalil al-Sakakini and Zionism before WWI." *Jerusalem Quarterly* 63–64 (2015): 40–53.

Billington, Michael. "My Name Is Rachel Corrie." *The Guardian*, April 14, 2005. https://www.theguardian.com/stage/2005/apr/14/theatre.politicaltheatre.

Billington, Michael. "Seven Jewish Children." *The Guardian*, February 11, 2009. https://www.theguardian.com/stage/2009/feb/11/seven-jewish-children.

79 Fredrik Sandberg, "The Times View on Sally Rooney's Boycott: Conversations with Ends," *The Times*, October 13, 2021, https://www.thetimes.co.uk/article/the-times-view-on-sally-rooneys-boycott-conversations-with-ends-5h6895wh7.

Billington, Michael. "Via Dolorosa." *The Guardian*, July 19, 2002. https://www.theguardian.com/stage/2002/jul/19/theatre.artsfeatures.
"British Theatre Has an Enemy, and Its Name Is Israel." *Mosaic*, September 1, 2017. https://mosaicmagazine.com/picks/israel-zionism/2017/09/british-theater-has-an-enemy-and-its-name-is-israel/.
"Bulldozed by Naïveté." *Wall Street Journal*, October 20, 2006. https://www.wsj.com/articles/SB116129439880998208.
Cantrell, Tom. *Acting in Documentary Theatre*. London: Palgrave Macmillan, 2013.
Churchill, Caryl. *Seven Jewish Children* [e-Book]. London: Bloomsbury, 2015.
Clements, Rachel. "Framing War, Staging Precarity: Caryl Churchill's *Seven Jewish Children* and the Spectres of Vulnerability." *Contemporary Theatre Review* 23, no. 3 (2013): 357–367.
Collier, David. *Antisemitism in Ireland*. October 2021. https://david-collier.com/wp-content/uploads/2021/10/211007_-ireland_final_ed_online.pdf.
Contini, George. "My Name Is Rachel Corrie." *Theatre Journal* 59, no. 1 (2007): 116–117.
Crowne, Ben. "Is Outrage the Right Response to a Play about Activism?" *Jewish Chronicle*, August 10, 2017. https://www.thejc.com/lets-talk/all/is-outrage-the-right-response-to-a-play-about-activism-1.442737.
Curtis, Nick. "*Rare Earth Mettle* Review: Anti-Semitic? No. Worth Seeing? No." *London Evening Standard*, November 17, 2021. https://www.standard.co.uk/culture/theatre/rare-earth-mettle-review-royal-court-b966627.html.
Davis, Clive. "My Name Is Rachel Corrie." *The Times*, April 18, 2005. https://www.thetimes.co.uk/article/my-name-is-rachel-corrie-hohpbfjhckw.
El-Ad, Hagai. "Netanyahu Exploits the Holocaust to Brutalize the Palestinians." *Haaretz*, January 23, 2020. https://www.haaretz.com/israel-news/.premium-netanyahu-exploits-the-holocaust-to-brutalize-the-palestinians-1.8437715.
Ferguson, Yale H., and R. J. Barry Jones, eds. *Political Space: Frontiers of Change and Governance in a Globalizing World*. Albany: State University of New York Press, 2002.
Goldberg, Jeffrey. "Caryl Churchill: Gaza's Shakespeare, or Fetid Jew-Baiter?" *The Atlantic*, March 25, 2009. https://www.theatlantic.com/international/archive/2009/03/caryl-churchill-gaza-apos-s-shakespeare-or-fetid-jew-baiter/9823/.
Green, Fiona. "*A Land without People*: A Play without Principle." *Jewish News*, July 14, 2015. https://www.jewishnews.co.uk/a-land-without-people-a-play-without-principle/.
Green, Fiona. "*A Land without People*: An Israel State of Mind." *Jewish News*, June 23, 2015. https://www.jewishnews.co.uk/a-land-without-people-an-israel-state-of-mind/.
Hare, David. *Via Dolorosa and Where Shall We Live?* London: Faber & Faber, 1998.
Harris, Emma Jude. "The Jews Are Tired: The Royal Court, Rare Earth Mettle, and Why Enough is Enough." *Exeunt*, November 2, 2021. http://exeuntmagazine.com/features/jews-tired-royal-court-rare-earth-mettle-enough-enough/.

Hart, Christopher. "*The Stone* and *Seven Jewish Children: A Play for Gaza* at the Royal Court, SW1." *The Times*, February 15, 2009. https://www.thetimes.co.uk/article/the-stone-and-seven-jewish-children-a-play-for-gaza-at-the-royal-court-sw1-kx78rwrqzg8.

Hood, Alun. "*Rare Earth Mettle* at the Royal Court—Review." *What's on Stage*, November 21, 2021. https://www.whatsonstage.com/london-theatre/reviews/rare-earth-mettle-royal-court_55383.html.

I24NewsEnglish. "Play in Jaffa: My Name Is Rachel Corrie Created by Alan Rickman." January 20, 2016, *YouTube*. 15:36. https://www.youtube.com/watch?v=bLaPPgG7IWo.

Isherwood, Charles. "Via Dolorosa," *Variety*, March 18, 1999. https://variety.com/1999/legit/reviews/via-dolorosa-2-1200456948/#!.

Jacobson, Howard. "Let's See the 'Criticism' of Israel for What It Really Is." *The Independent*, February 18, 2009. https://www.independent.co.uk/voices/commentators/howard-jacobson/howard-jacobson-let-rsquo-s-see-the-criticism-of-israel-for-what-it-really-is-1624827.html.

Judd, Terri. "Churchill Defends 'Anti-Semitic Play.'" *The Independent*, February 21, 2009. https://www.independent.co.uk/arts-entertainment/theatre-dance/news/churchill-defends-8216-antisemitic-8217-play-1628250.html.

Kritzer, Amelia Howe. "Enough! Women Playwrights Confront the Israeli-Palestinian Conflict." *Theatre Journal* 62, no. 4 (2010): 611–626.

Kushner, Tony. "Notes about Political Theater." *The Kenyon Review* 19, 3–4 (Summer-Autumn 1997): 19–34.

Kushner, Tony, and Alisa Solomon. "'Tell Her the Truth': On Caryl Churchill's *Seven Jewish Children: A Play for Gaza*." *The Nation*, March 26, 2009. https://www.thenation.com/article/archive/tell-her-truth/.

Lachman, Michal. "Performing History: Caryl Churchill's Theatrical Historiography from *Light Shining in Buckinghamshire* to *Seven Jewish Children*." *Hungarian Journal of English and American Studies* 19, no. 2 (2013): 415–435.

Leader, Kate. "'Tell Her to Be Careful': Caryl Churchill's *Seven Jewish Children: A Play for Gaza* at the Royal Court Theatre." *Platform* 4, no. 1 (2009): 133–136.

"Lincoln's Blood Libel." *CST Blog*, January 20, 2011. https://cst.org.uk/news/blog/2011/01/20/lincolns-blood-libel-and-seven-jewish-children.

Liphshiz, Cnaan. "Liverpool Cuts Funding for Festival That Includes 'Anti-Semitic' Play." *Haaretz*, May 17, 2009, https://www.haaretz.com/1.5053311.

Lynskey, Dorian. "Tricycle Theatre and Israel: The Politics of the Cultural Boycott." *The Guardian*, August 6, 2014. https://www.theguardian.com/culture/2014/aug/06/-sp-tricycle-theatre-row-is-cultural-isolation-ever-right.

Maltby, Kate. "The Inside Story of the Royal Court Theatre's Antisemitism." *The Times*, November 21, 2021. https://www.thetimes.co.uk/article/the-inside-story-of-the-royal-court-theatres-antisemitism-ggln306lf.

Norton, Ben. "Remembering Alan Rickman's Pro-Palestinian Play about Rachel Corrie, American Activist Crushed by Israeli Bulldozer." *Salon*, January 14, 2016. www.short url.at/qyABT.

"Review: *A Land without People*." *The Jewish Chronicle*, July 16, 2015. https://www.thejc.com/culture/theatre/review-a-land-without-people-1.67693.

Rotman, Brian. *A Land without People*. https://brianrotman.wordpress.com/plays/a-land-without-people/.

Rotman, Brian. "Why I Wrote a Play Charting Israel's Violent Birth." *Red Pepper*, July 17, 2015. https://www.redpepper.org.uk/why-i-wrote-a-play-charting-israels-violent-birth/.

Sandberg, Fredrik. "The Times View on Sally Rooney's Boycott: Conversations with Ends." *The Times*, October 13, 2021. https://www.thetimes.co.uk/article/the-times-view-on-sally-rooneys-boycott-conversations-with-ends-5h6895wh7.

"Seven Jewish Children." *Jewish Chronicle*, February 12, 2009. https://www.thejc.com/news/all/review-seven-jewish-children-1.7642.

Sherwood, Harriet. "Life Imitates Art." *The Guardian*, December 9, 2018. https://www.theguardian.com/news/2018/dec/09/one-jewish-boy-abuse-campaign-play-london-antisemitism.

Sierz, Aleks. "*Rare Earth Mettle*, Royal Court Review—One Long Unsatisfying Slog." *The Arts Desk*, November 19, 2021. https://www.theartsdesk.com/node/87401/view.

"Via Dolorosa by David Hare." *The Guardian*, October 28, 2000. https://www.theguardian.com/books/2000/oct/28/books.israelandthepalestinians.

Viner, Katherine, and Alan Rickman. *My Name is Rachel Corrie*. London: NHB Modern Plays, 2017.

Wolf, Matt. "'Rare Earth Mettle' Review—An Appealingly Acted Play that Deserves Consideration." *London Theatre*, November 23, 2021. https://www.londontheatre.co.uk/reviews/rare-earth-mettle-review-royal-court.

PART 4

Realizing Visions: Israel Reimagined

∴

CHAPTER 13

Resemblance, Difference, and Simulacrum in Palestinian and Israeli Parafiction Art

Keren Goldberg

> Israel-Palestine are a pair of monstrous Siamese twins, joined at all the vital organs, and yet separated by the teeth and claws with which each twin tries to tear its uncanny double to pieces.
> W. J. T. MITCHELL, 2007[1]

∴

In the past year, following the strengthening impact of the Boycott, Divestment, and Sanctions (BDS) movement, combined with the current social media obsession with imagery and online appearances, heated social and political debates have taken place in Israel, exposing a pressing concern with the way Israel is perceived by the eyes of the world. Such a concern, I would argue, is symptomatic of a pathological repression characterizing a people who, for the most part, refuses to acknowledge the severity of its own internal situation and therefore focuses its attention on its external "image" instead of turning its critical gaze inward.

Against this backdrop, this chapter aims to examine a subgenre of artworks that construct fictive images of Israel, Palestine, or the relation between this "pair of monstrous Siamese twins." It will focus on two case studies created around the same time: *Gaza Canal*, a short video work by Israeli artist Tamir Zadok from 2010, which enacts a fictive scenario or alternative history, in which Gaza was separated from Israel by a canal, resulting in an ecological and touristic wonder—the "Gaza Island," and *State of Palestine*, a project by Khaled Jarrar,

1 W. J. T. Mitchell, "An American Drifter in Israel-Palestine: Reflections on a Contested Landscape," unpublished keynote address, Fifth International Shenkar Conference on Contested Landscape, Shenkar Forum for Culture and Society (Ramat Gan, Israel: Shenkar College, 2007). Mitchell retrospectively adds that "the 'twinning' of Israel/Palestine is radically unequal. One of the Siamese twins controls space and violence. I think it means not merely to kill its Palestinian neighbors, but to devour them, or worse: spit them out."

ongoing since 2011, for which the Palestinian artist designed a passport stamp and postal stamp for Palestine.[2] Unlike other artworks that straddle the border between fiction and reality but stay in the safe zone of the aesthetic sphere, these works obscure the fact of their fictionality, or were not perceived as artworks in different manners and for different reasons. Once it was released online, *Gaza Canal* was mistaken as a deadpan political proposal and was even used as real propaganda, and Jarrar's passport stamps were stamped on real passports, while his postal stamps were printed by official postal services. In this sense, these works can be encompassed under Carrie Lambert-Beatty's term "parafiction": fiction that is perceived as fact—that is, as part of reality, rather than art.[3]

As parafictions, these works break loose from the circulation of the art world and join the various media representations of Israel and Palestine, but do so in subversive ways. Although they mimic specific national symbols and constructs, both present an ideal reality with hardly any mention of the current Israeli occupation of the Palestinian people and its grave implications. In this sense, they are not openly critical, nor do they offer any concrete solutions, as some socially engaged or "artivist" artworks dealing with political issues tend to do nowadays. Moreover, posing as non-art, these works construct a new kind of aesthetic illusion. In order to decipher the relation between these works' ambivalent political position and unique artistic representation, I will turn to Gilles Deleuze's articulation of the simulacrum as an image that derives from difference rather than resemblance. The Deleuzian simulacrum challenges the very notion of the copy and model[4]—in our case, the imaginary model most media images of Israel and Palestine derive from.

1 The Story of a Canal

Using the familiar format of a visitor center promotional video, *Gaza Canal* tells in detail the story of an imaginary solution for the Israeli-Palestinian conflict in Gaza: the digging of a canal to separate the Gaza Strip from Israel.[5]

2 Tamir Zadok, "Gaza Canal," *Vimeo*, 09:00, 2010, https://vimeo.com/12130736. Accessed November 18, 2021. Khaled Jarrar's project is documented in his Facebook page: *Live and Work in Palestine*, https://www.facebook.com/lawi.pal/. Accessed June 21, 2022.
3 Carrie Lambert-Beatty, "Make-Believe: Parafiction and Plausibility," *October* 129 (2009): 51–84.
4 Gilles Deleuze, "The Simulacrum and Ancient Philosophy," in *The Logic of Sense*, ed. Constantine V. Boundas, trans. Mark Lester and Charles Stivale (London: The Athlone Press, 1990), 253–279.
5 The Palestinian Occupied Territories include the West Bank and Gaza. While the West Bank is governed by the Palestinian National Authority, Gaza is ruled by Hamas, and is under blockade by the Israeli government. Its approximately 2.1 million residents suffer from a

It does so by meticulously following the conventional aesthetic and rhetoric of national institutions' promotional videos. These in turn borrow from commercial aesthetic strategies and documentary conventions, resulting in the deliverance of national narratives as alluring consumption products.

The video, allegedly produced by the "Yitzhak Rabin Gaza Canal Visitor Center," opens with the center's logo featuring a graphic aerial view of the canal. Images of the globe and various maps then zoom in on the Gaza Strip, surrounding the enlarged area with a yellow rectangular frame reminiscent of the visual language of *National Geographic*, thus granting the story the quasi-authority of popular natural science reportage and the air of a "world wonder." Sequences of animations and 3D, bird's-eye view simulations of the island, accompanied by informative graphics, explain how the island functions as a "green island," and grant it a utopian aura combined with a practical allure. Also included are staged interviews with non-actors, mimicking the formats of street survey and expert talking heads, which ground the story in reality and validate it. Finally, "archival materials"—staged photographs taken by Zadok for a previous, shelved art project combined with real news footage and found images—give a historical background and align "Gaza Canal" with other famous canals.[6]

FIGURE 13.1 Tamir Zadok, *Gaza Canal*, 2010, 09:00 min video, film still
IMAGE COURTESY OF THE ARTIST

severe humanitarian crisis, and repeated military confrontation between Hamas and the Israeli Defence Force.
6 Interview with the artist (Tel Aviv, September 2019).

The clever cross-editing of these real and fabricated materials not only presents the island as a success story, a human-made attraction drawing tourists from across the world, but also charges its construction narrative with characteristic Israeli national themes of heroism and overcoming. At the beginning of the video, staged scenes show young, enthusiastic female teachers who operate the visitor center and further deliver the story of the canal, which is entirely fabricated by Zadok, thus indicating the mechanism of implementation and dissemination of such narratives.

No reference to the Israeli occupation is to be found throughout the film, other than a brief description of the area's past as a "beaten and battered region."[7] The Israeli-Palestinian conflict is the elephant in the room: obviously the reason for the separation of Gaza, it is nonetheless completely ignored. It was a different event that disturbed the peaceful collaboration—a natural disaster in the shape of an unforeseen earthquake, which is cheekily told about against the backdrop of images showing bombarded neighborhoods in Gaza. The earthquake caused fatalities, but also further distanced the island from the shore, a fact that contributes to the glorification of the island as an outcome of heroic scarification.

The canal project was carried out by Israel in collaboration with the Egyptian government under the title "Still Waters"—a reference to the dramatic titles given to the Israel Defense Forces' (IDF) operations in Gaza throughout the years, such as "Defensive Shield," "Autumn Clouds," and "Cast Lead." Thus, although the IDF is absent from the narrative, the title of the project, as well as other features discussed below, imply its presence. As opposed to the massive destruction and numerous victims that the IDF's operations in Gaza brought about, "Still Waters" was the outcome of a utopian collaboration: the canal was dug by Israeli and Palestinian workers in complete harmony, together with young Israeli construction volunteers who are seen in the video working at sundown and express how they feel that they are "part of something important" and "making a difference."[8] These statements are preceded by a voice of an Arab man explaining in Arabic about the construction aspects of the project.[9] As opposed to the Hebrew-speaking construction volunteers, the Arab man is not seen, only heard. His absent presence cheekily hints at the absurd fact that most construction work in Israel is done by "invisible" Palestinians, and that such labor is almost the sole reason that grants Palestinians entry to Israel. All in all, considering its goal of separation, the presentation of the

7 Zadok, *Gaza Canal*, 02:19.
8 Ibid., 04:37, 04:46.
9 Ibid., 03:57.

digging project as the outcome of a harmonious joint effort gains additional sardonic meanings.

The video's audio is another formal way in which the story is constructed as an allegedly apolitical narrative, while actually charging it with implicit political references and strengthening the video's authoritative *voice*. The film is narrated by Ehud Graf, a famous Israeli newscaster, whose distinctive voice is synonymous with the IDF newsreels for the Israeli public ear.[10] This grants the video the alleged neutrality of news reportage, while again inserting the IDF presence and specific political motivations through the backdoor. Another important voice is that of Uri Abraham, a geology professor from Ben Gurion University. He is interviewed in the video as an expert talking head, explaining how the earthquake and consequential tsunami turned the island into a "natural island." He further describes the island as "one of the Wonders of the World," and adds to the video's whitewashing of the occupation and complete ignorance of the political context by pondering whether the island can even be called "Gaza."[11] In reality, Abraham is the artist's brother-in-law, indeed a professor at Ben Gurion University, but an expert in computer science rather than geology.

The video opens and ends with upbeat pop music, which is meant to excite the listener, while its middle section, describing the digging project, is accompanied by a more emotional, slow tune. This part is interspersed with a dramatic, non-lyric piano cover version of the song *Flowers in the Barrel (Prachim Bakaneh)*, a famous Israeli war song identified with the military band of the IDF Artillery Brigade, which was written in 1970 and expressed the sense of optimism and appreciation for the IDF soldiers following what was perceived as Israel's heroic victory in the Six Day War. The part repeated in the film is the one accompanying the famous first line of the refrain: "The sun will stand still between Gaza and Rafah," thus replicating the sense of military triumph and national pride for the allegedly apolitical digging project.

An interesting anecdote is the inclusion in the video of an image of Robert Smithson's iconic land artwork *Spiral Jetty* (1970). Included as part of a montage of human-made islands, it is wrongly labeled "Palm Island, dubai."[12] This

10 Graf's voice was delivered to the Israeli public mainly through Galei Tzahal, a radio station operated by the IDF, which is one of the most popular radio stations in Israel, and lends its hourly news reportages to many other stations (newscasts are highly present in Israeli day-to-day life. Most radio stations in Israel broadcast hourly news updates, and watching one of the various evening news shows broadcasted on TV is a daily custom for many Israelis).

11 Zadok, *Gaza Canal*, 05:57–06:18, 07:19–07:30.

12 Ibid., 07:11. The lower-case letter is in the original.

can be seen as a way to key the spectator into the work's fictiveness—a rip in the work's mimicking, which is a tactic used in many other parafictional works. Moreover, the comparison with the famous artwork equates "Gaza Canal" with the former's artistic status, as if the artist is telling us: "like *Spiral Jetty*, *Gaza Canal* is also an artwork." The equation may also imply the borrowing of the criticism turned against land art's appropriation of nature: like *Spiral Jetty*, the imagined digging project forced nature to comply with certain motivations, this time political rather than artistic. However, since the work was not created with a parafictional objective in mind, it makes more sense to read the inclusion of *Spiral Jetty* as another layer in the work's mimicking of products of national pedagogy or newsreels. Such products often incorporate similar mistakes in their hurried and frugal attempt to gather found materials into a cohesive argument. Thus, such a "mistake in origin" makes the work *more* real, rather than less real.

The video ends with Graf's distinctive voiceover proclaiming that the island is "a beacon of progress, creating new life, tourism, prosperity, industry and commerce, a symbol for a more wholesome reality."[13] However, the reality of *Gaza Canal* itself as an artwork is far from wholesome. The video functions on several fractured ontological levels: the imagined but fact-based reality presented in the film—a kind of literary fiction; the idyll the promotional video tries to make of this imagined reality; and the meta-reality of the work itself, in which it was framed as a real future political proposal or experienced as a real documentation of the past, as will soon be explained.

Already as an artwork, the video's inner, "diegetic" reality addresses how certain facts are shaped in order to serve a single, hegemonic national narrative, in which even forces of nature such as an earthquake are coerced to fit clear political interests. *Gaza Canal* was created following extensive research conducted by Zadok in various history museums around the world, in an attempt to understand how aesthetic tools are used to affix a national narrative as singular and, more importantly, as morally just. Zadok says he was especially amazed by how The 6th of October War Panorama in Egypt[14] and The Edifice of The Martyrs Museum in Jordan "use exactly the same means, the same photographs and artworks, the same residue of war, in order to tell a story contradictory to ours."[15]

13 Ibid., 01:17.
14 A museum dedicated to the 1973 Arab-Israeli War, known in Israel as the Yom Kippur War.
15 By "ours," Zadok is referring to Israelis. All quotes by Zadok are taken from an interview with the artist, and are translated from Hebrew by me, unless otherwise mentioned (Tel Aviv, September 2019).

To a certain extent, a similar inversion happened with *Gaza Canal* itself, as it gained various meanings throughout its journey in real life. First exhibited as a satirical video work in a gallery show,[16] it was only later that the work gained parafictional features when it was uploaded online, where it went viral. Flowing through social media, the video functioned as a kind of seismograph for the Israeli sociopolitical climate and a point of contention in heated political discussions. Whereas the left-wing viewers saw it as a dark-humored, painful reminder of the way Israel treats the humanitarian crises in Gaza as a nuisance needing to be whitewashed away, the right-wing saw it as a far-fetched dream or a concrete proposal, reversing the infamous accusation of many Israelis toward the Palestinians that they all "wish to throw us to the sea." In 2014, right-wing activist Yehuda Avrashi uploaded the video to his Facebook page, commencing a long thread of excited comments mostly supporting the idea, such as "imaginary but plausible"; "if only"; and "If you will, it is no dream" (a reference to Theodor Herzl's famous 1902 saying predicting the establishment of a Jewish state).[17]

"While I was imagining the past," Zadok says, "some spectators saw it as imagining the future." And indeed, a political proposal curiously similar to the one depicted in *Gaza Canal* was soon introduced. In 2011, then Israeli Minister of Transportation Yisrael Katz conceived of a "separation plan": constructing an artificial island off the Gaza shore that would include a seaport, airport, and infrastructure facilities, which would be connected to Gaza by a bridge and be overseen by international authorities.[18] The plan is a double-edged sword for Gaza and a fig leaf for Israel: on the one hand, it would allegedly remove the international blockade from Gaza, allowing it world access. On the other hand, Gaza itself would remain under Israeli control, thus allowing Israel to remove responsibility for Gaza's humanitarian crises without losing its security grip. The plan was accompanied by an animated video released in 2017 clearly resembling *Gaza Canal*'s aesthetic.[19] Although it is currently unclear whether Katz was aware of Zadok's work,[20] the overall resemblance between

16 Tamir Zadok, *Marking Territories* [Exhibition] (Tel-Aviv: Rosenfeld Gallery, 2010).
17 Yehuda Avrashi's Facebook page, June 30, 2014, https://www.facebook.com/yehuda.avrashi/videos/10202557649248985. Accessed June 21, 2022. Avrashi tagged various extreme right-wing organizations that were later removed following Zadok's request.
18 For the first report of the plan in Hebrew, see Odi Segal, "Artificial Island for Final Disengagement from Gaza" [Hebrew], *Mako*, March 29, 2011, https://www.mako.co.il/news-military/israel/Article-7855e4060a20f21004.htm. Accessed June 21, 2022.
19 The promotional video is available on Yisrael Katz's Facebook page (in Hebrew), June 13, 2017, https://www.facebook.com/katzisraellikud/videos/1368742223212585/. Accessed June 21, 2022.
20 My attempts to receive information from the Ministry went unanswered.

the artwork and the governmental proposal demonstrates that *Gaza Canal* was not a delirious artistic project, but rather stemmed from a very concrete political climate in which removing Israel's responsibility for Gaza's humanitarian crises was a legitimate solution.

In August 2015, Egypt began to dig tunnels alongside the border of Gaza in an attempt to combat Hamas's tunnels, which were used mainly for weapon-smuggling.[21] This brought the most astonishing reaction to the work, when Shehab, Hamas's news agency, shared the video on their Facebook page later that year.[22] It was shortened and framed as an *official* plan by the Israeli government, which, considering Katz's proposal, was not far from true. The long text accompanying the video in the Facebook post concluded that

> the Egyptian project is only part of an Israeli scheme that was "left on the shelf" until the existence of an Ally, Al-Sisi, that will take the financial load from the Egyptian side. However, the Israeli project does not conclude with isolating Gaza from Egypt, but will continue to the border between Gaza and the 1948 Occupied Territories. This is the *harsh reality* under Israeli occupation.[23]

Zadok's work, and its appropriation by Hamas as fake news, reveals how many aspects of the *reality* of the occupation are fabricated by the use of propaganda. However, the work amounts to more than simply indicating the fiction-based nature of propaganda, which was much discussed in our post-truth political climate. In the case of *Gaza Canal*, the same aesthetic technique was appropriated by *both sides* of the conflict for opposing purposes—first by Zadok as fictive propaganda in an attempt to parody the way national narratives of heritage are constructed, and specifically the way Israel's national position as an occupier is systematically self-ignored and whitewashed, and second by Hamas as real propaganda to foster public rage against the Israeli government. Most importantly, it was exactly when the video work started to function as a concrete political suggestion that it shed its utopic character and its problematic political implications were revealed.

21 The Associated Press, "Egypt Starts Digging along Gaza Border in Bid to Flood Tunnels," *Haaretz*, August 31, 2015, https://www.haaretz.com/egypt-starts-work-to-flood-gazan-tunnels-1.5393402. Accessed June 21, 2022.

22 Shebab News Agency's official Facebook page, September 29, 2015, webpage no longer available.

23 Ibid. The passage was translated to Hebrew by Yuval Avraham and then to English by me, and the italics are my own.

The work's dubious online effects may resonate with the dangerous implications of the illusionistic power of art, the ones Plato famously warned against when condemning the representative arts as "an inferior child born of inferior parents" in the tenth book of *The Republic*.[24] Plato distinguishes between two forms of imitation, or images (idols): *eikon*, meaning a "good and useful copy," twice removed from the Idea and based on semblance; and "phantasma," a distorted copy, third removed from the Idea, and based on apparition.[25] The creations of artists belong to the latter kind: while a carpenter's bed is an imitation of God's form of a bed; a painter's painting of a bed is an imitation of an appearance. And while the first has a functional value and is produced from within a "true belief," the latter is not useful in any way, and is created in a "beautifully ill-informed" manner.[26] Furthermore, the painter's bed is a partial representation, as it only depicts the object as it appears to be from a certain perspective, and not wholly as it truly is. His representation is one of apparition and not of truth.[27] According to Plato, this third-removed representation of reality further distances us from the world of Ideas, corrupts the mind, creates illusions, and encourages lies.

It is tempting to label parafiction art as an extreme phantasma, a copy three times removed from the truth, which, as opposed to Plato's approach toward these representations, exposes reality rather than obstructs it, or, perhaps, in a postmodernist line of thinking, reveals the absence of any single "truth." However, Lambert-Beatty suggests that parafictions are "post-simulacral" and "are oriented less toward the disappearance of the real than toward the pragmatics of trust."[28] She adds that "rather than a representation with no original, we are beset by attempts to launch something false into quasi-truthfulness,"[29] and concurs with Michael Nash and Okwui Enwezor, "who in their various writings on mixtures of fiction and documentary in contemporary art have suggested that such experiments actually defend against notions of failure of reference."[30] Indeed, parafictional art cannot be thought of as defying any intention toward a single origin, on the one hand; on the other hand, the way its images operate within reality exceeds the mere attempt to expose some kind of hidden reality.

24 Plato, *The Republic*, trans. Desmond Lee (London: Penguin Books, 1955), 346 (§603b).
25 Plato, trans. Seth Benardete, *The Being of the Beautiful: Plato's Theaetetus, Sophist, and Statesman* (Chicago: Chicago University Press, 1984), II.26–II.27 (§235d–236c).
26 Plato, *The Republic*, 344 (§602a).
27 Ibid., 390–340 (§598b).
28 Lambert-Beatty, "Make-Believe: Parafiction and Plausibility," 54.
29 Ibid., fn. 17.
30 Ibid., fn. 12.

I would like to argue that, rather than "post-simulacral," parafiction should be thought of as simulacrum, but in the Deleuzian sense of the term. Articulated as part of his major philosophical project of "over-turning Platonism,"[31] Deleuze opposes Plato's definition of the simulacrum as a degraded copy or a deceiving "phantasma" (and his ideas also contradict Jean Baudrillard's later argument that the simulacrum forgoes representation altogether). Rather, the simulacrum for Deleuze "harbors a positive power which denies *the original and the copy, the model and the reproduction*" while producing an effect of resemblance through difference.[32] In Platonism, difference is externalized and transcendental, as it lies in the relation between images and Ideas (the model). Deleuze reverses this scheme: the difference of the simulacrum is intrinsic; it does not stand in opposition to any outer model, and allows for an articulation of a concept of difference for itself. Thus, the simulacrum in fact destabilizes the entire Platonic framework of dividing, selecting, and distinguishing appearances from essences.[33]

Deleuze offers Pop Art as the artistic moment in which the copy is *"pushed to the point where it changes its nature and is reversed into a simulacrum,"* because Pop Art freed the copy from the constraints of multiplicity and semblance, turning it into an inherently different creation that destabilizes the hierarchy of the production line and mass media.[34] In our current virtual age of hypermedia, I argue that parafiction functions as another critical point in the ongoing evolution of aesthetic representation, because it creates a new and unique relation between reality and art, as will be demonstrated below.

In its careful mimicry of specific national conventions, *Gaza Canal* created a reference-less image (a "Gaza Island") not to uncover reality or to criticize a semblance to a model or a national Idea, but to break out of the constraints of a very model of images and counter-images, representations and misrepresentations, of Israel and Palestine. Such an effect is achieved not merely by the aesthetics of the work, but more precisely by the way this aesthetics is appropriated and interpreted through the work's reception. It was the lack of a clear political position, the meticulous mimicking of the aesthetic of national institutions' promotional videos, and the communicative and approachable language of the work that allowed it to seep through various political circuits while shifting between different ontological positions: an artwork, a reportage

31 Or more specifically, as part of his attempt to decipher the motivation behind what began as Friedrich Nietzsche's project of "over-turning Platonism." See Deleuze, "The Simulacrum and Ancient Philosophy."
32 Deleuze, "The Simulacrum and Ancient Philosophy," 262. Italics are in the original.
33 Ibid., 254.
34 Ibid., 265. Italics are in the original.

of reality, means for propaganda, and a political suggestion—all according to its different framings by users.[35]

In this sense, the spectators' point of view changed the nature of the *Gaza Canal* simulacrum. Deleuze recalls how Plato regarded the illusion of the simulacrum as a distorted representation because it forms a two-dimensional aesthetic perspective that takes into consideration the viewer's point of view:

> Plato specifies how this unproductive effect is obtained: the simulacrum implies great dimensions, depths, and distances that the observer cannot master. It is precisely because he cannot master them that he experiences an impression of resemblance. The simulacrum includes the differential point of view; and the spectator becomes part of the simulacrum itself, which is *transformed and deformed by his point of view*.[36]

As opposed to Plato, Deleuze finds a liberating power in such an aesthetic illusion: it takes in the spectator, and in so doing is transformed by virtue of the spectator observing it. In this regard, parafiction is a further step from the above-mentioned simulacrum of Pop Art, because the spectator's perception of a parafictional work changes its ontological nature and, concurrently, its alleged political position. In the case of *Gaza Canal*, when the spectators learned that it was a work of art rather than a political suggestion, they also understood its political predisposition differently. The internal difference of the parafictional simulacrum is achieved through, and by, the process of spectatorship.

2 State(lessness) of Palestine

In a similar but *different* manner, Jarrar's *State of Palestine* creates another difference-based simulacrum in both its aesthetic and its reception. For the project, the artist designed a passport stamp and postal stamp, both featuring a Palestinian sunbird and Jasmine flower. The creation of the most basic state

35 In this sense, *Gaza Canal* follows Sage Elwell's definition of a "generative work of art" instead of an "interactive work of art," as it generates a semi-autonomous process in which Internet users take part in order to realize its completion. Elwell used this term in relation to a different parafictional work that was implemented on the Internet, the fictive artist Darko Maver, created by Franco and Eva Mattes (1998–9). See Sage Elwell, *Crisis of Transcendence: A Theology of Digital Art and Culture* (Lanham, MD: Lexington Books, 2010), 107.

36 Deleuze, "The Simulacrum and Ancient Philosophy," 258. Italics are my own.

symbols to define national identity, as well as the use of locally known and nationally prided fauna and flora, can be, and indeed was read as a kind of wishful thinking, an attempt to summon a desired reality and take part in the process of nation-building.[37] However, a close reading of the way such national symbols appear in the work, as well as the way the work was implemented in real life, will reveal that this project holds a much more complex position toward the idea of the nation state.

Jarrar's passport stamp is aesthetically very different from the Palestinian National Authority's (PNA) official symbol, the Palestinian "Eagle of Saladin,"[38] which is inscribed on the cover of the Palestinian passport.[39] Featuring the Palestine Sunbird and jasmine flower, circled with the words "State of Palestine" and دولة فلسطين in black with light touches of blue, pink and Boudreaux, Jarrar's passport stamp bares a much less powerful and menacing air. The scandalous passport stamps' difference from and challenging of their represented model—a national apparatus—manifests not only through their design and aesthetic, but also by subverting the use of this apparatus when they were inserted into reality.

Since 2011, Jarrar has stamped approximately 700 passports at Ramallah bus station and at various stamping actions around the world, on the occasions

37 *State of Palestine* was often reported on and discussed in relation to Palestine 194, the ongoing PNA campaign to gain membership in the UN, as it was created and gained attention at the time when the campaign was making headlines in late 2011–early 2012. This can be seen with CNN's and Reuters' coverage of *State of Palestine*, among rest. Atika Shubert and Kareem Khadder, "Palestinian passport art cries freedom," CNN, July 3, 2011, http://www.cnn.com/2011/WORLD/meast/07/01/palestinian.passport.art/index.html; "Artist's Palestinian passport stamp," CNN, June 30, 2011, https://www.youtube.com/watch?v=VjFAeuWRGFg; Jihan Abdalla, "Palestinian makes artistic mark on passports," *Reuters*, May 30, 2011, https://www.reuters.com/article/us-palestinians-passport/palestinian-makes-artistic-mark-on-passports-idUKTRE74T2K020110530; "An Artistic Stamp for Palestine," *AlArabiya*, May 31, 2011, https://www.youtube.com/watch?v=qQJiyLn6mEQ. All accessed June 21, 2022. See also Gil Hochberg, "Jerusalem, we have a problem: Larisa Sansour's Sci-Fi Trilogy and the Impetus of Dystopic Imagination," *Arab Studies Journal*, vol. 26 no. 1 (Spring 2018): 39. A relevant term in this sense is "anticipatory aesthetic," see Chiara De Cesari, "Anticipatory Representation: Building the Palestinian Nation(-State) through Artistic Performance," *Studies in Ethnicity and Nationalism*, vol. 12, no. 1 (2012): 82–100. It is important to note that Jarrar himself is reluctant for his project to be associated with the PNA campaign; private correspondence with the artist, May 27, 2022.

38 The "Eagle of Saladin" is a heraldic sign serving as the coat of arms of several Arab countries, and is especially associated with Arab national independence and anti-imperialism.

39 In April 1995, following the Oslo Accords, the PNA started issuing Palestinian passports, or as they are referred to by some authorities—travel documents. However, these are not considered official passports by most countries.

RESEMBLANCE, DIFFERENCE, AND SIMULACRUM IN ART 243

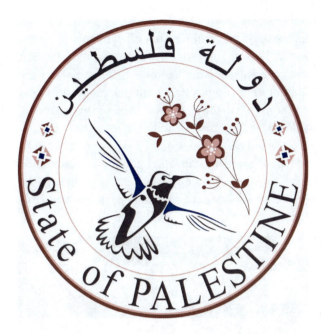

FIGURE 13.2 Khaled Jarrar, *State of Palestine*, 2011, the design
of a passport stamp, c-print diasec on aluminum,
125 cm (diameter)
IMAGE COURTESY OF WILDE GALLERY

of biennales and exhibitions. The insertion of the stamps into real bureaucratic systems as official signifiers brought various results: some stamped passport owners were held for interrogation at Israeli and Jordanian border controls, and there was even one case of an Israeli passport cancelled due to the stamp,[40] while most have traveled and continue to travel the world freely.[41]

40 The passport owner is Alison Carmel, a Jewish-American human rights activist living in Ramallah, who tells of her experience at the Ben Gurion Airport in a documentary short film about the project, as well as in the 7th Berlin Biennale's catalogue. See *Palestine Sunbird: A Stamp of Defiance*, a film made by Aljazeraa in 2013 and made available for non-Arabic speaking audience in 2020. https://www.aljazeera.com/programmes/aljazeeraworld/2020/05/palestine-sunbird-stamp-defiance-200519074310318.html. Accessed March 1, 2021; Alison Ramer (sic), "State of Palestine," *Forget Fear*, eds. Artur Żmijewski und Joanna Warsza (Berlin: KW Institute for Contemporary Art, 2012), 113–117.
41 Alistair George, "An Interview with Khaled Jarrar: Stamping Palestine into Passports," *International Solidarity Movement*, November 21, 2011, https://palsolidarity.org/2011/11/an-interview-with-khaled-jarrar-stamping-palestine-into-passports/. Accessed September 29, 2022, and interview with the artist, Tel-Aviv, 2017. It is important to note that Jarrar keeps contact with the people whose passports he stamped in order to keep track of such

The stamp could have been seen as a political gesture wishing to validate and strengthen the Palestinian passport by granting it an official looking stamp. However, Jarrar explains that he was more interested in stamping foreign passports abroad than stamping Palestinian passports at the borders of the Occupied Territories.[42] Rather than duplicating national procedures that delineate territory, Jarrar's stamps break through the idea of a cohesive nation tied to a specific land, while referring to the Palestinian tradition of hospitality and initiating an act of generosity. In this sense, the passport stamp can be defined as a differentiated simulacrum, for it creates a unique representation that objects to any concrete model of origin and copy, and it challenges the very notion of the passport stamp: its functionality, validity, and authenticity.

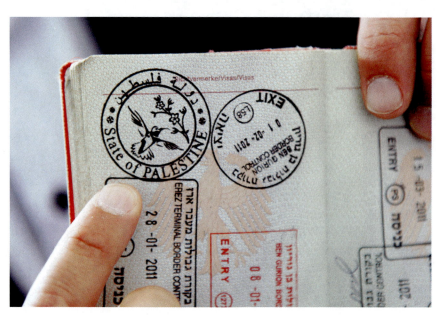

FIGURE 13.3　A passport stamped with Khaled Jarrar's *State of Palestine* stamp
　　　　　　IMAGE COURTESY OF THE ARTIST

　　　　reactions to the stamps. His consideration of these reactions as part of the work strengthens the idea that the outcome and reception of parafictional works become part of the work as it changes throughout time.

42　Only two Palestinian passports (Jarrar's and another one) and 27 Israeli passports were stamped. Interview with the artist, Tel-Aviv, 2017.

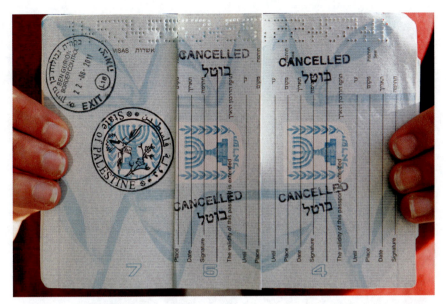

FIGURE 13.4 Allison Carmel's cancelled passport
IMAGE COURTESY OF THE ARTIST

Although the passport stamps are the more known and provocative element of *State of Palestine*, I would like to focus on the postal stamp, as it includes several different designs through which its complex aesthetic representation, and its relation to reality, can be addressed. The stamps include symbols which are induced with opposing national meanings. The Palestinian sunbird, featured in both the passport stamp and the original postal stamp design and its later, most known design,[43] was declared Palestine's national bird in 2015, and its name, in English and Arabic as well as in other languages, includes the adjective "Palestinian" as a reference to the bird's historic geographical habitat. However, in Hebrew it is known as Israeli *zufit*.

The 2015 postal stamp design features the red *anemone coronaria* flower, also known as the "windflower," or "poppy anemone."[44] Although Jarrar testifies that he chose this flower for personal reasons, as he remembers seeing its red blooming covering the hills near Jenin as a child—the flower's Palestinian

43 The first design was created in 2011, on the occasion of Galerie Polaris participation in the Parisian art fair Fiac. The second design was created in 2012, on the occasion of the 7th Berlin Biennale.

44 Created for a solo show of Jarrar, titled "That Thou Canst not Stir a Flower Without Troubling of a Star" (Geneva: Wilde gallery (then called Bartschi & Cie), 2015).

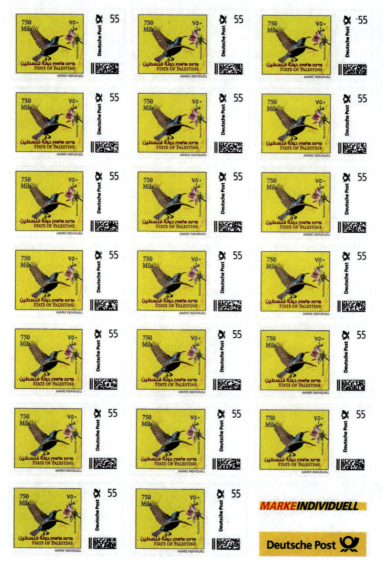

FIGURE 13.5 Khaled Jarrar, *State of Palestine*, 2012, German post edition, 26 × 18 cm, edition of 50
IMAGE COURTESY OF WILDE GALLERY

national associations, which are imposed exactly due to the fact that Palestine is one of the natural habitats of the poppy anemone, cannot be ignored. The flower is considered one of Palestine's national flowers, as it features all four colors of the Palestinian flag. Like many other countries, which use the originally British "remembrance poppy" to commemorate military causalities, the

RESEMBLANCE, DIFFERENCE, AND SIMULACRUM IN ART 245

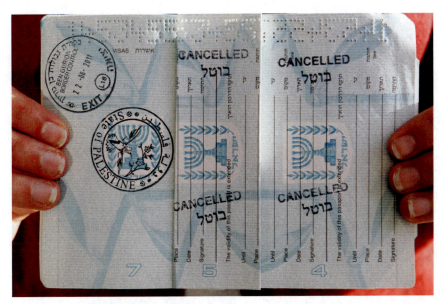

FIGURE 13.4 Allison Carmel's cancelled passport
IMAGE COURTESY OF THE ARTIST

Although the passport stamps are the more known and provocative element of *State of Palestine*, I would like to focus on the postal stamp, as it includes several different designs through which its complex aesthetic representation, and its relation to reality, can be addressed. The stamps include symbols which are induced with opposing national meanings. The Palestinian sunbird, featured in both the passport stamp and the original postal stamp design and its later, most known design,[43] was declared Palestine's national bird in 2015, and its name, in English and Arabic as well as in other languages, includes the adjective "Palestinian" as a reference to the bird's historic geographical habitat. However, in Hebrew it is known as Israeli *zufit*.

The 2015 postal stamp design features the red *anemone coronaria* flower, also known as the "windflower," or "poppy anemone."[44] Although Jarrar testifies that he chose this flower for personal reasons, as he remembers seeing its red blooming covering the hills near Jenin as a child—the flower's Palestinian

43 The first design was created in 2011, on the occasion of Galerie Polaris participation in the Parisian art fair Fiac. The second design was created in 2012, on the occasion of the 7th Berlin Biennale.
44 Created for a solo show of Jarrar, titled "That Thou Canst not Stir a Flower Without Troubling of a Star" (Geneva: Wilde gallery (then called Bartschi & Cie), 2015).

FIGURE 13.5 Khaled Jarrar, *State of Palestine*, 2012, German post edition, 26 × 18 cm, edition of 50
IMAGE COURTESY OF WILDE GALLERY

national associations, which are imposed exactly due to the fact that Palestine is one of the natural habitats of the poppy anemone, cannot be ignored. The flower is considered one of Palestine's national flowers, as it features all four colors of the Palestinian flag. Like many other countries, which use the originally British "remembrance poppy" to commemorate military casualities, the

FIGURE 13.6 Khaled Jarrar, *State of Palestine*, 2015, Anemone stamps, C-print on diasect, 145 × 165 cm
IMAGE COURTESY OF WILDE GALLERY

poppy anemone is considered to symbolize the blood of Palestinian victims who were killed fighting for their land. In Arab literature, it is an important motif, attributed to Al-Nu'mān III ibn al-Mundhir, an ancient Lakhmid king known for his bravery. At the same time, it plays a major role in Israeli culture under the Hebrew name *kalanit*. In 2013, it was chosen as Israel's national flower, and its blooming across the country is celebrated with a month-long festival. During the British Mandate in Palestine, a period that, as will be mentioned, the stamps' design draws from, the British paratroopers were nicknamed *kalaniot* (the Hebrew plural form of *kalanit*), after their red berets.

The stamps' ambivalent national and political identification is further strengthened by the use of language. As opposed to the passport stamp, the postal stamp includes Hebrew wording alongside Arabic and English. Different designs use different Hebrew names for Palestine, including "Medinat Palestine," meaning "State of Palestine" (מדינת פלסטין, an uncommon concatenation in Hebrew); "Palestina" (פלשתינה), which is the common

Hebrew name for pre-1948 Israel; and "Palestine" (פלסטין), which in Arabic usually refers to historic Palestine,[45] and in Hebrew, when at all used, stands for merely the Occupied Territories. In Arabic, the stamps feature دولة فلسطين ("Palestine State") or simply فلسطين ("Palestine"). According to Jarrar, the inclusion of Hebrew was meant to better resemble the design of official historical documents used in Mandate Palestine, a time when the Jewish and Palestinian people were not separated by national definitions, and stems from his motivation to avoid any racial or national exclusion and to portray Palestine as a place accepting differences.[46] This is also why the stamps are sold for the local currency equivalent of 750 mils, the old Palestinian currency used in British Palestine, which worth approximately 75 Euro cents.[47] The price and historic currency are featured visibly in English and Arabic on the stamps' upper corners. However, the use of Hebrew and the aesthetic references to the time of British Palestine amount to more than just a simplified gesture of acceptance. The various meanings of the words "Medinat Palestine," "Palestina," and "Palestine" stress their existence as word-symbols whose connection to their signified is completely arbitrary. Moreover, as will be demonstrated later, this design complicates the identification of the stamps with a specific political position, as well as an ontological being.

The way the doubled and opposing national meanings of the *anemone coronaria/kalanit* flower and the Palestinian sunbird/Israeli *zufit* unfold in Jarrar's postal stamps indicates not only the factitiousness and arbitrariness of national identifications given to a certain region's fauna and flora. It also holds implications regarding the resemblance and difference between Israel and Palestine. Deleuze offers two formulas for thinking about icons and simulacra in terms of difference and resemblance:

> Let us consider the two formulas: "only that which resembles differs" and "only differences can resemble each other." These are two distinct readings of the world: one invites us to think of difference from the standpoint of a previous similitude or identity, whereas the other invites us to think similitude and even identity as the product of a deep disparity. The first reading precisely defines the world of copies or representations; it posits

45 The term "Historic Palestine" refers to the pre-1948 borders, and includes Israel, Gaza, and the West Bank. The corresponding term in Hebrew, charged with religious meanings, is "Greater Israel" (Hebrew: ארץ ישראל השלמה; *Eretz Yisrael Hashlema*).
46 Private correspondence with the artist, July 2020.
47 Today, no official Palestinian currency is being used, and residents of the Occupied Territories use Euros, US dollars, Israeli shekels, and Jordanian dinars.

the world as icon. The second, contrary to the first, defines the world of simulacra; it posits the world itself as phantasm.[48]

The equation of the simulacra with the formulation "only differences can resemble each other," whose endpoint is similarity but which derives from difference, corresponds to the way the difference between Israel and Palestine reflected in the stamps derives not from two cohesive and contentious identities—in this case clear national identities specific to, and righteous of, a certain land. Rather, the similarities between Israel and Palestine are an outcome of an inherent geographical *disparity*, a difference in and of itself that exists not only in a relation (of aggressiveness and superiority) to the other. If we return to the epigraph by W. J. T. Mitchell, then Israel and Palestine can be described as a pair of Siamese twins who do not differ because of their similarity, but who can rather resemble each other because of their internal difference.

At this point, it is important to note that there are real *official* postal stamps for Palestine. In 1994, following the Oslo Accords, the PNA began to operate postal services and to issue postage stamps, among them one carrying the Palestinian Sunbird sitting on a flower (1999), and one featuring the poppy anemone, as part of a "Wildlife in Palestine" stamp series from 2013 (the series was issued just a few months before the same flower was declared as Israel's national flower).[49] Both the *kalanit* and the Israeli *zufit* also adorned many designs of official Israeli postal stamps. According to agreements with the Israeli government, PNA mail, at least initially, could not be sent internationally, but only between the Occupied Territories, and the PNA stamps, which were printed in Germany, could not carry the word "Palestine," but only "The Palestinian Council" or "Palestinian Authority." Like Jarrar, the PNA also referenced the time of the British Mandate, when they issued in 1995 a series of three stamps paying tribute to stamps of Mandate Palestine in which the word "Palestine" appeared (as well "פלשתינה(א״י)", meaning "Palestina (Israel)"). Because of the use of these words, the stamps were banned by Israeli government. Moreover, when the first PNA stamps used "Mils" as their currency designation, all stamps had to be overprinted with the designation "Fils" (the currency used in Iraq, Bahrain, Kuwait and Yemen), following Israel's protest.

48 Deleuze, "The Simulacrum and Ancient Philosophy," 261–262.

49 In 2019, the PNA has applied for membership in the Universal Postal Union, however, following a vote, the application was denied, and Palestine retained its "privileged observer" status in the union. "UPU issues statement on membership application from the State of Palestine," *Universal Postal Union*, September 18, 2019, https://www.upu.int/en/News/2019/9/UPU-issues-statement-on-membership-application-from-State-of-Palestine. Accessed June 2, 2022.

While Jarrar was looking to Mandate Palestine as a positive period in which both people co-existed, Israeli authorities saw aesthetic references to that period in the PNA official stamps as a dangerous subversion that should be censored. Perhaps this is due to the national ambivalence such references entail as evident in the concatenation "Palestina (Israel)." Considering such harsh censorship, Jarrar's use of the words "Palestine State" and the mil currency becomes a clear act of resistance to censorship, which, through the work's parafictionality, challenges the state of affairs in reality.

That being said, it is important to note that, in a paradoxical manner, the production and distribution of Jarrar's stamps as real stamps also cracked their functioning as real and official stamps for Palestine. Using the option many postal services offer to issue personalized stamps, Jarrar printed the stamps through various official postal services, on occasion of his exhibitions abroad, or independently, through "ambassadors," as Jarrar calls them, who were interested in issuing the stamps in their home countries. Approximately 27,000 stamps have been sold so far.[50] In this sense, *State of Palestine* postal stamps exceeded their status as art, or as "Cinderella stamps."[51] Like the real PNA stamps, *State of Palestine* stamps were printed outside of Palestine; but they can only be used to send mail from the countries in which they were printed, rather than from the Occupied Territories. In this sense, they do not fulfill the true function of national stamps—to facilitate and regulate the sending of mail from their associated country and to function as an identifier of origin.

At the same time, the printing of the stamps in other countries makes them official stamps of those countries, rather than of Palestine. These subtilties are crucial, because when the stamps are experienced parafictionaly, meaning on letters rather than on gallery walls, every small detail effects the way they are perceived. For example, in the editions printed in Germany, Belgium and Norway, the name and logo of the respective postal services is visible, obstructing the allusion that the stamps are official postal stamps for Palestine. In other cases, the restriction of the postal offices further heightened the stamps' confusing national identification. In the Netherlands, for example, Jarrar attempted to print the stamps independently through an "ambassador" in 2012, however, PostNL, the Dutch postal services, refused. Jarrar then created a different design and submitted it, trying to confuse PostNL, which indeed worked. The design features the image of the Monarch Butterfly, which became a symbol for immigration.[52] However, PostNL required for the word "Nederland" to

50 Private correspondence with the artist, July 2020.
51 Meaning unofficial and unauthorized stamps, usually designed for marketing purposes or political propaganda, or by scammers faking rare stamps.
52 PostNL later also printed the design featuring the Palestine Sunbird.

be added to the stamps. In Czech Republic, Česká pošta demanded to print the stamp alongside an official Czech Republic stamp.[53] These cases created hybrid objects, whose national identification is unclear: a Dutch stamp for Palestine, or a Palestinian-Czech stamp.

Considering the fact that the spectator might encounter these stamps not as artworks but as real postal stamps, the double-meaning visual signifiers, the inclusion of Arabic, Hebrew, and English, the use of historic currency and the added references to the stamps' production localities obscures their temporal, national, and political identification. Although they cannot be perceived as passport stamps for Israel, it is unclear whether they are a renewed version of historic stamps from the time of the British Mandate; stamps for a new and imaginary binational state—a hybrid product of "Palestine-Israel"; stamps for Palestine, a yet-to-become state, or simply stamps of their respective issuing countries. In this sense, the stamps are a Deleuzian simulacrum "built upon a disparity or upon a difference," and they "interiorize(s) a dissimilarity."[54] They create an external resemblance to a postal stamp, but maintain an internal difference as a "representation," as a quasi-national signifier that destabilizes the entire model of national regulations, symbols, and identities.

All in all, the stamps were approved for printing in Germany, the Czech Republic, Belgium, Norway and The Netherlands, and rejected in Canada, France, Spain and the UAE. The dynamics with the postal services—which ones refused to print the stamps and which one agreed—are telling of the international political atmosphere regarding Palestine's fight for self-determination. The first attempt to print the stamp in 2011, on the occasion of Galerie Polaris booth at the Parisian art fair Fiac, was rejected by the French postal services, who stated an article in the general conditions of the sale of personalized postage stamps, according to which the postal services have the right to refuse an order for any reason, political or otherwise.[55] In 2014, when attempting to print the stamps in Canada through a local "ambassador," the order was rejected by Canada Post, tellingly stating that they cannot print stamps for another country.[56] Jarrar then tried to submit a censored design, in which the words "State of Palestine" were covered, however, it was also rejected.

The printing difficulties of a recent stamp design with the German postal services are especially telling. The stamp was created in July 2020, as a response

53 The stamps were printed on the occasion of Jarrar's 2012 solo show at SPZ, Prague titled "A Palestinian State" (exhibited as part of "Middle East Europe," a project curated by Tamara Moyzes and Zuzana Štefková at DOX Centre for Contemporary Art, Prague).
54 Deleuze, "The Simulacrum and Ancient Philosophy," 258.
55 Email correspondence with Bernard Utudjian from Galerie Polaris, June 3, 2022.
56 Email correspondence with Myriam Faraj, the project's "ambassador" in Canada, May 29, 2022.

FIGURE 13.7 Khaled Jarrar, *State of Palestine*, 2020, annexation postal stamp design
IMAGE COURTESY OF THE ARTIST

to the unilateral annexation plan of the West Bank.[57] The stamp shows the picturesque image of the Palestine sunbird and the jasmine flower covered by pixels in various shades of green and black and abstract red stains, and the word "annexation" appears in a see-through grey font on the image's bottom. The use and distribution of pixels resembles various maps of the region, which visualize how the Occupied Territories are dispersed by multiple settlements, testifying to the practical difficulty of separating the two nations.[58]

57 In 2020, as part of Donald Trump's administration's Peace to Prosperity: A Vision to Improve the Lives of the Palestinian and Israeli People (also known as Trump's "Deal of the Century"), a concrete plan to unilaterally annex significant parts of the West Bank by Israel was put on the table, and supported by then Israeli Prime Minister Benjamin Netanyahu. However, the move, which met international resistance and was condemned as illegal by the United Nations, was eventually halted as part of the Israel-United Arab Emirates peace agreement.

58 This is also the reason for the increasing infeasibility of a two-state solution, which for many years was championed by the Israeli left. As a result, the Israeli left, as well as some voices in the Palestinian left, has begun to consider alternative solutions, such as a

These stamps were initially approved for print by the Deutsche Post, which withdrew its approval in August 2020, stating that "due to the existing conflicts on the annexation between Israel and Palestine, we reject the order after internal consultation."[59] The decision was made after the annexation plan was officially halted due to the normalization of relations between Israel and the United Arab Emirates. A month later, Deutsche Post changed its decision again. In a sense, the post office officials are the ultimate parafictional spectators of the postal stamp, because they encounter the work without necessarily knowing it is an artwork. In this sense, they "become(s) part of the simulacrum itself, which is transformed and deformed by" their point of view.[60] The possible printing by Deutsche Post would turn the design—the artwork—into a real postal stamp, while the post office would become its producer-owner and therefore a supporter of its message, however elusive that message might be. Indeed, the fickle conundrum with Deutsche Post is a clear indication of the ambiguity of the stamps' political stance—are they opting for the annexation or against it? Germany warned against the illegal annexation, and declared that it would not recognize it. If the stamps would have been perceived as resisting the annexation, why would the German post office cancel their issuance, especially after they have issued other stamp designs by Jarrar in the past? And why would it withdraw their refusal after the annexation was officially off the table?

The aesthetics and reception of Jarrar's stamps are telling of the way their hybrid images do not adhere to any national model, stance, or ideal. Rather, the elusive illusionistic character of the stamps as both a referenceless representation of a stamp and a real stamp, and the related different political affiliations they can be given, grant them an internal, inherent difference. Like *Gaza Canal*, the stamps' simulacrum operates on two interrelated levels: the political and the ontological. Moreover, when considering the function of a postal stamp—to allow messages and words to cross borders and bridge distances, all through the state infrastructure and its circulation mechanisms—Jarrar's stamps' intrinsic difference becomes even more evident: it is not clear where they are coming from and what their destination is, nor which authority they represent. Much like any valuable art, they are subject to interpretation, but because they directly deal with a political matter, and because of their functioning in real life, this interpretation holds crucial implications for their functioning *as* art.

 binational state; a state whose future postal stamps could be similar to those designed by Jarrar.
59 As quoted in an email sent to people who pre-purchased the stamps, August 16, 2020.
60 Deleuze, "The Simulacrum and Ancient Philosophy," 258.

3 Conclusion

Gaza Canal and *State of Palestine* are just two examples of parafictional works dealing with the Israeli-Palestinian conflict, each drafting a unique life span of its own.[61] These works approach their subject matter in complex ways, acknowledging the desire, and need, for national identity while nonetheless recognizing its problematic implications. They do not seek to construct, imitate, or negate, but rather to shift the ontological existence of certain structures through their functioning in between art and life. I believe that the parafictional tactic allows both Israeli and Palestinian artists an ambivalent political standpoint they could not have expressed otherwise.[62] Such ambivalence does not manifest in simply shifting between right- or left-wing standpoints, but rather in challenging the very dichotomy between left and right, aggressor and victim—much like the way the simulacrum challenges the distinction between pure and impure, or authentic and inauthentic claimants. In the Israeli-Palestinian context, such claims regard the authenticity of a primordial connection to a land. The discussed works resist the very notion of the national state and its geographical fixation.

Deleuze argues that "aesthetics suffers from a wrenching duality" between "the form of possible experience" and "the reflection of real experience," and that the "aggression of the simulacra" may reunite the real experience with the structures of the work of art.[63] This might be the horizon drawn by parafiction art, which can operate in real life exactly by the power of its aesthetic illusion. By shifting the ontology of the artwork in parallel to its political predispositions, all through the spectator's perception, it tightens up the long-lasting bond between aesthetics and politics, as well as the love-hate relationship between art and reality.

61 Other such works include Emily Jacir's *O Little Town of Bethlehem* (1999) and *Sexy Semite* (2000–2002), Khalil Rabah's *Palestinian Museum of Natural History and Humankind* (2003–), Yossi Atia and Itamar Rose's *The Teletrom for the IDF Soldiers* (2006), Scandar Copti's *Coptico* (2018), and the early works of Public Movement, among others.

62 In their book on the origin of Palestinian art, Bashir Makhoul and Gordon Hon recognize in contemporary Palestinian art a departure from the nostalgic or romanticized image of the state as described by the older generation of Palestinian artists "towards a harder, projective and ironic image of the nation." See Bashir Makhoul and Gordon Hon, *The Origins of Palestinian Art* (Liverpool: Liverpool University Press, 2013), 40.

63 Deleuze, "The Simulacrum and Ancient Philosophy," 260–261.

Bibliography

Abdalla, Jihan. "Palestinian makes artistic mark on passports." *Reuters.* May 30, 2011. https://www.reuters.com/article/us-palestinians-passport/palestinian-makes-artistic-mark-on-passports-idUKTRE74T2K020110530.

Alistair, George. "An Interview with Khaled Jarrar: Stamping Palestine into Passports." *International Solidarity Movement,* November 21, 2011. https://palsolidarity.org/2011/11/an-interview-with-khaled-jarrar-stamping-palestine-into-passports/.

"An Artistic Stamp for Palestine." AlArabiya. May 31, 2011. https://www.youtube.com/watch?v=qQJiyLn6mEQ.

"Artist's Palestinian passport stamp." *CNN.* June 30, 2011. https://www.youtube.com/watch?v=VjFAeuWRGFg.

De Cesari, Chiara. "Anticipatory Representation: Building the Palestinian Nation (-State) through Artistic Performance," Studies in Ethnicity and Nationalism 12, no. 1 (2012): 82–100.

Deleuze, Gilles. "The Simulacrum and Ancient Philosophy," in *The Logic of Sense.* Edited by Constantine V. Boundas. Translated by Mark Lester and Charles Stivale, 253–279. London: The Athlone Press, 1990.

Elwell, Sage. *Crisis of Transcendence: A Theology of Digital Art and Culture.* Lanham, MD: Lexington Books, 2010.

Hochberg, Gil. "Jerusalem, we have a problem: Larisa Sansour's Sci-Fi Trilogy and the Impetus of Dystopic Imagination," Arab Studies Journal, vol. 26, no. 1 (Spring 2018): 34–57.

Lambert-Beatty, Carrie. "Make-Believe: Parafiction and Plausibility." *October* 129 (2009): 51–84.

Makhoul, Bashir, and Gordon Hon. *The Origins of Palestinian Art.* Liverpool: Liverpool University Press, 2013.

Mitchell, W. J. T. "An American Drifter in Israel-Palestine: Reflections on a Contested Landscape." Unpublished keynote address, Fifth International Shenkar Conference on Contested Landscape, Shenkar Forum for Culture and Society. Ramat Gan, Israel: Shenkar College, 2007.

"Palestine Sunbird: A Stamp of Defiance." Aljazeraa, 03:30. 2013. https://www.aljazeera.com/programmes/aljazeeraworld/2020/05/palestine-sunbird-stamp-defiance-200519074310318.html.

Plato. *The Being of the Beautiful: Plato's Theaetetus, Sophist, and Statesman.* Translated by Seth Benardete. Chicago: Chicago University Press, 1984.

Plato. *The Republic.* Translated by Desmond Lee. London: Penguin Books, 1955.

Ramer, Alison. "State of Palestine." *Forget Fear.* Edited by Artur Żmijewski und Joanna Warsza. Berlin: KW Institute for Contemporary Art, 2012. 113–117.

Segal, Odi. "Artificial Island for Final Disengagement from Gaza" [Hebrew]. *Mako*, March 29, 2011. http://www.mako.co.il/news-military/israel/Article-7855e4060a20f21004.htm.

Shubert, Atikaand and Khadder, Kareem. "Palestinian passport art cries freedom." CNN. July 3, 2011. http://www.cnn.com/2011/WORLD/meast/07/01/palestinian.passport.art/index.html.

The Associated Press. "Egypt Starts Digging along Gaza Border in Bid to Flood Tunnels." *Haaretz*, August 31, 2015. https://www.haaretz.com/egypt-starts-work-to-flood-gazan-tunnels-1.5393402.

Zadok, Tamir. "Gaza Canal." *Vimeo*, 09:00. 2010. Accessed November 18, 2021. https://vimeo.com/12130736.

Zadok, Tamir. *Marking Territories* [Exhibition]. Tel-Aviv: Rosenfeld Gallery, 2010.

CHAPTER 14

Playing Soldiers: Reimagining the Israeli Defense Forces on the Fringe Stage

Jacob Hellman

The late twentieth century brought about a new avenue for Israeli theater in a location outside the cultural mecca of Tel Aviv. Fringe theater found a home in an unconventional setting, at the Akko Festival of Alternative Israeli Theater. Also known as the Akko Fringe, this festival trends toward supporting fringe theater from both within Israel and beyond its borders. As a city founded in the Early Bronze Age and continuously inhabited ever since, Akko, sometimes spelled Acco or Acre, is synonymous with the ancient world. While not traditionally known as a holy place, Akko appears by name in records from the earliest days of the Egyptian and Assyrian Empires. Its Crusader-era structures and coastal fortifications, declared a UNESCO World Heritage Site in 2002, are among the oldest of their kind in the Middle East, proving the city to be a curious and unusual setting for a festival representing the peak of cutting-edge contemporary fringe theater. Alternatively, this site's connection to the beginnings of civilization can be seen favorably, as, according to Shimon Levy in a 1987 interview conducted during his tenure as the festival's artistic director, Akko is "the 'nature preserve' of Israeli culture."[1]

When fringe theater is seen as a rebellion against the mainstream and commercial entertainments that have emerged as more prevalent in more recent years, a return to the roots of civilization is conducive to incubating projects that question and reexamine the nature of performance as a part of human existence. As Angela Bartie explains in her monograph on the origins of the Edinburgh Festival Fringe, the first theater festival to utilize the word "fringe" in its description of itself, the essential purpose of the fringe festival is to reexamine the very nature of performance and its role in society, giving us new insights into its meaning and its implications for the future.[2] To this end,

1 Naphtaly Shem-Tov, *Acco Festival: Between Celebration and Confrontation* (Boston: Academic Studies Press, 2016), 11.
2 Angela Bartie, *The Edinburgh Festivals: Culture and Society in Post-War Britain* (Edinburgh: Edinburgh University Press, 2013), 7.

the process of the breaking down of performance to its cultural roots lends itself to both an eye toward the past and the future as well as, in the case of the Akko Fringe, the contrast of the unexpected, daring, and cutting-edge performances juxtaposed against a backdrop of streets and buildings that have existed for millennia.

The Akko Fringe began in 1980 in the place for which it is named, a medium-sized town in Israel's Northern District. Akko is home to 50,000 residents, three-quarters of whom are Jewish and one-quarter of whom are Palestinian.[3] It is the only alternative theater festival in the entire Middle Eastern region. The festival's founding artistic director was Oded Kotler, formerly the artistic director of the Haifa Municipal Theater. Also an actor and entrepreneur, Kotler envisioned the Akko Fringe to be a forum for furthering artistic expression and alternative political viewpoints. In 2009, theater researcher and festival historian Naphtaly Shem-Tov reported that the event attracted 300,000 visitors to Akko. Most came to enjoy the many free outdoor performances, but 25,000 people purchased tickets to the festival's indoor performances.[4] The festival occurs each year in October, during the Jewish holiday of Sukkot, and its performances fall into three categories: street performances, which are free shows performed by clowns, puppeteers, and other performance artists in public among Akko's various plazas, streets, and alleys; unsubsidized ticketed shows sponsored by private producers, who utilize the festival as a testing ground for future productions; and competitive productions. The competitive productions receive government subsidies and are adjudicated by a committee, which awards a financial prize to one production each year. It is in this last category that the majority of the festival's productions fall.

Since its inception, the festival has had a succession of artistic directors, including Atay Citron, a University of Haifa professor who also served as director of the School of Visual Theatre in Jerusalem from 1993 to 2000, at which point he transitioned into the role of artistic director beginning with the 2001 season. Citron reinforced the notion that the nature of the festival was not to be "a supply of oxygen for mainstream theatre" but rather a radical event that would challenge core concepts of theater and performance. Under Citron's suggestion, the festival expanded the languages of its productions and its advertising to include Arabic, despite the overwhelmingly Hebrew- and English-speaking makeup of the festival's attendees, with the goal of making the city of Akko

3 Naphtaly Shem-Tov, "Celebration and Confrontation: Akko Festival of Israeli Alternative Theatre," *Studies in Theatre and Performance* 29, no. 1 (2009): 93–105, here 93–94.
4 Ibid., 93.

an "island of sanity" for the duration of the festival.[5] The controversial nature of the festival's choices of content is apparent through sometimes-canceled performances and occasional threats of the festival's complete shutdown over the years. Many performances in the Akko Fringe's first two decades sparked controversy by being blatant and unapologetic in their criticism of Israel's government, a concept that would have been and is still considered to be unthinkable on such a public scale in neighboring countries in the region. *The Protocols* by Igal Ezraty was, in the 1990s, a direct response to the actions undertaken by the Israeli Defense Forces (IDF) in the First Intifada, utilizing documentary evidence from the Givati Bet trials, which investigated the documented beating of a Palestinian man outside Gaza City, and the trial of Colonel Yehuda Meir, who spearheaded the abduction of Palestinian men from villages in the West Bank. Inspired by *The Investigation*, a documentary drama by Peter Weiss, Ezraty's play amplified the misdeeds of the Israeli army in seven acts performed over a series of 35 hours with over 100 actors. Technology played a distinct role in *The Protocols*, as the play was streamed live via closed-circuit television to audiences stationed in gardens surrounding the playing space, emulating the effects of media on amplifying the controversies of the First Intifada and utilizing new ways of defining performance.[6]

During the Second Intifada, in the first five years of the twenty-first century, the festival's performances took an even more outwardly direct and political turn toward the national situation. In 2001, *Cannon Fodder*, created by the Honi Hame'agal Collective, employed local tour guide Abdu Mata, a Palestinian resident of Akko, to lead audience members on a mobile, site-specific performance through Akko's alleyways and Arab neighborhoods. Rather than lead the tour as himself, Mata led the tour in character as an IDF soldier, interacting with the audience as if they were army recruits on a routine drill march. This reversal of ethnicity, status, and position led its primarily Jewish audience into unfamiliar territory in more ways than one.[7] The 2003 Fringe was described by critics as taking place during "a year of return to distinctly oppositional political theater, with blunt, transgressive messages."[8] A landmark production of that year was *Medea X* by Neora Shem-Shaul and Amir Orian, a contemporary artistic reimagining of the classic by Euripides. With Jason as an Israeli soldier and Medea as a wheelchair-using Palestinian civilian, *Medea X*'s

5 Dorit Yerushalmi, "From a Transient to a Resident: The Acco Festival of Alternative Israeli Theatre, 2001–2004," *TDR* 51, no. 4 (2007): 47–67, here 47–51.
6 Shem-Tov, *Acco Festival*, 35.
7 Yerushalmi, "From a Transient to a Resident," 51.
8 Shem-Tov, *Acco Festival*, 38–39.

casting alone clapped back at the country's political actions. In an interactive move, audiences used their mobile phones to navigate through the plot via text messaging, adding another layer of moral choice and responsibility to the Israeli public, almost all of whom were directly affected by the actions of the army. Here, spectators who may have been passive members of the audience in other plays were thrust into the role of collaborators, thanks to technology.[9]

The propulsion of the Akko Fringe and its productions into the mainstream Israeli consciousness is not, as its title may seem, a fringe affair. The unconventional way through which playwrights and their texts deal with the world around them is a continual process, and the Akko Fringe is the natural progression of this artistic development. Though their styles of performance may be unconventional at times, at their roots the plays seen at the Akko Fringe address the same issues as mainstream Israeli plays, such as the corporeality of the Israeli Jew, especially the soldier. Israeli writer and literary critic Yitzhak La'or, known as a cultural agitator in addition to being the author of the controversial, initially banned 1984 play *Ephraim Returns to the Army*,[10] once referred to the works of fellow Israeli playwright Hanoch Levin as exaltations of the bodily existence of the Jew. La'or deemed Levin's characterizations of the nation in the soldier characters seen in his plays, which played on the stages of the Cameri and Haifa Municipal Theaters, as ones of resurrection of the national spirit and cultural *Zeitgeist*, which, at one point, fed on civil religion for sustenance.[11] In an interview published in Naphtaly Shem-Tov's 2016 monograph on the Akko Fringe, well-known Israeli author and playwright A. B. Yehoshua referred to the works of the festival in very similar terms to those used by La'or in his assessment of Levin and to the playwright's importance to the fabric of the nation. Yehoshua referred to the Akko Fringe as an overall reexamination of the bodily existence of the Jew, with its works juxtaposing the exilic body of the diasporic Jew with the Jew of contemporary Israel. Through the diversity of its participants, Yehoshua saw Jewish bodies as those consisting of a different composition, referring to them as a "melting pot of Jews of different backgrounds."[12]

The allusions to the Akko Fringe as reminiscent of the evolution of the Jewish body by La'or and Yehoshua are echoed in observations on the changing nature

9 Shem-Tov, *Acco Festival*, 38–39; Yerushalmi, "From a Transient to a Resident," 61.
10 *Ephraim Returns to the Army* was scheduled to premiere at the Haifa Municipal Theater in 1985. Its production was completely shut down by a ruling from the High Court of Israel before its opening.
11 Avraham Oz, "Dried Dreams and Bloody Subjects: Body Politics in the Theatre of Hanoch Levin," *Journal of Theatre and Drama* 1 (1995): 109–146, here 124.
12 Shem-Tov, *Acco Festival*, 140.

of the IDF in the twenty-first century. In a 2008 article, Tel Aviv University political science professor Yagil Levy added to the nationally observed definition of the armed forces as a "nation-builder," positing that the military is a "melting pot" as well, despite a dominant presence of White Ashkenazi men among its ranks.[13] As the nation passed through an era of a rapid succession of conflicts considered smaller in scope than those of the 1940s, 1960s, and 1970s, reimagining the internal and external goals of its army was essential. With the First Lebanon War of the early 1980s deemed by Levy as a "war of choice" with an unexpectedly large number of casualties, Israel had reached a major turning point.[14] As the 1980s became the 1990s and the First Intifada occurred, Israel found the status of its relationship with Lebanon to be back where it was in 1982, as the nation careened into the Second Lebanon War, which began in 2006.

Interest in taking an introspective look into the psychological warfare waged by the army both against the enemy and against itself grew as changes in technology provided additional physical distance between soldier and combat zone. The ideology of military ethics and its contrast with the war machine, battling against the Lebanese and engaging in armed conflict with the Palestinians, brought about more tension, scrutiny, and frustration between Israeli soldiers and their government. This, in turn, manifested in a heightening of criticism by increasingly vocal young Israelis and was reflected in works by younger, contemporary playwrights from Generation X and Generation Y, the latter group known colloquially as "Millennials."[15] The 2013 Akko Fringe featured among its offerings the premieres of two plays whose content addressed the nuances of soldiering in the 2010s: *My Book of Faces* by Inna Eizenberg and *Pffffff* by Aharon Levin and Yaron Edelstein. *Pffffff* was the eventual winner of the competitive portion of the festival and earned its playwrights the grand prize of 30,000 NIS (New Israeli Shekels), which was financed by the Municipality of Akko. Both plays deal with contemporary issues of the soldiering experience and its aftershocks in different ways, reimagining them through the virtual world and a callback to the theater of the absurd.

13 Yagil Levy, "Military-Society Relations: The Demise of the 'People's Army.'" In *Israel Since 1980*, ed. Guy Ben-Porat et al. (Cambridge: Cambridge University Press, 2008), 117–145, here 119.
14 Ibid., 121.
15 Uzi Ben-Shalom and Shaul Fox, "Military Psychology in the Israeli Defense Forces: A Perspective of Continuity and Change," *Armed Forces and Society* 36, no. 1 (2009): 103–119, here 111; Levy, "Military-Society Relations," 117.

1 *Sefer HaPanim Sheli* (*My Book of Faces*, 2013)

My Book of Faces, written by Inna Eizenberg (1981–) and directed by Nohar Lazarovich, premiered at the Akko Fringe on September 21, 2013, before its eventual transfer to the Tmu-Na Theater, a performance center in Tel Aviv.[16] The play's Hebrew title, *Sefer HaPanim Sheli*, is a transposition in word order of the American-founded social networking site Facebook, which is one of the most popular websites in Israel. In 2015, Facebook had around 3.9 million registered users in Israel, a country of 8 million people, as opposed to Twitter, whose platform registered only 155,000 Israeli users.[17] However, rather than a literal translation, which would be *HaFacebook Sheli*, the playwright's choice of title and her transposition of words lends a decidedly different tone to social media. Rather than name-checking Mark Zuckerberg's trademark juggernaut, Inna Eizenberg refers to the popular social media platform that provides the play's backdrop as a "book of faces." Besides skirting a potential infringement of copyright, Eizenberg's choice of title captures the essential meaning of social media for society: a system of virtual categorization of human beings through their individual profiles. Collectively, social media accounts make up an endless network of interconnected individuals. However, when browsing through the profiles more closely, individual faces materialize on the screen, each representing a uniquely chosen public identity, whether real or fictional. Profiles of both types emerge onstage in Eizenberg's play, which takes place in two worlds at the same time: a large Israeli city on the coast of the Mediterranean Sea and the virtual landscape of the social network.

My Book of Faces centers on a group of three men and two women who have all been best friends since childhood. Several years after completion of their mandatory military service in the IDF, Windbag, who is male, and Pigmy, who is female, are a married couple. Spigot, who is male, is single and is employed as a cab driver. Frizzle, who is a female lawyer, has just gotten engaged to Gecko, who is a male technology-addicted music producer, at the beginning of the play. The play's action opens with Frizzle verbally announcing her change of relationship status from "single" to "engaged to Gecko" on her social media profile, eliciting positive comments from her friends Pigmy, Windbag, and Spigot. After Frizzle posts a link on her profile page to a video of an Israeli soldier

16 Barry Davis, "Acre Struts Its New Stuff," *Jerusalem Post*, September 3, 2013, http://www.jpost.com/Arts-and-Culture/Arts/Acre-struts-its-new-stuff-325144.

17 Nicholas A. John and Shira Dvir-Gvirsman, "'I Don't Like You Anymore': Facebook Unfriending by Israelis during the Israel-Gaza Conflict of 2014," *Journal of Communication* 65, no. 6 (2015): 953–974, here 954.

attacking an unarmed Palestinian teenage boy, writing the caption "the writing remains on the wall" beneath it, her husband-to-be, the quiet, distant Gecko becomes incensed. His anger manifests in a comment posted publicly to his fiancée's profile, containing a furious polemic in which he criticizes the system put in place by the state, delivering a virtual flogging to his fiancée Frizzle for her actions in an extremely public venue:

> FRIZZLE: Comments. Frizzle: The writing remains on the wall. Gecko: Well done, genius. Take an 18-year-old boy, give him a weapon, and throw him into a hell-hole where everyone is trying to kill him. Now wash his brain on a daily basis with tenacity and pride and persistence and purpose. Then turn the video camera on every time he gets spat at or pinched by some fat old granny with a full-face hijab that he is not allowed to touch ... Any parrot can scream "Occupation! Occupation!" just as loud. Learn your shit. Then you will see that the leaders you have chosen to rule over you are a bunch of greedy arseholes who put soldiers in impossible situations while they drive their Mercedes to their private jets. See that every time you feel like trashing an 18-year-old soldier who just wants to survive ... Nothing is more embarrassing to me than the ignorance of demagogues.[18]

This turn of events splinters the quintet of friends. Rather than siding with her best female friend, Pigmy takes Gecko's side against Frizzle, accusing her of not understanding the military experience, despite having undergone one of her own, and being callous to the aftershocks of her fiancé's soldiering experience. During a later scene, a philosophical conversation occurs between Frizzle and Spigot as he is driving her to law school. As they break down the interaction between Frizzle and her fiancé, she realizes that she is trapped in her own downward emotional spiral. Rather than continuing to address the post-traumatic stress of soldiering, she is now preoccupied with the exasperation of planning a wedding while repairing her relationship with the man who she will soon marry. In the process, Frizzle has lost her sense of self. Through presenting hypothetical scenarios containing hard-hitting ethical questions to the constantly overthinking, eternally frustrated law student Frizzle, Spigot helps her rethink her perspective alongside Gecko's, reimagine her own viewpoints of the war, and recontextualize the experience of being a soldier in the IDF through a greater scope than that of her own perception:

18 Inna Eizenberg, *My Book of Faces*. Unpublished manuscript, 22–23.

FRIZZLE: You think that I'm a stupid demagogue too, don't you? And you also think that some people should just get beaten up by soldiers who barge into their homes in the middle of the night.

SPIGOT: Let's try something new. Spigot's going to piss you off, intentionally, and you're just going to go with it. How does that sound?

FRIZZLE: Refreshingly new. Never happened to me before.

SPIGOT: Perfect. Now, do you agree, that the reason that soldiers enter houses in Gaza at night is either because there were weapons and terrorists hiding in those houses before, or because there is intel saying that there might be some now?

FRIZZLE: Yes, but that's no reason to-

SPIGOT: Hold it, mate. I'm not finished. Do you agree that Hamas has been firing missiles at us, from schools and hospitals intentionally?

FRIZZLE: But still-

SPIGOT: Right. Now, do you agree that only a fucked-up government would allow an 18-year-old boy to make the decisions in that kind of situation?

FRIZZLE: Yes, I do.

SPIGOT: So you would also agree that the soldier in that video is not the primary person to blame for what happened there? That the ones to blame are the people who put him there and told him over and over again that "they're all scum, terrorists, and weapon-hiding thieves who just want to kill you?"

FRIZZLE: Yes.

SPIGOT: Then you agree with our mate Gecko.

FRIZZLE: No, I don't!

SPIGOT: Why not? That's exactly what he said.[19]

In a concerted effort to find herself after this revelatory conversation, Frizzle creates what is known in the online community as a "sock puppet," or a fake social media profile for herself. She calls this profile "Simone de Beauvoir" as a way of letting out her true feelings. Under the name of the famous French philosopher, she copes with her situation by indulging in a fantasy character. She initiates conversations with the other four characters by "adding them as friends"—enabling communication via online private messaging—under this new alias, in the hope of finding out what they are really thinking but cannot tell Frizzle to her face. Intrigued by the poetic, philosophical postings of "Simone" but unaware of her identity, Gecko also creates a fake profile, a sock

19 Ibid., 29–30.

puppet character of his own. Calling himself "Jean-Paul Sartre," after Simone de Beauvoir's lifelong partner, he begins conversing across the network with the virtual "Simone," creating an online relationship. At one point during their conversations, Gecko, as "Jean-Paul," quotes the famous line from Sartre's play *No Exit*, "Hell is other people." Remembering that Spigot referenced that same line in their earlier conversation in the cab, Frizzle jumps to the incorrect conclusion that she is talking with Spigot. She begins to feel great affection for "Jean-Paul," believing that it is Spigot attempting to cheer her up, not knowing that she is talking with her own fiancé, with whom her offline relationship is rapidly deteriorating. The play ends on an abrupt and quizzical note as the three men—Spigot, Windbag, and Gecko—are called up to go fight in the war. As Frizzle and Pigmy see them off at the bus station, it is implied via a one-sided conversation with Spigot that Frizzle still thinks he is indeed the real identity behind the "Jean-Paul" profile. Meanwhile, Gecko departs, still knowing nothing about the truth of who is behind "Simone" and pondering her real identity. The questions of whether Frizzle and Gecko ever find out the truth about each other and of whether the men will come home from the conflict remain unresolved.

While the play itself deals with both high levels of emotion and modern technology, the playwright specifies in her text that "all text in the play is spoken and no computers appear on stage. There are two kinds of dialog: as 'in reality' (regular font) and 'online' (italics), indicating two different theatrical languages used on the stage."[20] By eliminating the physical technology and making the screens between them invisible, Eizenberg intends for her characters to communicate their messages merely through the actors' faces and voices. As the characters recite their italicized "virtual" words to the audience, they blur the worlds of reality and social media, of Israel and the Internet, on the stage. While Helen Kaye of *The Jerusalem Post* in her review of the play referred to Facebook as a "security blanket" for soldiers in the war zone of twenty-first-century Israel, the reality they must face at the play's end undercuts this veneer.[21] In the "real world" of the play, the ending leaves the characters vulnerable, as they have nothing behind which to hide, while, in the virtual world, they are all hiding behind online identities, either their real profiles or sock puppets.

20 Ibid., 2.
21 Helen Kaye, "War and Social Media Come Out Tops at Acre Festival 2013," *Jerusalem Post*, September 30, 2013, www.jpost.com/Arts-and-Culture/Arts/War-and-social-media-come-out-tops-at-Acre-Festival-2013-327487.

My Book of Faces also adds a twenty-first-century technological spin to the soldiering experience. The 2010s predisposition of communicating through social media platforms and apps is especially applicable for soldiers in the IDF. In past wars, soldiers located at the front and stationed on bases usually communicated with civilians via censored letters and telegrams. Even in more recent times, with the advances of phones and computers, some soldiers lack access to these modes of communication due to being stationed at a far geographical distance from cell towers or in a location that is classified or high-security. For most soldiers, however, smartphones are ubiquitous, which leads them to post messages and pictures on their social media accounts, largely uncensored. Social media can be a source of contention for military communication, as evinced by the Facebook posts and photographs taken by American soldiers in Abu Ghraib and the trials that resulted from the choices they made. Unsurprisingly, Israel saw a similar situation three years after the play in 2016, which was known as the "Hebron shooting incident," where the upload to Facebook of a video showing Israeli soldier Elor Azaria shooting a Palestinian Arab at close range in Tel Rumeida, a neighborhood in the West Bank city of Hebron, led to its viral viewing by over 24,000 Facebook users in Israel and around the world, over 6,000 "shares" reposted across the platform, and a 14-month prison sentence.[22]

In Israel, social media is a necessity if not an obsession, with most of its population possessing profiles on Facebook or communicating with one another via programs such as WhatsApp, an SMS app. According to Eizenberg, social media has a greater role in the everyday life of an Israeli soldier than merely as a form of communication between friends or family members. Her reason for writing a play entirely based on this digital platform reflects her viewpoint that social media is a "civil means of control/monitoring over a system that is very easy to lose yourself, your values and your identity inside of, like the army."[23] Through social media websites like Facebook, soldiers in the IDF can create, adjust, and monitor their own public images, an unusual form of individual expression that is seemingly not in line with the collectivist nature of the armed forces. They can express themselves freely by sharing their day-to-day lives through text, image, and video. Soldiers can also use social media to publicly air their opinions, whether in support of or against their government,

22 Moran Yarchi, "Security Issues as Mirrored in the Digital Social Media," in *Routledge Handbook on Israeli Security*, ed. Stuart A. Cohen and Aharon Klieman (New York: Routledge, 2019), 65–75, here 67–68.
23 Inna Eizenberg, email message, August 24, 2018. SMS = Short Messaging System.

creating ethnographic counter-narratives to the traditionally unified and carefully curated message of the Israeli army of previous eras.[24]

During Inna Eizenberg's tenure in the IDF in the late 1990s and early 2000s, social media was not as developed and as prevalent as it is for today's young soldiers. She posits that access to it could have helped her deal with her unhappiness as a soldier, granting her a degree of control over her own identity by sharing her experiences and commiserating with those undergoing the same experiences—or, alternatively, hiding behind them much like her character Frizzle chooses to do as "Simone." As time has gone on, there has been an increase in the amounts and forms of online anonymity seen on Facebook pages such as the semi-anonymous collective account entitled "IDF Tweets," which has existed since 2014, expanding to Twitter and the blogosphere, and the "IDF Confessions" page, launched in 2018 to share completely anonymous thoughts of Israeli soldiers to the world.[25] Rather than merely making a page on social media, Eizenberg's purpose for writing this play and staging it at the Akko Fringe was to spotlight a sometimes unseen or ignored aspect of the twenty-first-century IDF experience, showcasing the inner thoughts and personal struggles of soldiers to an audience composed of Israelis from older generations intermixed with those from younger generations:

> All my friends do reserve duty. They all suffer from PTSD on some level. They all lead full, rich lives with careers, travels and families and are all left-wing humanists. And that's all very nice, but they are called up, they drop everything, and they wear their old uniform and go "be with their friends" which really means plunging into a reality of war and pain, which is always only millimeters away here in Israel/Palestine. Every year, sometimes twice a year.
>
> I wanted to give them a voice, I guess.[26]

Eizenberg's above assessment of the frustrations of the military lifestyle as experienced by Generation X and Millennial reservists bears a striking similarity to the theory put forward by Christopher Coker in his 2013 text *Warrior Geeks: How 21st Century Technology Is Changing the Way We Fight and Think About War*. Though Coker's work covers a wider range of military concepts,

24 Nehemia Stern and Uzi Ben-Shalom, "Confessions and Tweets: Social Media and Everyday Experience in the Israel Defense Forces," *Armed Forces and Society* 47, no. 2 (2021): 344–346.
25 Ibid., 348–351.
26 Eizenberg, email message, August 24, 2018.

expanding on the roots of soldiering and extending outward, his description of modern-day soldiers as "living permanently in a wooden horse" resonate especially well with Eizenberg's words and her opinions on the struggles of life for Israeli soldiers and reservists of the digital age.[27] The rising rates of post-traumatic stress disorder, amplified by increasing numbers of civilians caught up in violence, affect soldiers who are in the reserves or are transitioning to becoming private citizens.[28] Compared to civilian life, the daily experiences of the modern-day soldier are still repetitive but are now intensified due to the rapid growth of the virtual world: intense isolation, intense boredom, and the formation of intense friendships.[29]

Likewise, the patterns into which Frizzle, Gecko, and their friends have fallen do not stray far from what they must have experienced in their army lives. Although Frizzle and Gecko can have a close physical relationship as an engaged couple, they turn to the Internet to isolate themselves from this reality, much like they were separated from friends, family, and each other while in their military service. In an ironic turn, they grow closer as sock puppet profiles on the social media as their real-life relationship suffers and deteriorates. The intense war of words between the couple on their actual profiles, triggered by Frizzle's repost of the video, is an expression of post-traumatic aggression. These feelings emerge due to both the traumatic events seen on their computer screens and on the monitors of Gecko's memory. The resulting adrenaline leads to an even stronger emotional reaction despite neither character physically being a part of the video itself aside from viewing it and sharing it.[30] Frizzle's degree of inability to identify with her fiancé's struggle, even after Spigot spells it out for her in the cab, shows just how far apart an engaged couple can be from each other mentally and emotionally, even while living together.

Reactions from audience members at the Akko Fringe in 2013 were largely supportive and understanding. Those who served during the Yom Kippur War or even earlier were defenders of a different Israel, existing under a different set of circumstances and a different political regime. Due to their age, they are now long exempt from military reserve duty and cannot see the world through the eyes of their children, who still face the possibility of being called up to serve

27 Christopher Coker, *Warrior Geeks: How 21st Century Technology Is Changing the Way We Fight and Think About War* (Oxford: Oxford University Press, 2013), 117.
28 Keren Friedman-Peleg, "Building Resilience: The Public Discourse," in *Routledge Handbook on Israeli Security*, ed. Stuart A. Cohen and Aharon Klieman (New York: Routledge, 2019), 285–296, here 287.
29 Coker, *Warrior Geeks*, 117.
30 Ibid., 241.

again, and their grandchildren and great-grandchildren, who are currently in their initial tenure with the IDF. After the play, Eizenberg heard poignant revelations from female audience members who were actively serving in the late 1990s and early-to-mid 2000s. As women who have since experienced some temporal distance from the IDF, they have now started families of their own. Those audience members who were mothers to young boys commented on their sudden realizations of becoming an active part of this "terrifying conveyor of soldier-making" in Israel—that their sons would, over the next few years, be entering a military world bearing a closer resemblance to that of Frizzle, Gecko, and their friends, than their own. Overall, the production's reception by the Akko audience reflected the importance of the social network to the lives and identities of twenty-first-century Israeli soldiers, much like Benedict Anderson's concept of *imagined communities*, only on a virtual level. Through the creation of a "virtual Israel" on the stage of the Akko Fringe, Eizenberg's play not only depicts the invisible, somewhat ephemeral world of the Internet, but an imagined network connecting soldiers of different generations.

2 *Pffffff* (2013)

The production that earned the top spot in the competitive portion of 2013's Akko Fringe crossed genres as well as political factions. With its mixture of postmodern and absurdist tendencies, *Pffffff*, by Aharon Levin (1980–) and Yaron Edelstein (1979–), imagines the extreme implications of a hypothetical doomsday situation. This black comedy with a seemingly unpronounceable title depicts how all levels of military might react in this scenario, up the chain of command from the lowest soldiers to the highest officers in the military, akin to Stanley Kubrick's 1964 farcical American cinema classic *Dr. Strangelove or: How I Stopped Worrying and Learned to Love the Bomb*.[31] Although the play takes place in a modern setting, the questions it posits and the emotions it elicits are closer to those seen in Natan Shaham's absurdist 1950 play *They'll Arrive Tomorrow*[32] than in *My Book of Faces*. *Pffffff* also brings the Israeli soldiers from the cities, deserts, and battlefields down into the sea, in an unusual look at a branch not often seen on the Israeli stage: the navy. As Israel's recently discovered undersea deposits of oil and other potentially valuable natural resources

31 Stanley Kubrick, dir. *Dr. Strangelove or: How I Stopped Worrying and Learned to Love the Bomb* (USA: Stanley Kubrick Productions, 1964).
32 Natan Shaham, *They'll Arrive Tomorrow* (Tel Aviv: Cameri Theater, 1950).

have gained more attention and importance, so have its soldiers stationed offshore.[33]

The plot is set into motion in the confines of the Dolphin, an Israeli submarine deep beneath the Persian Gulf, when Samion, a naval communications operating technician, and Shuki, a cook, encounter an anomaly of unknown origin on their radar screen, a mysterious message that sounds like "pffffff." The curiosity of this strange sound coming from the seemingly calm waters of the Persian Gulf is not initially a cause for concern, until it triggers the submarine's commander, Pinkus, to reveal that it is not a random occurrence; rather, it is the initiation of an offensive launch on nearby Iran. As a result of this revelation, Pinkus loses control. He maniacally confronts First Lieutenant Tzvika, tying him up while engaging in innocuous activities such as singing Israeli folk songs and watering a plant in a small flowerpot, a MacGuffin on a naval vessel with no source of natural light. Through radio communications, the Prime Minister and Minister of Defense become aware of the situation on the Dolphin, but are unaware of the plan's provenance, with no records of a plan of that name. An emergency meeting with Mukauma, a high-ranking member of the Palestinian military group Hamas, reveals that the organization's technology to combat this threat of annihilation is not as advanced as they have previously advertised to the public. As the Israeli and Palestinian leaders attempt to work together to prevent war—or worse, total annihilation of the Middle Eastern region—they discover an oblique reference among Pinkus's recorded ranting from the Dolphin. Together, they hear him say the two-word phrase "never again," and make the mental leap from there to interpret that Pinkus is making a reference to the initiatory phrase of a doomsday plan from the Ben-Gurion era also called "Never Again." Subsequently, they prepare for the end of the world, since the only exit strategy is a code written solely on a piece of paper that they discover Pinkus has swallowed.

In both arenas, panic ensues. On the Dolphin, the team of Samion, Shuki, and Tzvika attempts to extract the paper with the code, first by administering disgusting laxatives to Pinkus and sifting through his feces, and then by vivisecting his body through a comical removal of his internal organs. At the same time, in Israel, the Prime Minister and Minister of Defense launch a nonsensical "nuclear winter" plan, placing bikini models in a bunker to potentially repopulate the earth with them. Their madness leads them to undress and parade around their office when word comes in that the operation "Pffffff" has

[33] Yaakov Amidror, "The Evolution and Development of the IDF," in *Routledge Handbook on Israeli Security*, ed. Stuart A. Cohen and Aharon Klieman. (New York: Routledge, 2019), 36–48, here 45.

been aborted. As the higher-ups sober up from their high, uttering a miserably numb "we're saved," the crew of the Dolphin prepares to ascend to the surface, with Samion and Shuki contemplating their decisions, speculating what the end of the world might truly be like. There is, however, no indication of how the plan was aborted, or if there even was an assault plan at all—in essence, there is no proof whether the ambiguous "pffffff" was or was not just an anomalous sound from somewhere in the ocean.

Though on the surface, this play is a black comedy about the end of the world, its implications lie deeper. For any group of soldiers in an enclosed space, there is a definite physical demarcation between the inside and outside, "here" and "there." This physical boundary, be it land or water, establishes these two worlds as one of permanence and one of the unknown. The boundaries of the stage, in these cases, act as even more of a division of these zones, as the characters do not leave.

When comparing *Pfffff* to *They'll Arrive Tomorrow* despite the decades separating the creation and performance of these two plays, we see similar relationships between the soldiers and their environment. In Shaham's landmine-ridden landscape, whoever is killed by the landmines, friend or foe, will be eliminated. Similarly, in a situation involving nuclear war, the aftermath will spare no army, friendly or hostile, albeit on a much larger scale. The level of sanity and humanity of those involved in the decision-making process—Jonah and Bumah in *They'll Arrive Tomorrow* and the crew of the Dolphin and the leadership of the nation of Israel in *Pfffff*—is a teetering set of scales, which holds the lives of others in the balance at the expense of their own. This "better him/them than me/us" mentality, exemplified by the mislabelled map in *They'll Arrive Tomorrow* and the ambiguous sound in *Pfffff*, shows the true nature of the characters when confronted with life-or-death decisions. In both plays as well, the soldiers whose task it is to link the smaller contingent with the larger one, radio operator Nogah in *They'll Arrive Tomorrow* and Samion in *Pfffff*, hold the fulcrum in their hands. Nogah chooses to flee, eliminating herself from the situation, which ultimately solves nothing. Samion chooses to spearhead the vivisection of his commander, and though the way he solves the problem is not shown on stage, the resulting effect on the larger world is the same—nothing. In both cases, the actions of the Israeli soldier are those that quell the intensity of the moment, preventing the possibility of the worst possible outcome.

The absurdity of war and the possibility of inching closer to the end of humankind, as seen in the post-World War II dramatic works of Samuel Beckett and Eugène Ionesco, arise again in *Pfffff*. Only this time, the opinions are not of a splinter group, but of a united public living on the edge emotionally,

metaphorically, and geographically. Even though the behaviors and activities of the soldiers in the play reflect the experiences of Edelstein, Levin, and the nation of soldier-citizens, the unabashed cruelty and subsequent inclination toward chaos filters from the higher-ups down to the levels of the smaller, less-powerful soldiers. Pinkus creates his own evil by tying up Tzvika, threatening to kill him, and sending unnerving messages from the submarine up to the surface. His madness appears through his bursts into song and the nonsensical way he tenderly cares for the small flower in the corner of the submarine. His ruthless nature leaves him without any fear, either of punishment or death. Even Samion and Shuki are not immune from the madness resulting from the combination of panic, paranoia, and claustrophobic quarters. In Scene 5, while Samion is busy at the switchboard, Shuki, who is ostensibly responsible for feeding all those on the submarine, drowns his doubts in food as he sits nearby, gorging on grilled cheese sandwiches and chocolate bars while debating with himself whether it makes a difference if he wears a helmet or not, a darkly humorous moment inspired by a memory from Edelstein's own army experience.[34] In a later moment of pure confusion in Scene 8, Shuki frets and says prayers while randomly snacking on peanuts, as Samion acts out a Rambo fantasy in the control room, taking off his shirt, smearing shoe polish on his face, and yelling in Russian.

In addition to showing the feelings of today's soldiers—from the initial boredom of the first scene to the panicked reactions of the soldiers, to the ending scene, where Shuki and Samion reflect on their decisions—*Pfffff* also displays the extreme endpoints of deep-rooted feelings of modern-day soldiering, both those of the soldiers themselves and of what they must think about their higher-ups. According to playwright Yaron Edelstein, *Pfffff* quintessentially demonstrates the "banality of evil" as posited by Hannah Arendt, showing how it manifests in the actions of the members of the military and is still a relevant concept today.[35] The scene wherein Samion, Shuki, and Tzvika dissect their commander, pulling out his intestines and organs in what may appear to resemble a moment of *commedia dell'arte*, can be seen as both physical and metaphorical. Much like Hanoch Levin's conceptualization of the soldier in his plays, in this scene by Levin and Edelstein, Pinkus is being mined for parts by those under him. Whether they remove his internal organs in earnest or in a more comedic manner, he is reduced to no more than a human body. He has no rank and no prestige. In fact, he becomes less of a soldier and more like a science experiment, as the trio searches for a solution to their problem

34 Yaron Edelstein, personal interview, October 4, 2018.
35 Edelstein, personal interview, October 4, 2018.

among his innards as methodically as they can. The maniacal, extreme lengths to which the Prime Minister and Minister of Defense go after they give up finding a solution are reminiscent of what outsiders must think their superiors do from outside the closed doors. Indeed, they drink, party, remove their clothing, and charter planes full of swimsuit models, as they hole up in their war room and prepare for imminent disaster. The quickness with which they resort to these activities, before exhausting all possible solutions, is alarming. As soon as they discover the reference to a plan that may or may not exist and may or may not be set in motion, their attitude becomes celebratory. Rather than taking courses of action to save the public and uncover the truth, they have already written off their country as a loss, extracting from it what they need and want to survive. Although this scenario may seem like one of wish-fulfillment, the crash back to reality provides a contrast to what has just taken place.

> PRIME MINISTER: Excuse me! (The music stops, he answers the phone) Hello? Yes ... yes ... my sweetie pie, my dumpling, listen, I'm not gonna make it tonight. It's this emergency thing. I'm really sorry ... (Suddenly an idea pops into his head) Ummm ... I just remembered ... (Smiles mysteriously to the others) You're gonna die. Yes. Die. In less than an hour!
> (They all look at him with horror mixed with excitement.)
> Why did you stop crying, sweetheart? It's oh, so very sad! You're gonna turn into dust! Into nothing! I gotta go, babe. Best of luck.
> (Hangs up. Silence—then they all laugh hysterically. MINISTER OF DEFENSE barges in, climbs on the table and dances to the tune of *"The Godfather"* as he pulls down his pants.)
> MOD: What right do I have to wear underwear? What right do I have to wear underwear? What right? What right? What right do I have to wear underwear!!
> (Everyone joins him, pulling down their own pants. PRIME MINISTER passes around champagne glasses.)
> PM: Fellas, fellas!
> (Clinks his glass. Everyone is quiet.)
> Fellas, this isn't an easy moment, for any of us. But I want us to raise our glasses, for our country, for the future. The Jewish people has known many hardships throughout history and time after time, like a phoenix, or that doll, you know, the rubber thingy, Bobo doll, that thing knows how to bounce back, to rise from the wrecks, from darkness to light, to pick up the pieces, and at the end of the day, it's all for the best. L'Chaim!
> ALL: L'Chaim!

>(The phone rings. MOD answers.)
>MOD: Hello??
>(After a few seconds of listening to the other side, he turns pale. He finally puts down the phone, all choked up.)
>There's not going to be a launch. There's no bomb.
>CHIEF OF STAFF: How come??! (To the phone) How come??
>MOD: Someone activated the abort code at the last minute.
>(Long pause. They're in complete shock.)
>PM: (Miserably) That's ... great. We're saved.[36]

After receiving the call that the plan of destruction is no longer their future, there is a moment of shared misery among these officials before the scene shifts back to the Dolphin. Against what would be a normal action, in this case, one of celebration that there will be no war and that the world has been saved, those in power react to the news with disappointment, in contrast to their celebratory atmosphere moments before. The rapid, sobering, falling-back-to-earth reaction of the government officials outwardly exhibits the internally disappointing implications of not having a war. Aside from the fact that no one will die, there is a shared feeling of misery, as if those in power truly desire war rather than peace. Transitioning back to the Dolphin and its crew, the final scene is identical to that seen at the opening of the play, with Samion and Shuki seated calmly at their stations as they ascend back to the earth's surface, calmly discussing the situation and what could have been. Their rise to the top of the ocean consciously counteracts the scene we have just witnessed, one of governmental chaos plummeting and crashing to the ground at the revelation of the same news.

Audience reaction to *Pfffff* praised the comedy and the portrayals of the soldiering experience to the extent that it was awarded the top prize in the festival. The judging panel for the 2013 edition of the festival, which included dramaturge Ben Bar-Shavit, director Noam Shmuel, actor/director Ami Weinberg, and poet Maya Bejerano, justified their choice in a written statement, comparing the play's dramatization to that of a black farce that "calls for total freedom of imagination, but at a second or third glance, might not be so imaginary, and much more real than we think."[37] These thoughts are expressly echoed

36 Aharon Levin and Yaron Edelstein, *Pfffff*, trans. Natalie Fainstein, Unpublished manuscript, 23–24.
37 Merav Yudilovitch, "The Winners of the Akko Festival: *Pfffff* and *My Book of Faces*" [Hebrew], *Yediot Aharonot*, September 24, 2013, www.ynet.co.il/articles/0,7340,L-4433304,00.html.

by Edelstein, who stated regarding the overall situation that his and Levin's creative reimagining of Israel is not completely one of a pretend nation with made-up soldiers and military leaders, saying that "[i]t's not only Bibi [Benjamin Netanyahu], it's [sic] all over the political map in Israel. The left wing, and the right-wing, and there's a truly broken system of leadership—something is rotten in the Kingdom of Denmark."[38]

Far from the lofty portrayals of soldiers in early, well-known Israeli plays like Aharon Megged's *Hanna Senesh* and Moshe Shamir's *He Walked Through the Fields*, the latter of which saw its life extended far beyond the stage through its seminal, nation-defining 1967 film version, the avant-garde *Pfffff* echoes life as Israelis experience it, with larger-than-life military ministers and lower-ranking officers alike acting with small-mindedness.[39] *Pfffff*'s position on the government's attitude toward the war is neither one of support nor one of branding the military as inherently evil. The playwrights' intentions, rather, were to illuminate and elucidate the stupidity in the characters' antics and the lack of foresight in the opening chords of a potentially complex international conflict.[40] Rather than praising or demonizing the military, Levin and Edelstein took a wider angle in reflecting the behavior of Israel's military leadership as one of largely small ambitions. Instead of a looming shadow overlooking its world, *Pfffff* takes the severity of such a situation and shrinks it down to a size that is smaller than one soldier, indeed, to the size of an almost imperceptible anomaly on the radar screen of humanity. In contrast to the serious reactions that the situation would receive if it were indeed occurring, the play follows the examples of Stanley Kubrick's *Dr. Strangelove* and Sidney Lumet's *Fail-Safe*[41] in imagining the end of the world, even to twenty-first-century audiences, as something seriously kooky, mined for both laughs and grimaces. Much like in Scene 14 of the play, when a high-ranking officer enters the war room carrying a stack of board games including Clue, Monopoly, and chess, preparing for the end of the world by amassing sources of distraction and entertainment shortly before the mission is called off, Levin and Edelstein treat audiences to an absurdist, postmodern "game night" through their play, reimagining Israel and the Middle Eastern conflict zones as the board and the former's military characters as the tokens.

38 Edelstein, personal interview, November 15, 2018.
39 Aharon Megged, *Hanna Senesh* [Hebrew] (Tel Aviv: Or-Am, 1972); Moshe Shamir, *He Walked Through the Fields* [Hebrew] (Jerusalem: World Zionist Organization, 1959).
40 Ibid.
41 Sidney Lumet, dir., *Fail-Safe* (USA: Columbia Pictures, 1964).

3 Conclusion

The image of the Israeli soldier on the twenty-first-century stage in Israel is much more diverse than in past decades, as seen most clearly on the stages of the Akko Fringe. Playwrights of the twenty-first century have emphasized the more vulnerable, human qualities of the soldier, creating characters like Inna Eizenberg's troubled Frizzle and Gecko in *My Book of Faces*, with their complicated stories belying the flatness of the soldiers seen in Hanoch Levin's cabarets of the 1960s and 1970s. The balancing act of friendship between two soldiers like Avi and Jonah in Shaham's *They'll Arrive Tomorrow* of 1950 is seen again onstage in 2013 through Shuki and Samion in *Pfffff*. The expressions of brotherhood among soldiers in the contemporary plays go further, as Shuki and Samion work together to race against the clock and their lax superiors. And finally, the culturally memorialized soldier is no longer the superhuman goddess-like Hanna Senesh or son-of-the-nation Uri in *He Walked through the Fields*. Instead, the soldier's personal traits are offered up to the audience, as in the "ritual of memorialization" argued by Emmanuel Sivan, noting the Israeli attitude toward emphasizing the individual man above the collective and the way in which he died.[42]

Furthermore, it is this showcase of intense engagement of character development and personal choices before backdrops like the virtual battleground of the Internet and darkly comedic war scenarios that emphasizes how Generation X and Millennial Israelis see, experience, and interpret the world around them. The lengths to which the characters in *My Book of Faces* go to avoid direct confrontation reflects the constant, up-to-the-minute online world in which we now live. The world created by Levin and Edelstein in *Pfffff* shows the ridiculousness of the actions and behaviors of the higher-ups, now adjudicated by newer, younger generations who no longer accept the IDF's claim to be the "most moral army in the world" at face value. While the imagination of these playwrights' works flits and flows through these artificial paradigms and scenarios, it also acknowledges the sometimes sad and sober realities facing their generation and those that will emerge in the future. By projecting these images of soldiers and the soldiering experience onto the fringe stage, they address the current situation and imagine scenarios that show that they are actively looking towards the future, showing that the fringes of performance may be more telling and closer to reality than one might think.

42 Emmanuel Sivan, *The 1948 Generation: Myth, Profile, and Memory* [Hebrew] (Tel Aviv: Maarachot, 1991), 166.

Bibliography

Amidror, Yaakov. "The Evolution and Development of the IDF." In *Routledge Handbook on Israeli Security*. Edited by Stuart A. Cohen and Aharon Klieman, 36–48. New York: Routledge, 2019.

Bartie, Angela. *The Edinburgh Festivals: Culture and Society in Post-War Britain*. Edinburgh: Edinburgh University Press, 2013.

Ben-Shalom, Uzi, and Shaul Fox. "Military Psychology in the Israeli Defense Forces: A Perspective of Continuity and Change." *Armed Forces and Society* 36, no. 1 (2009): 103–119.

Coker, Christopher. *Warrior Geeks: How 21st Century Technology Is Changing the Way We Fight and Think About War*. Oxford: Oxford University Press, 2013.

Davis, Barry. "Acre Struts Its New Stuff." *Jerusalem Post*, September 3, 2013. http://www.jpost.com/Arts-and-Culture/Arts/Acre-struts-its-new-stuff-325144.

Eizenberg, Inna. *My Book of Faces*. Unpublished manuscript.

Friedman-Peleg, Keren. "Building Resilience: The Public Discourse." In *Routledge Handbook on Israeli Security*. Edited by Stuart A. Cohen and Aharon Klieman, 285–296. New York: Routledge, 2019.

John, Nicholas A., and Shira Dvir-Gvirsman. "'I Don't Like You Anymore': Facebook Unfriending by Israelis during the Israel-Gaza Conflict of 2014." *Journal of Communication* 65, no. 6 (2015): 953–974.

Kaye, Helen. "War and Social Media Come Out Tops at Acre Festival 2013." *Jerusalem Post*, September 30, 2013. www.jpost.com/Arts-and-Culture/Arts/War-and-social-media-come-out-tops-at-Acre-Festival-2013-327487.

Kubrick, Stanley, dir. *Dr. Strangelove or: How I Stopped Worrying and Learned to Love the Bomb*. USA: Stanley Kubrick Productions, 1964.

Levin, Aharon, and Yaron Edelstein. *Pffffff*. Translated by Natalie Fainstein. Unpublished manuscript.

Levy, Yagil. "Military-Society Relations: The Demise of the 'People's Army.'" In *Israel Since 1980*. Edited by Guy Ben-Porat, Yagil Levy, Shlomo Mizrahi, Arye Naor, and Erez Tzfadia, 117–145. Cambridge: Cambridge University Press, 2008.

Lumet, Sidney, dir., *Fail-Safe*. USA: Columbia Pictures, 1964.

Megged, Aharon. *Hanna Senesh* [Hebrew]. Tel Aviv: Or-Am, 1972.

Oz, Avraham. "Dried Dreams and Bloody Subjects: Body Politics in the Theatre of Hanoch Levin." *Journal of Theatre and Drama* 1 (1995): 109–146.

Shaham, Natan. *They'll Arrive Tomorrow* [Hebrew]. Tel Aviv: Cameri Theater, 1950.

Shamir, Moshe. *He Walked Through the Fields* [Hebrew]. Jerusalem: World Zionist Organization, 1959.

Shem-Tov, Naphtaly. *Acco Festival: Between Celebration and Confrontation*. Boston: Academic Studies Press, 2016.

Shem-Tov, Naphtaly. "Celebration and Confrontation: Akko Festival of Israeli Alternative Theatre." *Studies in Theatre and Performance* 29, no. 1 (2009): 93–105.

Sivan, Emmanuel. *The 1948 Generation: Myth, Profile, and Memory* [Hebrew]. Tel Aviv: Maarachot, 1991.

Stern, Nehemia, and Uzi Ben-Shalom. "Confessions and Tweets: Social Media and Everyday Experience in the Israel Defense Forces." *Armed Forces and Society* 47, no. 2 (2021): 343–366.

Yarchi, Moran. "Security Issues as Mirrored in the Digital Social Media." In *Routledge Handbook on Israeli Security*. Edited by Stuart A. Cohen and Aharon Klieman, 65–75. New York: Routledge, 2019.

Yerushalmi, Dorit. "From a Transient to a Resident: The Acco Festival of Alternative Israeli Theatre, 2001–2004." *TDR* 51, no. 4 (2007): 47–67.

Yudilovitch, Merav. "The Winners of the Akko Festival: *Pffffff* and *My Book of Faces*" [Hebrew]. *Yediot Ahronot*, September 24, 2013. www.ynet.co.il/articles/0,7340,L-4433304,00.html.

CHAPTER 15

Disrupting Holy Binaries: the Work of Gil and Rona Yefman

Yarden Stern

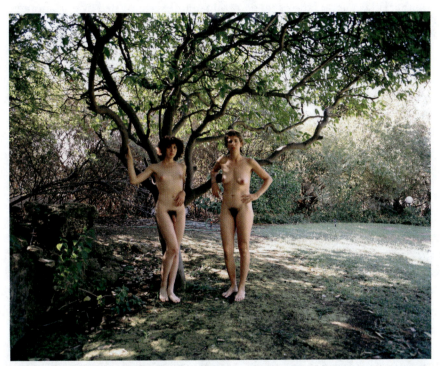

FIGURE 15.1 *The Garden of Eden*
RONA YEFMAN, 2002

It starts with a centerfold: in *The Garden of Eden* (Fig. 15.1, 2002), two nude figures are bathed in light, surrounded by idyllic greens, rooted at a grand tree that branches out of the photograph. One mimics Eve's famous pose from the paintings of Cranach the Elder, their legs slightly bent in fragility while stretching one hand out toward the tree. The other rests their hand on their waist, exuding masculinity in the role of Adam. The viewer's knowledge of the conventional creation story collides with genitalia in the wrong places: a penis prominently rests between Eve's legs and Adam displays breasts and a vagina. But the photograph disturbs the creation story in other ways, too. This is not

a recreation of serpent-crossed lovers, but an affectively charged story of siblinghood. Rona Yefman, like Adam, recasts the roles of Adam and Eve to fit her intimate familial situation. Her sibling, Gil, assumes the unwarranted role of the original sinner. Gil marks and mocks gender's conception as natural, as they are captured in the midst of a transition. With hormone treatment, Gil has begun developing breasts, their facial features slightly softening, as their small frame and slender figure exude femininity. The siblings, isolated in their surroundings, stare directly into the lens of the camera, presenting another subversion of the usual depiction of lovers captivated by one another.

Rona's genesis story shakes and shatters a religious commitment to the gender dichotomy. She questions the origins of such divisions, highlighting the physical confusion of an Eve physically descended from Adam, coming from his own rib. Further, by assigning the role of mother to a non-biological woman, and the role of father to a self-identifying woman, the siblings subvert the foundational engendering of humanity, so that creation is no longer the privilege of the divine. By offering such a complex representation of the originary myth of creation, Rona takes up Dana Luciano and Mel Y. Chen's question: "Has the queer ever been human?" They assert that "the figure of the queer/trans body does not merely unsettle the human as the norm; it generates other possibilities—multiple, cyborgian, spectral, transcorporeal, transmaterial—for living."[1] Inserting the trans body, with its multiplicity and provocative corporeality, into the ontological scene of human origins, Rona generates other possibilities of being. She applies pressure on prevailing assumptions regarding the clear gender divide while blurring the charged boundary between lover and sibling.

Gil is positioned in the damned role of woman, but as they expose their naked body, it becomes the ground for further contemplation, as it is unclear what sin Eve has committed: is it her striving for knowledge, or her gendered transgression? Luciano and Chen's project, which "keep[s] in mind both the promise and the costs of the call to move 'beyond' the human," could take this image of the Yefman siblings, one potent distillation of their critical practices, as paradigmatic of their calls to attend to the intimate, entangled nature of queer embodiments.[2] The Yefmans are champions of an alternative form of familial and social sanctity: one that they articulate by queering, defamiliarizing, and trans-forming biblical, rabbinic, and Jewish cultural tropes. It would be inaccurate to posit religion, Judaism in particular, as the object or target

[1] Dana Luciano and Mel Y. Chen, "Has The Queer Ever Been Human?" *GLQ: A Journal of Lesbian and Gay Studies* 21, no. 2–3 (2015): 183–207, here 187.
[2] Ibid., 189.

of their work. Rather, the religious—its discourses, rituals, and performative logics—enters into their collaborations to animate the works' aura and deconstructive operations. Gil, cast as the seductress in a queer reworking of the creation narrative, also offers commentary on the seductive operations through which religious narrative engenders notions of history, belonging, and authenticity. The Yefman siblings move with the understanding that, while Jewish tradition privileges the unique role of humanity in the world to foster a sense of democratic participation, it also, as Ella Shohat explains,

> embed[s] a series of hierarchies: man over woman (whose existence derives from Adam's rib), humans over animals, and animate over inanimate. God endows Adam—whom He created from 'Adama,' or earth in Hebrew—with the power of the word, the power to name, and thus granted him a verbal dominion over a world entrusted to him by his creator.[3]

As Adam and Eve, and as artistic counterparts, the reproduction of these binaries becomes a subversive matter and process, spurring multiple blurs and settled boundaries; breaking through and from the cemented barriers and limits of gender expression, grounded in notions of "nature"; and reconstituting the family via an exploration of its disavowal and disciplining of femininity. This chapter will explore these moves in greater depth by focusing on the reconceptualizing of sibling relationships in Rona Yefman's family album, *Let It Bleed*,[4] and Gil Yefman's joint body of work.

Covering over a decade of sibling relations, from the Yefmans' time as teenagers to young adults, *Let It Bleed* is a reconstructed family album composed of a variety of photographs, videos, collages, and pieces of writing that tread vernacular and fine art traditions. The publication followed Rona's 2011–2012 solo exhibition at New York City's Participant Inc., and it serves, I argue, as an intervention into articulations of the multiplicity and complexity of gender transitions and queer siblinghood. Gil is this album's protagonist, and their transition from an assigned male identity to life as a woman ends with an understanding that they belong outside of the gender binary, "beyond any gender."[5] As an intimate document of the Yefman siblings' identity transformations, the album shifts between the liberation and exhaustion that emerges when assertions of selfhood are construed as a challenge to foundational social and

[3] Ella Shohat, *Taboo Memories: Diasporic Voices* (Durham, NC: Duke University Press, 2006), 73.
[4] Rona Yefman, *Let It Bleed*, 1st ed. (Los Angeles: Little Big Man, 2016).
[5] Ibid.

religious structures. To develop this argument, I first explore Rona's reconstruction of the family album, especially how she contours its aims and strategies to fit her sibling's transition. In order to place Gil's non-binary femininity within their family structure, she presses the matter of their similarity and difference. I understand this choice by putting Sigmund Freud's elaboration of "uncanny" logic next to Juliet Mitchell's psychoanalytic thinking about the matter of sibling relations. I extend the matters of siblinghood and gender as they inform tactile experience, which is taken up by Gil's own artistic methods. This strategy is felt throughout both siblings' work and can productively integrate their practices. This is specifically the case with the siblings' artistic interventions, which involve one another and emerge from their kinship explorations, "by virtue of [their] composition and the variety of [their] methods and sites, … [they] think through and across the false division of theory/practice."[6] Their mutual sensitivity toward form allows them to unravel, expand, contour, and expose the malleability of structures that govern modern life.

1 Letting It Bleed

In Rona's afterword in the elaborate album, she explains the circumstances that brought about her reconnection with her youngest sibling. Coming home from a drug-fueled trip abroad, a 23-year-old Rona, needing rest and refuge, is reintroduced to her younger sibling Gil, who is suffering from a dire case of anorexia at the tender age of 15. She writes:

> One weekend we went to the beach and took some pictures in the sun. Gil posed on the rocks and the shoot felt magical and liberating. On the way back, Gil shared his big secret with me: his wish to become a woman. This revelation was essential to the exploratory nature of our work together.[7]

At a point where both siblings struggle with the confines of their own bodies, with normalized forms and oppressive definitions, they find refuge and comfort in the presence of one another. Their familial bond underpins their understanding of each other's dissatisfaction. A mutual trust proliferated, and normative ideals assigned to their bodies could be reconstructed into desired

6 Jeanne Vaccaro, "Transbiological Bodies: Mine, Yours, Ours," *Women & Performance: A Journal of Feminist Theory* 20, no. 3 (2010): 221–224, here 223.
7 Yefman, *Let It Bleed*.

FIGURE 15.2 *Gil on The Rocks*
RONA YEFMAN, 1995

ones. The photo Rona mentions, *Gil on the Rocks* (Fig. 15.2, 1995), is both the image opening the book and a formative moment that initiates dual journeys of documentation and transition. We see a pubescent Gil standing in a skimpy pair of swimsuit underwear on a rocky pier on the beach, posing with one hand behind their head: a slender, inviting, yet fragile image. The ambiguity of gender that emerges as a body loses its vitality marks both the gender-dysphoric body and the malnourished anorexic body. Gil's body is operating in an economy of loss in which absence doubles on itself.

In his famous meditation on the uncanny, first published in 1919, Sigmund Freud provides psychoanalytic and literary analysis simultaneously. Offering a thorough etymological explanation to qualify the uneasiness or horror that he attributes to the uncanny, Freud suggests that the term "belongs to two sets of ideas, which without being contradictory are yet very different: on the one hand, it means that which is familiar and congenial, and on the other hand, that which is concealed and kept out of sight."[8] The dynamics of concealing and revealing, like the uncanny's collapse between "homelike" and "unhomelike" in Freud's native German, suggests the importance of the feminine gender

8 Sigmund Freud, David McLintock, and Hugh Haughton, *The Uncanny* (New York: Penguin Books, 2003), 132.

to the concept Freud elaborates. Through a retelling of myths and horror stories, Freud gives multiple examples of an uncanny sensation relating to the fear of control over one's eyesight: sometimes it is an inability to believe an image that surfaces visually, and sometimes it is a fear of losing the sense of sight. For Freud, this substitutes for a fear of castration. In uncanny visions, inanimate objects come to life or doubles keep emerging. Freud goes on to explain this phenomenon of doubling as derived from the language of dreams.[9]

It is striking how the male subject of Freud's theories expresses fears about the feminine difference in terms of male loss, so much so that the two uncannily double for one another. I find this to be very interesting when thinking of trans-ness in general and trans-femininity specifically, whose biological discourses have centered on the idea of a desired castration as a way to gain a "whole" female body. What might it mean to visualize femininity or transfemininity in the face of this ontological violence? What is gained through concepts of wholeness rather than lack, or through a multiplicity that works in femininity beyond its place as a site of lack or fear?

This question gets even more complicated when the Yefman siblings' Jewishness and Israeliness are taken into account, as they relate ontologically to the history of the Jew as feminized and the conception of Zionism as a gendered project. One of the foundational tasks of Zionism has been to combat the image of the placid and scholarly Jew, forcefully rejecting that figure.[10] With deliberate effort, the new Israeli Jew, the Tzabar (Sabra), was produced as a healthy, tall, robust man and colonialist: a worker and settler of the land. Amalia Ziv argues that the figure of the transgender Jewish woman stands in complete opposition to the goal of the Zionist project of settlement and the masculine figure of the settler. "The Israeli transsexual is the man who refuses the Zionist injunction to 'be a man,' the man who refuses to embody the Zionist ideal of the muscular and robust (i.e., phallic) male body, thus reversing the direction of the Zionist project—from the normalized male body back to the feminized one."[11] Rona's exploration of Gil's femininity is bound up as much in questions of absence and lack as it is in the historical conditions through which Jewish masculinity was feminized and reclaimed.

Rona's authorship involves deploying her own body to create eerie sensations as seen throughout *Let It Bleed*. In *Owls* (Fig. 15.3, 1998), both siblings squat down on the floor, entirely covered by long woolly sweaters, only their

9 Ibid., 142.
10 Amalia Ziv, "Diva Interventions: Dana International and Israeli Gender Culture," in *Queer Popular Culture*, ed. Thomas Peele (New York: Palgrave Macmillan, 2011), 119–135, here 127.
11 Ibid., 128.

DISRUPTING HOLY BINARIES: THE WORK OF GIL AND RONAN YEFMAN 285

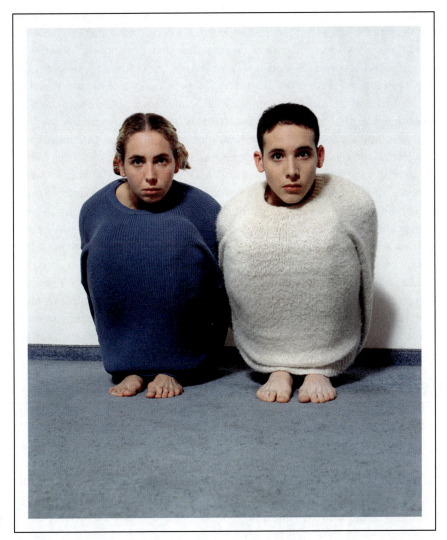

FIGURE 15.3 *Owls*
 RONA YEFMAN, 1998

feet sticking out from under them. Gil and Rona's facial expressions are identical: their wide-open eyes stare, again, directly into the camera lens. It is easy to see the resemblance of the two, but harder to pin down their desire to double as each other. I would argue that Rona and Gil, operating as dual authors in *Let It Bleed* (2016), elaborate and complicate different aspects of the uncanny offered to us by Freud. The feminine body that Rona conjures in her earliest depictions of Gil is one that dares to transgress binaries, setting the ground for further complex negotiations of loss. In their dialogues, doubling moves away

from harm and castration to a newly found wholeness in which a feminized ontology is embraced rather than rejected. As they cultivate these uncanny sensations, they create a critical through-line that disrupts the binaries of Zionism and Judaism. Within a religion based on matrilineal descent, the transsexual subversion talked about by Ziv is not only a distinct reversal of the Zionist project but also a complication to matters of Jewish reproduction, an ontological disruption that goes all the way back to Adam and Eve.

It was initially not my own inclination that brought me to connect this psychoanalytic concept to the work and image of the Yefman siblings. When presenting the work to colleagues and friends, the beautiful and haunting imagery from *Let It Bleed* would often make their viewers begin to refer to them as twins, doubles of one another. While I would correct them that the pair were merely siblings, the conversation would often go back to the uncanny nature of their similarity. Rona speaks about the experience in similar terms: "I had always loved the uncanny feeling found in family albums and they inspired me to draw upon my own childhood pictures in which the dissolution of boundaries became apparent."[12] As Gil becomes like Rona, an uncanny double through her eyes, what is modeled is not so much a realization of identity, but a notion of the fulfillment found in strong familial ties and a supportive structure based on the multiplicity of the feminine.

Gil's resemblance to Rona is seen not as something new but, as Freud would have it, "something old and familiar—established in the mind that has been estranged only by the process of repression ... concealed but which nevertheless come to light."[13] In Rona's hands, Gil's transition is depicted not only as the fulfillment of a repressed desire to become a woman, but specifically as the desire to occupy the place of their sister. This desire is hardly innate, but is authored by Rona as a photographer and documenter who is constructing this process of transition for the reader. As Freud reminds his readers, the uncanny is a firmly manufactured sensation:

> The Story-teller has a peculiarly direct influence over us; by means of the states of mind into which he can put us and the expectations he can rouse in us, he is able to guide the current of our emotions, dam it up in one direction and make it flow in another, and he often obtains a great variety of effects from the same material.[14]

12 Yefman, *Let It Bleed*.
13 Freud, McLintock, and Haughton, *The Uncanny*, 148.
14 Ibid., 157–158.

Using their resemblance to conjure an uncanny sensation, Rona marks her brother's transition into womanhood as a blurring of the boundaries of their individuality, as a threat to that basic form of individuality—gender—that the family structure offers children. This new family album manufactures gender as uncanny: as a repressed form with a normalizing function that must come to light and never can.

To say this differently: the uncanny sensation that Gil provokes throughout their documented journey is not one that fits Freud's model of the uncanny as fundamentally about childhood fears of castration and repressed infantile complexes. As Gary Indiana, a contributing author in *Let It Bleed* suggests: "Yefman introduces into this trope [the album] the nuance of a family member whose core identity is experimental and open to revision, which in turn alters the reflected understandings of what the basic relationships between family's members are, and how we interpret them by looking at their photographs."[15] The uncanny sensation of doubling becomes not only about not fitting but about creating a new fit and with it a new network of relations. Rona's documents are not the successful manifesting of a twin, but the complicated doubling of consciousness that unites photographer and subject and muddles a gendered national project.

Whereas Freud's conception of the uncanny, with its interest in sight and doubling, gives a theoretical grounding to discuss the strategies of exchange occurring between twinning siblings, the work of psychoanalyst Juliet Mitchell deals explicitly with the issue. Mitchell's career has been spent working toward finding enabling uses of Freudian psychoanalysis for feminism. Her interventions argue that there is a horizontal relation that psychoanalysis has omitted.[16] Mitchell suggests that peers are responsible for an early relation that informs the subject's self-understanding as gendered. Mitchell divides the occurrence of siblinghood into two events: the first is the sibling trauma, an event that involves the child finding out they are going to have a sibling and therefore experiencing a fear of being replaced by a new baby. This event shatters the ego, which gets rebuilt as a sibling to the emergent child. This, according to Mitchell, leads the child to develop a gender identity in relation to the newborn baby, which in infancy fulfills the role of the baby regardless of its gender, creating a need and notion for the sibling to become an older boy or girl: "It's that shattered ego, the sibling trauma, the rebuilding of the toddler's ego from being a baby as a self to being a social person, boy or girl, relating to others in

15 Gary Indiana, "How Do I Look?" in *Let It Bleed* by Rona Yefman (Los Angeles: Little Big Man, 2016).
16 Juliet Mitchell, *Siblings: Sex and Violence* (Cambridge: Polity Press, 2003).

the world."[17] Finally, Mitchell argues that it is the conception of a sibling that is embedded in our unconscious as a developmental stage; whether one has a sibling or not becomes irrelevant, as it is the very notion of siblinghood that sets off this process of events.

The intensity of the photographic relationship points toward an intimate relation between Rona and Gil, one that is marked by the confines of gender and is a united struggle against its closed borders. Following Mitchell's doctrine, it was through Gil's coming into the world that Rona discovered and confronted her own gender identity; in this photographic journey presented by Rona, we witness her exploring the boundaries of a newly discovered gender identity, caused again by the presence of her younger sibling Gil. The sibling trauma Mitchell speaks of might leave its resonances, causing violent or volatile feelings toward the infant who caused the traumatic infliction, but in fact it can be a relationship that contributes toward a development of a safe space for later explorations in adulthood. This marks siblinghood and gender as arenas that are made, unmade, and remade across a lifetime, as this developed relation is highly sensitive and malleable.

Mitchell distinguishes gender from sexuality by saying that "sexual play—playing games with each other—that is what I think gender is, as opposed to sexual difference, which involves an identification with the mother or the father post-Oedipal, post-castration complex."[18] This is distinctly related to one last image from *Let It Bleed*, an intimate shot of the pair named *Sexual Dependency* (Fig. 15.4, 1998) where a sexually charged game of hide-and-seek is performed through Rona's concealment of Gil's penis, hiding it in her grasp.[19] In the infantile regression that this image symbolizes, the Yefmans' seemingly incestuous relation explores, as Mitchell indicates, how gender is played out in the sexual, not defined by it. Rona's fist conceals Gil's penis, at once making their male biological body like her own. This move is not a Freudian enactment of femininity, nor simply the fulfillment of two castrative wishes. Through the language of sibling desire, in attempts to honor similarity and difference, it is a

17 Juliet Mitchell, UCLTV *Mini-Lecture: The Sibling Complex*, 2010, https://www.youtube.com/watch?v=GoLLn1a6DPU&ab_channel=UCL.

18 Tamar Garb and Mignon Nixon, "A Conversation with Juliet Mitchell," in *October* 113 (2005): 9–26, here 22–23.

19 By naming the extremely graphic image after Nan Goldin's "The Ballad of Sexual Dependency" (1986), Rona encapsulates Goldin's highly intimate documentation of her own sexual escapades, alongside her friends, in the 1970–1980s. Goldin's photographs are unique for their aesthetics of invasiveness into real sexual moments. Goldin's photographs, which document an abusive relationship, cast the sexual not for its reproductive functions but for the way it is lived as a peer relation.

DISRUPTING HOLY BINARIES: THE WORK OF GIL AND RONAN YEFMAN

FIGURE 15.4 *Sexual Dependency*
RONA YEFMAN, 1998

protective act instead. The penis is not concealed to later appear; it symbolizes the connection of non-binary presences, a sharing that is also a divestment from the authority of phallic possession. This not only affirms their closeness and mutual understanding, but does so by virtue of a multiple, divine, and encompassing femininity.

2 Imaginative Interrogations

Rona's queering and estranging of sibling dynamics references popular conceptions of gender founded in religious narrative and in discourses of Israeli Jewish masculinity. It is by intervening in these narratives with the force of Rona and Gil's multiple expressions of femininity that Rona's work models a different way of sharing the problem as well as the privilege of individuality. Gil's own improvisation with inherited religious histories takes ritual and rabbinic traditions legible within Jewish communities as a source and method of their improvisations with the intimacy—the porosity of interiority—of

social relations. Confronting the problematic notion of the body as a closed set of definitions, as a united or whole entity, Rona and Gil photographically challenge it together in *Let It Bleed*. Influenced by the journey detailed by Rona, Gil is not merely an object of photographic examination but emerges from the album as its artist-subject. With a vast range of their artworks, Gil turns to the felt and woolly ecology of the handmade to express their artistic vision and a nonconforming sensibility. This felt matter is interpreted by Gil as means to explore the malleability of boundaries, as their object of choice often comes to confront supposed natural barriers by questioning and undoing their cementation.

In *One Summer Evening* (2006), in which Israel's national laureate Haim Nahman Bialik's titular poem is read aloud, Gil explores and embodies both male and female gender positions through a short video piece. As Bialik's poem, a condemnation against orthodox hypocrisy regarding sexual desire, expounds on the fallacy of the separation of man and woman, a moon appears in the dark night sky. Soon, the darkness is replaced by a white sheet with a hole cut in it, through which the moon glistens and perspires. The cut sheet evokes a specific myth, one that suggests that certain Jewish orthodox communities copulate only through a sheet with a hole.[20] In Gil's version, the sheet quickly becomes a screen: a scene is projected onto it in which Gil, in the garb of an orthodox male, hastily walks through a public park when he suddenly reaches the same cut-up sheet, spread now in the middle of a wooded area. He squats and peaks through the sheet, as a slender female shadow appears on the other side. The camera zooms in on a high-heeled woman, her shoes secured using the leather straps of prayer phylacteries, or *tefillin* (Fig. 15.5, 2006). Presenting as a woman, covered with male religious relics fashioned as accessories, she has biblical verses sprawled across her legs. In her discussion of *tefillin*, Ella Shohat suggests that Jewish and Islamic theology share a reverence for the written over the visual:

> the word reigns, whether in the form of the mezuzah ... or in the tefillin (phylacteries—a leather case also containing a scroll designed for Jewish men to bind words to their hands and between their eyes during prayer) ... Judaic culture's enthusiastic embrace of textuality as a generative (and regenerative) matrix founded a way of life. It cultivated the

20 Stacey Grenrock Woods, "Is Hole-in-the-Sheet Sex Real?" *Esquire Magazine*, June 25, 2013, http://www.esquire.com/lifestyle/sex/a23230/hole-in-sheet-sex-0613/.

DISRUPTING HOLY BINARIES: THE WORK OF GIL AND RONAN YEFMAN 291

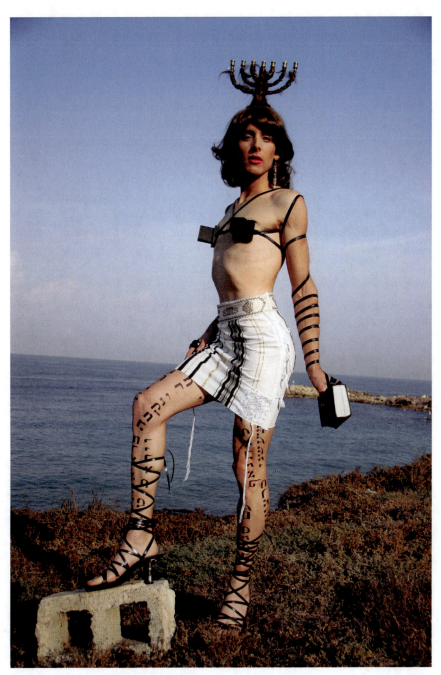

FIGURE 15.5 *One Summer Evening*
GIL YEFMAN, 2006

mystique and even the erotics of the text in its physicality: the touch of the tefillin on the male body, the kissing of the mezuzah at the threshold, and the dance around the Torah scroll.[21]

Shohat's examination of the erotics of textuality gestures to the way that the religious relic is taken up by Gil; by exploding the written word onto their body, making it visual and visible, they allow for a reimagining of the *tefillin*. The sacred word is no longer to be contained but rather worn, used as a feminine adornment. With *tefillin* on their chest as well, the black leather straps become a sensual referent to bondage, while the black boxes, meant to contain the sanctified parchment, are utilized as tassels for breasts. The smooth silky fabric used to store the *tefillin* is refashioned as underwear, as a Star of David is strategically placed to cover a sacrilegious bulge. As a headpiece, a menorah is weaved into the wig on top of Gil's head. As the full figure is revealed, an enticing, minimally dressed, sanctified gazelle is seen standing on a rock. Suddenly, the viewer is transported back to the park, where Gil, dressed as a religious man, is now being serviced by the promiscuous religious entity through the glorified hole in the sheet; one candle burns atop of her head. As the religious man reaches a climax, the candle atop the gazelle's head blows out, and the screen returns to darkness. Similar to discourses around gender and sexuality, religious discourse in Israel carries the violence of another false binary—religious/secular—which edifies other abuses of power, personal and political.[22] When Gil allows religious and secular to co-mingle and to fuck, their difference is no longer like the uncanniness of the twin, but the divisions and accretions of the self. The confrontation with the performativity of the gender divide is taken up in almost all of their artworks and installations. Gil's intervention insists that the body's formal multiplicity results in more blurring and proliferation.

This can be clearly seen in Gil's work *Tumtum* (Fig. 15.6, 2012), where they explore a biblical restriction and dislodge it from an ambiguous position. This piece stemmed from searching for the origin of the Hebrew word *tumtum*. In colloquial slang, the word *tumtum* means "stupid," "a fool," "lacking knowledge and sense." Deciphering the meaning of *tumtum*, Gil writes to the official Academy of Hebrew Language, knowing that the etymology of the word has its genealogical origin in biblical and Babylonian references to the androgynous body. Upon receiving a response from the Hebrew academy, Gil expands the term by exploring its range of meaning: *tumtum* is a combination of the

21 Shohat, *Taboo Memories*, 76.
22 Janet Jakobsen and Ann Pellegrini, *Secularisms* (Durham: Duke University Press, 2008).

DISRUPTING HOLY BINARIES: THE WORK OF GIL AND RONAN YEFMAN 293

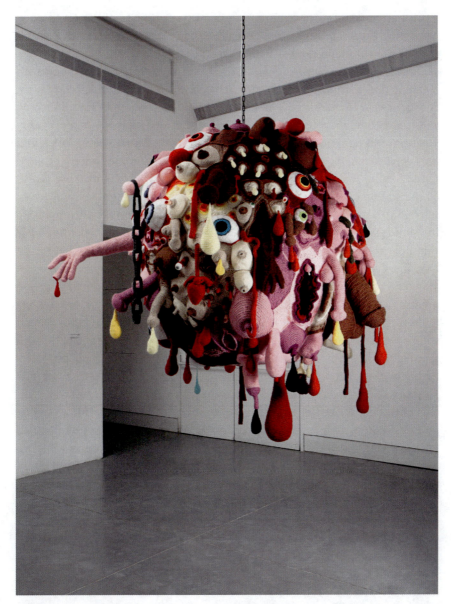

FIGURE 15.6 *Tumtum*
GIL YEFMAN, 2008

word for "sealed" (*atum* in Hebrew) and the word for "unclear, ambiguous genitalia," that which performs and looks different from the normative. The term acquired phonetic presence and primacy through a rabbinic sage, the Rambam, and his Jewish legal (halakhic) rulings on the laws of keeping kosher, because it became necessary to distinguish the gender of the animal destined for slaughter, connecting the term *tum'aa*, which means "unclean" or "impure."

Gil's artworks tend to feature a plethora of dripping, multicolored body parts hung in mid-air from hands, eyeballs, and breasts to reproductive organs such as the vulva and penis. The amalgamation is crocheted together to create a beautifully monstrous creation, one that is unclear yet abundant with meaning and matter. The craftwork hangs in the gallery, and spectators are encouraged to interact with the felt matter of the crocheted body, touching and feeling the crocheted organs. The interior of this body matters primarily in terms of its penetrability: fingers pierce through the interlocking loops, and they don't so much get inside as become a part of this unique and soft ecology.

In the 2010 self-portrait, *Rona & I Doll* (Fig. 15.7), Gil presents a self that is bound to Rona. The title seeks to have no space separating Rona and themselves, and they likewise create two dolls fundamentally connected, presenting the siblings as a desiring unit. The dolls hang from the ceiling, continuously spinning, and they are connected by their excrement, strung together by the hair, and share one big bleeding heart; their necks collared and chained to one another, they are imprisoned in crocheted golden shackles, covered in prison uniform stripes. The dolls are not whole or able-bodied, as both are missing multiple limbs. One doll has its mouth sewn shut, and both her eyes remain wide open. The other doll is sticking out a crocheted, pierced tongue through thoroughly shut eyes. As a sign of a beloved indeterminacy that characterizes their closeness, Gil endows both dolls with large breasts that ooze with milk and blood, and two large penises that connect by a drop of urine. A brown crochet chain leaves one doll's asshole and connects to the other. This grotesque portrayal marks their interconnectedness to one another, exemplified by an intimacy that is forged in the confrontation with boundaries of the appropriate and proper, through the intimacy of entanglement. This is a departure from the holistic Adam and Eve that Rona and Gil depicted just eight years earlier, but the theme of connectivity remains apparent. Where the origin story maintains a connective rib, in Gil's productive hands it is a heart, a penis, strings of hair, and multiple shackles that bind the siblings together, through abjectness and a pain, with distinct playfulness and soft textures. Reproduction is yet again complicated similarly to *The Garden of Eden*; whereas the pair seemed to have the wrong reproductive sex organs when standing in as Adam and Eve, now both are endowed with large penises, skewing gender even further.

The only non-organ(ic) part that is attached to this assemblage of siblings is the two crocheted chains holding the pair by the legs and neck. They come to symbolize both siblings' enchainment to one another and, I wish to argue, to notions of gender. The chain is knitted to represent a feeling of gender's imprisonment, but here it is a transformative reconfiguration of those shackles from ungiving metal to soft, woven matter. The chain also binds these bodies together, revealing them to be a collective effort through and through, one

DISRUPTING HOLY BINARIES: THE WORK OF GIL AND RONAN YEFMAN 295

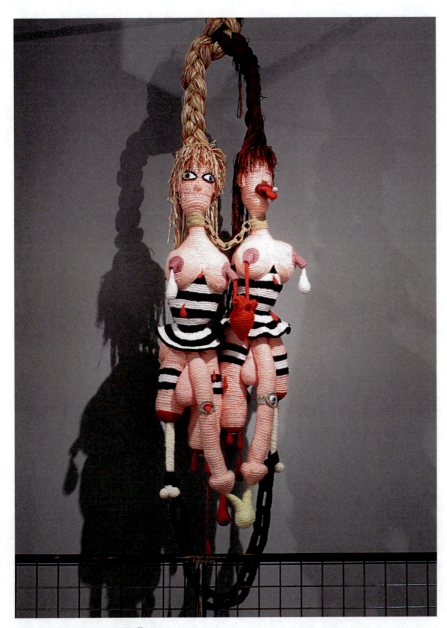

FIGURE 15.7 *Rona&I Doll*
 GIL YEFMAN, 2010

that is made into a multiply gendered and celebratory entity through a valuation of traditionally feminine labor. Gil's work is produced and labored over by a collective, and it also gestures to the crocheting that happens at the treasured site of Israeli collectivism—the *kibbutz*, the same location that stars in

so many of the images captured by Rona in her photographic documentation and is still considered the pinnacle of secular socialist life in Israel. The pooling of labor that the *kibbutz* represents becomes, for the Yefmans, a metaphor for the utopic possibility of pooling and remaking gender expressions. As Gil's artworks invite their viewers to see with their hands, an assemblage of bodies emerges; hands that constructed the piece now meet the hands that experience the wool, as felt matter ascends over mere sight and surface.

Queer theorist Jeanne Vaccaro contemplates the felt matter of trans materiality as it emerges from the deliberate privileging of the labor of texture and touch.[23] Commenting on the prefix trans-, Vaccaro argues that it is that "which remains open-ended and resists premature foreclosure by attachment to a single suffix."[24] Thus, a new and different way of thinking through trans materiality is clarified as "thinking of transgender as, for example, a body, a collection of skin and organs, the organizing of social and sexual exchange, a politic, an aspiration, a keyword, a 'special guest,' a way of being in the world. The handmade, in this spirit, is a frictional offering of transgender experiment, provocation, potential."[25]

Vaccaro reads into the commitment to matter, felt and vibrant, boldly contending that if sight and knowledge are as intimately connected as so many have argued, then "thought itself is transformed as hands look and eyes touch."[26] Following Mitchell, the vibrancy of Gil's meticulously felt and created pieces engages in the work of symbolizing many kinds of subjectivities toward a new ethics of peer relations. This emerging dimensional field, according to Vaccaro, "provides another method to measure the relation between bodies and objects differently, to resist the limited and oppositional categories of surface and depth that locate transgender either on or inside the body."[27] Gil refuses to perform a narrative of a wrong and wronged body and instead celebrates a felt body that is present and deformed in the sense that it disregards boundaries so that fantasy has a space to run wild. It is no longer simply male or female, nor male and female, but a boundless body celebrated for its ambiguity, grotesqueness, and othered form. Grasping at materials that allow for the questions of exterior to disconnect from the visual, the felt matter of trans-embodiment

23 Jeanne Vaccaro, "Felt Matters," *Women & Performance: A Journal of Feminist Theory* 20, no. 3 (2011): 253–266.
24 Jeanne Vaccaro, "Feelings and Fractals: Woolly Ecologies of Transgender Matter," *GLQ: A Journal of Lesbian and Gay Studies* 21, no. 2–3 (2015): 273–293, here 276.
25 Ibid., 277.
26 Ibid., 281.
27 Ibid., 283.

changes knowledge-formation, rupturing and meddling binary oppositions. Gil's crocheted matter disturbs and allows surface and depth, human and animal, brother and sister to exist together in states of disharmony in an existence whose grotesqueness becomes endearing and inviting. Gil's work allows for a trans aesthetic to emerge through an explosion of parts, which attests to the way that gender is always operating and organizing bodies. This disregard of borders is not a shedding of chains: it is an acknowledgment, from a place beyond definitive and punitive gender categories, that gender is made and therefore can and must be remade.

Gil's experimentation with matter is similar to Rona's engagement with the family album, as she transforms this site into an evocative and felt matter. As Gil invites participants to touch their crocheted creations, Rona designs *Let It Bleed* to be an emotional experience led by touch, as Gary Indiana elaborates through his experience of this artwork:

> Its tactile delicacy makes its human subjects seem almost physically vulnerable to the viewer's gaze, even though, like all photographers, [Rona] Yefman's have the immutability of a fait accompli. Something restive in them persists, immediate and ambiguous, that I attribute to the mutability they introduce into usually various, otherwise familiar-looking situations.[28]

Rona's multimedia exposure of her family, narrated not by a coming-of-age narrative but by a coming of and out of gender, is a *touching* and personal narrative that is unfamiliar in the Israeli landscape it captures. It is a touching presence in Gil's work as well, as it takes on archetypal moments of kinship and injects them with a multiplicity that breaks the bounds of the album through a rejection of appropriate behavior between siblings and family members.

Gil and Rona's imaginative interrogations of the sibling relation become legible through their explorations of religious and secular histories of Jewish myth and tradition: they surface and plumb religious practices and binaries that are both inherited and embodied. In Rona's case, it is the queer failure of her album—an inability to approximate the normative ideologies that the family album demands—that becomes the site of an unraveling of hierarchies and a remaking of connection in gender's multiplicity. Gil's crochets create a holiness—possibilities for integrity and communion—in their explorations of singular bodies that were never singular at all. The uncanny sensibility that the Yefmans invite into their work signifies the corporeal limits of gendered

28 Indiana, "How Do I Look?"

knowledge by playing its present against its familial and social—that is, its Jewish and Israeli—pasts. Rona and Gil's bodies are marked by an excessiveness, by a rejection of—and entanglement with—a Jewish orthodoxy of singularities that results from their celebration of the feminine and the trans as linked sets of possibilities in the bodies and media with which they work. Refusing expected forms and norms, the Yefmans feel out different possibilities of relating.

Bibliography

Freud, Sigmund, David McLintock, and Hugh Haughton. *The Uncanny*. New York: Penguin Books, 2003.

Garb, Tamar, and Mignon Nixon. "A Conversation with Juliet Mitchell." *October* 113 (2005): 9–26.

Grenrock Woods, Stacey. "Is Hole-in-the-Sheet Sex Real?" *Esquire Magazine*. June 25, 2013. http://www.esquire.com/lifestyle/sex/a23230/hole-in-sheet-sex-0613/.

Indiana, Gary. "How Do I Look?" In *Let It Bleed* by Rona Yefman. 1st ed. Los Angeles: Little Big Man, 2016.

Jakobsen, Janet R. and Pellegrini, Annette. *Love the Sin: Sexual Relation and Limits of Religious Tolerance*. New York: New York University Press, 2003.

Luciano, Dana, and Mel Y. Chen. "Has the Queer Ever Been Human?" *GLQ: A Journal of Lesbian and Gay Studies* 21, no. 2–3 (2015): 183–207.

Mitchell, Juliet. *Siblings: Sex and Violence*. 1st ed. Cambridge: Polity Press, 2003.

Mitchell, Juliet. *UCLTV Mini-Lecture: The Sibling Complex*, 2010. https://www.youtube.com/watch?v=GoLLn1a6DPU&ab_channel=UCL.

Shohat, Ella. *Taboo Memories: Diasporic Voices*. Durham, NC: Duke University Press, 2006.

Vaccaro, Jeanne. "Feelings and Fractals: Woolly Ecologies of Transgender Matter." *GLQ: A Journal of Lesbian and Gay Studies* 21, no. 2–3 (2015): 273–293.

Vaccaro, Jeanne. "Felt Matters." *Women & Performance: A Journal of Feminist Theory* 20, no. 3 (2011): 253–266.

Vaccaro, Jeanne. "Transbiological Bodies: Mine, Yours, Ours." *Women & Performance: A Journal of Feminist Theory* 20, no. 3 (2010): 221–224.

Yefman, Rona. *Let It Bleed*. 1st ed. Los Angeles: Little Big Man, 2016.

Ziv, Amalia. "Diva Interventions: Dana International and Israeli Gender Culture." In *Queer Popular Culture*. Edited by Thomas Peele, 119–135. New York: Palgrave Macmillan, 2007.

Index

A Century of Israeli Art 40, 42
Ada (typeface) 30
 Aharoni, Tuvia 25
 Aharoni (typeface) 25
 Alchima'ee (typeface) 33
 Alef (typeface) 34
 Alef-Alef-Alef 34
 Aravrit (typeface) 34
 Arial (typeface) 31
 Avraham ben Garton ben Yishaq 21
 Avraham ben Shlomo Conat 21
Adams, John 110, 113
Aghazerin, Albert 209
Akerman, Chantal
 Down there 147
Al-e Ahmad, Jalal 196–203
Allen, Jim
 Perdition 222n77
Alive from Palestine: Stories Under Occupation 209n20
Al Kasaba 209n20
Almog, Oz 67n, 176n3
Aliyah (Jewish Immigration to Israel) 92, 119
 Olim ("Jews who immigrate to Israel") 148
America-Israel Cultural Foundation 180
American Liberal milieu 148
American Revolution 111
Anderson, Benedict
 Imagined Communities 147, 153, 269
Anti-Semitism 198, 204, 205, 209, 211, 213, 216, 217, 220, 221, 223
Arafat, Yassir 86n31, 209, 218
Arab-Israel Conflict 131, 132, 134, 141, 142, 155n33, 155n34, 214, 236n14
Arendt, Hannah 126, 272
Ashdod 151
Ashkenazi
 Gaze 181, 187, 191
 Ethnic origin/identity 176n3, 178
 Paternalism 178, 187, 191
Assimilation
 Cultural 178
 And stylistic appropriation 178, 179
 See also Ashkenazi
Atlantic, The 88, 107n38, 204, 211
Auschwitz 152

Baddiel, David 221
 Jews Don't Count 221n73
Balfour Declaration 214
Baniel, Eran 208
Barthes, Roland
 The Empire of Signs 150
Baruch, Franziska 26
 Bauhaus 25, 28
 Bodoni (typeface) 22
 Bomberg, Daniel 24, 33
Bauhaus 162, 163–169
Bellow, Saul 95–96, 109, 145n1
Ben Dayan, Ortal 40–42
Ben Gurion, David 152, 198, 214, 215
Bezalel Academy of Arts and Design 25, 26, 33, 61
Bhabha, Homi 153, 183
Bible [Hebrew] 110, 113, 208
 New Testament 112
Birzeit University 209
Bloch, Jacob 104–109
 See also Here I Am
Blood Libel, The 211
Body
 Bodily bilingualism 188
 Body knowledge 190
 Body Technique 188, 189
 And corporeal intelligence 190
 And walking 188, 189
Bogler, Shmuel 152
 See also Why Israel
Boycott, Divestment and Sanctions Movement (BDS) 231
Bourdieu, Pierre 189
Brantley, Ben 85–86
British Broadcasting Corporation 212
British Labour Party 204
British Israelism (Anglo Israelism) 117
Butcher, Justin 213

CanStage (Toronto) 217
Castel, Moshe 50
Central Intelligence Agency (CIA) 114
Cinema
 Israeli 146, 149
 Novo (Portuguese) 149
Christianity 116, 119

Christian Zionists 112
Churchill, Caryl 87–90 204, 210–213, 215, 218, 222
 Seven Jewish Children 204, 206, 210–231
Collective memory 56–57, 60, 72
Connerton, Paul 161
Contemporary Choreography 176, 183
Cooke, Dominic 210
Corbyn, Jeremy 204, 223
Corrie, Rachel 83–87, 92, 216–220
The Counterlife
 And emasculation 98–100, 101–102, 103
 And Israel 98–100, 101–103
 And Jewish authenticity 99–100, 101–102, 103
Courtyard Theatre 213
Covid-19 188
Crime fiction 130–132
CUFI (Christians United for Israel) 111, 113, 115, 120

Daneshvar, Simin 196, 200
Dance Styes and Genres
 Appropriation of 178
 Arab Dabke 178
 Argentinian tango 184
 Ballroom 184
 Contemporary 183, 184, 190
 Ethnic 190, 191
 German Ausdruckstanz 179
 Hip Hop 184
 Israeli hora 184
 Irish 184
 Modern dance 176, 179
 Street 189
Darom (typeface) 34
 David, Itamar (Ismar) 27
 David (typeface) 27, 28
 Didot (typeface) 22
 Didot, Firmin 22
Dassah 186, 188
Dassin, Jules
 Survival 1967 147
Davar Leyeladim 58–59, 68
David (King) 117, 120
Dayan, Moshe 198
Deir Yassin 215

Deleuze, Gilles 232n, 240–241, 248, 249n48, 251n54, 253n60, 254
Denver 120
de Salazar, António 149
Diaspora
 And gender 96, 101, 103, 105–106, 108–109
 And Jewish authenticity 96, 98, 101–103, 106–109
 And the Holocaust 96
 Galut versus Golah 103, 109
 See also Galut
 Jewish 145, 147, 148, 153, 154, 157
 Stories 148
Diasporism 99–100, 102–103
 See also Operation Shylock
Diver Festival 183
du Simitiere, Pierre Eugene 110

Eban, Abba 181
Edelkayt 108
Edelstein, Yaron 261, 269, 272, 274, 275, 276
Edgar, David 79
Eichman, Adolf 132, 200
Eisen 95–97, 109
 See also Mr. Sammler's Planet
Eisenstadt, Shmuel 147, 148n11, 153n28, 154n31
Eizenberg, Inna 261, 262, 263n, 266n23
el Sakakini, Khalil 215
 See also Sakakini
Egypt 116, 119, 131, 137, 238
Eshel, Ruth 182
Ethnicity 176, 185, 190
Evangelical 139–140
Ezekiel (Book of) 117
Ezer, Oded 33–34
Ezra, Nadav 32

Folklore 177, 184
 Folk Dance/Dances 184, 185
 Global Folklore 184, 185
 Hybrid 176
 Urban folklore 189
 See also Ashkenazi; Inbal Dance Theater; Mizrachi; Mor Shani; Simple Dance
Franko, Mark 183

INDEX

Fedra (typeface) 34
 Fontbit 32
 Frank, Rafael 24–25, 33, 36
 Frank-Rühl (typeface) 24–25, 26n47, 27, 32, 33, 36
Fink, Uri
 Havlei Mashiah 61
 Zbeng 55n6
Finn, William
 Falsettos 221n72
Fitzgerald, Jason 92
Foer, Jonathan Safran 104, 108
Frank, Anne 86
Franklin, Benjamin 110, 111, 114, 118, 123
French Jews 148
French Revolution 119
Freud, Sigmund 96, 282–5
Fried, Eliyahu 34
 Friedlander, Henri 29, 33
Frodon, Jean Michel 149
Frye, Northrop 44, 48

Gal, Meir 40–41
Galut 96–97, 99–100, 103, 109
 See also Diaspora
Gaza 121, 153, 205, 206, 207, 209, 209, 211, 213, 214, 216, 217, 223, 231–238, 248n
 Operation Cast Lead 210, 212, 214
 Operation Protective Edge 213
 Gaza Canal 231–233, 236–238, 240–241, 253–254
Gender
 and Zionism 283–4
 and religion 279, 284, 288, 290–1
 and Hebrew language 280, 291–2
Genesis
 The Akedah 106–107
 Jacob 107–108
Giardino, Vittorio
 And Bauhaus 61
 And Tel Aviv 61–62
Globalism 182
 Global Culture 185
Globalization 146, 165
Globe Theatre, London 205
Globe to Globe Festival 205
Glocalization 72n76

Goldberg, Jeffrey 88–89, 204
Goldberg, Leah
 Comics 59
Gordis, Daniel 79
Gorkin, Baruch 31
 Greta (typeface) 34
 Grumer, Daniel 34
 Gutman, Shmuel 31
Granach, Gad 153
 See also Why Israel
The Great Seal 110, 111, 112, 114, 116, 124
Gringras, Robbie 90
Grossman, David 208
Guardian, The 84, 211
Gutman, Nachum (Nahum) 42, 50, 58, 68

Habitus 189
Haaretz Shelanu 64, 70n68
Habima 205
Haganah, The 131, 215
Hagee, John 111, 112, 113, 114, 120
Ha'Gilda 34
 Hadassah (typeface) 29–30, 33
 Haim (typeface) 25, 30
 Haskalah movement 23
 Hatzvi (typeface) 28
 Hausman, Zvi (Theo) 28
Haifa District Court 217n52
Hamas 216, 232n5, 238
Hanukah, Assaf 69
Hare, David 204, 206, 207–210
 Via Dolorosa 204, 206, 207–210
 Wall 207, 208
Haredim ("Ultra-Orthodox") 146, 151
Hebron (West Bank) 151
Hebrew University of Jerusalem, The 197
Helena (Empress) 119
Here I Am
 and "counter-Zionism" 107–108
 and Genesis 106–108
 as rumination on contemporary American ambivalence about Israel 106–107
 and setting 103–104
 and stereotypes of American Jewish/Israeli men 104–105
Herman, David 206
Hermon (Mount) 153

Heroes
 American 141–142
 Israeli 129, 133, 135
Herzl, Theodor 96
Hine, Edward 117
Hirshhorn, Sara Yael 148
Historicity 183
Hitler, Adolf 113
Holocaust (Shoah) 95–97, 99, 101, 114, 125, 148, 151, 154, 155, 196, 199, 200, 201, 202 210, 213, 214, 215
 Survivors 151
 Righteous Among the Nations 200
 Post-holocaust image 157
Holy Land 116, 119
Hybridity 182, 184, 185
 Hybrid 176, 185
 Transformational hybrid 187, 187*n*61
Hytner, Nicholas 206

Ibrahim, George 209, 209*n*20
Identity
 Jewish 145
Independent, The 213
IDF (Israel Defence Forces) 121, 216, 219, 234–235, 254*n*61
 Soldiers 120
 Tze'elim Military Base (Baladia) 121
Im Nin'alu 186
Inbal Dance Theater
 Company 176, 177, 180, 195
 In the present 176, 177
 And contemporary choreographers 182, 183
 As exotic folklore 180, 187
 Financial/organizational difficulties 182
 First tour 181
 Heritage and legacy of 177, 182, 190
 Inbalite body/bodies 179, 185, 187
 Inbalite language/technique 176, 177, 179, 183, 184, 185, 187, 188
 And innovation 177
 Reception abroad of 177, 180, 181
 Reception in Israel of 177, 180, 181, 182
 And stylistic integration 176, 177, 179
 And Yemenite ethnicity 176
International Solidarity Movement (ISM) 216, 217, 219

International Style
 Bauhaus style 59
 In collective memory 59
 In Tel Aviv 60
 School 63
Iontef, Yanek 33
Iranian Revolution 197
Irgun 215
Islam, Shia 197, 198
Israel
 Ministry of Culture 220
 The Children of Israel 110
 And relation to United States 95–96, 97–98, 99–100, 101, 102, 104, 106–108, 111
 As authentic Jewish homeland 96, 99–100, 101–102, 103, 107–108
 As "Jewish pastoral" 103
 Jewish State 145
 State 113, 114, 115, 120, 123, 204, 205, 206, 207, 209, 211, 213, 214, 215, 217, 220, 223
 Zion 114, 116
 Dance field in 178, 180, 181, 182, 188
 Israeliness as image of 176, 191
 Institutionalized Dance Companies in 177, 181, 182*n*32
 Israel Festival Jerusalem 185
 Israeli folk dances 176, 176*n*2, 177, 178
 New Israel 176, 176*n*2, 181
 New Jew 177*n*3
 State of 178
 Secular Israelis 148, 151
 Religious Israelis 148, 151
 Yishuv of pre-State 178
 See also Kibbutz; *Masekhet*
Israel Museum 40–42
Israeli Art canon 41–43, 52

Jacobson, Howard 211, 213
Jaffa 220
 Al-Bahr mosque 70
 And Gentrification 71
 As the Levant 68–69
 Churches 71
 In pop culture 67
 Libyan synagogue 71
 Modern Jaffa 69, 71
 Old City 68–70
 Port 68

INDEX

Jarrar, Khaled 231–232, 241–242, 244–245, 248–252, 253
Jefferson, Thomas 110, 111, 114, 118, 123
Jerusalem 111, 113, 116, 117, 118, 119, 209
 City of God 111
 Christian Quarter 156
 Mount Scopus (British Military Cemetery) 156
 New Jerusalem 116, 125
 Old City 156
 Via Dolorosa 209
Jewish Art in Eretz Yisrael (book) 43, 45–47
Jewish authenticity
 And gender 96–97, 108–109
 Identity
 In history 96–97
 In literature 98, 100–101, 103, 107, 108
Jewish Chronicle, The 211, 213, 217
Jewish stereotypes 131, 133
Jewish Virtual Library 216
Jewish Yishuv 23
Jezreel Valley 170, 174
Jones, Bill T. 87
Jordan 153
Judean Mountains 117
Judeo-Christian 115, 121

Kahanoff, Jacqueline
 Levant 56n9, 63n42, 70n71
Kaniuk, Yoram 156
Kaplan, Amy 113
Kay, Adah 206n7
 Welcome to Ramallah 206
Keret, Etgar 69
Keren, Tali 110, 111, 112, 114, 116, 122, 123, 124, 125, 126
Kermode, Frank 43–44, 48
Khlefi, Muna 209
Khomeini, Ruhallah, Ayatollah 197
Kibbutz 197
 Kibbutz Ayelet Hashar 197
 Kibbutzniks 151
 Kibbutzim (plural) 178, 179
 Zionist ethos and the 178n6
 See also Israeli Folk Dances
Kirkland & Ellis (law firm) 221
Kichka, Michel 60
 And Bauhaus 61

Kis, Nicholas 22
 Korén (Korngold), Eliyahu 28–29
 Korén (typeface) 28–29
Kornfeld, Avraham 34
Koolhaas, Rem
 Delirious New York 118
Ku Klux Klan 117
Kushner, Tony 88, 211, 212, 213
Kustow, Michael 206

Lachman, Michal 212
Laughton, Stephen
 One Jewish Boy 205
Lambert-Beatty, Carrie 232, 239
Lanzmann, Claude 145, 148, 150, 151, 152, 153, 154, 155, 157
 Why Israel 150
 Shoah 151
 Tsahal 152
La'or, Yitzhak 260
Lavi-Turkenich, Liron 34
 Le Bé, Guillaume 22
 Le Witt, Jan (Yacov) 25
 Letraset 30
Leader, Kate 210
Lebanon 121
Le Corbusier 168
Lechet 176, 188, 189, 190, 191, 195
Lepecki, André 182
Levi-Tanai, Sara
 Artistic Approach of 176, 177, 179, 180, 190, 191
 A Wedding in Yemen by 187n57
 Biography 179
 Cultural Pluralism 177, 180, 185, 191
 Inbal Dance Theater and 176, 177
 Innovation 179
 Resignation 182
 Stylistic Integration 179, 189
 Yemenite tradition 177, 179
Levin, Aharon 261, 269, 274n36
Levin, Hanoch 260, 271, 275
Levinson, Jerrold 187n61
Levant 117
 Area 55, 63–64, 69
 Culture 55n3, 69
Levenson, Steve 81
Levy, Shimon 258

Levy, Yagil 261
The Life and Morals of Jesus of Nazareth
 ("Jefferson Bible") 112
Lichtenstein, Jonathan
 Memory 206n7
Linden, Sonja
 Welcome to Ramallah 206n7
Liverpool 213
Likud 113, 115
Loach, Ken 222n77
Locke, John 81
Loos, Adolf 172
Lubtchansky, William 151

Ma'apach ("upheaval") 150
Machado, Edward 92
Maleki, Khalil 201
Malka Yellin, Liora 180
Manchester Library Theatre 222n77
Marber, Patrick 221
Margolin, Deb 87, 89
Marker, Chris 147
 Third Side of the Coin 147
Marketing 130–133, 137, 142
Martin, Carol 84–85
Martin, John 181
Marvel Comics
 Excalibur 65
 Incredible Hulk 58–59
Masculinity
 In American culture 97, 99–100, 101–102, 104, 106, 108–109
 In Israeli culture 96–97, 99–100, 101–102, 105, 108
 Paradigms of 95–97, 99–101, 102–103, 104–105, 107, 108
Masekhet 178
 Masekhtot (plural) 179
 See also Israeli Folk Dances
Maskit (company) 186
 Galabias 186
 A Wedding in Yemen 187n57
Masoud, Ahmed 213
 Go to Gaza Drink the Sea 213
Masterfont 32
 Meirav, Danny (Ha'Tayas) 34
 melting pot 30
 Meruba (typeface) 22–23

Meshullam Cusi Rafa ben Moshe
 Ya'acov 21
Miriam (typeface) 25
Moshe Spitzer 26, 28, 29
Multi-Gender Hebrew (typeface) 34
Mauss, Marcel 189
McCain, John 113
Megged, Aharon 275
Melting Pot 178, 183
Mensch 108
Merchant of Venice, The 205
Messiah 111, 125
 Messianic vision 120
 Messianic affinity 123
Mishory, Alec 45
Mitchell, Juliet 286–8
Mitchell, W. J. T. 231, 249
Mizrachi
 Immigration of 178
 ethnic origin/identity 176n3, 177n3
 Exclusion 184
 exoticism 176, 191
 Living in Dimona 151
Mizug Galuyot 180
Modan, Rutu
 And Bauhaus 61, 63
Modern Jewish art 40, 42–43, 45–47, 49–52
Moffatt, Lynn 85
Mormons 114
Morrison, Cheryl 120, 121, 123
 Israel Outreach of the Faith Bible Chapel 120, 125
Mosaic (magazine) 217
Mossad, The
 And Tel Aviv 65
Moses (Prophet)
 Red Sea Parting 110
 and the Israelites 114
Most, Andrea 80–81
Mr. Sammler's Planet 95–97, 109
Muscle Judaism 96–97

Naderpour, Nader 201
Napoleon Bonaparte 119
Narkis Block (typeface) 30
 Narkis Hadash (typeface) 30
 Narkis Tam (typeface) 30
Narkis, Zvi 27, 30
Natan, Ben 34

INDEX

National Theatre, London 206
Nationalism 43, 45, 48
Native Americans 123
Navon, Aryeh 59–60
Nebbish 104
Ne'eman, Yuval 156
Netanyahu, Benjamin 113
New Jew, The 96, 105
The New Jew (TV show) 145n2
New York Theater Workshop 216
Nicola, James 85, 92, 216
Nordau, Max 96
Nouvelle Vague 149

Occupied Territories 148, 205, 220
Ofakim Hadashim (artist group) 45
Olim. See Aliyah
Olympia, Washington 219
Operation Shylock: A Confession
 And emasculation 98–99, 100, 102–103
 And Israel 98–99, 100, 102–103
 And Jewish authenticity 100, 102–103
Oriental 177n3, 178
 Orientalist 187
 See also Mizrachi
Orientalism
 Christian 120
Ornamentation 171–172
Oron, Asher
 Oron (typeface) 30
Oslo (play) 79, 79n2
Oslo Accord 208
Our American Israel: The Story of an Entangled Alliance 113
Oz, Amos 145

Pahlavi, Mohamad Reza, Shah 197
Palestine 157, 208, 216, 223, 231–232, 240–242, 245–254
 Ottoman 119
 Palestinians 121, 148, 157, 206, 208, 215, 218, 219
 Palestinian National Authority (PNA) 232n5, 242, 249, 250
 State of Palestine 231, 241–242, 243n39, 245, 247, 250, 251, 254
Parafiction 232, 236–237, 239–241, 244n40, 250, 253, 254

Parmigiano (typeface) 33
Pascal, Julia 90
Passport(s) 232, 242–244
 Passport stamps 231–232, 241–245, 247, 251
Pence, Mike 115
Philadelphia 118
Pinkus, Yirmi
 And Azrieli Center Complex 66
 And Bauhaus 61, 63
 Hamora Hava 61
Pinter, Harold 206, 217
Pipik 98–103
 See also Operation Shylock
Plato 239–241
Plots 129, 132–133, 134, 138, 141
Portnoy's Complaint 98
Postal stamps 232, 241, 245, 247–253
Postec, Ziva 151n19
Postmodern
 Features 182
 See also globalism, transculturation hybridity

Quran 112

Rafah 216, 219
Ramallah 209
Rancière, Jacques 146n
Rashi (typeface style) 21n11
 Rosenberg, Zvika 32
 Rutz (typeface) 33
Ram, Uri 146n4
Rechter, Zeev 163, 166–168
Redgrave, Vanessa 92
Remez, Ari 220
Reshef, Nimrod
 And Bauhaus 63
 Uzi: Urban legend 63, 65, 67–68, 71
Richard Brothers 116, 118, 119
Rickman, Alan 84 204, 216–220
 My Name is Rachel Corrie 204, 206, 216–220
Rivlin, Reuven 146n6
Robbins, Jerome 180
Rogers, J. T. 79
Roman Empire 119
Ronen, Dan 178

Rooney, Sally 224
Roosevelt, Franklin Delano 114, 115
Rose, Jacqueline 211
Rotbard, Sharon 164–165, 169
Roth, Ari 86, 88–89
Rothberg, Michael
 Implicated subject 126
Roth, Philip
 And literary stand-ins 98–99, 101
 Role of Jewish-American male identity in literary oeuvre 98–100, 101–103
 Character in *Operation Shylock* 98–103
Rotman, Brian 204, 213–216, 220
 A Land Without People 204, 206, 207, 213–216
Royal Court Theatre (London) 210, 216, 220, 221, 222, 222n77, 223
Ruach Acheret (exhibition) 45
Rubasingham, Indhu 206

Sabra 177n3, 178
 Project 96, 109
 See also Ashkenazi; Israel; New Jew
Sack, Matanya 167
Sacks, Jonathan 93
Saffold, Tom 216
Sahar, Michal 34
 Sal'it (typeface) 30
 Sapir (typeface) 25
 Schocken-Baruch (typeface) 26
 Sela, Shmuel 30
 Shomer, Michal 34
 Soncino family (printers) 21–22, 33
 Soncino (typeface) 21–22, 26, 36
 Stam (typeface) 26
Said, Edward 69n64, 119
Sakakini, Khalil el 215
Salon (magazine) 218
Sammler, Artur 95–97, 109
 See also *Mr. Sammler's Planet*
Sartre, Jean-Paul 149n14, 153n29
Schlemiel 104
Schwartz, Karl 45–51
Second Intifada 121
Segev, Ilana 120, 121, 123, 125
 Gvanim Dance Company 120
Settlers (Israeli) 151
Shafi, Haider Abdel 209

Shaham, Natan 269
Shamir, Moshe 275
Sharm El-Sheik 153
Shani, Mor
 And artistic ethics 190, 191
 Artistic practices 183, 186, 191
 And contemporary features 182, 184
 And contemporary folklore 184, 185, 187, 188, 189
 Critical reflection 176, 182, 187, 190, 191
 And cultural pluralism 182
 Dance trilogy 176, 177, 182, 191, 195
 And Inbal's present 182
 hybrid bodies 187
 And re-historicizing/renegotiating Inbal 183, 184, 191
 And re-imagining the Inbalite language 185, 186
 And Sara Levi-Tanai's legacy 176, 177, 183
 And stylistic integration 177, 182, 184, 189
Sharon, Ariel 216
Sharon, Aryeh 165–166
Shem-Tov, Naphtaly 257n, 258, 259n, 260
Shohat, Ella 281, 290
Sholem, Gershom 151
Shovrim Shetikah (Breaking the Silence) 220
Schrobsdorff, Angelika 152n23
Sierz, Aleks 90
Silas, Shelley
 Eating Ice Cream on Gaza Beach 206n7
Simple Dance 176, 182, 183, 184, 185, 188, 190, 191, 195
Sinai Desert 156
Six Day War 153, 154, 198
Smith, Al 220, 221, 222
 Rare Earth Mettle 220, 221, 222, 223
Simulacrum 121, 232, 240–241, 244, 248n47, 251, 253–254
Society
 Israeli 146, 148, 153, 156
 French 149
 Portuguese 149
Sokolow, Anna 180
Solomon, Alisa 88, 211, 212, 213
Sontag, Susan 145, 148, 155, 156, 157
 Promised Land 155–157
Soviet Union 115

INDEX

Stafford-Clark, Max 222*n*77
Starmer, Keir 222*n*77
Steinhardt, Jacob 51–52
Stephens, Bret 88
Stirling, Richard
 Seven Other Children 213
Sykes-Picot Agreement 214
Syria 119, 121
Szmuk, Nitza 169

Talmud 113
Tamir 104–105, 107–109
 See also *Here I Am*
Tammuz, Benjamin 52
Tehran (Iran) 196
Tel Aviv
 As garden city 58–59, 66
 As global metropolis 72
 As Oriental Mediterranean city 59
 As white city 59, 61, 63, 66
 Azrieli Center Complex, The 66, 67
 Carmel open market 65
 Famous Bauhaus buildings 63*n*39
 Herzliya Hebrew Gymnasium 58–59, 64, 66
 in Pop culture 55, 64
 Meonot Ovdim (labourer's housing) 60
 Neve Sha'anan Neighbourhood 63*n*38
 Representation 56
 Shalom Meir Tower 64–65, 67
 Skyscrapers 61, 63, 67
 Tel Aviv port 58–59
 The ship building (56 Levanda St.) 63
 urban icons 55, 58, 61, 66–67, 72
Tel-Aviv Circle 166
Tel Aviv Museum of Art 45–46
Theatermania 219
Third Space 176, 182, 183, 191
 In culture 183
 Mor Shani and 176, 177, 182, 191
 Sara Levi-Tanai and 177
 See also *Three Suggestions for Dealing with Time*
Three Suggestions for Dealing with Time 176, 177, 182, 183, 190, 195
Times, The (London) 218, 224
Transculturation 182, 184
Tricycle Theatre (London) 206

Trouillot, Michel-Rolph 161
Truman, Harry 115
Trump, Donald 115
Tudeh Party of Iran 197, 201, 202*n*24

UK Jewish Film Festival 206
Uncanny 284–286
Un-Charting 110, 116, 123, 124, 125
Underground Culture 72
UNESCO 169
United States 110, 111, 114, 115, 120, 123, 124
 Army Corps of Engineers 121
 As authentic Jewish homeland 97–98, 101–102, 103, 106–108, 109
 And Israel 97–98, 99–100, 101, 102–103, 104, 106–109
 Constitution 112
 Declaration of Independence 110, 112
 Embassy in Jerusalem 115
Upton, Dell 118
Urban symbols
 Concept 56
 Herzliya Hebrew Gymnasium 58
 Levant Fair Grounds 59
 Symbolic value 57
 Vs urban icon 56–57
Utah 114
Utopia (Thomas More) 124

van Dijck, Christoffel 22
 Vesper (typeface) 33
Variety 208
Vaccaro, Jeanne 282, 296
Venice Biennale 162, 163–169, 174
 Israeli Pavilion 162, 163–169, 170–174
Villains
 Arab 134, 137
 Israeli 135, 137, 141
Viner, Katherine 84, 204
 My Name is Rachel Corrie 204, 206, 216–220
Visual culture 55*n*3

Wall Street Journal, The 223
Wallin, Moshe 181
Wallish Block (typeface) 25
War of 1948 (War of Independence) 123
Washington DC 111

Waxman, Dov 81, 83
Weil, Gotshal & Manges (law firm) 221
Weinstein, Gal 161–163, 169–174
 Jezreel Valley in the Dark 170–171, 173–174
 Ornament 171–173
 Sun Stand Still 169–174
 The Valley of Jezreel 173
 Persistent, Durable, and Invisible 170, 172–173
Weiss, Meira 178
Weiss, Sarah and Danny 208
Weizmann, Chaim 214, 215
Wesker, Arnold 206
West Bank 113, 121
Wilson, John 117
While the Fireflies Disappear 176, 185, 186, 187, 188, 191, 195
White City 164–165, 166, 169, 172, 174
White, Hayden 43–44, 48
Wolman, Dan 149
World War 1 156, 204
World War 2
 Italy 149

Yad Vashem 151, 153, 154, 209, 196, 199, 200, 202
Yahalom (typeface) 30
 Yardeni, Ada 30
 Yenni, Nir 34
Yemenite
 Israeli social attitude and 176
 Contemporizing of 177
 cultural ethnicity 176
 dance step 178, 186, 187, 188
 Mizrachi exoticism and 176, 187
 Tradition 185

See also Inbal Dance Theater; Sara Levi-Tanai
Yeshiva-bokhur 108
Yehoshua, A. B. 152n, 260
Young Vic (London) 216, 217
Yom Kippur War 150, 155, 156

Zalmona, Yigal 40–43, 45–46
Zer Aviv, Mushon 34
 Zionist movement 23, 25, 30
Zertal, Idith 154
 Death and the Nation 154
Zion Canyon (Zion National Park) 114
Zionism 42, 48, 114, 120, 198
 American Zionism 133–135, 137–138
 And National pride 64, 66, 70
 Anti-Zionism 146
 As narrative 67, 70, 72
 As political ideology 96
 Founders 55
 Ideology 56, 63, 66, 71
 In America 97
 In literature 95–96, 97–98, 99–100, 102–103, 105, 107
 vs Levant 56
 Literature 48
 Movement 114, 119
 Zionist ideology 150
 Zionist "short century" 154
 Zionist values 149
Zohar, Uri 149
Zuckerman, Henry/Hanoch 98–101, 103, 105
 See Also: The Counterlife
Zuckerman, Nathan 98–103, 105
 See Also: The Counterlife

Printed in the United States
by Baker & Taylor Publisher Services